blue
rider
press

After
ANDY

ALSO BY NATASHA FRASER-CAVASSONI

*Sam Spiegel: The Incredible Life and Times of Hollywood's
Most Iconoclastic Producer, the Miracle Worker Who Went
from Penniless Refugee to Show Biz Legend, and Made Possible*
The African Queen, On the Waterfront,
The Bridge on the River Kwai, *and* Lawrence of Arabia

Tino Zervudachi: A Portfolio

Dior Glamour

Monsieur Dior: Once Upon a Time

Loulou de la Falaise

BiYan

Vogue *on Yves Saint Laurent*

Vogue *on Calvin Klein*

After ANDY

– Adventures in Warhol Land –

NATASHA FRASER-CAVASSONI

Blue Rider Press
New York

blue
rider
press

An imprint of Penguin Random House LLC
375 Hudson Street
New York, New York 10014

Photography credits can be found on pages 323–324.

Blue Rider Press is a registered trademark and its colophon
is a trademark of Penguin Random House LLC

Library of Congress Cataloging-in-Publication Data

Names: Fraser-Cavassoni, Natasha, author.
Title: After Andy : adventures in Warhol Land / Natasha Fraser-Cavassoni.
Description: New York : Blue Rider Press, 2017.
Identifiers: LCCN 2017012299 (print) | LCCN 2017013244 (ebook) |
ISBN 9780399183553 (ebook) | ISBN 9780399183539 (hardback)
Subjects: LCSH: Warhol, Andy, 1928–1987—Influence. | Fraser-Cavassoni, Natasha—
Travel—New York (State)—New York. | Warhol, Andy, 1928–1987—Friends and associates. |
Artists' studios—New York (State)—New York. | Pop art—New York (State)—New York. |
New York (N.Y.)—Intellectual life—20th century. | New York (N.Y.)—Social life and customs—
20th century. | Socialites—New York (State)—New York—Biography. | British—New York (State)—
New York—Biography. | Young women—New York (State)—New York—Biography. |
BISAC: BIOGRAPHY & AUTOBIOGRAPHY / Personal Memoirs. |
BIOGRAPHY & AUTOBIOGRAPHY / Artists, Architects,
Photographers. | ART / History / Contemporary (1945–).
Classification: LCC N6537.W28 (ebook) | LCC N6537.W28 F73 2017 (print) | DDC 700.92—dc23
LC record available at https://lccn.loc.gov/2017012299
p. cm.

Printed in the United States of America
1 3 5 7 9 10 8 6 4 2

Book design by Lauren Kolm

FOR REBECCA, FLORA, BENJIE,
DAMIAN & ORLANDO

———

01 *Andy's Memorial*

When I moved to Manhattan, Andy Warhol's memorial was my first New York society event. It took place on April 1, 1987. *The New York Times'* Grace Glueck described the attendees as a "glittering" crowd and some of "the world's most droppable" names in "art, fashion, society and entertainment." In many ways, it was the perfect way to start my adventures in Warhol Land.

I knew most of the service's details in advance because I was working at the Warhol Studio. Four days before Andy's death on February 22, I'd been officially hired. After lunch, Fred Hughes, Andy's business manager, had set my terms and salary—five hundred dollars per week—and then we met up with the artist, who'd just arrived from one of his shopping

expeditions. It was about twelve hours before he checked into New York Hospital.

This made me the last employee to be hired under Andy. Or the last English Muffin, which was the term for well-born British women working in the place. It was a tradition that was put down to Fred's love of Old Blighty and its customs. Still, the artist was not averse. Noticing that there's an acceptance and even veneration of the different among the English. When meeting Andy for the first time in 1980, I had no idea that his white hair was a wig. Having been brought up around eccentricity, I thought Andy looked pretty straight and normal in his jacket and jeans, actually.

Sabrina Guinness, who never worked for Warhol but was part of his extended circle, senses that "Andy was surprised by the English girl's confidence. The type who turned up in laddered tights, showed no fear, and chattered away," she says. The social ease was of the utmost importance. "Andy liked beauties and talkers," says Bob Colacello, who ran Warhol's *Interview* magazine for twelve years. To focus on the latter, I have yet to meet a British woman who doesn't have the gift of the gab. Or, taking it to extremes—my case—couldn't talk the ear off a donkey. There was also the lively sense of the ridiculous. Again to quote Colacello: "You couldn't be around Andy for any length of time unless you had a sort of camp sensibility and Oscar Wilde approach to life."

My chat-up and charm-school skills made Fred think I was the perfect casting for Andy's MTV program. Being self-effacing and energetic, I would be the ideal interviewer on-screen and foil to the enigmatic Pop artist. So imagine Fred's irritation and fury when I pretended to be blasé about Andy's memorial when the guest list was hopping—gasp!—with names like Richard Gere, Roy Lichtenstein, Calvin Klein, Yoko Ono, and Raquel Welch and actually sent me

into a total tailspin. Fortunately, such behavior came to a grinding halt when Fred asked what I was going to wear. "Oh, I really don't know," I said. A major case of Pinocchio because as soon as I heard about the event I knew it would be my Max Mara wool skirt suit and Manolo Blahnik suede pumps that I'd worn to my father's funeral in 1984. And I can still picture Fred turning to me, dapper as ever in his dark charcoal-gray suit, crisp white shirt, and yellow-and-orange stripy tie with gold tiepin, and saying, "This doesn't happen every day, Natasha." Andy's memorial was huge for Fred, and he expected enthusiasm. The artist's death must have devastated Fred, just as it had everyone else. Vincent Fremont, vice president of Andy Warhol Enterprises, compared hearing the news to "being punched in the stomach and thrown out the window." However, the Texan-born Fred was too stoic to voice such feelings. "He behaved like Jackie Kennedy did when her husband was assassinated," recalls Peter Frankfurt, who knew Andy from childhood. "He was determined to keep it all together."

Keeping it together meant focusing on appearance. Fred also reveled in women making an effort and was slightly miffed if they didn't. One of his favorite quotes about dressing up came from Loulou de la Falaise, designer Yves Saint Laurent's fabled muse, who once admitted, "Whenever I hear that someone has died, I always think, 'What *am* I going to wear to the funeral?'"

Initially, there was a plan that Zara Metcalfe, my flatmate, and all the other Manhattan-based smart Brits, like *Vanity Fair*'s Sarah Giles, *Tatler*'s Isabella Delves Broughton, and Miranda Guinness, who worked for Mick Jagger, would go in together. That idea didn't pan out. It was just as well, because I was much more interested in standing outside and people-watching. Even then, I sensed that we would be witnessing history. Andy's memorial service was the Big Apple's

equivalent of a royal event like the Queen's Jubilee or Charles and Diana's wedding. There was also the fact that, like Andy, I loved celebrities. Bob Colacello reckons that being "the kid from the wrong side of the tracks from Pittsburgh" made Andy impressed with famous people. Not quite my case. I wasn't so much a groupie craving a mosh pit as I was someone who wanted to stand and stare from a distance. Andy's first autograph was Shirley Temple's. Mine was George Savalas's—Kojak's younger brother. Never has a B TV star been more thrilled to be spotted on the Fulham Road. The situation had then dramatically improved when my mother, the bestselling historian Antonia Fraser, went off with the playwright Harold Pinter. And suddenly I had Edward Fox, Steve McQueen, and Jack Nicholson in my collection of autographs.

Although the morning of Andy's service was crisp and springlike, the limousines lined up outside St. Patrick's Cathedral looked dark, foreboding, and vaguely out of place, suggesting a night at Nell's or another nightclub. Guests emerged from their cars in front of the neo-Gothic architecture and two soaring steeples on Fifth Avenue, and passed the crowd gathered on the pavement. Along with the public, and the policemen monitoring the events, I hovered and watched.

Wearing large insectlike sunglasses, Yoko Ono appeared in a black pantsuit with a preppy-looking escort who I discovered was Sam Havadtoy, her boyfriend. Nick Love, an actor pal from Los Angeles, then appeared with Fred. John Warhola, one of Andy's brothers, made his entrance. With his hat, he reminded me of a racing bookie. And then there was a flood of celebrities.

Calvin Klein, wearing a loud pinstripe suit, resembled his *Interview* cover even if he was senator-handsome. His appearance was all-American, and Kelly, his wife, was slim and coltish. They were the fashion power couple.

Liza Minnelli arrived on the arms of Mark Gero, her younger sculptor boyfriend, and Halston. As she was Hollywood royalty and instantly recognizable, the crowd was more excited by her than the Kleins. I'd already met Halston. That day, he was a wearing a suit, tie, and red scarf with the requisite large sunglasses. Albeit film star–like, the fashion designer looked better casual. On various occasions, he'd come into the Warhol Studio wearing gray slacks and a pale-colored cashmere sweater with another one wrapped around his neck. There was also the hair, the height, and the walk. The fifty-four-year-old's brief appearances lingered for hours afterward. Graceful, he gave an impression that his body was both fluid and faultless. When I answered the telephone, there was a bit of a ridiculous English accent. "Is Mr. Hughes there?" he'd say. If it was a tease, I held back from tittering. Halston never hid his impatience, and ultimately had a regard that withered.

No question, Raquel Welch was the most famous celebrity in the group. Sporting cropped, spiky hair, she arrived in a fur coat and seamlessly posed in teetering high heels. Beautiful and vivacious as she was, her height was a surprise. Raquel Squelch (my nickname for her because of her generous cleavage) was a pocket Venus! It made no difference to the crowds. They were delighted. Not to be outdone, Grace Jones, wearing leather and wool—I presume Azzedine Alaïa—gave a sort of mini press conference on the cathedral's steps. Meanwhile, the photographer Robert Mapplethorpe walked past. Good-looking, he had a peachy bloom and possessed a major mane of hair. There was also a sense of purpose in his stride.

Richard Gere rushed in with his Brazilian girlfriend, Sylvia Martins. The Hollywood heartthrob was wearing jeans. Almost on cue, Bianca Jagger arrived very late, with Italian film producer Franco Rossellini. Not a morning person, she still looked fetching in a black

felt hat, large gold bauble necklace and chunky bracelets, long black trench, and flat shoes. Then singer Debbie Harry and fashion designer Stephen Sprouse appeared. Although she was sensual—a case of messy blond hair and Slavic cheekbones—the punkish-looking Sprouse had his eyes cast down and was smoking. Unmade bed in attitude, Harry and Sprouse personified cool. In fact, out of all the looks that I viewed that day, they and Fred Hughes defined the term *timeless*.

One person who summed up the 1980s was Isabella "Issy" Delves Broughton, who later morphed into Isabella Blow, the outrageous Philip Treacy hat–wearing fashion icon. Her outfit consisted of a boxy skirt suit with vast gold buttons and a hornets' nest of a hat made of net and black-lacquered straw.

Issy captivated Andy. Like him, she got the big picture and had a truffle nose for people who counted. She also intrigued the artist Jean-Michel Basquiat, who hung out at her desk when she had worked at *Vogue*. On initial contact, she seemed like the naughty little cherub who would tug at God's beard. Nothing then seemed sacred to Issy.

A cousin of mine by marriage, she spoke briefly with me before the service. Her suit was Valentino, the very expensive Italian couturier. Surprising, until Issy then revealed that her £50,000 trust fund had been blown on designer clothes. A detail that Andy would have appreciated, even if it was mildly exaggerated. That morning, when putting on her sinister square sunglasses and applying yet more garish red lipstick, she became pure Fellini, bringing to mind his films from the 1970s.

Andy's service had been strangely moving. I write "strangely" because I discovered facets of his personality that I hadn't been aware of. Going through the program, I read the tribute by the Reverend C. Hugh Hildesley, the pastor of the Church of the Heavenly Rest,

who described Andy serving food to the homeless at the church at Thanksgiving, Christmas, and Easter. I knew Andy was Catholic. It was an element of our childhoods that we had in common. However, I hadn't realized what a believer he was. Most Catholic people I knew were lapsed.

On the altar banked with tulips and forsythia, the Reverend Anthony Dalla Villa eulogized Andy as "a simple, humble, modest person, a child of God who in his own life cherished others." I wondered about this. Andy was reputed for using others. Like everyone, I had gobbled up *Edie: American Girl*, the biography of Edie Sedgwick, written by Jean Stein and edited by George Plimpton. The book showed Andy in a fairly poor light, except that, if you read between the lines, it was obvious that Edie was a complete addict. Whether in a heightened anorexic state or flying high on heroin, she had her finger on the autodestruct button.

John Richardson addressed this side of Andy in his eulogy. Now known for being Picasso's biographer, Richardson was then revered as an establishment figure—an erudite art historian, exhibition curator, and critic who didn't mind Warhol photographing him wearing full leather "cruising" regalia. In Richardson's opinion, the "hangers-on" at the Factory in the 1960s were "hell-bent on destroying themselves" and Andy was "not to blame. . . . He was not cut out to be his brother's keeper," said Richardson, because that would have destroyed Andy's detachment, which was "his special gift." However, Richardson felt that Andy had "fooled the world into believing that his only obsessions were money, fame, and glamor and that he was cool to the point of callousness." In fact, Richardson viewed him as more of a "recording angel" and thought that the "distance he established between the world and himself was above all a matter of innocence and of art."

In her eulogy, Yoko Ono, the widow of John Lennon, noted

Andy's kindness toward her son when his father was assassinated. She viewed him as "a mentor to Sean." When Ono said that, I looked around the room and wondered where Jade Jagger was. Andy had been important to her. Then again, her parents were alive.

Afterward, Nick Love read from Andy's writings. They captured the artist's self-effacement. "A lot of people thought that it was me everyone at the Factory was hanging around, that I was some kind of big attraction that everyone came to see, but that's absolutely backward," he wrote in *POPism*. "It was me who was hanging around everyone else. I just paid the rent, and the crowds came simply because the door was open." This caused a ripple of laughter. As did Andy's sentiment about death. "I do like the idea of people turning into sand," he wrote in *The Philosophy of Andy Warhol*. "And it would be very glamorous to be reincarnated as a great big ring on Elizabeth Taylor's finger."

To the sound of Ravel—piano music that had been chosen by Fred—we poured out of the cathedral. There was a brilliant blue sky, and I remember seeing the likes of fashion designer Diane von Furstenberg, who was with Alain Elkann, her Italian writer boyfriend; São Schlumberger, the Paris-based art patron, accompanied by Bob Colacello; Lynn Wyatt, the lively Texas socialite, with Jerry Zipkin, Nancy Reagan's favorite walker. Andy had done portraits of Furstenberg, Schlumberger, and Wyatt.

En route to the memorial luncheon, Issy Delves Broughton grabbed me. "Come with us," she said, hailing down a taxi. "Us" was the actor John Stockwell, who was an Andy intimate. An odd coincidence, but when I first met Andy in 1980, he had teased me about how I should step out with Beauty Samuels (Stockwell's occasional nickname and original surname). I briefly mused on this as the recently separated Issy batted her spiderlike lashes and chirped away

at Stockwell, who took it in his stride. When we arrived at Billy Rose's Diamond Horseshoe (aka the Paramount Hotel), however, and Issy started doing her favorite party trick—flashing her tits—Stockwell looked briefly surprised. Having flown in from London, Issy was up for fun and games. And showing her ample pair was part of that.

Done with finesse, the flashing was quick as a wink. So quick that it had fellow guests wondering if they had imagined the deed. Just as I was having an intense conversation with John Richardson—it concerned Brigid Berlin's elegant look that day—Issy caught my eye and flashed. Covering my mouth, I both could and couldn't quite believe it.

Wherever I went—whether being introduced to Calvin Klein, Diane von Furstenberg, or other notables by Fred—the threat of Issy's tits hovered. Fortunately, Mr. Hughes did not see what she was doing. Being wound-up and nervous, he was not in the right mood, when normally he was as amused by Issy's antics as Andy was. They both admired her utter disregard for other people's opinion. There was also her flapper girl–like appearance: the then naturally champagne-blond hair, the heavy lids, and the shredded state of her satin pumps.

The buffet lunch was *the* art world event, further enhanced by *The Last Supper*, one of Andy's paintings from his final show, and the waiters wearing a Stephen Sprouse–designed apron using Andy's camouflage print. When talking to everyone, it was hard not to be struck by the genuine fondness and good feeling toward the artist. Kenneth Jay Lane, the king of costume jewelry, who had known Andy from the 1950s, watched him evolve from "the sweetest thing but ugly as sin with a green nose" to a character "who sorted his skin out" and then succeeded spectacularly.

Andy managed to keep in with his old acquaintances and

effectively create new ones. He seamlessly swam in the worlds of both uptown and downtown. It was not the case of Frederick W. Hughes. "Fred was intimidating, the way he dressed, no one was Mr. Style like Fred," recalls Vincent Fremont. "There were preconceived ideas. . . . Unlike Andy, he didn't do the Mudd Club and places like that." Fred preferred the company of the well-born and/or elegant; he didn't like crowds or mess. Having had my share of the latter in London in the 1980s, I understood. But the downtown art world was not at ease with his attitude.

I realized this when harmlessly mentioning his name. There were frowns and even a *froideur*, whereas the ever popular Vincent Fremont was perceived as Andy's adopted nephew—he had worked at the Factory since 1969—and Paige Powell, who ran *Interview*'s advertising, was viewed as Andy's widow. They had hung out constantly, and she had briefly gone out with Basquiat.

Fred was different. Peter Frankfurt reasons that "he represented the changing of the guard at the Factory. After the assassination attempt on Andy, Fred was the first one to put a barrier and cleaned up a lot of the downtown freak-show business. He was going to make a proper business." In the opinion of Peter Brant, one of Warhol's most prominent collectors, "Fred was the perfect person to filter Andy's genius. He was one of the most interesting, well-rounded people, but he never got the credit that he deserved. No one understood how right and special he was." Bruno Bischofberger, Warhol's main European dealer, who had right of first refusal from 1969, recalls the partnership: "I'd look at new work, ask 'How much?' to Andy. He'd say, 'You have to talk to Fred.' Then Fred would say, 'Oh, I have to talk to Andy.' But they always knew what they wanted."

Nevertheless, there was a lingering sense that Fred's business dealings, including the highly profitable commissioned portraits, made

Andy more social than serious. It was hard to agree. During Andy's lost years—the lean times of the 1970s when his work was dismissed by the American art establishment—Fred had taken him to Europe, where he had enjoyed major shows at top galleries like Anthony d'Offay, Daniel Templon, and Lucio Amelio. "He fashioned Andy into an international icon," says Colacello. However, I soon realized that the society portraits were the constant carp against Fred. Although as Vincent Fremont rightly points out, "throughout history, art patrons have been commissioning portraits of themselves, wives, and family." Or to quote Nicholas Haslam, an international tastemaker, "Fred made Andy into an old master." He also introduced Larry Gagosian to Andy. The art dealer would become a key proponent to revitalizing the Warhol market as well as exhibiting the *Oxidation* work in 1986, marking Andy's final Manhattan show of paintings.

During my three years of living in New York, "I miss Andy" was a frequent refrain. Some people opined that the Big Apple changed with Andy's passing. "The steam went out," says photographer Eric Boman. Andy's death created an immediate vacuum, because it was universally agreed that no one was like him. "He was Mr. New York," says Vincent Fremont. Andy was omnipresent: his social schedule for one day may have consisted of a department store perfume launch, followed by the cocktail party of a Park Avenue swell, a cozy dinner for Diana Ross, and finally visiting a club to see a hot New Wave band. "Andy made it seem as if he was everywhere even if he sometimes arrived at places and slipped out by the VIP exit," recalls Fremont. However, a Warhol appearance made an event. "Andy would walk into a room and people would stop," says Wilfredo Rosado, who worked at *Interview* and was a frequent Warhol escort.

Not only was the "Andy suit" recognizable—Warhol's term for his wig, the l.a.Eyeworks glasses, and his uniform of sober jacket, shirt,

and jeans—but everyone felt a benign, approachable vibe about him. "I always say this," says Len Morgan, who worked at the Warhol Studio in the mid-'80s. "We got a lot more out of Andy than he got out of us." Morgan recalls "a generosity to taking you places—I wanted to be an architect, and Andy introduced me to Philip Johnson"—and how "it never felt icky."

It was the business side that impressed Rosado. "When Andy went out, he was always hustling on every angle, getting ads for *Interview*, drumming up portraits," he says. "He often said, 'I've got to keep the lights on.' He did feel this sense of responsibility." Rosado found him "fatherly and concerned. When I say that, people look at me as if I've got three heads!"

CATHERINE HESKETH (NÉE GUINNESS), the Factory's second English Muffin, refers to a curiosity that motivated everything. "Andy would sit next to someone and really want to find out about them, whether they were a lord, a film star, or someone handsome," she says. Far from being "a Svengali" and "a bad influence," he was positive. "That film [*Factory Girl*] that showed him encouraging [Edie Sedgwick] to do all those ghastly things, it wasn't like that at all," she says. "Andy wanted everyone to do the best they could if they were an actor or a writer . . . and work hard. That was his great ethic."

There was also a magnanimous attitude toward other artists. All apart from Robert Mapplethorpe. "They really didn't like each other," states Hesketh. "Maybe they were jealous, but they were pretty rude about one another." Otherwise, Fremont recalls how Andy "never trashed other artists, particularly his fellow Pop ones," and "loved trading work with other artists, particularly the young ones from the 1980s like Keith Haring." When becoming a mentor to Jean-Michel

Basquiat, Warhol collaborated with him and tried to get the troubled artist off drugs. "I found Basquiat scary," says Florence Grinda, a French socialite. "But Andy insisted on bringing him to an important fashion dinner that I organized at Mortimer's." Andy helped young, unknown gallery owners such as Thaddaeus Ropac, then based in Salzburg. "Andy was the only person to take me seriously," he recalls. "Our first night together, he introduced me to Basquiat—that led to a show." Warhol also optioned the film rights of Tama Janowitz's short story collection *Slaves of New York*, based on her relationship with artist Ronnie Cutrone, one of his previous assistants.

Contrary to rumors about Andy's fear of AIDS, he was tender and supportive to Antonio Lopez, the brilliant fashion illustrator who died of the disease a month after him. "Antonio was really worried about his legacy," recalls Rosado. "Andy was so kind and said, 'Antonio, you're the best, you're better than Erté, you're better than all of us.'" He also went to Madonna's AIDS benefit at the Pyramid Club for Martin Burgoyne. "Andy gave money and hugged Martin. He showed up for friends," says Rosado.

There was the sweetness. "I remember him snowballing with my daughter Victoria and other children in St. Moritz," says Doris Brynner. "When I made him the godfather of our youngest son, he came to the church and held the baby," says Bischofberger. There was also the lineup of his mini *Mao* and *Flower* paintings that were easy to sell and handed out as presents. "That's what Andy did and expected," says Fremont.

STILL, WARHOL'S FAME AND CHARISMA could lead to problems. "Everyone wanted to perform for Andy and get his attention," says Hesketh. "They would say things they really shouldn't just to engage

him and his magic quality." Geraldine Harmsworth, the fourth English Muffin, remembers parties where "people behaved like complete twits. They would say, 'Look at me, Andy, I'm really kooky and wild.' What do you say to that? Since he was shy, he would say, 'Gee.' But in private, he talked like a normal person."

Since Andy's magnetism was extraordinary and touched so many different worlds, Ropac wonders if people got tied up with the performance and not the art. "I am sure that Andy was very clear about what he wanted to do," Ropac says. "But it was only later, when his performance was finished, that we could look at his work."

TOWARD THE END OF HIS LIFE, Warhol felt profoundly undervalued and ignored. At a group show in 1982, Leo Castelli exhibited his *Dollar Signs* and *Knives* in the basement and gave star positioning to Donald Judd's ninety-foot sculpture in the front upstairs. The esteemed Castelli had been Warhol's representative since 1964. "It was really the last straw," says Larry Gagosian. "Every artist has an ego, and he called Judd's sculpture 'the spice rack.'" From Castelli's gallery, Andy made a frantic call to Jay Shriver, his studio assistant. "He was very upset and not pleased by how [his work] was hung," says Fremont.

Warhol did not die on a career high, either. "It is possible that he was anticipating something extraordinary, but there was not a new dialogue," states Abigail Asher, an international art advisor. She points out that "his genius was mixing culture and low art—Coke and Campbell's soup tins—and making it into high art" and that his 1960s body of work—*Marilyn, Liz, Elvis,* and the *Death and Disaster* paintings—"created a new language."

Yet thirty years later, the Warhol market has exploded. "Tastes change," says Gagosian, who confirms that all the young prominent

collectors are after Warhol. Nowadays, there's an Andy Warhol Museum; exhibitions are held at major museums—the Metropolitan Museum of Art, Tate Modern, and the Musée d'Art Moderne de la Ville de Paris come to mind—and the artist's prices have soared beyond measure. Jacques Grange, a leading interior designer, puts it down to "the freshness of the work. He remains contemporary and that is the sign of a great artist. Not only was Warhol an exceptional colorist—exceptional!—but he covered so much territory with his repetitions and subject matter."

To give an idea of prices: *200 One Dollar Bills* (1962), bought in 1986 for $385,000, sold for $43.8 million in 2009, and *Triple Elvis*, sold in 1987 for $400,000, is valued at over $80 million today. Warhol, as an artist, has become "really up there"—to quote a favorite Andyism—alongside Pablo Picasso, one of his heroes. He has affirmed the prediction of the German artist and Warhol subject Joseph Beuys, who said that "if the first half of the twentieth century belonged to Picasso, the second half belonged to Warhol."

Asher wonders if the "prohibitive prices of his iconic work have caused a reevaluation of Warhol's late work." A market exists "where there is a supply," she says, but adds: "Does Warhol transport like Rothko?" Still, he greatly suits "a new breed of collector who wants everyone to understand the value hanging on his wall. There is nothing subtle about Warhol. As an artist, he manifests wealth and functions on many different levels."

Whereas many dismissed Warhol as a lightweight during his lifetime—especially the American art establishment—Joseph Beuys pegged that he had "a kind of observing sense in the back of his mind" and an "imaginative process going on." Indeed, with his famous line "In the future, everybody will be famous for fifteen minutes" and his daily tendency to tape and photograph everything, Warhol was a

precursor for celebrity culture, reality TV, and Instagram and other social media. "He was a prophet," says Norman Rosenthal, the art expert. Indeed, thirty years after he died, we are almost living in a Warhol-imagined world. "Andy guessed and predicted it all," says Diane von Furstenberg. "The era of fame, icons, branding . . . he started it all."

Warhol still influences the art world. "When I go and see young artists, they only want to talk about Andy," says Irving Blum, the legendary art dealer. "By silkscreening a canvas and calling it a painting, he started a revolution that continues today." There is also the depth to Warhol's talent. Peter Brant is reminded of religious medieval art of the thirteenth century; collector Éric de Rothschild compares him to Fragonard; Pierre Bergé says he is "as important as Marcel Duchamp." More than anything, Andy was an artist's artist. When Cy Twombly was asked who was the greatest artist of his generation, "without hesitation, he said Andy," recalls Gagosian. Yet in spite of all this praise, Warhol avoided the self-laudatory. "At his home, he kept his own canvases in the cupboard and covered the walls with other artists," recalls Bruno Bischofberger.

Early Years

I first heard Andy Warhol's name via my father, Hugh Fraser. My elder brother, Benjie, and I were in his forest-green Jaguar, headed for our holiday home in the Scottish Highlands. A long drive, or so it seemed to an eight-year-old schoolgirl who lived in London and rarely traveled. The hours were spent asking my father questions. Benjie, older by two years, was the main perpetrator, and *The Guinness Book of Records*—a childhood bible—influenced his line of thought. It tended to be "What's the tallest . . . the biggest . . . most expensive," and my father always seemed to know and often added a further aside on the topic. And that was how Andy came up.

Somewhat typically, the conversation had bounced from the world record of hiccuping—a

man had almost died from hiccuping for twenty-four hours—to mention of Warhol and his film *Sleep*. "He filmed a man sleeping for hours and hours," my father said. Both Benjie and I were rather amazed. Poppa went on to explain that Andy was a New York–based artist who had initially caught attention with his paintings of Campbell's soup cans.

Warhol, Campbell's soup cans, American artist. I loved the idea of America. Upbeat, colorful, it catered to kids. It also represented Elvis, an early heartthrob whose films I devoured on a grainy black-and-white television, and gripping, lighthearted entertainment via American TV series like *The Man from U.N.C.L.E.*, *Hawaii 5-O*, *Mission: Impossible*, and *Star Trek*. They presented a universe that was flash yet predictable in content. The baddies always lost. Then there were my father's friends, the Kennedys. An alliance started by their father, Joe Kennedy, when he was the American ambassador in England in 1938. Socially ambitious, he was keen that his children mix with Catholic bluebloods. In 1945, JFK had canvassed for my father in his first election campaign. And in 1969, my father had been part of Bobby Kennedy's funeral entourage. In their yearly Christmas cards, Bobby's brood appeared white-toothed, sporty, and all-American. Eunice Shriver, his sister, would send glossy JFK memorial books to my brother Damian, who was her godson. Years later, in 1980, when the Queen knighted my father, the next generation of Kennedys— Caroline Kennedy and Maria Shriver—joined us for a small celebratory lunch. There was also the fact that America had brought fame and fortune to my mother, Antonia Fraser. Her book *Mary Queen of Scots* had been a sleeper hit in 1969. It caught the nation's interest via romance and tragedy. Thanks to the American royalties, she saved my father from selling his inherited home in northern Scotland. She then transformed the dark, dismal, and icy place by putting in seven

bathrooms, central heating, a tennis court, and eventually a swimming pool; every single element considered the height of luxury at the time.

Discovering Andy via my father was the best way possible because everything he said to me remained etched in my memory. Officially, Poppa was a conservative politician and member of Parliament, but unofficially he was my everyday hero. My mother was beautiful and charismatic, and I was proud to be her daughter. She was publicly active and worked—rare for that period—and I loved seeing photographs of her in magazines and watching her on television. Still, there was a distance. Her business of writing books was exclusive. She performed magic by locking herself away in an invisible tower that was jokingly referred to as "the Boudoir." I even illustrated a sign confirming the fact:

NOBODY ALOUD IN THIS ROOM NOT EVEN YOURSELF OR ELSE:

NO CONVERSATION

NO POCKET MONEY

AND WORSE OF ALL NO MOTHER

I can still envision her typing away at her Olivetti, an array of Florentine notebooks packed with her handwritten research.

My father's profession, on the other hand, was inclusive, dependent on others, and involved my two older sisters, three brothers, and me. Before each general election, happening every four years, my siblings and I would canvass for him. We would ring doorbells, talk him up to grannies and young mothers, accost smiling individuals on the main street, and bellow "Vote for Fraser!" from a loudspeaker in a car driving at a snail's pace, smothered in posters of his image. It was fun. I really enjoyed meeting strangers, eating their biscuits and cakes,

occasionally persuading them to vote differently or being amused when they told me to "push off." (I also thought it was hilarious that one of my father's political opponents was called "Screaming Lord Sutch" of the "Go to Hell" party.) I'm often asked where I learned to talk to a door. I could! It was out on the Stafford and Stone (Poppa's constituency) campaign trail that I developed my social fearlessness.

Meanwhile, nothing beat waiting for the election results and then hearing that my father had won. From waiting up late—a treat—to celebrating the final outcome, it was always exciting. Personal computers didn't exist then. It was a case of bringing in the ballot boxes and counting. Photographs show my father joining hands with his election team led by Lilian Wood, his ever-enthusiastic agent, and pushing them up in the air. An unforgettable sight, since his long, noble face looked flushed with success. And in spite of everything that later happened to him, that vision never waned. My father had presented himself, sold himself, and won. Politics is, after all, fairly straightforward. A popularity contest, it equals the business of selling as much as rock and roll, theater, and the art world. A curious aside, but nearly all the English Muffins who worked in Andy Warhol's Factory had parents in politics. Well accustomed to the public eye, they were unfazed when handling their own adventures in Warhol Land.

My maternal grandfather, Frank Longford, a former cabinet minister and peer of the realm, never stopped making his own political noise in the United Kingdom. Having been involved in penal reform, he was nicknamed "Lord Porn" by the press in the 1970s because of his campaign against pornography. Grandpa became involved with a notorious murderess, Myra Hindley, and campaigned to have her sentence repealed. Public opinion was aghast, but I was too young to realize. In 1972, the Queen made him a Knight of the Garter—a huge

honor, almost marred when his trousers nearly fell down at an annual royal procession. An eccentric intellectual, he had no interest in clothes.

I can still remember my father's television appearances. That feeling of excitement of watching him debate on the box and that feeling of loyalty that led to loathing his opponent. Nevertheless, my favorite moments were in the early morning, before school, when I would join him in his cell-like bedroom, where the bedspread was messily covered with the *Financial Times* and other daily newspapers. Dressed in his cotton pajamas and red wool dressing gown with houndstooth lapel, he would be smoking his fourth Benson & Hedges, listening to the radio. A favorite program was Alistair Cooke's *Letter from America*. When concentrated on something, Poppa's regard would be quite remote, his large almond-shaped eyes staring ahead and his long fingers holding a cigarette. I would listen but not quite understand. It didn't matter. The stillness of his company calmed. Unless we were bothered by one of my three brothers, it became our unspoken private time together.

My father could get "ratty," his expression for losing his temper. But it tended to be a cloudburst that meant nothing. In general, he was good-natured and had a terrific sense of the absurd that saw him through most situations. Rudeness annoyed him, although he could be detached about the bad behavior of others. "Silly arse," he'd say, but it was meant affectionately. In his company, I witnessed chivalry and an open-minded attitude. He had several causes outside his political party. The first concerned the famine and genocide of Biafra in Africa. He was horrified by Nigeria's aggressive behavior and the attitude of Britain's Labour government, which refused to help. Ultimately, Nigeria seized Biafra's oil fields and also swallowed up the country, but my father and other liberal-minded souls fought hard to prevent it.

The conflict began in 1967 and lasted almost three years. Toward the end, a Biafran woman and her young son came to our London house. I can still recall the lush, exotic African prints of her outfit and the smooth shape of her little boy's head. In our garden, he stood proudly to attention while his shaking mother poured out her woes. Although I was only about six years old, I sensed the desperation of the situation yet felt sure that my father could save her. He inspired that confidence.

In 1971, he became involved with Bangladesh when it sought independence and fought a bloody war against Pakistan. Then there was Israel, a cause that lasted until his death. Around Christmas, a wooden crate filled with vibrant-colored oranges and grapefruits arrived from Jaffa: a gesture acknowledging his support. Eventually, Poppa became the chairman of the Conservative Friends of Israel. Prior to that, I attended a march in Trafalgar Square and watched him share the podium with Topol, the Israeli actor, famous for his role in *Fiddler on the Roof.*

All these experiences happened nearly fifty years ago, yet I remember Poppa's key message: "When you could, you helped." Being the second son of a Scottish laird—the Fourteenth Baron Lovat and the Twenty-third chief of Clan Fraser—meant that he had inherited very little. Indeed, following the British custom of primogeniture meant that his first brother, Shimi Lovat, got the entire estate. In this case, it was the family castle, several houses, a vast river, magnificent forest, and romantic glen. As can be imagined, certain second sons become quite bitter and suffer from "second-son-itis." Fortunately, it was never my father's problem. He was too interested in politics, the world, and life, and it has to be stressed that my mother's surprise success helped. Born in 1918, he was quite different from the other fathers I encountered, who were usually twenty years younger. My

father had experienced Europe in the 1930s. From all accounts, until
the outbreak of the Second World War, there had been this innocence
and optimism in attitude. At Oxford University he became president
of the Oxford Union, and he attended the Sorbonne in Paris. Being
well connected, he had wandered around key European destinations.
At the Le Touquet casino he had lost a fortune playing chemin de fer.
On the French Riviera, he had danced with Marlene Dietrich. "She
was furious," he admitted, "but had no choice, since it was in the days
that you could cut in by tapping a man on the shoulder." In Berlin,
where he stayed with Eric Phipps, Britain's ambassador to Germany,
he had witnessed Hitler entertain his friends at a large round table in
a tearoom. "No one mentions this," my father used to say, "but Hitler
was brilliant at impersonations." Like others who had been initially
intrigued by the idea of Social Nationalism, he and his contemporar-
ies had steadily watched the evil genie escape out of the bottle and
explode into Nazism. With regard to the Second World War, he was
mentioned in David Niven's book *The Moon's a Balloon*, but my fa-
ther rarely spoke about it. Or rather there were set pieces such as
waking up naked in the desert, having had all his clothes stolen off
him by "a crafty Bedouin Arab" or getting rid of his hepatitis by driv-
ing a motorbike over bumpy roads and shaking his liver into health
or parachuting secretly into Belgium and being served lamb chops in
a religious chalice by the local priest. I never fathomed how much of
a hero he was and how he had been awarded the Belgian Croix de
Guerre and other medals for his bravery in Belgium and Holland.

Just as my father was fueled by a fierce need for justice, he pos-
sessed originality of thought. For instance, he was convinced that
geniuses could come from all sorts of worlds. "The Beatles are ge-
niuses of the music world, Lester Piggott [the jockey] is a genius of
racing," he used to say. Such an idea was quite alternative for the early

1970s, a period that strictly associated geniuses with Einstein and other learned greats. He was also convinced that children were individuals who evolved and/or peaked at different times, another alternative thought that was tailor-made for me. Unlike most of my siblings, I was incapable of shining academically. And to demonstrate the level of sensitivity of the British private school system in the 1970s, a letter was sent questioning why I was not as brilliant as my two elder sisters, Rebecca and Flora.

Comparison has to be the killer of every childhood. I was fully aware that I was a disappointment to my teachers at Lady Eden's girls' school, who noticed that I couldn't concentrate and was generally off the radar. To be honest, I flipped from caring—a few bouts of tears—to not, because I was caught up by my vivid imagination and interior life, which were so much more reliable and enchanting than school. In my self-created world, I was the heroine, the orphan, the princess . . .

My childhood was spent at Campden Hill Square in Notting Hill Gate, then considered a bohemian neighborhood frequented by writers, painters, and other large families such as ourselves. The family home was a broad late-eighteenth-century house with three stories and a large basement. When my paternal grandmother—Laura, Lady Lovat—heard that my parents had bought the house in 1960, she was horrified, announcing that my mother had "ruined [her] son." The general attitude among the upper classes then being that "no one lived north of the park"—a much-used expression even if Campden Hill Square was actually west of the park. But live we did. In fact, my elder brother and I were born in my mother's bedroom. She had and continues to have an eighteenth-century angel fixed above the bed.

When I was born, a photograph was taken of my mother, the family dog (a basset hound called Bertie), and me. Two and a half

years later, the three of us were back on the bed and being painted by Olwyn Bowey, a member of the Royal Academy. The portrait that depicts me as doll-like is now in the National Portrait Gallery. It betrays no inkling of the drama that took place. I had been given a tube of Smarties, the British equivalent of M&M's, and was putting "some for me" in my mouth then giving "some for you" to Bertie. My mother was in the bathroom, combing her hair, when I finished the tube. She missed my seizing back Bertie's Smarties, which I swiftly shoved in my mouth. To my shock, he went for my face. Mum heard screams and discovered he had nearly bitten off my nose. My mother rushed me, with blood pouring down my black-velvet and lace dress, to our local National Health GP, who sent us to Dr. Robin Beare, then working as the resident plastic surgeon at Queen Victoria Hospital, East Grinstead. Refusing to stitch, Beare cleansed and smoothed my nose. I barely have a scar. Extremely lucky; Beare later became *the* plastic surgeon in London. Ava Gardner visited him when she smashed up her face riding a bull in Spain. Audrey Hepburn allowed him to smooth her neck. And quite a few European aristocrats let him fix noses that were deemed too long for their elegantly narrow faces.

The Bertie story illustrated my curiosity and impulsiveness. These are two elements that would lead to endless near mishaps throughout my life. Like Alice in Lewis Carroll's classic, I've always had that "What if I ate . . . opened . . . said . . . that?" feeling, often ignoring that bleating voice warning "Don't."

About eighteen months later, I almost drowned in the Serpentine's Round Pond in Kensington Gardens. It was a family excursion that involved my father, two older sisters, and elder brother but not my mother. The pond had frozen over, and to test whether the ice was safe, I would be used as a guinea pig. It was the bright idea of one of my siblings. Still, my father had agreed. He was evidently otherwise

engaged, because I certainly couldn't swim. After a few steps I fell through. Fortunately, this happened near the edge, I was hauled out by my father and then stripped and rubbed down roughly by a woman using a dog towel. I can still see her furious hatchetlike face—the towel was meant for her doggie, not a little girl. Look no further for the mentality of the female British animal lover: a race apart.

I don't remember the fall being addressed in the family. Nor was it addressed that I could have drowned. And the brother of Issy Delves Broughton, to give an example, managed to drown in a few inches of water. Instead, jokes were made about the dog towel and so forth. Still, I do think the fall—another Alice element in my life— gave this inexplicable detachment. A sense that whatever happened, I would be fine. It installed a courage or even madness on occasion. Thinking back, I was equivalent to the little girl in the horror film who, faced with the door barring her from the evil demons, happily opens it. And then disarms the beasts with her somewhat bonkers behavior! Physically I've never really been scared. The promise of ad- venture has always made me brave.

When young, it took different forms. If dared, I spoke to strang- ers. This was a childhood no-no on every level. One time, an African man had been hovering around our square for hours. It was a bit strange. A gang of my elder brother's friends bet that I wouldn't talk to him. Naturally I did, and *naturally* he was sweet if somewhat sur- prised. Another practice was sneaking into my sisters' bedroom and going through their things. With good reason, this seriously irritated them. I doubt anyone else in their right mind would have done this. Alas, such nosiness led to the occasional drama, such as the breaking of a cello. Determined to open a stiff drawer in a chest of drawers, I hadn't noticed that the musical instrument was leaning against the piece of furniture. I pulled and pulled. Then watched to my horror as

the cello fell timberlike and broke in half on the floor. The elder sibling was fit to be tied. My parents were less annoyed than I thought they would be, no doubt relieved by the idea that it would be an end to "Bobby Shafto's Gone to Sea" and other sad but scratchy-sounding tunes.

Such dramas gave me no need for books. True, I enjoyed my mother reading aloud from her favorite books like *Orlando (The Marmalade Cat)*, *The Tiger Who Came to Tea*, and *Gone Is Gone*. A born actress, she had a beautiful voice and instinctively knew how to play all the characters. But I disliked reading on my own. At home, almost everyone would be going at it fast and furiously, and I would draw, write illustrated stories, or cut out new pictures of Tutankhamen. I was quite unnaturally obsessed with the boy pharaoh.

There was a family joke that, aside from schoolwork, I read one classic during our entire childhood. It was *Villette* by Charlotte Brontë. In fact, it was the actual idea of reading in bed that I enjoyed. Propping myself up against my pillow, pulling down the white string chord to turn on the reading light, then opening the navy blue leather-bound book that had smooth, onion skin–type paper. The reality being that I would read a few pages intensely and close the tome. Exhausted! For three years this continued, and the family joke became, "Tasha still hasn't finished *Villette*." I never did and never minded.

It was a bit weird for someone whose mother wrote, whose grandparents wrote, and whose aunts and uncles wrote. In the press, they were referred to as the Literary Longfords. But my mother took it in her long-legged stride. The eldest of eight children, she was wise enough to realize that it would eventually pass.

She also accepted my passion for television, albeit unaware of the startling degree. I knew the entire week's programming by heart

because, once back from school, I was superglued to the sofa. It might be *Blue Peter*, a series that encouraged DIY for kids. A loo roll and sticky-backed plastic were often involved. Or a cartoon called *Wacky Races* that had eccentric characters like Penelope Pitstop and Muttley, a cheating dog. After an early supper of baked beans on toast or alphabet pasta heated from a can—a diet that I thank for my exceptional health (I was and am rarely ill)—it was yet more television like *The Persuaders!*, a series that starred handsome actors Roger Moore and Tony Curtis, or *Top of the Pops*, which featured the latest musical hit parade. I would watch, imagine, and be transported. Often my brothers accompanied me, except they would take a break by playing football in the square outside our house. Being sedentary (read: exceptionally lazy), I rarely joined them. Occasionally, our nose-in-a-book, intellectual sisters would complain about our TV addiction to our mother. And her usual retort was, "Since they're all so charming, I don't see the problem."

I was also a telephone addict. A familiar voice at the other end of the line soothed in the same way that television did. I could gab for a good twenty minutes with a classmate I had just left on the school bus. While talking, I would imagine her face, her hair, and her bedroom.

The idea of people and their existence became my personal reality as opposed to school. Parties were a highlight. Fun was always to be had with my contemporaries. I threw myself into the act of playing pass the parcel and musical chairs, and eating a terrifying amount of sugar. Nevertheless, parties given by my parents, at our home, shot me into another orbit entirely. It was the exhilaration of undiscovered territory: meeting new people. "You can only come down if you're charming"—charming being requisite for my childhood—my mother would say to my brothers and me. Not a problem, ever.

Dressed in my pink brushed-nylon nightdress with a rabbit on the chest and my quilted dressing gown, I naturally knew to compliment or ask questions.

My parents' social gatherings were packed with the intellectual, elegant, and privileged. In ambience, they were not that dissimilar to parties given in New York by Peter Frankfurt's mother, Suzie, and father, Stephen, the wunderkind president of Young & Rubicam, the advertising agency. Women were well coiffed, and feminine, whereas men always wore suits. Almost everyone had a glass of alcohol in hand, and even pregnant guests puffed away like chimneys.

Occasionally, there was an element of the surprise. Peter recalls Andy Warhol, one of his mother's best friends ("They did that *Wild Raspberries* cookbook together," he says), appearing with Edie Sedgwick in the mid-'60s. "Smitten, I thought she was a superstar, right out of *Batman*, the TV show," he says. On the other hand, Kirk Douglas became my first taste of Hollywood stardom. The impeccably turned-out Douglas arrived early, unaccompanied, and afterward delivered a handwritten note to my mother. I remember being shocked by the deep dimple in his chin, and his height. "He's so short," I said, because the agile Douglas walked so tall on-screen.

Then I changed from being sweet, dreamy, and loving everyone to becoming socially aware. It happened after I'd had a boil in my ear. The pain was excruciating. Nothing has come close since. And during that recuperation period of several weeks, I had time to think and subsequently morphed into a mini Elsa Maxwell, the social fixer. Among my parents' acquaintances, I suddenly made it my business to know exactly who had titles, who was wealthy, and who was foreign. For instance, I was delighted to glean that two of my godparents— Simon Fraser, the Master of Lovat, and Tony, Lord Lambton, had both titles and money. The same could be said for my classmates. I

felt that I'd scored if a girlfriend had a courtesy title (meaning "the Lady" or "the Honorable" in front of her name) or was very rich (in my naive world that meant a chauffeur, and an elevator in her house) or was foreign (meaning that her parents weren't born English). Befriending Dominique Lacloche put me in a state of elation because her mother was Italian and her father was French: a double whammy.

My fascination for foreign stemmed from having never left the shores of Britain and longing to do so. Money intrigued because, as a family, we really didn't have it. My parents always seemed to be scrimping and saving to send us to private schools. A member of Parliament made famously little then, while my mother's flush from *Mary Queen of Scots* seemed to wax, then wane, then wax, as it can with bestselling writers. I remember the issue consuming me. It got to a point that the parents of one classmate, Lisa Loudon, complained that I spoke "much too much about money." I was not one of those children who feared the plight of poverty. Never. I just wanted to meet or know about people who were rich!

In general, Mum viewed my love of the foreign and exotic as romantic and my excitement about titles and money as a phase. However, it annoyed my sister Flora, who viewed herself as antiestablishment and left-wing. She found my address book—I was beyond proud of all the neatly written entries—and wrote *RP* (for "rich pig") by the names of my titled or well-heeled conquests. To paraphrase Warhol, I had a chronic case of "social disease." Well, the junior version. At least Andy had paintings to sell.

Regarding my social disease, I was in pig heaven at Lady Eden's School, which managed to be both socially mobile and international. ("Where are your plaits?" I asked one girl, newly arrived from Mexico. Fortunately, she was amused.) The parents included aristocrats, politicians, diplomats, businessmen, and Harry Saltzman, co-

producer of the James Bond movies, who was then a household name. Lady Eden, the sister-in-law of former Prime Minister Sir Anthony Eden, had begun the establishment in the 1920s. Sophisticated, she had encouraged creative self-expression via Russian ballet, handicraft, and painting. Fifty years later, it was less innovative and resembled other London establishments. Nevertheless there were quirks, such as the lacquered straw boaters, plays performed in French, skating presented as a winter sport, and weekly ballet lessons given by Miss Vacani, who famously taught the royal princesses: Elizabeth, the future queen, and her sister, Margaret.

To my delight, Mademoiselle—the French teacher—cast me as Le Chasseur (the Huntsman) in our form's production of *Blanche Neige* (*Snow White*). "It's because you have such a kind heart," she had said. Words that still reverberate and began my long romance with La France. Great pleasure was also had from organizing my birthday party. Since we were six children, we were allowed a major one every other year. Nevertheless, my mother's birthday gifts tended to be memorable: a doll's house that was an exact replica of Campden Hill Square, and a custom-made prima ballerina outfit that had an embellished pink satin bodice and pink diamanté crown and a wand.

Like many little girls, I didn't want to invite everyone. Possessed with a rare moment of power, I tried to exclude one or two enemies. (I remember loathing a certain Arianne Napier for borrowing my Skippy doll and undoing her braids.) Still, my mother was adamant: Everyone in my class had to receive an invitation that I would handwrite and then leave on their little wooden school desk.

The party was always held at our family home in Notting Hill Gate. Rich kids who lived in either Belgravia or Chelsea would have Smarty Arty, a popular children's entertainer. He would create dogs out of balloons and do other party tricks. We tended to have a fancy-dress

parade. In wobbly procession, my friends would walk through the kitchen into the dining room's left door and then leave through the right, and my mother would pick out the best costume. A tea followed. The table would be covered with sandwiches, biscuits, Twiglets and crisps, paper cups and plates. A huge ice cream birthday cake from Harrods was presented. I blew out the candles, and while cutting into the cake that was striped with vanilla, strawberry, and chocolate ice cream, I screamed to get rid of the devil. (A tradition that seemed to exist only in our family and my mother's.) Afterward, we went to the drawing room, where a film from the St. Trinian's series—movies about mischievous English schoolgirls—was screened. Having large reception rooms, Campden Hill was and remains an ideal place to give parties. Like perfect Lady Eden pupils, my entire class was beautifully behaved. We made up for the hooligans my brothers tended to invite, who ran riot and always managed to break the black leather sofa in the nursery. That said, my favorite fancy dress costume was worn to my elder brother's party. Wearing blue tights and a painted bare chest, I went as a devil with wooden fork in hand. Being extremely proud of my black eye makeup, I wiggled around madly and got on his friends' nerves.

My birthday parties also had to take place on Sunday. Mum flatly refused to organize them during a weekday. It was a bone of contention because a lot of my friends went away for the weekend to family homes in the countryside. Lady Eden's even finished at lunchtime on Friday in order to allow the chauffeur of "mummy and daddy" to drive their darlings there. This infuriated my mother. Yet all in all, Lady Eden's suited. Like my father, Sir John Eden, the founder's son, was a conservative MP; there was also the convenience of the location—it was fifteen minutes away—and academically it did pretty well. The best students got into St. Paul's and other top schools.

03 *Early Lessons in Style*

My mother dressed according to her mood. She often wore big earrings and rings and managed to look glamorous during the day and romantic at night. Several outfits come to mind: a black suede waistcoat and matching skirt piped with black leather; a white blouse, wide belt, and midi-length stripy black-and-white skirt; a camel-wool tunic with matching trousers, jazzed up by an Ethiopian Lion of Judah medal given to her by Haile Selassie. Nevertheless, my favorite dress was a green taffeta ball gown inlaid with ivory lace, designed by Miss Dior. She wore it in a Norman Parkinson shoot for British *Vogue*. Photographing her in the square outside our house, "Parks" had used smoke bombs to further her allure. Among all the numerous portraits by the likes

of David Bailey, Patrick Lichfield, David Montgomery, Jerry Schatzberg, and Lord Snowdon, Parkinson's remains my favorite.

My sisters were Biba babes, Biba being the hip and happening London boutique of the late '60s. Occasionally, I was dragged to the boutique on Kensington High Street on the weekend. Pandemonium—the atmosphere was frenzied and the queues to buy were ridiculously long.

Still, there was an activity that was not the case for the rest of the boutiques near the end of Kensington High Street. And I knew them by heart because every time our Scottish nannies—Caroline Cameron and Margaret MacDonald—received their paychecks, they would head on down there. Upon entry, there was a smell of burning joss sticks, or incense, and a lineup of the dreariest-looking display of tunics, flares, and maxi-skirts in crushed velvet, nylon jersey, or crumpled exotic Indian print. About eight boutiques, or so it seemed, were selling exactly the same types of hippie-drippy clothes, and Caroline and Margaret left no stone unturned. Those trips put me off shopping for life. It was the sameness, the exhausting lack of decision, the utter lack of quality in the product, and the hideous shades of browns and purples that were the bane of that period.

I greatly preferred Caroline and Margaret's taste in music, which included Rod Stewart—I knew all the words to "Maggie May"—and Jim Reeves, the American country pop singer who had died in a plane crash. His "Please Release Me" has to be one of the all-time-greatest love ballads. Caroline would listen to it endlessly and cry. Her tears, however, were nothing in comparison to mine when hearing "How Much Is That Doggie in the Window?" I couldn't bear the idea that it didn't have a home. And then several years later there was Harry Nilsson wailing "I can't live if living is without you" on *Top of the Pops*. Staring at the screen, British schoolgirls would line up and blub.

If this behavior sounds quite mad, there was a strong element of that in London during the late sixties and early seventies. Music was of the most utmost importance. It was possible to loathe someone because of their record collection.

As periods go, it was a pretty miserable one in England. The writer Nicholas Coleridge describes it as "a long period of recession and grayness." Then at Eton College, the establishment boarding school attended by most of England's conservative prime ministers, he recalled how "the famous three-day week" meant "two nights of no electricity" and led the privileged pupils to "sitting in the dining room and doing all their homework by candlelight." There were endless strikes, three-day power cuts, the beginning of the Irish Republican Army terrorist attacks, and most people had no money. Or the super-rich had fled because the government was taxing ninety-eight percent on the pound. Hence George Harrison's song "Taxman." Still, the television—particularly the comedy programming—was sensational, as was the pop music. It was the beginning of David Bowie and other extraordinary talents.

Across the board, David Bowie broke boundaries. His album *Space Oddity* was a commercial hit and considered the coolest. It was endlessly played in most hip households, and ours was no exception. On his following album, *Hunky Dory*, Bowie sang, "Andy Warhol looks a scream, Hang him on my wall." According to Catherine Hesketh, the Factory's second English Muffin, the Pop artist thought it was "depressing and really rude. He really minded that Bowie wrote that song, and did not like him because of that," she says. However, it probably introduced a younger generation to Warhol if they hadn't already read about him in one of the weekend color-supplement magazines. I remember staring at the *Hunky Dory* album cover and

finding it both arresting and weird. Bowie resembled a woman and looked out of it. It was everything I couldn't cope with at the age of nine. Best explained that I had become appallingly conventional.

I wonder if it was the result of becoming very podgy. Having been fairly average in weight, having been a popular bridesmaid as well as photographed for *Vogue* by Norman Parkinson, and having appeared on *Whose Baby?*, a successful TV game show, I blew up. Attempts were made for me to lose the puppy fat. On my first diet, I retaliated by eating thirteen oranges in quick succession. This amused Tessy, our Filipino cook, but appalled my parents. Child psychology was a little lacking in various quarters in our household. There just wasn't the time.

I once spoke about this to the actor John Malkovich, who had also been a childhood blimp. I began with "Wasn't it awful? Could you believe the lack of sensitivity?" and he cut me to the quick. "Oh, come on, Natasha, we would have been impossible if it hadn't happened. Besides, it gave us a great sense of humor." Certainly a different take! Still, I thank John for that because he has a point, particularly about the latter. Humor is the best way to deal with humiliation until discovering the benefits of self-forgiveness and so forth.

Nevertheless, in spite of the criticism toward me, around me, and about me—it's amazing what people feel they can say and get away with if you're labeled as fat!—I sensed that I had an eye. My mother was the first to encourage it. When she was going out and having her hair done by her hairdresser Mr. John, I would come in, look at her red jewelry box, and pick out her accessories for the evening. She accepted all my choices. I even drew and designed an entire wardrobe for her. A little too American and 1950s in feel; a cake-baking outfit was hardly her scene. Nor was a loud pink golfing ensemble. But it had been an enjoyable exercise.

Mum also allowed me to have a Barbie doll. Hard to believe, but certain British mothers prohibited Barbie because of her tremendous chest. Instead, they opted for the flat-as-a-pancake Sindy doll that lacked Barbie's legs, glamorous wardrobe, holiday camper, sister, and boyfriend Ken. To be honest, I think Mum preferred my Sasha dolls because they were ethnic-looking with coffee-colored skin, long limbs, and tons of hair. Still, Barbie was never verboten.

Meanwhile, the appearance of Camilla Mavroleon, one of the mothers at Lady Eden's, fixated me. She looked like no one else. Her choice of wardrobe suggested a different world that I later discovered meant skiing at St. Moritz in the winter and vacationing on a private island in the Mediterranean during the summer. I'd heard that her husband was Greek. And during that era, only the Greeks were seriously rich. No mention was made of the fact that her grandfather was W. Somerset Maugham, the world-famous novelist. Nor would I have gotten the importance. Camilla would speed in with her blond coif, lightly made-up face, and slim racing-horse legs to collect her adorable younger daughters, who had shiny, straight hair and nut-brown skin. I remember her turtlenecks and a fur coat that looked light in weight and fell mid-thigh. This was in contrast to most of the other mothers, who wore heavy-looking mid-calf mink ones. Camilla's aura was understated. It was my first encounter with international chic.

As much as elegance impressed, I was embarrassed by the untidy ways of my family. In order to feel grand, I occasionally lied. A whopper concerned having tea with the Queen. "Really?" said the nanny of Camilla Lawman, a classmate. "And what does the Queen eat?" Her question rather threw me. "I guess she has sandwiches and biscuits like everyone else," she continued. I hastily agreed and knew to stop boasting about the dear Queen and me. Another occasion concerned

Michael Heseltine, the father of another classmate. Later christened "Goldilocks" by the English press, he was a wonderful-looking member of Parliament noted for his thick blond hair. He'd driven me home and, being a gent, walked me up to the front door. To my horror, there was a large green crate outside filled with grubby milk bottles. "Well that's convenient," he said, and meant it kindly. But I immediately invented some rubbish about a new servant making a mistake. I wish! But it demonstrates what a heinous little snot I had become.

During this phase, I took to wearing kilts and matching Shetland wool sweaters. Beyond unflattering even if I was convinced that I looked tidy and smart: both being my goal. My new friend was Cristina Zobel, whose father was the Filipino ambassador. And I reveled in going to her house, which was on Millionaires' Row off Kensington High Street and had high ceilings and several elevators. She and her younger sisters—Monica and Sofia—had their own personal maids who wore pale yellow uniforms with starched white aprons: my idea of bliss. In their company, I pretended that I was living their existence, when my reality was Agnes, the new Scottish nanny, who flaunted her F-cup bosom and claimed that she had exactly the same hair as Princess Margaret. A strange boast, even if it looked to be the case. I wonder if Agnes thought she had royal blood. The poor woman was adopted and slightly deluded. A lazy slob, she taught me how to cook so she wouldn't have to. Never bothered to buy loo paper, rarely cleaned up, and would bring strange men back to the house. "Who's there?" I once asked, knocking on Agnes's bedroom door. "I'm the milkman," came the reply, followed by her saucy cackle.

Riding lessons were my other bid for a conventional existence. Every Friday, I would accompany Lady Susanna Ward—one of my

best friends—and her younger sister Melissa and be driven to Richmond Stables by their parents' chauffeur: heaven!

The Ward girls resembled dolls. They had long hair and wore Petit Bateau vests and pants—then an extravagance—that suited their coltish limbs. I really was twice or even thrice their size, a fact that was demonstrated by my jodhpurs. In appearance, I resembled a character from Thelwell, a British cartoonist whose specialty was drawing messy, plump girls on Shetland ponies.

Susanna had a voice that was distinctly upper-class yet sleepy and sweet. She always had her nose in a book and excelled in English lessons. My silly stories made her laugh even if there was a mystery and remoteness to her. That said, there was innate gentleness; she never snapped or hurt my feelings. In many ways, she was like her father, Billy Ward, who was the Fourth Earl of Dudley.

Like mine, he was an older father. However, unlike my father, he had inherited a great deal of wealth from both sides. Maureen Swanson, Susanna's mother, was Billy's second wife. She was a Glasgow-born dancer who had appeared in *Carousel* in the West End when she was nineteen. She had Snow White coloring and feline features—a pair of daring green eyes—and certain admirers described her as a young Vivien Leigh.

After a small role in John Huston's *Moulin Rouge*, a fairly busy career ensued for her until 1960 when she met Billy, then Viscount Ednam. An affair began, and he divorced his first wife, the daughter of the Argentinean ambassador and mother of his son and heir and twin daughters. Not everyone approved of the match. But I was mad about Maureen. She was my very first rags-to-riches adventuress. A breath of fresh air, Maureen was frank as well as quite vulnerable. At her children's parties, she showed all her old films, as if to remind

what she had done. I understood and cheered on such behavior, even if others were surprised. Maureen also admitted to eavesdropping outside Susanna's door, convinced that her daughter preferred her husband. Being touched by her admission, I tried to console her and convince her that it wasn't the case.

Nevertheless, Maureen had tremendous confidence in her taste. Her bedroom was a symphony in pearl-gray satin, which felt smooth and cool to the touch. When I first entered her bedroom, I stared at the opulent display of curtains, pelmets, tassels, and large embroidered M's. It was worlds apart from what I had grown up with. Nineteenth century–like, it was showier and more Parisian in decor than London homes, which were reputed for their low-key, effortless attitude. At a loss for words, I was in a state that can only be compared to Kay's when he climbs into the sleigh of the Snow Queen in Hans Christian Andersen's tale.

Maureen also gave me a tour of her cupboards. I was transfixed by the rainbowlike array of her shoes—a mix of silk, satin, and leather—which were mostly from Rayne, a leading brand. Cuckoo about sweaters from Courrèges, Maureen was the first to point out the importance of the French designer's white embroidered insignia. She also showed me all her dresses and coats from Hardy Amies—the Queen's favorite designer. Naturally, there were jewels. I never saw her evening pieces, which must have blinked with diamonds. But during the day, she always wore three chokers formed with baroque pearls. One time when we'd gone to the cinema, she lost a choker. A panic arose until a nice American student came forward and said, "Are these your beads?" The baroque pearls were that large.

The American-born Caroline Gruber was my other kind and reliable friend. She, Susanna, and I were the Modest 1, 2, and 3 gang. The name was due to our shyness about taking our clothes off in

front of our classmates. Not that Caroline had anything to hide. From the age of five she wanted to be a ballerina, and to see her in a leotard was to witness the perfect width of shoulder, height of waist, and extended stretch of leg and arms. I am happy to recount that she was snapped up by White Lodge, the Royal Ballet School, and became renowned for her extremely high jetés when joining ballet companies in the Netherlands and Canada. A funny aside, but the ballet world was then the dream of privileged English schoolgirls, as much as becoming an actress and/or fashion model. It was probably because of Margot Fonteyn, the British-born prima ballerina. A household name, she was today's equivalent of Audrey Hepburn. There was also a craze for Noel Streatfeild's *Ballet Shoes*. The novel concerned the three adopted sisters Pauline, Petrova, and Posy Fossil, their missing guardian, and their adventures within ballet.

Elinor, Caroline's mother, owned and ran the Upstairs Shop on Pimlico Road. Cath Kidston in style, but thirty-five years earlier, it was a thriving lifestyle boutique that sold all types of toiletry bags, Kleenex box covers, plastic trays, padded coat hangers, and other items for the home covered in a choice of attractive cotton prints. The bright candy colors—not dissimilar to Lilly Pulitzer prints—eclipsed the British equivalent that were miserable-looking and often made of nylon, the period's practical fabric.

Elinor had acquired her taste and strong commercial sense from working in New York fashion during the 1950s. Her friends included Richard Avedon, Dorian Leigh, and Diana Vreeland. Skinny Elinor wore large tortoiseshell glasses and was often in the New Yorker uniform of charcoal-gray sweater and matching pants. Watching her in action fascinated because she was outspoken yet had warmth.

Outside of work, she gave everything that she had to Caroline and her younger sister, Juliette. No doubt because when they were young,

Elinor and her sister, Carol Saroyan Matthau, wife of the actor Walter Matthau, were put in a series of foster homes. That was until Elinor was six and her mother married Charles Marcus, an executive with the Bendix Aviation Corporation, who adopted both girls.

The Grubers lived in a large apartment building that had a doorman. This was fairly unusual in my circle. They also showed Hollywood movies—*Barefoot in the Park* and *The Way We Were*—at their birthday parties and served Kentucky Fried Chicken; the franchise had just arrived in London. It was through Caroline that I discovered American movie stars of the late 1960s and early 1970s. I had never seen anyone as blond and appealing as Robert Redford.

The Grubers were the first children I encountered who wore jeans. Then a rare commodity, they had to be purchased in the United States. My brothers and I were dressed in corduroy trousers from Marks & Spencer during the winter and the cotton equivalent in the summer. They suited my brothers' skinny frames but looked awful on me. Unless it was an expensive party dress from The White House or Harrods, clothes for teenage-proportioned ten-year-olds were pretty unattractive.

Regarding my size there were bizarre episodes. Like the time my mother invited novelist Jean Rhys over for a cup of tea. They were friendly but not close. Heaven knows why, but my mother insisted that I do ballet exercises for Jean, a noted balletomane. So the reportedly anorexic Jean, who arrived in a cocktail hat with net and needed a stick to walk, had to tolerate a baby elephant massacre one of her favorite arts. Even when I was bending my knees, I did wonder if it wasn't quite mad. But smart Mum made me write about it later. "Although she [Jean] was old, she was still beautiful," I scribbled. Miss Rhys was in her early eighties.

What I didn't pen was my experience with V. S. Naipaul and his

then wife, Pat, who were my mother's contemporaries at Oxford University. Even though that was the early 1950s, Mum had always recognized Vidia's literary brilliance. Still, he was one of those "famous writooors" who made no effort with Antonia's kin. That was until a niece arrived in London. We were the same age, and I was roped into a Royal Tournament evening at Earl's Court. The world's largest military pageant, the Royal Tournament was popular in the 1970s and consisted of soldiers in uniforms on horses trotting up and down. Very boys-only entertainment and absolutely everything I couldn't stand. One uniform was fine, but two hours of it? Anyway, we went, and all Vidia did was groan and see fault. His behavior made me uneasy. Privately, I wished he would leave. Instead he stayed, perhaps viewing me as a potential toady who would laugh at everything he said. There was a slight problem—he used words that "Tasha who still has not finished *Villette*" did not understand. After a few missed witticisms, I could see that there was an adjustment in his behavior. A sort of discovery that I was the non-smart-aleck of the family. Fat too! It was at that moment that I perversely started enjoying myself.

04 *Holiday Home*

It was difficult not to be hit by the romance of Eilean Aigas, our home in the Scottish Highlands. Meaning Island of Aigas in Gaelic, it was a rocky islet in the middle of the River Beauly that was surrounded by black melancholy water. On the north side, there were dramatically rugged cliffs covered with pine trees hanging at all angles, casting a strange reflection on the water. On the south side—where my mother chose to write—it was peaceful and calm. Wearing a Texan cowboy hat and a Fraser tartan wool rug over her legs, she would type away in a wooden hut overlooking the river.

Inland, Eilean Aigas was then rife with azalea bushes, tall lichen-covered beech trees, a monkey puzzle tree, and roe deer intent on destroying the annual

plantation of firs. Since it measured three-quarters of a mile in length and one mile and a quarter in circumference, it was possible to walk around and note the contrasting landscape and vegetation.

Our house, a nineteenth-century hunting lodge, was a testament to my mother's unique sense of the Highlands. A broken golden harp greeted guests in the hallway; David Hicks's tartan chintz covered the book room's walls and windows; nineteenth-century prints of cows hung on William Morris wallpaper; caps were thrown on a framed pair of stag's antlers; and a pink Fraser dress tartan carpet ebbed along the two staircases and spilled into the hallways. Somehow it all worked, creating a welcoming, bohemian atmosphere. Except for uncouth behavior, drugs, peacock feathers, and thirteen at the table (both my parents were extremely superstitious), anything went in our household.

My mother, our nanny, and whoever did not drive with my father would take the sleeper train from London. Not pleasant; I disliked Euston Station. Concrete gray and harshly lit, it had a humidity that most British train stations seem to have. A humidity that soaks through to the bone and causes mild discomfort if you're female. It also gave me a horror of traveling with others. Nothing went wrong. Trains weren't missed, suitcases weren't lost, little children weren't abandoned, but I felt roughed up by the unspoken panic. Nor did I help matters with my flotilla of plastic bags.

Nevertheless, I enjoyed the sleeper train compartment. The sheets of the bunk bed were starched and pulled drum-tight. It was fun breaking into them. The sink was well designed even if the porcelain chamber pot was to be avoided with the shakiness of the train. The pièce de résistance was the Schweppes glass bottle of still water that had its own separate wooden cabinet. Bottled water was a rarity then. I liked hearing the crack of the seal opening and didn't mind that it rattled throughout the night.

My favorite time in Scotland was the Christmas holidays. No doubt it was because my mother poured her whimsy and imagination into it. A massive pine tree, cut from my cousin's forest, would stand in the hall and my mother, aided by my elder sisters, would decorate it with gusto. There was none of that restrained "only silver and blue" or "only gold and green" or "only white" business. They believed that more was more and used every single decoration that they could get their hands on, craftily using the broken ones for the back. The range included cloth angels with blond ringlets, turbanlike glass spirals, and a thick mass of furry tinsel. When it was finished, all the wrapped Christmas presents were placed under the tree. On every level, it was my idea of magnificent. When seeing Ingmar Bergman's masterpiece *Fanny and Alexander*, I was reminded of our imperfect but captivating trees.

Mum also injected her impish sense of humor when filling our red-and-white Santa stockings that came from Bloomingdale's and had our names written in gold glitter. More exciting than any Christmas present—she took months preparing them—they were crammed with monogrammed pencils, inscribed mugs, witty jokes, and surprises such as newspapers with fake headlines claiming that Natasha Fraser had streaked across London.

Just as the post-Christmas season would begin to lull in atmosphere—a case of too much television, too many Quality Street caramels, and too many petty fights among siblings—my parents' guests would arrive. Eilean Aigas was one of those houses that became better when filled. It was built to entertain, since there were two large reception rooms, a fair-sized dining room, and a rabbit warren of bedrooms.

A long lunch tended to be followed by an energetic walk. In fact, in the warmer months, there would be picnics up the glen beside Honeymoon Isle, a picturesque spot where my paternal grandparents spent

their first nights together. Picnics meant Scotch eggs, sausage rolls (pigs in a blanket), and sitting on Fraser rugs. Afterward, there would be excursions to explore the surrounding scenery. Whatever the outcome of the afternoon, there was always tea—my preferred moment, the dining room table covered with homemade scones, pancakes, sponge cakes, and chocolate biscuit cake. Everyone would then peel off for a bath, or rather my mother and guests did.

Regarding the hot-water situation, there was never enough. And in the winter, pipes would even freeze. ("Choose your bush," guests were occasionally told.) My father attempted to install an Eilean Aigas rule that family members should hold back and not have baths every day. But my older sisters would always sneak off to the nursery bathroom and disobey his orders. It drove him mad. I can still hear him knocking on bathroom doors, searching for the hot-water hogs.

Before dinner, an event that everyone was expected to dress up for, family and guests would gather in all their finery in the drawing room. The transformation was something to behold. Skin glowed, jewels twinkled, and there was the individuality of styles. I can still remember the full wool skirts of novelist Alison Lurie, the neat ankles and lacy hose of novelist Edna O'Brien, and the long scarves of playwright Tom Stoppard.

After dinner, there was often a game of charades that was totally lawless and highly entertaining. In what resembled amateur dramatics, the team in question would run to the dress-up cupboard halfway up the stairs and then reappear—often in my mother's leftovers—and act out the word either in one scene or in several. "In the manner of the word" was another favorite. Someone would leave the room and the rest of us would choose an adverb. Then the person would return and ask us to act out commands, such as "Lift that vase in the manner of the word," and he'd try to guess the adverb.

When the guests left, I always felt rather low: a result of missing all the group activities. In many ways, I was one of those solitary kids who were at their best when surrounded yet essentially left alone. Tremendous fun was to be had with my good-natured family. Rehearsing plays that were written and directed by, and seemed to also star, my two sisters. Having major sing-alongs in our "yellow submarine"—the name for our yellow Vauxhall car. Attempting not to fall at Twister with my brothers. But at mealtimes, in the company of my parents, my siblings made me feel inadequate. It was equivalent to watching an intellectual tennis match: the tales were recounted with panache, as were the quick barbs and jokes. But I was incapable. Or rather, if I tried, I belly flopped.

I now understand the fascination with large, clever families. Since there's competitiveness with an urge to shine and score, it can make for exhilarating company. However, having been the weaker link, I view other large families with a jaundiced eye and secretly wonder about the dynamics that lie beneath. (Ha! And I'm rarely wrong.) As for eating, food was wolfed down. Thinking back, I believe only my little brother Orlando ever actually chewed a morsel.

Meanwhile, my dream excursion was taking the local bus into Inverness, our main town, having lunch at the Wimpy bar—the sight of the red-and-white sign, sandwiched between a hamburger bun, always welcomed—then watching Disney's *Bambi* at the local cinema. It didn't matter that the seat of the bus scratched; that the meat of the hamburger was flat, chewy, and tasteless; that the chips were frozen; that the chocolate milk shake lacked thickness; and that Bambi was decades old. That magical afternoon remained carved in my memory and gave me an inkling of how I planned to live my life. Whooping it up in the metropolis!

Going through my mother's British *Vogues* became a favorite holiday ritual. Having been a contributing editor, she had kept all the issues from the 1960s onward. The collection was kept in the drawing room. When alone, I would listen to the sound track of *American Graffiti* on the gramophone—"Step by Step," "Stay," I still love those 1950s songs—and go through piles and piles of the magazines. I was never bored; it was an enticing world filled with beauties who had luxuriant hair, gardens that had lily ponds, and smiling models whose lithe bodies seemed to sprint across the page. Several years later, when Susanna's cousin Rachel Ward, a model, came to stay, I was beside myself. That holiday, she was the cover girl of both *Vogue* and *Harpers & Queen*. Summing up male fantasy with her exquisite face, glossy hair, and curves, Rachel managed to be a tomboyish gypsy. Silver bangles jangled on her wrists, tight jeans were tucked into burgundy leather boots, and a masculine pinstripe jacket was teamed with a Sutherland tartan kilt and teetering heels.

Another holiday ritual was watching *The Banana Splits Adventure Hour* in the morning. The American TV show was irresistible. Or rather, the gaggle of young girls playing the Sour Grapes were. Defining my female ideal, they wore short purple tunics and knee-high boots and would arrive dancing and shaking their nonexistent hips. Considering my size, it was pretty masochistic to idolize them, but I did nurse intentions that, one day, I would be *thin*—as I chomped through bags of lemon sherbets or strawberry toffee bonbons, secret batches of candies that had been delivered by Don the Postman, who arrived with the mail and Scottish newspapers.

In the late afternoon, I watched Elvis films. Just one sighting of the King made me hooked. The fall of his hair, the shape of his nose, and the pout: I still cannot think of any other musical performer

whose Greek-coin beauty and presence compares. After seeing all his films, I can only dimly remember a few titles. But he became important to my life in Scotland.

As did all our six Fraser first cousins. Their father was Shimi Lovat, the chief of our clan and famous D-Day hero in Normandy. (Peter Lawford played him in the film *The Longest Day*.) Although he and my father were close, I was a little too cheeky for Uncle Shimi, who did demand respect.

Instead, I was more at ease with three of his children—a winning mix of daring and droll—who consisted of Tessa Reay, Andrew Fraser, and Simon, the Master of Lovat, who lived at Beaufort Castle with his young wife, Virginia.

We were never out of Beaufort or Braulen Lodge, another house that belonged to Simon. Braulen was up the glen and the place of many a picnic before Simon would take fearless guests up on a long afternoon jaunt. Since a fair amount of Bloody Mary, whiskey, and wine were consumed, not everyone was either wise or well equipped for the hike that included steep hills, rocks, and streams. On one occasion, I wore soft leather shoes that one hardy cousin described as "dancing slippers." Yet considering the conditions, there were very few accidents. One involved my lovely godmother Marigold Johnson, who fell and snapped her ankle in several places. My father carried her all the way down the hill: a St. Christopher–like image that I personally treasure.

Still, there were dramas. To everyone's horror, a deadly adder snake bit the leg of Rupert Wolfe-Murray, the son of dear family friends. My father rushed him to Raigmore, the local hospital, about an hour away. On arrival, a Pakistani doctor looked at Rupert's severely swollen leg and informed that it was a scorpion sting. His country of origin was certainly known for scorpions, but Scotland was

not. "Inverness is too cold for scorpions," my father tried. But the Pakistani doctor was insistent. Another remarkable tale concerned my friend Dominique Lacloche, who was haunted by a ghost when staying at Braulen. The man, in 1950s cloak and top hat, was so evil that she threw herself through her bedroom window on the second floor, cutting her knees to ribbons. I made her repeat the ghoulish story endlessly.

In the month of August—a popular time to go to Scotland—tragedies always seem to occur. My first experience was in 1969 and concerned Catherine, my mother's youngest sister, who was a twenty-three-year-old journalist. Benjie and I were watching the eight-o'clock news, when they suddenly showed her photograph—referring to "her" as the Earl of Longford's youngest daughter—and announced that she'd been killed in a car accident. We rushed into the dining room and told our mother. At first, she thought that it was a far-fetched practical joke. But it turned out that the telephone lines were down and no one could call in. A few weeks later, I asked my mother if Catherine was ever going to come back. According to a family friend, my large eyes were welling with tears. But Mum just shook her head. Saying anything was too painful. My parents planted a tree in Catherine's memory, and my grandparents created the Catherine Pakenham Award to encourage young women journalists. "When you lose a child, you lose something of yourself," Granny would later say. Wisdom that still makes me sad.

On a much lighter note, August 1971 was when Andy Cameron, the garage mechanic, hacked off my hair with oily shears. It happened in Beauly, the nearest town. Having just seen *Willy Wonka and the Chocolate Factory*, starring Gene Wilder, my little brother Damian dared me to chew ten Bazookas in a row and then stick them behind my ear. Veruca Salt had been his inspiration. I did, and my long hair

quickly stuck to the sugary pink bubble gum. I don't know whose idea it was to cut my mane there and then. Was my father distracted, again? But Andy, who was mildly walleyed, got out his shears and did major damage. Having had waist-length hair, suddenly I had a bob. Well, sort of.

Elvis keeled over in August 1977. The photographs in the newspapers after his death were a shock. He had morphed into a bloated blob wearing white embroidered outfits and vast sunglasses. Then there was the IRA assassination of Lord Mountbatten and his grandson that happened on my mother's birthday—August 27, 1979. My father had known the royal cousin, a renowned navy dignitary and former viceroy of India.

During the 1970s, Andy Warhol became keen to do the Shah of Iran's portrait. A much-criticized commission, it finally happened in 1976. Oddly enough, my family and I would entertain the Shah's children in Scotland in 1974. They had arrived at my cousin's castle—protected by a team of Scotland Yard detectives and snipers in the bushes—with the intention of seeing the Loch Ness Monster, the local legend. Not an easy task, because no one knows whether the dinosaurlike animal—nicknamed Nessie—actually exists. I lucked out because the Shah's daughter Farahnaz was almost my twin. Up for an adventure, I had charmed her away to a sneaky swim during a picnic. When the stream got choppy, a handsome Scotland Yard detective heard our cries. With Samson-like strength, he pulled her out but left me there, struggling. So I like to think that my adventures in Warhol Land began then. "Really up there." Not.

05 *The Bells of*
St. Mary's Ascot

To my considerable excitement, two tickets were organized to see the Tutankhamen exhibition in 1972. I'd had a crush on the boy king for several years, and it was the hit show at the British Museum. In fact, no attendance has been bettered there since. Over a million and a half visitors went, seven thousand a day, and it required patience. Queuing lasted as long as eight hours.

I remember the interminable wait. I remember looking at people who had brought foldout chairs. I remember huge disappointment. I had cut out so many photographs of Tutankhamen's gold and blue funerary mask and stuck them all over my bedroom. But somehow the color of the snaps was a lot better than the real thing. When walking into the room

where the mask was, I was struck by its size—it seemed smaller—and how it was a lot less magnificent than I'd imagined. I suffered this terrible sinking feeling. Had I been honest, I would have expressed it. Instead, I realized, or rather remembered, the protocol: having to be grateful to my nanny and having to lie and pretend how pleased I was to my mother.

My need to lie came under the heading of playing the role of the good girl in my family. Or so it seemed. In fact, I began to have this double life that would eventually consist of a shoplifting session at Biba, smoking my father's Hamlet cigarillos, and fooling around with the friends of my brother Benjie when they came to our house for their school's "play practice."

"Nicholasing" was the code name for my shoplifting activities (*nick* being the operative English slang for stealing). Never daring to go alone, I was always with Elsa. She lived about ten minutes away and had divorced parents who were on terrible terms. Her mother was an Australian architect; chic with tanned skin and a mass of dark hair, she clanked with bangles and lived in slinky clothes that were either black or olive.

Elsa, on the other hand, resembled a Pre-Raphaelite angel. At one of my fancy-dress parties, she came as a butterfly and won first prize. Her long Titian-blond hair almost touched her behind, and her full mouth pouted more than it smiled. I cannot remember any tremendous verbal exchanges. Instead, we sucked (never chewed!) quite a lot of Pez candies together and had a shared love of ransacking Biba.

In 1973, Biba moved to the Derry & Toms building on Kensington High Street. And Barbara Hulanicki, the fashion brand's founder, went all out emphasizing the Art Deco architecture. Spectacular, it was like stepping into a Hollywood movie set that had a link to the Jazz Age with a lineup of breathtaking-looking broads as sales

assistants. Boutiques come and go, but nothing can be compared to Biba. It was a retail phenomenon, and radical chic New Yorkers would move to London in the summer with the sole intention of shopping there on a daily basis. Thanks to my sisters, my only appealing pre-teen dress was from Biba. A signature style on every level, it was made of chocolate-brown crepe and had an empire waistline and leg-of-mutton sleeves. Using my mother's money, they paid for it. I was witness to the fact. Just as I was witness to the fact that few others did.

Imagine a fashion feast—as tempting as a candy store—boasting a multicolored range of flirty outfits, platform shoes, makeup, and countless accessories. And imagine a shoplifting phenomenon because none of the sales assistants—chosen for their physical charms—were on duty. The thieving became so prevalent among privately educated schoolgirls that the likes of Helen Brigstocke, the headmistress of St. Paul's Girls' School, one of London's top establishments, was forced to make a morning announcement that shoplifting at Biba had to stop.

Even though Biba flowed onto several floors, including a roof garden, Elsa and I stuck to the main hall. Pale gold in decor, it had leopard-print sofas lining the walls, palm tree–like lights, and a shiny chocolate-brown area in the middle, where earrings, bracelets, and necklaces were sold. The room's problem was the lighting. There was none. This was obviously of a distinct advantage to all the tramps snoring on the sofas. I am not exaggerating. It also helped two ten-year-old schoolgirls—Elsa and me. Wearing Lady Eden's boaters, blazers, and white gloves—our private school was ten minutes away—we would grab fistfuls of earrings and put them into our satchels.

Terrified that my two Biba-fanatic sisters would recognize the merchandise, I would leave all my booty at Elsa's house. Our shoplifting activity might have led to our eventual arrest if it hadn't been for Biba's

food department and Elsa's mother. Each time we raided, Elsa would give her a pair of earrings. After the third time, she said, "Elsa, I do hope you two aren't shoplifting." I can still hear her distinct Australian accent. Elsa and I caught each other's eyes. "Shoplifting" sounded different from "Nicholasing." It was a bit scary. And I believe we merrily talked about our need to stop . . . on our way to Biba. However, it was after graduating to the food department in the basement—I was determined to have a can of baked beans with Biba's Deco packaging—that we finally did. It was spelled out in the store's brown and gold signature colors: SHOPLIFTERS WILL BE PROSECUTED. Elsa and I turned on our heels, and like little piggies—well, in my case—ran squealing all along Kensington Church Street, all the way home.

Shoplifting was one issue, but fumbling upstairs in the nursery loo was another. In spite of being "painted suicide yellow"—as described by Prosper Keating, one of Benjie's best friends—it did not stop major amounts of snogging and innocent groping. Put bluntly, every Friday, his friends came for "play practice" and since I was the only girl around, well. Actually, I rather liked the attention.

Nevertheless, I was relieved to change schools—put a grinding halt to all activities—and attend a boarding school. St. Mary's Ascot was a convent school in Berkshire that my mother had attended. In 1974, she was probably their most famous old girl. I was happy to follow in her footsteps until a nun called Sister Alered (nicknamed Stale Bread) informed that my Common Entrance exam had been disastrous. "You were only accepted because of your mother," she said, with a certain glee.

In those days, I had a peaches-and-cream complexion, long reddish hair, as well as thick bangs. And I remember looking up at her face, noticing her bout of eczema, and thinking, *God is good*.

Otherwise, St. Mary's saved me. I was spirited and determined

but with no structure or discipline. No adult had taken the time to calmly sit me down and explain things. In some ways, this was liberating. I was completely independent. And my thoughts—both outlandish and wise—had nothing to do with anyone else. However, when adolescence hits, with all those hormones raging, personal order is fundamental and I discovered such powers via the nuns.

St. Mary's was child-oriented. My home hadn't been. It was exhilarating and fun, and there was a stalwart work ethic, but life was arranged around my parents. Typical for that period, we had to fit in and suit their schedule. At St. Mary's, the pupils were the stars. True, the nuns were married to God, but being from the order of IBVM—the Institute of the Blessed Virgin Mary—they were also devoted to their teaching vocation.

Although I'd been a total TV addict, I didn't miss watching the box once. Indeed, there was enough dialogue or activity between the classes, games, sports, and meals to make up for all the detective series and comedians. Nor did I miss my family. I never cried, unless I had been naughty and caught out on something. At night in the dormitory, sniffling and sobbing surrounded me—some girls were desperately homesick—but I never was. I hid the fact, naturally. I also pretended to dislike St. Mary's, like many. But the reality was that I eased into a relaxed and content state. I felt protected, looked after, and relieved that there would be loo paper in the bathrooms. For some reason, the "suicide yellow" loo never had any. Being at boarding school also began my lifelong love of stationery. Notebooks, stickers, pens, different-colored inks, and writing paper that might have envelopes to match—my mother had found sets at Harrods that had our first-name initials raised and illuminated—or blocks of paper decorated with Witchiepoo and other funny characters.

I also admired the nun's habit. Since it was flawless and since it

was individually fitted on each woman, it was my first taste of haute couture. Privately, I marveled at the details, ranging from the starched white wimple fixed to the head to the short cape covering the bodice to the flow of the veil and skirt. It also appealed that there was a button at the back that allowed the nuns to hitch up their skirts when whizzing down the stairs or running alongside the hockey field.

The tunic that was part of our winter uniform flattered and smoothed my figure. That kind of strict line tends to be forgiving. And hideous as the nylon-striped shirts were—they were hell for those who perspired a lot—it was a weekly thrill collecting them fresh from the laundry. After my previous experience of thoughtless Scottish cows turning my pink ballet clothes gray and other embarrassments, I worshipped at the feet of the laundry nuns. They did such an excellent job of cleaning clothes and folding everything immaculately.

It would be terrific to take this further and reveal that suddenly my thoughts cleared and I became top of the form. That never happened. I usually ranked eighth or ninth out of fifteen. That said, I was always good at French, occasionally excelled with my essays in history and poems in English, discovered a love of acting, became the youngest member of the choir organized by the wonderful Mother Ancilla—her spit flew when pronouncing "royal and rich." Yet best of all, I began to read. An interest ignited via peer pressure.

Going to the library was key to St. Mary's. It was an event that was done with friends. And I didn't want to miss out on the social action. Choosing books or joining the waiting list for an in-demand book was nifty. After lights-out, reading under the covers with a flashlight was also considered "nifty." And being caught reading was probably the niftiest. I never did that, sensing that it was bad for my eyes. Still, the joy of turning the page and dipping into a different world furthered my inner contentment.

06 *When Harold Met Antonia*

I first met Harold Pinter at the beginning of 1975. He was sitting in our drawing room. Mum insisted that I show him an example of my italic handwriting. Calligraphy was the one subject that I always excelled at, often coming first in my class. Smiling, Harold looked at my work and said it was very beautiful. I wondered who he was. His name meant nothing. Yet the atmosphere was charged. I felt uncomfortable. Call it a case of encountering something that didn't feel quite right but was being presented as normal.

Although Harold always wore thick-framed glasses, I don't remember them on that occasion. Instead, it was his apparel. In London, suits on men tended to be the norm in my experience. However,

he dressed casually, in a sports jacket, open-necked shirt, and wool pants. His legs were crossed in an eye-catching, confident manner. The pose was virile. Not that I knew the word then. Indeed, until Harold became really sick in 2008, he always exuded a certain virility. Although one of the great men of the theater, he was a keen sportsman. Proud of being a champion sprinter at his grammar school, he enjoyed playing squash and tennis and was captain of his own cricket team.

I thought nothing more of the meeting. Or rather, I pushed it right to the back of my mind, hoping that it wasn't serious. Then suddenly, in July 1975, I was confronted with Harold's picture, six months after the event, blasted all over national newspapers. With his dark hair and long sideburns, he looked both dramatic and distinctive. I was reminded of the singer Tom Jones. Harold was billed as the "famous Jewish playwright" with "working-class origins" or "modest background," and his wife, the renowned actress Vivien Merchant, was divorcing him and exposing my mother as the co-respondent. Her words were, "I am specifically naming Antonia because if she wants to play silly games with my husband, I am prepared to do the same to her." It must have been a fairly dull summer for newsworthy items, because the gutter press, or "grub street," went a little nuts and continued in that vein for the entire summer holiday.

The harassment—and it became a harassment—began with a few paparazzi lurking outside our house. I recall the photographers going great guns when my father arrived. Cornered by the flash of their cameras, first he covered his face and then lashed out and hit one of the men. Shocked by the experience and then horrified by his reaction, he went out to apologize. After all, the man was just doing his job.

It must have been about five p.m., still daylight in London, and yet all the curtains in our house had been closed, sending a warning

sign. Mum arrived home in a taxi, but she sped off when she saw the curtains and then the cameras. Naturally, a few pictures were snapped, but all they got was her back.

A few hours later, she returned by the garden's back entrance—equivalent to a heroine's return, or so it seemed. Mum looked extraordinarily beautiful. I was unaware that she was madly in love. But since she was in a good mood, I asked what exactly was happening. "Oh, it's because I'm so wonderful." Then Mum cantered on about a woman who was "wildly jealous" and "saying horrible things." There was a brief pause before she continued: "But what she's saying is all lies." There were no names, which was odd, but I went along with the "evil queen" and "all lies" scenario even if we, the four youngest children of her brood, were being packed off to Scotland three days earlier than planned.

We'd been instructed not to look at newspapers. Naturally I did, and saw separate pictures of my mother, Harold, and his wife, who was spilling the beans. Vivien's behavior and quotes exemplified the expression "hell hath no fury like a woman scorned." Yet, weird as it will sound, I still convinced myself that it was all lies.

Sophie, the daughter of my godmother Marigold Johnson, was staying with us. Ever frank and speaking for her household, she did say, "Oh well, your parents haven't been getting on for some time." But I still didn't believe it. Talk about the power of denial!

Then the press turned vicious, goaded by Nigel Dempster, the *Daily Mail*'s gossip columnist. His goal was to have power, and he soon earned it, becoming the British equivalent of Walter Winchell, a powerful American columnist from the 1920s into the 1960s. Dempster had targets before my mother. Infidelities revealed in his columns in 1974 had children crying home from school. Fergie, the Duchess of York, claims to have first heard about her parents' divorce via

Dempster. True, some *Daily Mail* readers were rather horrified, and then there were those who lapped it up and could not have enough.

Sharklike Dempster had being circling around my mother for some time. I wonder if he didn't watch my mother from a distance: the blondness, the batting of the eyelashes, the bestselling books, the dignified husband, the public allusiveness, and, since he couldn't be part of it, he wanted to blow it up and smash it to smithereens. Anyway, the moment came.

I remember taking the newspaper and sitting on the main stairs. Dempster's article was called "The Romantic Life Style of Lady Antonia Fraser." I looked at all the names and photographs. To be honest, I was both horrified and strangely fascinated. Why her? Then my survival instinct kicked in. What was I going to say about this at school? That was *my* world, and it was all I cared about. Indeed, my main concern was, "How am I going to deal and explain this to my friends?"

Unfortunately, Dempster's column led to a "Cry 'Havoc!' and let slip the dogs of war" situation. Suddenly the *Daily Express*, the *Daily Mirror*, and all the other scandal sheets started to point fingers at my mother's private life. There were also cruel cartoons in magazines. Within the second week, the television stand-up comedians began on my mother. It was ugly; the ugly side of fame and the ugly side of England. Of course, it made an impact. It gave lucidity. I realized that the press and popular opinion were fickle and couldn't be trusted. Nor was either going to hold me back, ever. Not bad lessons to learn early in life.

Yet in spite of all the newspaper articles, I still did not believe the story about my mother and Harold. I even remember being with Mrs. Hepburn, our cook, and Jean Leyland, my younger brother's nanny. They were complaining about the unpleasant tone, and I said words

to the effect of "Yes, it's amazing when you realize that it's all based on lies." Both looked a little embarrassed.

I returned to our house in London and found stacks of mail waiting for my mother. When remarking on the fact, I was informed that it was to be expected since she was living elsewhere with Harold. I froze. Barefaced lies can do that. After an argument with a sibling, I then decided that it was going to be the beginning of a new life. Much as I loved my parents, I couldn't stand being with them when they were together. The tension was intolerable.

On the other hand, the introduction of Harold in my life was a win-win situation and I never felt disloyal to my father either. I found Harold honest and straightforward, a force of nature. Let others beat around the bush, not HP. He avoided the hypocritical, back-biting behavior that could be prevalent among the English. We shared a love of Hollywood and film that became a key element of our relationship. He had just written the screenplay for *The Last Tycoon*, a film that would be directed by Elia Kazan and star Robert De Niro, Tony Curtis, and Jack Nicholson in 1976. When he began his relationship with my mother, he kept a considered distance. That "distance" thawed and then turned to a paternal type of love.

Around that period, *The New Yorker* published a cartoon with a fairly typical-looking intellectual Manhattan couple. Underneath, the punch line went something like "I don't know what you're complaining about. Even before Harold Pinter, our marriage was full of pregnant pauses." Ignorant about Harold's work, I had no idea what this meant. However, I did sense that having him in our lives meant a significant change. Representing the dire opposite of the British mentality—"Never complain and never explain"—Harold did furiously complain and want explanation. He could be trying and exhausting, but he had enough self-effacement and humor to get away

with it. As for the notion of becoming difficult with success, it was absolutely not the case. According to Henry Woolf, who'd been to grammar school with him and had both encouraged and staged his first play, *The Room*, "Harold was always the same."

Finding him touching and loyal, I admired Harold bringing his tailor father into retirement and what a devoted son he was to his parents. His convertible silver Mercedes with black leather lining—nicknamed "Myrtle" by Mum—wasn't bad either. There were balmy evenings spent in Dorset, a place that Harold favored, because of Thomas Hardy. After eating out at a local restaurant like Maisie's Farm, Harold and Mum would be sitting up front, my brothers and I behind. With the wind in my hair, I'd feel punch-drunk on the heady air. On one occasion, I recited a poem about a woman and her zither. An innocent, I couldn't quite understand why the lines "She twangs it and she twiddles it hither and thither" and "She tweaks it from the moment she takes her morning bath" led to so much laughter from the front-seat passengers.

Thanks to Harold—both gregarious and generous—our lifestyle soared. Suddenly my younger brothers and I were attending premieres of plays like *Dracula*, starring Terence Stamp, and meeting Hollywood producers like Sam Spiegel, and watching cricket matches with film stars like John Hurt or leading playwrights like Simon Gray, Ronnie Harwood, and Tom Stoppard, and eating in delicious restaurants like Mr Chow and Rowley's on Jermyn Street. There were no more jaunts to Paradiso & Inferno, a questionable eatery in the West End that my mother loved; every time we entered, the female owner would rush over and say, "Children, your mother is the most beautiful woman in the world."

I was often struck by Harold's precision, his choice of words to narrate a tale, his clarity, his large black handwriting, well spaced on

yellow legal pads, and his spontaneity. How he could burst into song—Irving Berlin's "Heat Wave" was a favorite—or dance with a baby step-granddaughter in his arms, singing "Falling in Love Again," and how his passion for theater and film was steeped in knowledge of the craft of acting. I discovered Carol Reed's films with him—*Odd Man Out, The Fallen Idol*, and *The Third Man*—and was exposed to a different standard of performance.

Still, it took time to acclimatize to the situation. I wasn't against my mother daring to get up and go. However, I was pretty annoyed about the lies during the holidays. We had a scene in her boudoir where I admonished her for lying about Harold and she swore that it had been my father's decision to lie about the situation. Oddly enough, it probably was. Still, I refused to write to her. Or rather, that first term of school, I would send letters to my father and in the postscript instruct him to pass them on to her, sensing that he might not. It got to the point where my headmistress, Mother Brigid, had to intervene. An atrocious snob who courted European royalty and power—this explained why Caroline of Monaco, Elena of Bourbon, and Irene Marcos were pupils—she was also worldly. In the intimacy of her study, she gave me a light lecture about life having twists and turns and, becoming eagle-eyed, said, "Natasha, you need to write to your mother as well." Eventually it became much easier.

As for my classmates and indeed their parents, I'll always be grateful for their grace and humanity. Only one person out of the thirty girls referred to the horrors of the press, and she was quickly hushed up. Everyone carried on as if nothing had happened. Nor did anyone else react at St. Mary's and that counted over two hundred pupils. It was a relief. Their behavior made me realize that there were decent types in England.

As for my poor father, his *annus horribilis* continued. In October

1975, the IRA attempted to kill him. He had been receiving death threats but refused to give them any credence. However, on the evening of October 22, they planted a car bomb under his forest-green Jaguar. The next morning, he was about to leave for the House of Commons when the telephone rang. The call saved my father's life. While talking, he was suddenly blown off his chair.

Binny, the dog of our neighbors, the Hamilton-Fairleys, had set off the bomb. Instead of my father, it had killed Professor Gordon Hamilton-Fairley, a leading cancer specialist. When I heard the news, I went numb. It was a feeling caused by profound relief and terrible guilt. My elder siblings and I knew his four children. His daughter Fiona Hamilton-Fairley was exactly my contemporary and had been at nursery school with me.

Australian in origin, the tight-knit family had a remarkable energy. Early pioneers of organic food, they were sporty, warm, and inclusive. I'd gone on a day-trip with them once and gotten seriously sunburned. Not a drama, they had the right cream and so forth. I didn't know the professor well, but he had the kindest eyes and the simplicity of the great. Later, I learned that he had turned down the appointment to be Elizabeth II's personal physician, choosing to work with the public. Such a decision typified him. Daphne Hamilton-Fairley, his very attractive Anne Bancroft–type wife, was his ideal counterpart, being punchy and clever and a recognized powerhouse with regard to dyslexia and dyspraxia.

At the time, Caroline Kennedy was staying with my father. The daughter of his friend Jackie Onassis, she was doing a course at Sotheby's in London. Certain newspapers even wondered if she was the IRA's target. Hardly. The Provisional IRA group, later identified as the Balcombe Street gang, went after my father because of his prominence as a politician and his hard line on republicanism in Northern

Ireland. In actual fact, being a Roman Catholic, he felt tremendous sympathy for those born of his religion.

The IRA terror campaign reigned throughout 1974 and 1975. Under the command of Brian Keenan, forty bombs were detonated across London in public places like the Green Park Tube station and Harrods. True, the IRA gave ten-minute warnings, but thirty-five people were killed, mostly civilians, and many more were injured. Professor Hamilton-Fairley was the only medical doctor to die. A blue plaque in the crypt of St. Paul's Cathedral commemorates him: GORDON HAMILTON-FAIRLEY DM FRCP, FIRST PROFESSOR OF MEDICAL ONCOLOGY, 1930–75. KILLED BY A TERRORIST BOMB. IT MATTERS NOT HOW A MAN DIES BUT HOW HE LIVES.

Just after the bomb incident, I returned to my father's home and found the dining room table covered in threatening letters sent by the IRA. In content, they were fairly similar, a lot of "STOP . . . OR ELSE," and were all created using a ransom-note typeface. Scotland Yard had given Poppa a long contraption with a mirror at the end that he was meant to use to check under his car. In typical fashion for him, he tried it out once and then ignored it. I do remember asking if he was scared and his replying that he refused "to be terrorized by such cowards." As a war hero, he could warrant such an attitude. Nevertheless, in retrospect, it did mark me. Why should cowards hold one back? And as the years unfolded, I began to believe that people could be divided between the brave and the fearful.

07 *The Effect of Punk Rock on England*

Andy Warhol was always the first to acknowledge an important new trend and/or movement. And this was demonstrated by his posing with Jordan. The event was the London premiere of *Saturday Night Fever* in 1977, the scintillating disco film of his producer friend Robert Stigwood. He might have posed with John Travolta, a new Hollywood star and future cover boy of his *Interview* magazine, but Andy recognized that the "hip pic" was the one with Jordan, universally recognized as the female embodiment of punk. According to Alexander Fury, the reputed fashion critic, "no one wore punk's trademark sartorial spit-in-your-face better than Jordan," yet nothing was gross in her general attitude.

As always, the American Pop artist was soberly dressed in signature white shirt, dark jacket, and jeans. Jordan, on the other hand, had tonsured hair and a face described by Fury as being "spliced up like a Picasso painting with eye shadow and kohl." There was also her attention-grabbing attire of big white panties worn over black panty hose, and a tank with *Venus* spelled out with safety pins and various pins worn over a lacy top. Andy looked lightly amused and Jordan defined nonchalant.

The American artist was world-famous, but she was the main attraction at Seditionaries, Malcolm McLaren and Vivienne Westwood's boutique. Bold about her wardrobe, she ignored efforts to arrest her for "being indecently dressed in public."

Punk rock aimed to cause turmoil and discord. Adopted by the young, poor and privileged alike, the cultural phenomenon swept through Britain in the mid-'70s. Bristling with rage, it rebelled against the class system, grim living situations, unemployment, and other social injustices.

It was pretty extreme and fairly dark, yet punk rock lit a quiet match within the heart of my generation and had an extraordinary and lasting effect. No doubt it was because punk rock's genesis was the music world and, as always, nothing was more influential on British youth than music.

There were bands such as the Damned, the Ramones, the Dead Kennedys, and the Clash, but few stirred like the Sex Pistols. It was a mixture of the intelligence of lead singer Johnny Rotten and the sharp, commercial sense of Malcolm McLaren, the band's manager, who described the venture as making "cash from chaos" and the rebellious nature of English youths who, given a chance, enjoyed behaving spectacularly badly. Neither Rotten nor McLaren trusted the

other, but their joint efforts were alchemic and exploded their world. Music-wise, there was definitely a before and an after the Sex Pistols; their influence was that relevant.

"Anarchy in the U.K.," released in 1976, was their first single. True, I was a privileged convent schoolgirl, but the music and the song's lines—such as "I am an anti-Christ, I am an anarchist" and "Destroy!"—hit a spot and offered a dramatic escape from my circumstances. Nihilism was promoted and that also attracted because it had nothing to do with my parents and background. The Sex Pistols became my own private place. I didn't pierce my nose and spike my hair, because I didn't need to. Occasionally my new, hardened attitude showed in my behavior at school. During my fencing class, I persuaded Princess Elena of Bourbon to step on a stink bomb. No one would touch her, as she was royalty, I reckoned. So taking her *épée en garde* position, Juan Carlos's daughter thrust her leg forward and crushed the stink bomb's glass phial. It was in St. Mary's gymnasium and, to the fury of our teacher, stank out the entire establishment. Blond, good-looking, and the proud owner of a Porsche, our fencing *maître* had been fairly tolerant of my cheeky behavior—I was always slightly pulling his beard—but this pushed him over the edge. Alas, that was the goal.

Nevertheless, it was mild in comparison with the Sex Pistols, who were christened "the filth and the fury!" by the *Daily Mirror* for swearing and behaving abominably on live television. A few weeks later, when leaving for concerts in the Netherlands, they were reported by the London *Evening News* as having "vomited and spat their way" to their plane at Heathrow Airport. According to *The Guardian*, their single "God Save the Queen"—released in Elizabeth II's Silver Jubilee year—was banned by the BBC and almost every independent radio station, making it "the most heavily censored

record in British history." Yet it sold, sold, sold. On a school outing at Chester Zoo, I marched into WHSmith asking for the notorious single. In clipped tones, I was informed that they did not stock or sell "such records." But while I was leaving the shop, a little old lady with gray hair and a lilac-colored coat came up and said, "Listen, if you go down this street, turn to the left after the traffic lights and then the immediate right, you'll find 'God Save the Queen' in the shop next to the newsagent."

In typical British fashion, the people on the street were rooting for the underdog, or rather, the "bad boys" of rock and roll, in this case. (The Queen was not as popular then as she is now; Princes William and Harry were yet to be born.) Meanwhile, the Sex Pistols' newcomer Sid Vicious, who couldn't play the guitar, was outrageous. "He was the knight in shining armor with a giant fist," said McLaren.

In many ways, Malcolm, often viewed as the Godfather of Punk, had Warhol-like elements. His version of the Factory was Seditionaries, the boutique he shared with Vivienne Westwood at World's End on King's Road, whose past employees included Chrissie Hynde. Like Andy, who had signed up Lou Reed and the Velvet Underground, Malcolm attracted young talent to his side. After the Sex Pistols, he managed Adam Ant, the handsome rock singer who was in *Jubilee*, Derek Jarman's film about punk. Malcolm also created Bow Wow Wow and launched the career of the singer Annabella Lwin.

Malcolm represented the wild side of the music world—types viewed as too unpredictable to be entertained by smart London society—whereas the likes of Mick Jagger and Bryan Ferry were definitely in the social swim and favorites with certain hostesses. I was introduced to Bryan Ferry at the eighteenth-birthday party of my sister Flora in October 1976. Despite being an important singer and ravishingly handsome, he spoke to whoever pushed themselves

onto him, including yours truly. On the same evening, I met his girl-friend, Jerry Hall, who resembled a Grecian statue. Her blond hair was pinned up and her asymmetrical white Antony Price dress emphasized her shoulders and neck.

Excited to have met both, I remember thinking, *That was easy*. Yet the encounter made me yearn to leave St. Mary's—I had two and a half years left—as had going to Paris in the summer of 1976. My godmother Marigold invited me to the ten-day trip. We drove, which was then a norm because flying was so expensive. Our group included her daughter Sophie and sons Luke and Daniel. The latter had just completed his first year at Oxford and was keen to discuss eighteenth-century French philosophers. Fat chance with Sophie, Luke, and me, who drove him mad with our tendency to break into song. "Mum, I can't believe that we're in the city of Voltaire and I have to tolerate this," Daniel would occasionally explode. But we stubbornly persisted. To give an idea, rue Barbet de Jouy, the street that we were staying on, became "Ba ba ba, Barbet de Jouy," inspired by the Beach Boys' song "Barbara Ann."

Nevertheless, Daniel, a gallant guy, was there to defend when a French jerk slapped me across the face for stepping on the lawn in Versailles. An incident that I quickly forgot and forgave because within a few days, I was smitten by the sophistication of the city even though it was August and emptied of chic Parisians. Fresh baguettes were baked several times a day. Fruit and vegetables were lovingly displayed like jewels in windows. Even exercise books with their different choice of bright-colored covers were attractive. The terraces of places like the Café de Flore had allure with their round tables, wicker chairs, and clutches of different-sized glasses. I still recall my first *citron pressé* and being struck by the civilized ritual of pouring the water and shaking the sugar.

I returned to England and became a Paris bore. When we went to Ireland, I continued raving about the city of lights. At the beginning of the trip we stayed with Robert Shaw, one of Harold's oldest friends. Years before starring in *Jaws*, Spielberg's mega smash hit, he had appeared in the original productions of *The Caretaker* and *The Birthday Party*. Harold was unbelievably charismatic, but Shaw had something else—he embodied danger. Apparent in his eyes, the mole on his cheek, his nose, his regard, and his voice: it was extraordinary to witness. Unfortunately, he had just returned from a press junket for *The Deep*, and his way of coping with jet lag was drinking morn, noon, and night. He also agonized about having sold out to Hollywood—a feeling that then cursed British thespians—and accused Harold of thinking likewise, when it was not the case. Having started as an actor, Harold understood. Shaw also had to support ten children.

Eighteen months later, I was rusticated from my school for sneaking out and visiting boys at Eton, the smart school. Five of us got caught. And we were sent away to our parents because it was felt that we were a bad influence on our class. I had changed, or rather, my taste in music had. My once cherished *American Graffiti* sound track, Supertramp, and Elton John albums had been cast aside. Instead, David Bowie's haunting face stared out from my *"Heroes"* album while the Stranglers sang two of my favorite singles—"Peaches" and "No More Heroes."

In London, I had read about the teenage issue of *Harpers & Queen*, the British monthly. The magazine was looking for young writers and models. It was an opportunity. I wrote in and was amazed by the reply. During the Easter holidays, Mayotte Magnus took my portrait. The French photographer caught a virginal innocence in me with my long straight hair. But the magazine decided that it wanted more sophistication.

Clive Arrowsmith, a renowned fashion photographer, was enlisted. Since it was during term time, I lied to my school and said I had a pressing dentist appointment. The words had tripped off my tongue. I was equally duplicitous with my mother, informing that I had been given permission to do the shoot. That day, I'd chosen to wear a brand-new pair of pearly leather perforated shoes. A mistake: I can still remember the lineup of painful blisters and thinking that God was paying me back for my fibs!

When I was introduced to Clive, he made noises about a Renaissance painting. My long hair was plaited and full makeup was applied. Totally at ease, I talked to everyone, determined to glean as much as possible. If they were surprised by my fifteen-year-old precociousness, they never said. I was lucky to have started with Clive, who would later photograph me for the *Observer Weekend Magazine*. He was a romantic and wit who made the most of a woman's face.

The photograph was never used. *Harpers & Queen* informed by way of a typed letter. "Write back and say how disappointed you are because of all the time and trouble," my mother advised. I did, and got a check for twenty pounds as well as all the negatives. It was an important lesson and fitted in with her dictum: "Try out everything but try to get paid."

Meanwhile, I was starting to catch the attention of older men. It rarely happened in the same way with boys in my own generation. Sometimes the incidents were funny. My first-ever day on skis, I appeared on the slopes in Saas-Fee resembling a pink-and-green ski bunny. A man appeared out of nowhere, doing a snow version of the tango, for my benefit. I attempted to join him and promptly fell on my face. Another time, I remember going to a gallery opening and wearing a gypsy-type dress that exposed my shoulders. Suddenly the likes of Terence Stamp and West End producer Michael White were

at my side. A few days later, I met Nicky Haslam in the Embassy nightclub, a trendy place to dance and have a drink. I knew who he was. As well as being a famous decorator, he wrote columns for *Vogue* and *Ritz* magazine, which was owned by David Bailey and David Litchfield and strongly resembled Warhol's *Interview*. Or, to quote Nicky, "I think we can safely say it was a rip-off."

Nicky, who was known for discovering people, came up and introduced himself. "I think you know my mother," I said. This surprised Nicky, who ended up writing about me in his monthly *Ritz* column in the spring of 1978. "Natasha Fraser, the daughter of Lady Antonia Fraser, who is already rivalling the beauty of her sisters Rebecca and Flora."

Nothing beat that first mention. Even if I kept it from every member of my entire family. Nevertheless, I read it again and again. I was fifteen, and although I was a wee bit young, I wasn't academic or particularly interested in my studies. I was eager to hit the big town and meet people. When Nicky sent me the invitation for his *tenue de chasse* ball—one of those soirées still viewed as legendary for the inspired hunting theme, the guest list, and the bucolic setting—I was both pleased to receive the stiff, engraved invite and annoyed that I couldn't go. Once again, I had badly caught what Andy coined as the "social disease," but I wanted to work too. I didn't nurse ambitions to model. I was photogenic but not a skinny mini, nor did I have the patience needed.

In my last year at St. Mary's, I swotted for my O-level exams and was accepted by Queen's College, a private girls' school on Harley Street. London beckoned.

08 *Early Euphoria Under Thatcher*

Before starting at Queen's College, I had a quick spin in Rome, where Andy and Fred Hughes had lived briefly in 1973. With director Paul Morrissey and actor Joe Dallesandro, they had shared a house with Andrew Braunsberg. Best known as Roman Polanski's producer, as well as being behind masterpieces like *Being There*, Andrew was working on *Frankenstein* and *Blood for Dracula* with Andy and Paul. "They were there to make money," Braunsberg says. "It wasn't particularly about creativity."

The American art market had dried up for Andy in the early '70s. It was a result of minimalism being in the forefront, with cutting-edge artists like Donald Judd, Dan Flavin, and Carl Andre who made Warhol look like old hat, or so some argued. Vincent

Fremont, in charge of Warhol Enterprises, also reasons that after the assassination attempt on Andy in 1968, the American art establishment took a position that he had "lost his creative energy. It was not true," argues Fremont. "Andy was physically healing but he had endless ideas."

Recognizing the situation, Fred decided to Europeanize Warhol's operation. Having been the protégé of Dominique and John de Menil, prominent collectors who were respected internationally, and having worked for Alexander Iolas, the Paris-based gallerist, he had all the right connections and was tailor-made for the job. In 1969, Fred got together with the powerful Zurich-based art dealer Bruno Bischofberger and Thomas Ammann, who was then working for him. "I invented the forty-by-forty-type portraits," recalls Bischofberger. "We called them 'Les Must de Warhol.'" ("Les Must" was a play on Cartier's famous campaign.) Starting in earnest in 1970, they were an instant hit and according to Fremont were "a good way to keep cash flow coming in in between exhibitions and other projects."

A constant source of income came via West Germany, Warhol's biggest European market, where Peter Ludwig, the country's most famous collector, and industrialists, their wives and families, and even politicians like Willy Brandt, the former chancellor, lined up to have their portraits done. "It was because the Germans understood and hungered for Pop art," states Fremont. "The idea being that you could buy part of American culture via Pop art. After the Second World War, England was in a bad shape financially. But the Americans were giving money away via the Marshall Plan and everything." Guided by Fred, Bischofberger took the business to another level.

During the 1970s, Fred also set up portrait sittings with members of European society such as Gianni and Marella Agnelli, Stavros Niarchos, Hélène Rochas, Éric de Rothschild, São Schlumberger, Silvia

de Waldner, and Gunter Sachs and his then wife Brigitte Bardot, the famous French bombshell. The lucrative portrait-commissioning business helped ease the way for "the five-star social climbing and shopping trips to Europe that Warhol, the awkward boy from Pittsburgh's Slavic ghetto, grew to love," as described by Bob Colacello in his *Vanity Fair* profile on Fred.

Nevertheless, Europeans were thrilled to meet Andy. "In Rome, he was treated like a film star," recalls Peter Brant. Jacques Grange, who was at the 1971 Venice Film Festival with Marisa Berenson and Paloma Picasso, was "electrified by Warhol's presence." Andy and Fred had turned up at the Palazzo Volpi, ruled by the social powerhouse Lili Volpi, and had dinner with the heiress and legendary collector Peggy Guggenheim and Yves Saint Laurent. "Peggy really wanted to meet him," recalls Grange.

When taking the sleeper train back to Paris, Andy bumped into Nico, one of his former Superstars, who had sung with the Velvet Underground. "Beautiful but quite out of it, she wanted to see Andy alone and then immediately stung him for money," recalls Clara Saint, who worked for Saint Laurent. "Of course, he gave it to her, but I think he was starting to tire of that type of behavior."

A year later, Andy attended the Volpi Ball, given for the eighteenth birthday of Olimpia Aldobrandini, Lili Volpi's granddaughter. It was viewed as the last of its kind by Cecil Beaton, the photographer and social diarist, who wrote, "It was interesting to see the influx of the new stars. Andy Warhol in a silk dinner jacket, Bianca Jagger with a swagger stick, Helmut Berger, very German and Marlene Dietrich–esque, his hair dyed yellow . . ."

Meanwhile, Fred didn't just make Warhol into "an old master," to requote Nicky Haslam, or "the Sargent of the Jet Set," to further quote Colacello: "He also established a network of important European

gallery owners such as London's Anthony d'Offay, Paris's Daniel Templon, Düsseldorf's Hans Mayer, and Naples' Lucio Amelio, who were later prepared to advance hundreds of thousands for shows of much more difficult work: the *Mao* series, the Drag Queens, the Hammer and Sickles, the Skulls."

Interior decorator Suzie Frankfurt had known Andy since the 1950s. However, during her trips to Europe with Warhol and Hughes, it was Fred who won her attention. "After her divorce, my mother became a bit of a groupie," explains Peter Frankfurt. "She was just dazzled by him. Fred had become an impresario."

Nevertheless, Warhol still fretted about funds and the need to finance his empire, which included the Velvet Underground and *Interview* magazine. "Every year, Andy would be paranoid that we had no money," says Fremont. "And I bought into it."

During the making of *Frankenstein* and *Blood for Dracula*, Elizabeth Taylor happened to be in Rome. Miserable at the Grand Hotel, she was boozing, having just been dumped by Richard Burton. "Anyway, Andy was convinced that I was going to be her next husband," recalls Braunsberg. "He did everything to push the situation, ignoring my pleas to the contrary." Including the fact that Braunsberg was romantically attached to Faye Dunaway. Andy relished playing the role of Cupid. He often did that. And years later when he saw Braunsberg on Fifth Avenue, he reminded him of the fact. "Andy said, 'Andrew, I am so disappointed in you. You should have married Elizabeth. You would have had it made.'"

Andy did like to match-make. In fact, when we first met in February 1980, at a lunch given by Marguerite Littman, a southern-born society hostess, he asked if I knew Johnnie Samuels (who has since morphed into John Stockwell, an actor and horror-film director). Nicknamed "Beauty" at the time, he was the son of John Samuels III,

a Warhol collector and prominent New York City Ballet benefactor who was referred to as "Beast." "You should meet him, he's an Armani model," Andy said. At first I was taken aback. He was, after all, Mr. Important Pop Artist who was mentioned in a David Bowie song— the latter being major for that period. And here he was being silly. Then I remembered that *Interview*, Andy's magazine, had recently published a portrait of my eldest sister. Besides, I didn't mind. Andy knew how to tease. There was mutual interest—I was the daughter of Lady A, quite a celebrity, and he was the famous American artist. As he and I bantered, it was like being with one of the girls. According to Bob Colacello, "Andy was curious about women. He felt that he could gossip [with women] more than he could with straight men." Still, I sensed to withhold personal details. When he was grilling me about the guy I was seeing—a dashing but dastardly playboy—I refused to reveal his name. And when Andy asked if he was married—the playboy wasn't the type to get hitched—I was a little relieved by the arrival of other guests, who included Bianca Jagger, John Richardson, and Nicky Haslam, who was giving a party that night in honor of Andy.

Marguerite, whose husband was one of the Queen's barristers, was renowned for her lunch parties. Held at her Chester Square house, they were not only delicious, with food ranging from fillets of sole with ginger, southern fried chicken, and prune soufflé, but they also had an incredible mix of folk. Inclusive, she would mingle her New York pals like Diana Vreeland, writer Brooke Hayward, socialites Nan Kempner and Pat Buckley, and designer Bill Blass with her London friends such as Lady Diana Cooper and the Queen's cousin John Bowes-Lyon.

Marguerite had known Andy since the beginning of his career. She cohosted a party for him in the 1960s that led to decorating the walls with silver foil. Meanwhile, her range of literary-lion friends included Christopher Isherwood, poet Stephen Spender, William

Faulkner, Norman Mailer, and Tennessee Williams. I liked her "Keep it light" style and the fact that my mother disapproved of her long, lingering lunches.

As for Marguerite's strong accent, she admitted that it was pure theater: "It may sound southern to you, but when I go back to Louisiana, a lot of people don't understand what I'm saying," she told British *Vogue*'s Louise Baring. Self-parody was one of Marguerite's many endearing features. That said, to Hollywood, she was considered the coach for a southern accent. She had prepared Elizabeth Taylor for *Cat on a Hot Tin Roof* and also worked with Claire Bloom, Orson Welles, Paul Newman, and Joanne Woodward.

As usual, Marguerite looked immaculate in one of her Yves Saint Laurent outfits. I, on the other hand, had arrived on a bicycle, sporting tight drainpipe jeans, a pink-and-white vintage sweater, and tasseled loafers. My hair had been dyed black, and my eyes, later described by *Tatler*'s Tina Brown as "large, dark, and grabby," were smudged with dark purple eyeliner. Everyone else was more formally dressed and a lot more important. However, I was sixteen years old, spilling out in the right places and charged with the best accessory in the world—youth! British *Vogue* had also just published my full-page portrait under the title "New Beauties for the Eighties—The World Is Their Oyster . . ." Stefano Massimo, a Roman-born prince and Andy acquaintance, had taken my photograph. John Frieda, the then happening hairdresser, had done my hair, while Tom Bell, the fashion designer du jour, stitched me into the silver lamé strapless gown that made my snowy cleavage look like a pair of shimmering shells.

Initially, I loathed the picture. Frieda made my hair resemble a dark haystack, and my dignified expression defined old-fashioned and uncool. Lord Snowdon's portrait of model and actress Catherine Oxenberg, another beauty in the series, was much more to my taste.

She looked very pretty and dream date–like. Yet if I think back, my *Vogue* portrait stoked mild interest and established me as a new person on London's scene.

Later, a school acquaintance described me as a London "it girl." To be honest, I usually felt more like a "hit girl," with the amount of insults I received because I was viewed as confident or even cocky, when I was actually confused by the attention yet determined to seize life by the horns. Besides, the "it girl" expression was hardly ever used during the 1980s. And to explain about the London social scene then, it was staggeringly provincial because most people were English. To quote Nicholas Coleridge (then a star writer at *Tatler*), "London had more of a village atmosphere and there was a feeling—certainly in the world of *Tatler*—that there were twenty surnames." I remember gate-crashing two exceedingly smart weddings—of Edwina Brudenell, the daughter of David Hicks and the goddaughter of the Queen, who was naturally there; and of Eddie Somerset, whose father was David Somerset, the future Duke of Beaufort—and both went without a glitch because someone knew a member of my family. Gate-crashing such events would be unheard-of now.

Having strong features, I was recognizable and quickly viewed as posh with cleavage. When I appeared at Nicky Haslam's party for Andy, held at Régine's nightclub, the crème de la crème of the paparazzi—I refer to Alan Davidson and Richard Young—made a point of taking my picture.

True to form, Mr. Warhol also snapped away. "You're so beautiful," he said. I felt fairly chuffed until he said exactly the same to an American heiress sporting dental braces. Nevertheless, I stuck close and he didn't mind my sharing his space. "You're so beautiful," he continued to gush as he aimlessly clicked away at London's *jeunesse dorée* crowd. Being my frank, practical self, I felt the need to blurt

out, "Andy, why aren't you looking through the lens?" He didn't reply but smiled as if to say, "I don't need to." And I remained hot on his heels until Bianca Jagger arrived.

In those days, it was considered impolite not to dress up for a smart party, particularly when the invitation was sent by Nicky, media king. So I wore my black tutu dress, bought from a boutique in Rome called Ginger. It had cost twenty pounds. Andy immediately asked who the designer was. I didn't quite get it. At sixteen, I didn't wear high fashion, nor did any of my contemporaries. That was firmly for the older generation. So I explained that the black tulle dress had been on a mannequin in a Roman side street. Andy was amazed by the price. Actually, it was normal.

Bianca, on the other hand, was wearing Halston. I shared a limousine with her, Andy, Fred, and Mark Shand—the hunky brother of Camilla Parker Bowles—who kept trying to take Bianca's hand. It was quite femme fatale and quite off-putting until we talked about her emerald-green taffeta trouser suit. The color looked sensational with her black hair.

Still, Halston equaled a fortune. It was serious money that I never spent on clothes. For instance, my Saturdays were taken up by either going early to Portobello Road and rummaging through the humid cardboard boxes that offered the occasional sensational bargain— sometimes the designer Ossie Clark kept me company, with his little dog stuffed in his coat—or trying the stalls at Camden Lock that were farther away but cheaper. In London then, there was a sort of inverted snob pact: the cheaper the clothes, the better. However, if parents splurged on a cocktail-length dress or ball gown, they relied upon Bellville Sassoon or Caroline Charles.

Mine did not splurge. Instead, I borrowed dresses from Tom Bell, who was the London equivalent of Halston for a moment. He always

had dresses to lend and I always had a party to go to. The atmosphere was heady and caught aptly by the *Tatler*, a sort of pictorial "upper-class comic" that, to quote Coleridge, was "full of jokes and insults. I remember Michael Roberts [*Tatler*'s fashion editor] saying that the spine line should have read 'the magazine that bites the hand that feeds it.'" His boss was tough and demanding—"With Tina, you could go from hero to zero in seconds"—but her staff had the finger on the pulse.

True, many parties were promotional, but such events were new and thrilling to London—they began after the election of Margaret Thatcher—and there was a ton of champagne to be quaffed. Tom Bell could be counted upon to arrive with a gaggle of women like Mitey Roche and me. Mitey was the daughter of the poet Paul Roche, known for his relationship with Duncan Grant, the Bloomsbury group painter, while her American mother, Clarissa, had been Sylvia Plath's close friend. Armed by our dyed black hair—the L'Oréal shade was "Brasilia"—and a ton of eye shadow, with prominent cleavage in tow, Mitey and I would make a complete exhibition of ourselves. Such soirées varied in tone, but we always caught attention with our youth and brashness.

Occasionally, we would go too far. Actor Oliver Tobias's fiesta jumps to mind. Suavely handsome, he was famous for one film—*The Stud*—that costarred Joan Collins, his older and fabulous-looking lover. Mitey and I managed to break some potted exotic plants and then get locked in the powder room—the place of choice to take cocaine. As a result, we encountered the wrath of the Stud. He told us to fuck off and leave. Far from being terrified, we collapsed in a heap, laughing.

There were also all the evenings spent at 11 Park Walk, the restaurant off the Fulham Road that was run by a group of Italians who had earned their stripes at Mr Chow. The management never fraternized

with the customers: an unusual formula. Instead, they were phenomenally efficient and skilled at seating everyone.

There was a mirrored staircase that led down to the eatery where people checked out either their makeup or their noses for white powder traces. On any given night, there were groups of friends who tended to be swigging back the white wine and generally showing off. Few people had money in London then, but those who were wealthy, like Jasper Guinness, the brother of Catherine Hesketh, were fantastically generous. They picked up the bill for twelve people without question.

There was always a sea of social activities, whether it was a crummy but entertaining eighteenth-birthday party in Battersea or a smart drinks party celebrating Wimbledon given by Patricia Rothermere, the wife of the press baron who owned the *Daily Mail* and the *Evening Standard* newspapers. She was also the mother of Geraldine Harmsworth, the fourth English Muffin.

Showing customary extravagance, Lady Rothermere—nicknamed "Bubbles" in the press for her love of champagne—gave a party for Andy. As did Lord and Lady Lambton—the parents of Anne Lambton, whom the artist had actually proposed to. "I had just had this massive car crash," she recalls. "And my father came in and said, 'You're not going to marry this Warhol character, are you?' I was in my hospital bed and said, 'I don't think so.'"

Discharging herself from the hospital and wearing a neck brace, Anne had attended her parents' party for Andy. "It was fantastic," she recalls. "My mother was dancing with what she thought was a black man." It was a transvestite. Whereas her father talking to Andy "was like China talking to America. They didn't understand one word [the other said]." A curious aside: Sabrina Guinness points out, "In London, parties were always being given for Andy and it was an era when

people didn't." The artist incited that. According to Nicholas Coleridge, the world of Warhol, Fred Hughes, and Bob Colacello was "considered fashionable by *Tatler* because of the English people working there. That's what cool girls did," he says.

One *Tatler* highlight that lacked Andy and company was the Belvoir ball. Extremely grand and given by the Duke and Duchess of Rutland, it was for their daughter Lady Theresa Manners, who'd been at St. Mary's Ascot with me. I had never seen so many diamond tiaras in my life. Suddenly women who lived in Barbour jackets and tweed skirts were transformed by the family jewels. The dark side of the party were the upper-class junkies. From a distance they looked Sargent-like and romantic in their white tails or black tie, but when viewed up close, it was obvious their eyes were pinned. I met a society beauty on the main staircase who burst into floods of tears because her boyfriend couldn't "score," putting him in a foul mood.

One junkie scene remains stamped in my memory. It happened at an apartment in Earl's Court. Three guys had just chased the dragon: strips of burned tinfoil were all over the floor. They were watching *The Texas Chain Saw Massacre*—it was at the noisiest, most violent scene in the movie—and they alternated between nodding off and opening their eyes, showing pale blue, lifeless orbs. Apparently there was a cool factor to heroin, the ultimate escapist drug. I never got it. The self-indulgence and deadbeat, dank aspect defined depressing.

A familiar scenario during the height of taking smack was going to dinner parties where the table was emptied of eighty percent of the guests, who were either taking heroin or organizing their next fix or having a meltdown because someone had stolen their fix. A lot of whining went on, as it can with addictive behavior. One plus point was

befriending Robin Hurlstone, the art dealer. I didn't know who the mysterious, good-looking blond was, but I certainly wondered. Yet again, he and I were left alone at a table, in the company of everyone else's food, and then he leaned over and said, "We've got to stop meeting like this."

09 *A Whirl with Michael J*

When I had lunched with Andy Warhol, fellow guest Harry Bailey mentioned his portraits of Mick Jagger. He reasoned that the portfolio, done in 1975, was one of his best. Harry was gay, extremely handsome, and a big flirt. When talking, or rather, when gossiping, he asked if I had met Mick. "Nooo," I said, and pulled a face. As if to say, "Why would I be interested in that old man?" (Mick was thirty-six.) At the time, Mitey Roche and I were really into flirting with skinheads, then a post-punk, apolitical subculture linked to bands like the Specials and other ska music. We did have our standards. They had to be funny, blue-eyed, and extremely cute, as well as look suitably lithe in their white T-shirts and Levi's. Not that it went anywhere, in my case.

I talked about my skinhead passion to Harry, who dismissed it as being a bit silly and rebellious. He had a point. The skinheads represented a certain shock value. And he kept on about Michael J (this was the nickname my mother later gave to the British-born rock star). "You'll like Mick," he said. "He's funny." It was strange that he was saying all this under the nose of Bianca, Mick's first wife, but Harry was a mischievous lounge lizard who liked to stir the pot. Alas, he was also one of the early victims of AIDS, closely followed by his boyfriend Adrian Ward-Jackson. The latter caught the British press's attention because Princess Diana was at his beck and call.

Six months later, I met Mick on Sam Spiegel's boat off the South of France. Sometimes it's odd how holidays turn out. "With freshly inked hair," to requote Tina Brown, I had gone to Saint-Tropez with my cousin Christabel McEwen. We went by sleeper train—then the cheapest way possible—and took fairly inappropriate clothes, like stiletto shoes and thrift-shop 1950s strapless dresses.

We stayed at Sam's villa, Mas d'Horizon, which was just near Saint-Raphael. The house party consisted of his teenage son, Adam; one of Adam's school friends; a nanny; and Margot, a Dutch nymphet and favorite of David Hamilton, the soft-porn lens man. With her white-blond hair and honey-colored limbs, she was fairly typical for a Spiegelette, my nickname for Sam's gals. When she was not playing topless tennis, she sat alone. After I tried to talk to her, it was obvious that we had no subject in common. She found me trite and I found her humorless.

Still, I was intrigued. Sam became different around her. Initially, he had complained to his masseur that she wasn't "experienced enough." Experienced to do what, I wondered. Most afternoons, she and Sam would disappear into his bedroom accompanied by the masseur. And there were also her portraits in David Hamilton's book,

featuring her with long legs wide apart or resembling a provocative milkmaid in transparent white lacy garb.

Two other young women arrived for Sam's pleasure, but they stayed on *Malahne*, his boat. They were American college girls who looked terrific in bikinis but resembled hotel hostesses at night: silk dresses, elaborate hairdos, and heavy makeup. It was slightly strange considering the heat. Then the dynamics changed when Mick arrived with Jerry Hall and his daughter Jade to stay on Sam's boat. He had been invited via Ahmet Ertegun, his producer and the owner of Atlantic Records.

During dinner, Mick was his cheeky chappie self. The Americans knew not to engage—Sam was extremely possessive—yet it was very hard not to smile. On form, no one was more bright or entertaining. Mick began to get more and more impish and Sam began to growl. The American Spiegelettes were sent to the end of the table, and suddenly Mick found himself next to Christabel and me. We were having a fine old time until Sam came over and said, "Mick, you are monopolizing my English girls," and he said, "No, Sam, they're monopolizing me." Mr. Spieeegel, as Greta Garbo referred to him, was furious. "How dare he?" he said later, and indeed continued in the same rant while driving us back home to his villa. Meanwhile, Christabel and I sat in the back, refusing to engage.

Fun and games continued when Mick, Jerry, and Jade hit the swimming pool at Sam's villa. Mick got hold of a giant water pistol and started fooling around. Calmly, I sat and watched him from a sunbed. Running around like a little boy, he was urging everyone to join in. The mix of humor and energy was endearing until he came over and tried to pull Christabel and me into the pool. "No, Mick," we said firmly. A tug-of-war began. He then rushed off when Ahmet Ertegun—his next victim—appeared. The potbellied musical power-

house soon had his arms around both American college girls. I wondered if Mick would dare to push him in, but he didn't. It had been enjoyable spying his antics from a distance.

On Mick's last night, I sat next to Jerry. From that one conversation, I learned about the fashion world: the relationship among designers, photographers, and models. Naturally, I was delighted when she said that I resembled Esmé Marshall, a dark-haired American supermodel with large eyes and powerful eyebrows. "You both have similar cameo-like profiles," she said. Jerry mentioned this to Mick, who sort of grunted. Attention could never be off him for too long. Taking it further, Jerry said, "Natasha is so pretty that she should be photographed by Terence [Donovan] or Bailey." And Mick came out with, "Well, her tits are big enough." Talk about uncouth. Bristling inside, I ignored him all evening. Since they were leaving in the morning by helicopter, there was an informal gathering of good-byes. I joined in and was surprised when Mick grabbed me and said, "See you in London." I replied, "Yes, see you with Jerry." He then repeated, "See you in London."

I thought nothing of it until a few weeks later when Mum informed that Mick had called. He'd spoken to my sister Rebecca, who had said, "Who is this?" "Mick," he replied. "Mick who?" she asked. "Mick Jagger," he said. "Yeah, and I'm the Queen of Sheba," she said. This still makes me smile.

I called the Chelsea number when I returned to London a few weeks later. It was Monday, and Mick guessed that I'd eaten ham and potatoes. "How did you know that?" I asked. "Because everyone eats ham for lunch in England on Monday," he said.

Our first date was seeing a Stevie Wonder concert. Robert Fraser, a gallery owner and Andy intimate, accompanied us. It was a relief that we weren't alone. When arriving at Wembley Stadium, we bumped into Sting, or rather, a contrite and morose-looking Sting

came up to Mick. "Listen, I'm really sorry about the *NME* [*New Musical Express* article]. I was misquoted . . ." After the apologetic diatribe, Mick smiled and very politely said, "Sorry, I don't know what you're talking about." Sting looked surprised. And of course Mick had read the article, was still seething about Sting's unflattering description of the Rolling Stones, but wisely knew not to engage because it furthered Sting's awkwardness.

A case of "Don't mess with the Mick." Nevertheless, I was impressed and reminded of Harold during that period. Both were kings in their world and knew how to pace themselves and play the role. Like Andy, they had that grounded "I've got to keep the lights on" attitude. I mention this because it does take a mix of inner discipline and strength of character to achieve this.

The Stevie Wonder concert was fine. He was an excellent performer, just not my taste. Every other song, he would refer to his friends in the sixth or seventh row. The spotlight would turn, and it was obvious from their way of swaying that they were all blind. "He always does that," said Mick. "That's a bit manipulative, isn't it?" I said. Mick smiled but didn't say anything.

In the car journey toward 11 Park Walk, Mick occasionally stroked my leg and said, "I'm going to look after you." It made me arch and made me regret my choice of cheap camouflage skirt, whose zipper kept riding up my thigh. Mick was fun at dinner but slightly cruel to a starstruck couple. When we went to Tramp nightclub, he was more in his element. After a while, I got bored of the fawning conversation and crowd. Standing up, I bid farewell to Mick and headed for the stairs. He looked rather put out, but I didn't care. However, just as I hit the staircase, "Some Girls" began to play. And I hastily returned to his side. Little did I know that he had already complained about my abrupt behavior. "I wore a suit, picked her up, took her to a Stevie

Wonder concert, then dinner, and she leaves like that," he had said to Robert Fraser, who had been delighted to repeat this to Oliver Musker, Anne Lambton's brother-in-law, who had been delighted to repeat this to me. And in a nutshell that was the problem of getting involved with someone like Mick. There was no hope of privacy.

Still, that night, I was floating when I left the nightclub. Mick had the power to intoxicate. We took a taxi to his rented flat in the Boltons, he signed an autograph for the cabdriver, and then I freaked when we arrived inside. "Listen, Mick, I'm not sleeping with you," I said. He was unruffled by my mini explosion. Within minutes, he was helping me brush my teeth, and when the lights went out, my cotton sweater, cheap skirt, and everything else were swiftly whipped off. Mick was very sweet and thoughtful, and made me laugh. I liked being nicknamed "Natty Dread." (Bob Marley was one of my heroes.) Still, I wasn't then or ever in love with him. He was a burning light who belonged to Jerry.

Foolishly I had changed schools. I left the regularity of lessons at Queen's College, overseen by Mrs. Fiertz, the inspired and wonderful headmistress, for reckless abandon at Mander Portman Woodward tutorials. In my last term at Queen's College, Mrs. Fiertz came up and said, "I hear you're leaving us, Natasha." I felt skewered on the spot because she and I had had a lovely rapport. Mrs. Fiertz was direct to the point of bluntness—she thought nothing of asking pupils, "Are you pregnant, dear, or have you just been eating too much?"—but she cared for everyone's welfare.

However, I wanted freedom that came via Mander Portman Woodward's schedule, even if I rarely turned up. My absence got to a point that my exasperated mother turned to me during a traffic jam—once again, we had been hauled in to meet with the concerned heads of the establishment—and she said, "I feel that I'm going to this place more than you are."

In general, Mum rose above my antics and was tolerant of my friends. However, it annoyed her when she found them spending the night. After a while, she attached a large pin that she found in one of my brother's rooms to her Liberty print housecoat. It stated: *Your story has truly touched me to the heart. Never before have I heard such a tragic tale. Now fuck off and quit bothering me.* It summed up her growing attitude toward finding sleeping youths, at all hours, in the basement area.

Another place to pass out or eat at ungodly hours was 213 King's Road, the house belonging to Bindy Lambton, the mother of Anne Lambton, and her brother Ned Durham, who was my contemporary. Whatever the gig, whether the Boomtown Rats (my first rock concert), Chrissie Hynde (her first in London), or the most revered Ramones (I must have seen them about five times), a gang of people that might include Hugh Cummings, Celestria Fenwick, Valentine Lindsay, Christabel McEwen, and Mitey ended up chez Ned and wolfed down cauliflower cheese or other delicious dishes that had been left out by Maria, Bindy's Spanish housekeeper.

Ned was paranoid about being taken advantage of. Playing the great judge of character, friends would be "in," then suddenly "out." But the appearance of a punkish aristocratic impostor fooled even Ned. The young man claimed to be the son of Spenny Compton, the Marquess of Northampton, an aristocrat who was not in our parents' circle. He also claimed to have tons of money and dye his hair blue-black when driven to school by the family chauffeur. It all sounded so outrageous and cool. We ignored that his accent was not posh. Nor did anyone bother to look at *Debrett's Peerage*—the great tome that records the birthdates of the noble and titled. Had we done so, we'd have seen that Spenny was born in 1946: making him a fourteen-year-old father. Fortunately, our reputation was saved by Kathryn Ireland.

Kathryn has become one of Hollywood's top interior decorators. At the time, she did public relations at Tokyo Joe's, a happening nightclub, even if their one record, according to Nicholas Coleridge, was "Celebration Time, Come On." Being sharp to the ways of the world—imagine "pussy pelmet" dresses and announcing her engagement to Tokyo Joe's doorman to get publicity—Kathryn nursed her doubts about the aristocratic impostor. When he called his chauffeur, Kathryn picked up the telephone line in another room and discovered that he was actually calling Tim, the talking clock: a number in England that gave the time. Naturally, we were all annoyed to have been conned. The ever-defensive Ned pretended otherwise.

Meanwhile, hanging out with Mick was both a laugh and educational. He'd arrange for Alan, his minder, to pick me up from my home. Early-afternoon screenings were arranged of films like *Dog Day Afternoon*. The director Sidney Lumet was interested in casting Mick for a role. He took me to see Buñuel's *Discreet Charm of the Bourgeoisie* at the Minema in Knightsbridge. The choice of restaurants, like Ken Lo's Memories of China, was delicious. He'd talk about upcoming projects like Werner Herzog's movie *Fitzcarraldo*. The German director had fallen out with his muse—Klaus Kinski—and wanted to replace him with Mick. Physically, there was a resemblance.

Our relationship was delightful on every level, and I must have defined light relief because I never got heavy and asked where it was all going. Never. No doubt, it explained why he would say, "You're just so charming, Natasha, you're just so charming." If seen rarely and in small doses! Seriously, it came down to being unspoiled and viewing my time spent with Mick as an adventure. He was firmly not of my world and I always knew that. So it was fine if I saw him and fine if I didn't.

At the beginning of October, I met all the members of the Rolling Stones at the transmission of the Muhammad Ali–Larry Holmes

fight, shown live by satellite at the Dominion Theatre, Tottenham Court Road. The place was packed and heady with the smell of cigarette smoke, beer, and sweat. A lot of money was running on the fight. According to Mick, most of the audience was cabdrivers. It was hard not to be hit by the rows and rows of male heads that faced the screen and were outlined by the light.

We had gathered in the forum before the fight. Mick had warned me about Stash Klossowski, the son of the painter Balthus. "Don't take anything he offers you," he said. It was protective though unnecessary, since hard drugs were never my deal. (True to form, Stash, who I thought was a bit of an "ooh, groovy baby" charmer, offered some "gold pills.") Mick had also mentioned Keith Richards, describing him as "very shy but a sweet person."

Mick had not, however, predicted Patti Hansen's weeny outburst. Sleek in a red jacket and black jeans, she sidled over and said, "Mick, where's Jerry?" He grinned and shot back with, "Jerry is doing the Paris fashion shows, Patti. It's where you should be." Yet another example of "Don't mess with the Mick," even if I admired Patti's loyalty. I then had Shirley Watts kidnap me with her lecture on not talking to the newspapers. "It's never a good idea, dear," she advised. "And haunts you for life, dear." Fortunately, I was saved by the appearance of Mick, who said, "Shirley, Natasha's mother is quite well-known." We laughed about that afterward.

By then, my family knew about the relationship. When giving me a book about Mexico, an elder sibling had written: *Don't mix Mex with Mick.* He'd also stayed at my mother's house. After coming out of my apartment in the basement, Mick bumped into the two workmen who were painting the house's facade. "Her ladyship says, 'Paint it purple,'" he advised. They quickly relayed the incident to my mother.

Harold and Mum were getting married on his fiftieth birthday, October 10. A double celebration had been organized, until his first wife put a wrench in the works by refusing to sign the divorce papers. Nevertheless, it ended up being an amazing party—London's and New York's great and good from the literary, theatrical, and film worlds—where I would wear an electric-blue shot-taffeta dress from PX, Steve Strange's short-lived fashion brand. There had been talk of inviting Mick. "But he can't smoke pot," said my mother, who was strongly anti-drugs. Talk about an old-fashioned expression. Harold disagreed. "Mick can do what he wants," he said. Having befriended Brian Jones, he'd known Mick since the 1960s. Still, the idea of inviting Mick to their party horrified me. First, he'd have run for the hills. Quickly followed by me.

The people I met rarely impressed Harold. However, when I danced into the room and informed that Mick had introduced me to Ian Botham, a British cricket player, he was quite taken aback. A love of cricket was something that Harold and Mick shared. It's a passion that's impossible to explain to anyone who isn't male and isn't fascinated by English tradition. But as the years passed, Harold would return from Lord's Cricket Ground and say, "I just saw your friend Mick." That Michael J was alone and thoroughly absorbed in the game struck a chord within Harold. He did the equivalent, as did many others, like his hero and mentor Samuel Beckett.

My brother Benjie had just returned from a year of living in Australia. When sharing the basement, we quickly became sibling partners in crime. The actor Rupert Everett, who'd known Benjie at boarding school, was in our lives, as were all his friends, like the producer Robert Fox; his casting director wife, Celestia Fox; and Min Hogg, then an out-of-work journalist. Rupert, a team leader, was the first of my friends to become famous. I always sensed that it would

happen. There was the charisma—he enchanted on so many levels. There was the sense of entitlement—he used to give loud al fresco dinner parties on the street outside his parents' house. There was the sharp practical sense—it ranged from knowing how to stuff lamb with garlic to surviving in any situation. Rupert was endlessly telling my brother and me off for not making Harold more accessible. "Come on, we could have lunch with him or something," he'd coax. Benjie and I never discussed it, but I sensed that it was absolutely not in the cards. Harold was then at his professional zenith, both directing and writing for the theater and film worlds.

Like many of our friends, the wicked and incorrigible Rupert used Harold's Radio Taxi account. He reasoned that it was the "Fraser family trust fund." The astronomical Radio Taxi monthly expenditure drove Harold berserk. It was always the same scenario: Either he or Mum would tell us off, holding the monthly statement, a thick wad of paper, in hand. Benjie and I would look suitably shamefaced. The account code would change. A miserable week would pass without taxis and then either Benjie or I would eavesdrop on Mum, her secretary, or Harold, and suddenly we were off to the races, or rather off sitting in splendor in the back of a black cab.

Bella Freud and her sister, Esther, also partook in the "Fraser family trust fund." They had appeared via Ned Durham. Their father was the celebrated painter Lucian Freud, and they seemed to lead a life of staying in Belgravia via the generosity of his patrons like Jane Willoughby. Meanwhile, their mother was living in what I then naively viewed as the deepest, darkest part of North London.

A Scottish cousin had had a wild affair with Lucian and, having been a ravishing beauty, had turned into a scrawny creature, hiding a pet rat in her hair. I thought of her when I first met Lucian. Our encounter was on Holland Park Avenue. In search of cigarettes, Benjie,

Bella, and I were walking to the "offie"—the nearest off-license shop. "Daaad," Bella abruptly said, and there was Lucian.

Dressed in a long coat, he had feral eyes set in a pale face and seemed to be craning and moving his neck as if searching for light. Benjie and I stood there for a good ten minutes and then I began to feel the heat of his stare. I dismissed it afterward. My orbit was pretty much filled with Michael J and a few other cuties. London pre-AIDS was sexually on fire. Many were footloose and up for it. If I had one rule, it was never sleeping with men who I didn't find attractive. This, I discovered, rattled Lucian's cage.

A few days after our meeting, Bella called and invited me to Annabel's nightclub. Lucian was a member and liked to go at midnight and drink Bollinger champagne with a gaggle of his daughter's friends. When I arrived, Lucian insisted that we dance. He'd been in his studio all day and it was his way to relax, or so he explained. Pressing himself against me, he said that he was enticed by the "ruthless determination" on my face. I really didn't know what he was referring to. However, when I felt his vast hard-on, misery and helplessness set in. Someone with a higher self-esteem would have stormed off. But I started inwardly freaking out. Somewhat pathetically, I didn't want to be rude. Still, I felt quite queasy as he perversely whispered his plans for me.

The nightmare, however, continued when Bella insisted that her father and I share a taxi home. "You're neighbors," she reasoned. On the ride home, Lucian became quite lighthearted and charming, until we reached my mother's house. "Why don't you come back to my home?" he said. "I have ultraviolet bean shoots and we can chew them like Chi Chi"—a famous panda at the London zoo. I thanked him but said, "I've got school tomorrow," and shot out of the taxi, propeller-charged.

The next morning, when seeing my mother, I narrated a watered-down version of my Lucian experience. She put down her cup of coffee and said, "Whatever you do, you're not having an affair with Lucian Freud." Her general argument being that she refused to deal with the filth. Her lecture was unnecessary. I had no intention of going there.

Lucian, however, took it very badly. He went around London saying how ridiculous and superficial I was, and even tried to kick me at publisher Naim Attallah's party for Tony Lambton's book *Snow and Other Stories*. I was astounded by Lucian's demented entitlement. Maybe he was a brilliant artist—one of the best from England—but maybe he was not my type. It took nine years for Lucian to thaw. And thanks to Bella's fashion career, I saw him again. As an acquaintance, Lucian was erudite and informed.

One fateful day, a friend gave me a newspaper clipping from the *Daily Express* that showed a romantic photograph of Jerry in a Paris nightclub under the title "Jagger Walks out on Jerry for a Teenager." It described her as talking openly about "her broken romance" and moaning at all the fashion shows about a certain Natasha Fraser. There was no mention of my mother, and I presumed that it would sink without a trace. Wrong.

Before the British national press seized hold of the story, I met Mick's parents. It happened after the ninth-birthday party of his daughter Jade. Hosted by Bianca, it had a mix of famous parents, my brother Benjie, and me. An anxious-looking Joan Collins was there with her daughter Katy Kass, who had just come out of hospital after having been in a coma. I dimly remembered details about Katy being run over by a car, and in precise detail, Mick told how Joan had fought at her side for months, how admirable it was, and how he reckoned the little girl would be fine. Mick's compassionate side was touching.

I also liked the image of him as "a shy teenager" helping out at the local mental asylum. The experience with the patients had given him insight into human psychology.

To celebrate the revamped issue of *Tatler* in November 1980, Tina Brown gave an elaborate party at the Café Royal that was too tempting to miss. I went in one of my tight cotton sweaters and presumed that I might get photographed. Little did I know that the word was finally out. Suddenly I was attacked by an onslaught of cameras. Feeling like a deer caught in the headlights, I gave them all the British "Fuck off" sign—resembling the equivalent of a reversed peace sign—and ran off to the nearest Tube. The next day, the *Daily Mirror*, among quite a few others, printed a picture and said that I got my V signs muddled up. "Schoolgirl Natasha Fraser Scents Victory over Her Rival in Love, Jerry Hall."

This was followed by journalists from *News of the World* and *Sunday People*—two popular rags—appearing on my doorstep and offering large sums for my story. Dream on. My grandfather was quoted as saying, "Mick Jagger's a bit old, isn't he?" It was more pleasant than Nigel Dempster, who wrote, "Any hopes that Natasha Fraser, the 17-year-old youngest and plainest daughter of Lady Antonia, may have had of prising Mick Jagger away from Jerry Hall were dispelled by the rock star, who informed: 'We have been out once to the Stevie Wonder concert.'" Interesting, but I understood. He *was* living with Jerry. A few months later, I got my own back on Nigel Dempster when he tried chumminess at a movie premiere. Looking at him straight in the eye, I said, "I'm Natasha Fraser, as in the youngest and plainest of Lady Antonia's daughters." He tried to claim that he hadn't written it. After that, the vile Nigel was never mean again.

Jerry, however, was furious. I'd warned my elder brother that if a woman with a Texas accent called, he was to say that I'd left England.

One Friday evening just as I was preparing a noshette (my mother's term for a well-greased snack), Benjie arrived and said that I had a call. His look was mischievous, but I was horrified to find Miss Hall on the other end of the phone. "Hi, it's Jerry," she began. "I thought you were ma friend, but I went to the modeling agency and they were all gigglin' about you and Mick. And I thought you were ma friend." This went on for several minutes. I was accused of stalking Mick, leaving earrings behind in his apartment (as if!), and making a nuisance of myself. So I reseized the horns and said, "Jerry, you're so beautiful, why would Mick be remotely interested in me?" There was a pause. "Perhaps you've got a point," she said, and then hung up.

Alas, I couldn't resist telling people the story, and it was repeated all over London—neither kind nor wise. I also continued to see Mick. It suited both of us for many years. But dear Jerry had a surprise in store. The event was Gael and Francesco Boglione's wedding. It was the best mix of London society, spiced up by Australian "it girls" like Nell Campbell and Lyndall Hobbs as well as Hollywood stars like Lauren Hutton.

I'd finally splashed out and bought a Tom Bell ball gown. Made out of magenta silk satin, it had a tight corset that continued to my hips and a large Scarlett O'Hara skirt, propped up by a mass of tulle. It felt fairly fabulous until I ran into Jerry wearing a sleek black velvet Saint Laurent dress that was buttoned on the side. We were in the outer tent that was empty of people but decorated with trees with sharp-looking branches. Doing her best catwalk stomp armed with swish of curtainlike hair, she railroaded me into a tree. Suddenly I fell and was left in a puddle of magenta silk satin. "So sorry," she said, peering down.

However, when asked about my affair by the socialite Denise Thyssen, Jerry said, "I got the fur coat and Natasha got the diamond

bracelet." Actually, I didn't. And I wonder if the woman who was given the bracelet deserved it in the same way that Jerry or I did. Though I understood her feelings, I always admired her. And when I congratulated Mick on their wedding and he quickly said, "Legally, it doesn't mean anything," I admonished him on the spot. His reaction being, "You're always so nice about Jerry and she's so awful about you."

10 *Discovering the Joys of a Monthly Paycheck*

As everyone including me might have predicted, the results of my A-level exams were a crashing disaster. Although mildly embarrassed, I was relieved that I had finally terminated my academic life and was firmly on the same page as my parents, whose dictum had always been: "Those who don't go to university have to work." Far from being "bred to wed"—certain women of my generation were raised to hook the title and estate—I often heard my mother say, "We are middle-class and we earn our keep." I wondered about the middle-class bit. She was the Lady Antonia, after all, and my father was born the Honorable. Still, I agreed with her approach.

With a career in mind, I was enrolled for four months at Pitman's Secretarial College. Attending

in my own fashion, I learned to type but now regret not having taken shorthand seriously. In fact, whenever I see fellow journalists going at breakneck speed with their shorthand, I'm reminded of my rebellious foolishness.

I did, however, want to earn my keep and not be financially reliant on a man. An affair with Roberto Shorto—a Brazilian-born playboy whose party trick was eating glass—had pushed me to this conclusion. His sister Denise was married to Heini Thyssen, the billionaire and major art collector. Staying at Daylesford, their house in Gloucestershire, meant sitting in a Jacuzzi surrounded by nubile Rodin statues and taking a bath below a Picasso. There were also Heini's morning visits to be endured. He would appear in Roberto's bedroom while I was naked, lying under the sheets. I think most people would have left under the circumstances, but Heini would just stand there with his dead eyes and odd, crocodile smile.

Heini possessed exceptional taste in paintings and had interesting pals all over Europe, as well as a terrific and dynamic daughter, Francesca, who became important in the hip New Romantics scene—but I simply couldn't figure him out. At the dining room table, he would take center stage, and recount a story that was both interminable and pointless. Once he finished, all his guests would laugh. They were singing for their supper. But surely Heini realized, and wasn't it a bit of a tiresome game? I attempted to say this to Shorto—that was how everyone referred to Roberto—who instantly climbed onto his crate of Coca-Cola bottles (his father owned the franchise in Brazil). "What do you know, you silly little girl?" he yelled. Well, quite a lot! My parents had rich friends, but they were stimulating, often brilliant conversationalists. They also didn't have Heini's sense of entitlement or decadence. When one was invited to their homes, they made an effort to entertain and engage.

Nevertheless, and now to get off my soapbox, it was actually the whiff of money around Shorto that partially attracted me to him. When we were introduced by my cousin Andrew Fraser, he was wearing a Cartier Tank watch, and I knew, within seconds of spotting it, that I was going to own it. I quickly did, and my mother quickly christened it the "watch of shame." This was followed by a glorious Antony Price dress with vast bustle-like bow at the back—quickly coined the "dress of shame."

There was also the fact that my boyfriend had told Shorto, "You don't stand a chance with Natasha because she's madly in love with me." Well, once I heard that, a lunch date with Shorto at the Ritz Hotel was swiftly arranged. All well and good if it hadn't been for Miss Everett's telephone calls interrupting. Rupert did this because Shorto had tried but miserably failed to have an affair with him. Roberto was many things but not homosexual. The first time the waiter appeared, he said, "A Mr. Jagger is on the line for you, Miss Fraser." I went to the telephone and found Rupert. And it continued in this vein until Shorto and I toddled out, blind drunk on champagne, and bumped into Lucian Freud before hitting Albemarle Street, then known for its art galleries. Shorto wanted to buy me a picture. Being Heini's brother-in-law helped. I was very keen on a Freud early self-portrait sketch. "It's haunting," I said grandly. Shorto liked the *haunting* word but chose a pornographic R. B. Kitaj pastel instead. It was two girls going down on each other. In spite of my inebriated state, I did wonder how I would explain this one to my mother.

If we weren't downing champagne, we were hoovering endless lines of cocaine. Shorto always had a ready supply: explaining his nickname "Professor Snorto," invented by Taki Theodoracopulos, the *Spectator* magazine columnist.

Then again, coke was very much the rage in London. A party at

Nona and Martin Summers's house demonstrated this. It was in honor of Jack Nicholson and his new film, a remake of *The Postman Always Rings Twice*, in 1981. Typical for that era, the action in the Mongiardino-decorated bathrooms was a lot more buoyant than in the salon. Martin was rushing around taking photographs of everyone, and a cousin and I—like many others—were feverishly hunting down the white stuff. Phew, I finally found one white pile but didn't see another one nearby. With my skirt, I managed to flip the cocaine mound into the marble sink. It was a huge amount. So while pretending to clean my hands, I started washing the white powder down the sink. I presumed no one had witnessed my shocking extravagance, until I posed with "Uncle Jack" and felt his hand up my skirt. "I won't tell anyone about that little incident if you don't tell anyone about this," Nicholson whispered.

A few weeks later, I bumped into Lionel, a French acquaintance of my brothers. "What 'ave you done to your skin?" he said. "It's covered in pimples." Fat or thin, my complexion had always been my crowning glory. Joan Collins, then a stranger, had even come up to me and advised, "Whatever you do, never go in the sun. Your skin is amazing." My encounter with Lionel was the needed wake-up call. I stopped snorting cocaine—never took another line again—cut back on the bubbly, began arguing with Shorto on an almighty level, did manage to meet David Hockney and Liberace through him, and then returned to the standby boyfriend.

That summer, Stefano Massimo photographed my elder brother and me for *Interview* magazine. Fred Hughes, who'd recently become a friend, had wanted a dose of elegant Brits, or hoorays (to use Rupert's less flattering term). I was also interviewed on Barry Norman's *London Season*, a BBC TV special capturing the ins and outs of British society. Norman was an important television star because of his

weekly film review program. I'd been invited to share my thoughts as a "party girl." The experience was enjoyable. Norman was a consummate professional and was impressed by my ease on camera. It was also terrific to get paid—my mother's idea—and receive royalties. Nevertheless, I sensed that my days as a soi-disant "it girl" were coming to a close. After a certain age, it was plain dumb.

Work beckoned. My first opportunity came via Sam Spiegel. He was producing the film of Harold's play *Betrayal*. I called him up and he proposed lunch at his apartment in Grosvenor Square. Although Sam had a weakness for pretty, young women—Andy Warhol wrote, "He'll do anything"—I never found that. Then again, coltish blonds with flat chests were his preference, the absolute opposite of my particular charms.

Since *Betrayal*'s filming was mildly delayed, I went to New York and stayed with Tracy Ward, the sister of the film star Rachel Ward. Ravishingly pretty with a Sophia Loren–like figure, Tracy worked at Christie's and had a magnetic effect on powerful males who were desperate to take her out. What made her even more attractive was her lack of interest.

Fred Hughes had been my first call in the Big Apple. I met him at the Factory. Naturally, he'd teased me about my Michael J dalliance. "Well, I didn't realize how much Jerry *loves* you . . ." he said, "like a gun." It was actually a good start. Fred instinctively knew how to break the ice.

Before befriending Fred, I'd always heard how he was as chic as the Duke of Windsor but as practical as a Boy Scout. The latter came about because of a trip with the younger Kennedys in the late '70s. They'd gone down the Orinoco River—with the intention of shooting rapids—and Fred had saved their lives by being prepared with maps, a first-aid kit, and a compass. I'd seen photographs from that

trip. Fred was immaculate in hat, polo shirt, and shorts, and the entire Kennedy clan looked shattered.

At our initial meeting at Marguerite Littman's house, I found him more nervous than Andy. But I was intrigued by his stylish appearance, from his boot-black hair to the watch worn on his shirt cuff to the fall of his suit pants to the sheen of his black lace-ups. There was also the allure of his gestures. During coffee, I noticed the intensity of his regard and the sensuality of his mouth when he spoke. It also appealed how his left arm protectively crossed his narrow torso when he smoked his cigarette with his right hand. Fred was someone to befriend, I decided. At Nicky Haslam's party for Andy, he had been complimentary in a way that boosted confidence. "You look like a Hollywood starlet from the 1930s," he had said. Fred was refined and got it.

There was also his enthusiasm. "You're nineteen, you should do all and everything," he advised when I talked about working on a film set. "And if someone wants to cast you in a film, you should do that too." With hindsight, I see that this was obviously Warhol-like in attitude and actually very like my mother, too, who often said, "Try out everything but try to get paid." During our lunch, Fred promised that there would always be a place for me in the Factory. Though flattered, I sensed it was too soon.

My first-ever week in New York became one big social whirl. A social whirl that, my mother teased, consisted of seeing mostly her friends. True, the likes of Kenneth Jay Lane, Jackie Onassis, and Grace Dudley were more her generation. The same applied to Andy. And that's what I instantly enjoyed about New York then: playing with the grown-ups who felt ageless. The lunch at Kenny Jay Lane's apartment was where I first spied Nan Kempner and Diane von Furstenberg, who both owned Andy portraits. Nan, dressed in a gray

flannel pantsuit, was the queen of the Park Avenue princesses, and Diane von Furstenberg—fixated by the baroque pearl bracelet of Gloria Thurn und Taxis—resembled an exotic gypsy who happened to be sitting on a fashion empire.

Jackie Onassis was somewhat different. Warhol had, after all, pinched and reproduced her image for his series of *Jackie* portraits. Portraits that have always haunted and portraits that made me want to meet her. I didn't know what to expect with Jackie. But I was pretty pushy about it. My father made the call. And an appointment for tea was scheduled at Jackie's Fifth Avenue apartment. It was St. Patrick's Day, there was a parade outside, but she only wanted to talk about the Claus von Bülow case. "He's guilty," Jackie said. Her certitude and directness were actually a surprise. She revealed that her sister Lee had been at school with his wife, Sunny von Bülow, and that Claus had always been viewed as sinister. Her opinion, however, went against Annabel Goldsmith and many in London, armed with social clout, who were vehemently defending Claus.

We had tea in a room that was dark and nineteenth-century in feel. Jackie was wearing a long-sleeved black wool top and black pants. The simple look was timeless. I then found it apt albeit dull. (After several decades of living in Paris, I realize that apt and dull equals genuine chic because only the wearer and her personality are apparent, not the clothes.) To my surprise, Jackie proceeded to devour three-quarters of a pound cake. "It's just so good," she kept saying in her funny breathy voice as she cut yet another slice. When I was leaving, she helped me put on my navy cashmere coat. Jackie had been amused by the boyish, school uniform–like style. I was glad that we'd met—she couldn't have been warmer—but I had no interest in a repeat experience. Our one meeting had satisfied my curiosity.

Lunch with Arthur and Alexandra Schlesinger had resulted in

meeting more Kennedys, whereas dinner at the apartment of Grace, Lady Dudley, Tracy's step-grandmother, had led to an encounter with Oscar de la Renta. "You have eyes like a cat," he told me. Since he was an important fashion designer, I was pleased. Tracy and I, on the other hand, tickled his famous sense of humor when we were caught red-handed trying on the fur coats of the other guests. Literally, in front of the mirror! He was also amused by the idea of us slumming it in Manhattan. "When you're young, it doesn't matter," he said.

Everyone in New York appeared to have a purpose, whether spending long hours at their office or fronting a charity. It was the needed boost and shot in the arm before beginning on the film set of *Betrayal*. I was a runner, or gofer—the lowest position on the totem pole—but since it was a small film set, I was on first-name terms with everyone. Even if the third assistant ticked me off for addressing Sam by his first name. "On a film set, he's Mr. Spiegel to you," he'd said. I stood corrected.

David Jones, the film's director, was a gentle-mannered talent, and that set the tone. There were the occasional outbursts from the ravishingly attractive Jeremy Irons, who had become a star since the TV series *Brideshead Revisited*, but otherwise it consisted of filming Harold's play around Kilburn with a cast that also included Ben Kingsley and Patricia Hodge. Having arrived in a gray corduroy dress on my first day, I appropriated a more practical style, much to the horror of Jeremy Irons. "Natasha, you were so pretty and feminine when you first appeared," he said. "And now you're chewing gum, wearing lumberjack checked shirts, jeans, and clumpy boots." I didn't mind, viewing his attitude as old-fashioned. There was also an exchange with a handsome and Cockney-born gaffer about Sabrina Guinness. "Do you know her, then?" he asked. I did. "During a shoot,

we [the crew] were all off our trolleys on top of a mountain. And Sabrina gets us in the bus and drives us back to safety. It was pretty dangerous, but she ignored all of us—a rowdy bunch—and kept her calm." I mention this story because it captures a practical, no-nonsense spirit that was also prevalent in the English Muffins and explains Warhol's relationship with them. "I did feel very protective of [Andy]," says Anne Lambton. Whereas Catherine Hesketh senses that the artist trusted his group of Englishwomen. "He knew they came from a sounder place and weren't going to do a dirty on him," she says.

Meanwhile, nothing beat the thrill of receiving my first paycheck. It was only sixty pounds and delivered in a tiny brown envelope. Still, it was money, money, money. I was keen to work on a film set again but lucked out and got a "researcher" job on *Reilly, Ace of Spies*, a TV series about the most romantic spy in history, who had inspired Ian Fleming. It paid eighty pounds per week and consisted of occasionally finding an image of a place like the Lubyanka, the KGB's notorious prison. I met one of the directors, Martin Campbell. He was the type to look you straight in the eyes, then unusual for England. Years later, he directed a few of the best James Bond films as well as Catherine Zeta-Jones in her Zorro romances.

Once a week, I would see Mark Byers, who educated me in the history of art. "Marsha," as he was then known, and I had met in the South of France when we were both guests of John Jermyn, an outrageous and debauched aristocrat who reminded me of Mr. Toad in *The Wind in the Willows*. I'd arrived at the villa at Beaulieu-sur-Mer and heard Mark playing the piano. It resembled a film from the 1930s except he was barefoot and dressed in white jeans.

Marsha with his flop of dark hair and suggestive eyes was an alley cat who strongly believed in "the lure of the gutter." A talented linguist, he could speak French, German, and Italian without accent

and was immensely knowledgeable about paintings. Turning up at the Wallace Collection or another important gallery, he'd shuffle around wearing a large gray sweater over a floppy white shirt, a long scarf, and black jeans over his boots, and we'd visit his favorites, where he would point out a subtle detail that characterized the painter or focus on a color scheme that was unexpected yet worked. And when bored, he looked around the room and noted the most attractive masculine behind. Like everyone who was gay, good-looking, and upper-class in London, Marsha had met Andy and Fred.

Another film opportunity came when Franc Roddam directed *The Lords of Discipline.* The nonspeaking role meant appearing at a prom ball and walking through a ring with Mitch Lichtenstein, the son of the famous Pop artist. The film experience was a blast. Apart from Judge Reinhold, David Keith, and Bill Paxton, the cast was full of young, unknown American actors who were obsessed with Marlon Brando and keen to hit the London nightlife—clubs like Camden Palace—and play bad boys.

For my role as Rosalee, I'd gone for wardrobe sessions but hadn't bothered to look at the script. Until I noticed that quite a few jokes were being made at my expense. So I got hold of a screenplay, turned to my scene's page, and read: "Enter Rosalee, stacked like an aircraft carrier." Suddenly I understood why wardrobe was snipping away at the neckline of my strapless canary-yellow dress.

During my ballroom scene, I admired the spirit of the pushy extras—particularly one man whose energy would have let him jive across Europe. "You're striking—like a young Joan Crawford—and could do something with it," he later told me. Joan Crawford, who mentally ate her children for breakfast? I was privately horrified. But I made him laugh when I said that playing "Miss Stacked Like an Aircraft Carrier" was enough for the time being. It was.

My plans changed. The film business no longer appealed. So I turned down Donald Cammell, who wanted to cast me as the queen of Naples in his planned film epic on Emma, Lady Hamilton. "You'll appear out of the sea," the great man and director said. "With your bare breasts cased in gold lace." I agreed, as long as he would appear in the trouser equivalent of my costume. Indeed, my new ambition was to become an agent and represent clients. My stepfather wrote to everyone he knew, and since he was Harold Pinter, meetings were arranged. However, there were no vacancies for assistant jobs.

For a few months, I was a temp secretary at Winston Solicitors, a Dickensian organization run by two brothers. Although they were sour-faced and suspicious, they had a solicitor, Mr. Sisley, who took me under his wing. A devoted Catholic, he was greatly tickled by life's absurdities. Some of his clients were so loud and irrational that he would bring out a baseball from his cupboard. "The first time they see it, it scares them into silence," he told me. "The second time, they just laugh." He had odd cases such as the mother and daughter who were suing each other but still took vacations together. "I often wonder what they talk about on the beach," he said. Alas, that gig stopped when Mr. Sisley went on his annual vacation and was informed by the grumps—the Winstons—that they would no longer need my services.

It was at the Rolling Stones' Steel Wheels concert that I had my meltdown, or Road to Damascus moment. Suddenly I felt rather washed out and over the hill. I don't think my Pocahontas chamois leather outfit helped! Nor did my long fake plait attached to my hair! As I looked around at all the fawning Rolling Stones fans, I thought: *I have to secure a proper job. I can't just be known for my affair with their hero.*

Then the divine Rosalind "Ros" Chatto made contact. During all

my interviews—and I met about seventeen hotshot agents—she was my favorite. Ros and her partner, Michael Linnit, had a client list of actors that included Alan Bates, Alan Bennett, Claire Bloom, Michael Crawford, Judy Davis, Robert Hardy, Felicity Kendal, and Robert Morley. They worked out of the Globe Theatre. The telephone rang off the hook. They made deals on a daily basis, but always took off for a two-hour lunch at Cecconi's or another renowned restaurant. I, on the other hand, would swim at the Marshall Street baths and eat at Cranks, one of the West End's few organic restaurants. On several occasions, I saw Francis Bacon, the brilliant painter. (Sam Spiegel owned one of Bacon's Screaming Popes—a favorite masterpiece.) However, as Bacon was renowned for his decadence, I was surprised. And I told Bacon so when he asked me to "stop staring."

Since I used my index finger to make a point, Michael called me the "Shop Steward"—the name given to individuals who defended their fellow employees' interests. "Look at that finger," he'd announce in the office when I was being my bossy-boots self. Ros Chatto preferred calling me Nat. She had short canary-blond hair, and her penchant for turquoise enhanced her bright blue eyes, as did the color of her lipstick. Her voice resembled actress Judi Dench's as M. In general, I was won over by Ros's strength, culture, and wit. A mother before anything—she was exceedingly proud of her sons, Jamie and Daniel, who had both attended Oxford—she was also a skilled cook who gave out the simplest recipes. Her list of memorable sayings included "What a lark, eh," "Life is not a rehearsal," "I can't defend a situation that I didn't create," and "If you want an answer now, it's no," the last taken from film producer Lew Grade. Ros—my mentor for a charged two and a half years—was good on men too. "Oh, darling Nat, there are many fish in the sea," she'd say. "If he's not right, you'll find someone else."

11 *Leaving England*

Even before my father died in March 1984, I wondered about leaving England. There was nothing to complain about, but I was secretly hounded by a sense of "Is that all there is?" I would look around and notice others settling down and not have any desire to do so.

Meanwhile, two women would make an impact for quite different reasons. The first was Anne Lambton and the second was Catherine Hesketh. True, they were English Muffins number one and number two, but I didn't take that into account at the time. It was their drive and disregard for the opinion of others that impressed. Out of the two, I was more at ease with Catherine—a lighter touch, she was wicked and playful with it—whereas Anne was very

funny but occasionally fierce. Still, I clocked that she was a force of nature.

It made sense that both Andy and Fred Hughes had tried to marry her. Instead Anne had turned down both and opted for a life in Los Angeles until returning to England, determined to become an actress. Being twenty-six years old, it was extremely brave. No one in her immediate circle had seemed supportive. Yet true to her word, Anne had gone off and secured a mature student's grant, attended drama school, and then joined the Glasgow Citizens Theatre, reputed for its productions. Meanwhile, Catherine, who had worked at *Interview* magazine during the day and been pretty wild at night—"with Robert Mapplethorpe she used to go to all the S&M clubs like everyone else did in the art world," recalls Bob Colacello—returned to England and made an impressive match, tying the knot with Jamie Neidpath, Thirteenth Earl of Wemyss and Ninth Earl of March. "Andy was certainly fascinated by Catherine," says Colacello. And it was easy to understand why. The dire opposite of a virginal goody-two-shoes (typified by Lady Di), she was one of those mercurial adventuresses who tried everything out—she was shown topless in Andy's book *Exposures*—and was key to the Warhol kingdom and then won the heart of Neidpath, a very eligible bachelor.

Photographer Christopher Makos, who accompanied Andy and Fred, recalls going to lunch at Stanway, the Neidpaths' Jacobean manor house in Gloucestershire, two hours outside London. "Camping up the fact that she was Lady Neidpath, she made a big fancy luncheon for us," he says. "And got this big fancy Rolls-Royce to take us there."

Andy hadn't attended Catherine's wedding in July 1983. I did, and also went to a pre-party given by her betrothed. The pre-party left a mark because it was the first time I heard about AIDS. A *Time*

magazine cover was totally freaking everyone out. I didn't think much about the threat, presuming it would eventually disappear. The phenomenon of Narcotics Anonymous affected me more. Suddenly the worst types of junkies and coke addicts from the upper and middle classes were squeaky clean, vulnerable, and attending NA meetings. The big expression was "Have a cup of coffee and share." It was positive news on every front. And at her wedding ball, Catherine had included a stronghold of coffee and tea for her NA pals who were either sharing or rustling around in the bushes—having rediscovered the joys of sex.

In many ways, the wedding felt like my last society ball because it included every generation of the smart families I knew, was intimate in atmosphere, and ended with a carefree skinny-dip in the swimming pool. It was the final hurrah before my father died and my life nosedived.

As soon as I heard about the shading on Poppa's lung, I knew it was curtains. His doctor tried to operate and my father had a stroke. He was installed at St Thomas' Hospital, across the river from the Houses of Parliament, and I would take the 12 or 88 bus to get there. Like others in my situation, I would sit by his side, take his hand, and talk. Occasionally, I'd say, "Squeeze my hand if you can hear me." He did. But ten days later, on March 6, 1984, he was gone. The commiseration letters became a solace. My first was from Kate Morris, one of my best friends; it was popped through the letterbox at midnight. All the others were equally touching, often referring to my father's principles, courage, and tolerance of the younger generation. Still, I was shattered and suffered a six-month haze of intense sadness that I doubted would ever lift.

That was until Frederick William John Augustus Hervey—aka John Jermyn, aka "the jerm"—announced his engagement. He was

notorious for his affairs with Rupert Everett and other gay beauties, so it was quite mad. No doubt, it was a result of becoming the Seventh Marquess of Bristol and deciding that he needed an heir for a family, whose motto was "I shall never forget."

Needless to say, the men outnumbered the women at the wedding ball in September 1984. Still, I was always grateful for the event because I met Ian Irving, a silver specialist at Sotheby's. He resembled Paul Newman, but with a certain Botticellian extravagance to his features. As was typical for him, Andy Warhol was chummy with the British-born, New York–based Ian. He had also featured him in *Interview*. Most important, it was Ian who persuaded me to leave England, recognizing that I was dissatisfied and could do something with my energy in the United States. After my father's death, I had an urge to break free from family ties and be independent.

"Go and stay with Fred Hughes first," Ian advised. "Share your plans with him and then come back to live." Fred had helped many Englishwomen arriving in New York. And according to Vincent Fremont, it used to drive Andy nuts. "He'd say, 'I can't believe Fred, he's paying all the bills.'" There was also the matter of "the whole closet full of women's clothes" in his house. "Everybody left their belongings there, like it was a hotel," continues Fremont.

As ever, Fred was a generous host. Naturally, we dined with Andy. But career-wise, Fred suggested that I stick to the agency world. His argument being that I had already stuck at it for a good two years. Before telling Ros and Michael, I received a negative response from Milton Goldman, a top New York agent and a friend of my parents. *His loss,* I arrogantly thought. By the end of March 1985, everything was sorted. I had sold my British Telecom shares—purchased with the five thousand pounds I had solely inherited from my father—but

it was when Annabel Brooks invited me to stay in Los Angeles that my West Coast adventure really began.

Beforehand, I met with two top talent agents in New York, Sam Cohn and Robert Lantz. They were about as keen to meet me as they were to drink ink. But I was persistent, sensing the importance. In spite of my being warned to the contrary, Cohn was delightful. Like director Willy Wyler, he was one of those gap-toothed powerhouses. A star in his game, he was living with actress Dianne Wiest and representing Meryl Streep and directors like Mike Nichols. "Listen, Broadway is dead at the moment and only Hollywood is happening," he advised. Lantz, who was quite different, Mitteleuropean in style with clients like Liv Ullmann, agreed with Cohn. "Go to Los Angeles, because you're young enough for a life of swimming pools and palm trees." He then added, "My only problem is that you seem so calm and the agency business is everything but." I assured him that since I was English, I hid my inner hysteria. I did, actually.

People often complain that Los Angeles is a boring place to live. Not after quitting England—a liberating feeling that has never, ever left. And not when staying with Annabel Brooks and Damian Harris meant joining their social swirl. It included breakfasts at the farmers' market, Sunday brunches at director Tony Richardson's, baby showers and other parties via hip couple Nick and Lisa Love, cozy suppers at Sabrina Guinness's Spanish Colonial pad, or hanging with actors Rachel Ward and Bryan Brown in Malibu.

The Harris house, situated on Hollywood Boulevard, was described by Catherine Oxenberg, a *Dynasty* actress, as resembling "a grown-up Wendy's house." Light-filled, it was welcoming and childlike because usually some *terrible* but fairly harmless drama would be happening. In the back, there was a set of apartments rented to actors like Eric Stoltz, who'd just made *Mask*; the infinitely more wonderful James Spader (his

mother was a Canadian Fraser!); and casting agent Andrea Stone, whose Barbie-doll proportions defined California babe.

At the time, Damian, Richard Harris's son, was preparing "The Nights of the Realm" an unrealized film project that was set to star Daryl Hannah and Rupert Everett and would be produced by Cassian Elwes, Damian's childhood friend. Annabel, a former model, was taking lessons with Peggy Feury, a great acting coach whose other students included Nicolas Cage and Anjelica Huston. But in no time, Annabel became my partner in crime. We shared secrets but mostly jokes that only an Englishwoman would understand. She introduced me to my first flatmate—a disaster; he turned out to be a 24/7 coke-head. I stopped her from doing a skin flick with a character who insisted that everyone began that way, including Jane Fonda. There was also the time that our Sunday buffet lunch almost poisoned key Hollywood players like the agent John Burnham. Hard to believe, but after making a hazelnut meringue cake, we took the leftover yolks and added them to the mayonnaise for the coronation chicken. The complaints began on Monday and lasted all week.

Just as Damian was broody and intense—imagine Brad Pitt's features but set off by thick dark hair and blue eyes—the sweet-natured and compassionate Annabel resembled a six-foot Sasha doll, with legendarily long legs and a metabolism that burned up dairy and sugar. The dark-haired and green-eyed Annabel also smoked. Sought out for her prowess on the tennis court, she shocked her fellow players when she lit up after each game and merrily puffed away.

She and I used to swim in the swimming pool of Tony Richardson, the British director who'd won an Academy Award for *Tom Jones* and had been married to Vanessa Redgrave. His house off Sunset Boulevard—a paradise of lemon trees and well-tended exotic plants— had previously belonged to Linda Lovelace. It was the ideal setting for

Tony's lunches, which included his daughters Natasha and Joely when they were around; artists David Hockney and Don Bachardy; actors Buck Henry and Fiona Lewis; writers like Brian Moore and Joan Didion and her husband, John Gregory Dunne. At the rowdy, casual affairs, the food consisted of quiches and cheesecakes from Tony's favorite bakery on Melrose Avenue.

At one of Tony's lunches, I met Jon Bradshaw, an American journalist and writer. Tony couldn't stick Bradshaw—he really didn't have much time for macho buccaneer charmers, and preferred his wife, the producer Carolyn Pfeiffer—but Bradshaw became a pal. Viewing himself as my mentor, he used to take me out for tea or dinner and say, "You have to write, it's ridiculous that you don't." He even called Tina Brown about it. Having left *Tatler*, she was running *Vanity Fair*. But it was a little early for that.

Another couple who adopted me were Veronique and Gregory Peck. I'd met them through Ian Irving, who knew their daughter, Cecilia. They had lunches in their Bel-Air home, where Hal Ashby had filmed *Shampoo*. Through the likes of Sabrina and Earl McGrath, a gallery owner, I met quite a few male stars, such as Dan Aykroyd, Warren Beatty, Michael Douglas, Rob Lowe, and Judd Nelson, but no one came close to Gregory Peck. Obviously there was that Atticus Finch voice—swoon—as well as a mix of dignity and humor. As for his French wife, a former *Paris Match* journalist, she was gutsy. The type to wear a series of Tina Turner wigs at lunch and get away with it.

Via Damian, I became the assistant of Joe Rosenberg, a literary agent at the Triad Artists Agency. In the mid-'80s, it had a roster of über-agents like Arnold Rifkin, Nicole David, Lee Rosenberg, and Ronda Gomez, while their clients included Tina Turner, Sam Shepard, Bruce Willis, Johnny Depp, and Alvin Sargent, the Oscar-winning screenwriter.

A good place to land, Triad was full of young guns determined to prove themselves. I sat in a cubicle across from Joe's office and would put calls through and keep dragons at bay—like Tracey Jacobs, an excellent agent who I snootily decided lacked manners. That said, I got into trouble for using the *c* word. There was a look of shocked horror on the faces on my fellow assistants, until Holli, the assistant of agent Ronda Gomez, came over and said, "We don't use that word in America." I was mildly surprised, since I thought the endless use of the word "asshole" was a lot more offensive. But I certainly wasn't going to argue. When in Hollywood . . .

Ensconced at my cubicle, I would argue with everyone about films, books, and actors—I didn't care if they were senior or important—and it led to my promotion, after only six months. That was the beginning of the end of my happiness at Triad. Officially, I was a junior agent, but unofficially I became a traffic cop for Caitlin Buchman, Triad's New York–based book agent. I would keep an eye out on books that she was hustling to make into films. It led to a few strange meetings with producers. "I want books like my clothes, I want hip books," said the producer Wendy Finerman. And having been voluptuous and opinionated at my assistant's cubicle, I became voluptuous and isolated in my grand office. As for the Triad staff meetings, in order to disguise my inertia and laziness, I spewed out endless nonsense in the best British accent. Occasionally, I would catch the eye of agents Michael Kane, Tracy Kramer, and Bob Hohman. They would smile and occasionally wink. Those guys knew exactly what I was up to but were too chivalrous to blow my cover. Alas, Caitlin, who was physically a cross between Lauren Bacall and Katharine Hepburn, set booby traps at every instance.

Around this period, I attracted the attention of Malcolm McLaren. Kitted out in the loudest flowery surfer shorts, his appearance was nothing like his one in England. "Do I know you?" was how he began

our first conversation. "Not really," I replied. "But my friends and I used to scream at you to make us into a star." We did. Malcolm would be buying fudge fingers and other candy from a newsagent in South Kensington and we'd be standing outside saying, "Oi, Malcolm, make us into a star." As already mentioned, he was the punk world's Andy Warhol and really did have that power to transform lives.

It turned out that Malcolm had a three-picture deal at CBS Studios that included projects like "Surfing Nazi Warlords" and "Art Boy," and *Fans*, which he was cowriting with Menno Meyjes, one of Steven Spielberg's favorite writers. Officially, he was going out with Lauren Hutton, but because she was working more on the East Coast, she was rarely with him. It was also a feisty relationship that was more off than on, or so Malcolm claimed.

He had his own particular way of courting, which was calling on a daily basis and booming, "What's up, then?" I didn't mind. And within no time, he joined the Harris family fold. It was hard not to be fond of "Talcy Malcy," as he occasionally referred to himself; he had a brilliant mind and an excellent sense of humor. Malcolm's relationship with others was best defined by a tale concerning Chris Blackwell, the owner of Island Records, and his girlfriend Nathalie Delon, a French actress. Chris was driving, Malcolm was in the back, and Nathalie turned around and said, "Malcolm, Chriiis, he 'ate you and he love you." This used to make Malcolm and me snort. But many felt that about him.

Initially, his two glaring weaknesses were tipping and driving. Malcolm would bum endless cigarettes from waiters and waitresses and forget to tip. This led to my grabbing his wallet, seizing his dollars, and his quickly squawking, "Well, I like the way you spend my money." As for his frenetic driving, it brought to mind Harpo Marx. As he sped all over the place, I gripped on for dear life. It was crazy that he was let loose on the road.

Whenever Malcolm drank, it led to an incident. On one occasion, he jumped on top of Ileen Maisel, his executive at CBS. It was at the Ivy Restaurant and he called her "a carpet muncher" who dared to steal his ideas. Typically, I didn't know what a "carpet muncher" was. There was also the time that Daryl Hannah, in a baby voice, introduced herself and said, "Hi, we met with Jackson [Browne] and we ate sweet potato chips and . . ." With a quizzical look on his face, he interrupted her and said, "Don't worry, I believe you." Daryl, then a Hollywood mermaid from the big box-office hit, was furious. But Malcolm didn't care. "She's going out with Jackson Browne, for God's sake. MOR [middle of the road], dear, MOR." Nevertheless, he was shy and low-key when I took him to Swifty Lazar's Oscar party, the 1980s version of the *Vanity Fair* one. In fact, it was I who got punchy. Swifty had purposely forgotten to put my name down. He was like that. So I acted tough—pretending that it was a Ramones gig—but super grand. The British accent helped. And like a teeny bespectacled turtle, Swifty appeared and then let me in. The first person we saw was Lionel Richie, who was smooching with Elizabeth Taylor. We were as surprised as pop singer George Michael was. "I don't know anyone here," the British singer lamented. He actually did but just wasn't on first-name terms with them, since Swifty had "more stars than there are in heaven," to quote studio head Louis B. Mayer.

Most of the night was spent chatting with George Michael, which I found surprising because Malcolm was quite a loathed figure in the music industry. However, I learned a quick lesson about the famous: In a social situation, they will fall and greet each other like members of a lost tribe.

This happened again at the premiere of Alex Cox's film *Sid & Nancy*, the biopic film about Sid Vicious that also featured Anne Lambton. The first person Malcolm and I ran into was Steve Jones, a

former member of the Sex Pistols. I was expecting an almighty argument. Steve and others from the band had publicly accused Malcolm of running off with all the dosh. Instead, Steve wanted his advice on everything including the fact that his daughter was going out with a "sooty." "A sooty," I said. "What's that?" Steve looked a bit horrified. I guess it was my posh accent and ignorance. In fact, "sooty" was British slang for a black person; it was taken from a TV puppet series.

Malcolm was convinced that, out of his three film projects, "Art Boy" had legs. His argument being that the art world was the new rock and roll. Jeff Koons was getting attention, but it was well before Damien Hirst became famous. However, in his wily way, Malcolm sensed that the art world was about to explode. Naturally, he mentioned Andy Warhol with regard to "Art Boy." "Everyone wants to be a young Andy," he reasoned.

Meanwhile, the old Andy was starting to create an impact with his MTV program. *Andy Warhol's Fifteen Minutes* started airing in 1985 and featured interviews with the known from the art, fashion, and rock-and-roll worlds, as well as the undiscovered, like Courtney Love or Frank Zappa's kids. It had endless potential. And when Fred Hughes asked whether I would be interested in getting involved, I jumped at the chance. "You'll have to move to New York," he said.

It happened at the ideal moment for two reasons: Triad had fired me—yes, they finally managed to get rid of me—and then there was the birthday party where no one came. I am not exaggerating. It was for a friend from London who had just been chucked by his wife, another friend.

I'd always entertained to great success in London. The word *party* and the promise of wine and/or food led to droves of pals in the early 1980s. But LA—the film factory in the sun—wasn't like that. Most people in the business suffered from the "something better" syndrome.

So even if they accepted, it didn't mean anything, especially if something more important turned up. In this case, that night's superior invitation was Carrie Fisher's thirtieth-birthday party. Not only was she a huge star and the ex–Mrs. Paul Simon, but she was genuinely popular. As a result, I sat with my newly dumped married friend surrounded by large bowls of chicken drumsticks, corn on the cob, and salads, as well as an enormous birthday cake with loud, colorful icing that seemed to grow each time it caught my eye. At about midnight, Damian and Annabel turned up. And I could hear him saying, "Listen, we're only going to spend half an hour here and then go." However, when he discovered that no one had turned up, he went into a Rumpelstiltskin-type rage. "Whaaat?" he yelled. "We just left a really good dinner party." Annabel, as always, was her adorable and caring self. But the entire experience did make me wonder what I was doing in Los Angeles.

With regard to Triad, of course, I burst into hot, angry tears when being told by big Lee Rosenberg that they were terminating my services. Nevertheless, Lee, a handsome-looking powerhouse, was terribly decent. "Listen, this will be the start of something else," he said. "Clearly, you're capable and we'll do everything to find you another job." But interviews with types such as Alan Greisman, then the producer husband of Sally Field, led nowhere.

Oddly enough, I got further with George Lucas and was counted among the last three candidates. Organized by the screenwriter Menno Meyjes, the first meeting was at the office of Lucas's lawyer, Barry Hirsch, and the second took place at the famous Skywalker Ranch. It really was a ranch—lots of land, a dark wood interior, and a stalwart staircase—and then there was George. I banged on about films needing to entertain and the relevance of sympathetic baddies. "Sympathetic baddies," he said. It was then that I admitted that Darth Vader was my favorite Star Wars character. He did smile.

Whereas most of my friends were understanding, Uberto Paso-lini, the future producer of *The Full Monty*, was not. "What do you expect, Natasha, you're not hungry enough," he said. True! And I thought of contemporaries such as Gerry Harrington, a junior talent agent, who was signing clients; David Heyman, who was slogging away at Warner Bros. Studio—he was booked up for breakfast three months in advance—and Peter Frankfurt, who was working for the director Richard Donner and was involved in *Lethal Weapon*, *Scrooged*, and other films.

Then again, maybe I didn't always get Hollywood. My first-ever gaffe was saying "No way, San José," thinking I was being extremely cool in a job interview. The second was thinking that La Cienega Bou-levard was more operatic-sounding and rhymed with *saga*. And then there was my blunder concerning my friend Catherine Oxenberg. She had been the darling of Aaron Spelling, TV's kingpin, but she was fired. Her sin had been asking for more money, backed up by the fact that Amanda, her character on *Dynasty*, was immensely popular. Spelling was furious. The kittenish Catherine dug her heels in. And she was unceremoniously dumped. Joan Collins, her colleague from the series and a seasoned pro, advised her to leave Hollywood. But Catherine had other plans. "From now on, I'm going to do feature films," she said confidently.

I was having dinner with a TV producer when I revealed how Catherine refused to listen to Joan. Though he had been flirtatious, his manner turned steely. "Wake up and smell the coffee, Natasha," he said. "No one goes against Aaron Spelling. Joan Collins was right." There was a brief silence, until I laughed, nervously.

When she was riding high at *Dynasty*, Catherine's twenty-fifth-birthday party was one of the glitziest soirées that I attended in Hollywood. It was held at the house of George Hamilton—her ex-boyfriend, who had nicknamed her "half a hip"—and every single

member of *Dynasty*, including John Forsythe and Linda Evans, had attended, as had Clint Eastwood and Sammy Davis Jr. George Hamilton was a personal favorite. His film *Love at First Bite* was one of the great B comedy movies. And his house—a temple to his good-natured narcissism—also demonstrated his sense of self-irony. The main staircase was lined with different portraits of him, dressed as a Second World War pilot and in other dashing poses. Then there was the great man's bathroom. I picked up his shaving mirror and found a cutout picture of Clark Gable slipped inside. And why not?

A few months later, I was driving with Catherine when we saw George in his pale gold Rolls-Royce that caught the light and enhanced his perma-tan perfectly. We screamed and waved frantically. He waved back, smiled, and barely looked in our direction. "My God, he thinks we're his fans," Catherine said. He did, and I'm sure continues to. George Hamilton reveled, and I hope continues to revel, in his life as a star. What a champ!

During my twenty-two months in La-La Land, there were other celebrity or Hollywood moments that could be divided between the surreal and just plain silly. It was perfect preparation for my adventures in Warhol Land. Stewart Granger, for instance, was one of the film heroes of my youth. I'd watched him in endless reruns of films like *Scaramouche*, *The Prisoner of Zenda*, and *Moonfleet*. So, spotting him in a supermarket, I surreptitiously shadowed him. No fool, he soon realized it. "Are you following me?" he said. It was a Hollywood faux pas on every single level. Shameless, I didn't really care.

Nor did I mind watching a very young and annoyed Winona Ryder deal with her skis and the snow in Utah. It was 1987 and her second film, *Square Dance*, was being presented at the Sundance Film Festival. Even though her hair was dyed orange, she was as pretty as a young Elizabeth Taylor and was clearly destined for the big time.

Bumping into Rod Stewart was different. A saucepot: he was cheeky, he was sexy, and he had elements of Mick Jagger. So I presumed most rock stars were fun until meeting Don Henley from the Eagles. Talk about self-important and humorless. It wasn't as if Il Don walked into the party and people stopped talking, which was certainly the case of Warren Beatty in July 1985. It happened at Robert Graham's studio in Venice: a groovy gathering that included his fellow California artists like Ed Ruscha, Ed Moses, and the actor Dennis Hopper. Warren's trick, I reckoned, was looking handsome but playing vague yet concerned. Ha—he had every corner covered! Witnessed when a woman sashayed up and said, "Hi, Warren, do you remember me? We met in 1972." "Why, yesss," he said. "Why, yesss not," I felt like squawking, but wisely refrained. Nor was I in great shakes, since I had decided to wear a wide-brimmed straw hat that I'd ordered from Nancy Reagan's milliner. "That's quite a hat," said *Vanity Fair*'s Wendy Stark as I nearly collided with several of her friends.

Still, nothing beat the embarrassment of visiting Griffin Dunne on the film set of *Who's That Girl*. A little voice did say, "Hmm, perhaps you shouldn't do this?" It was wisdom that was quickly eclipsed by my brief but arduous crush on the actor, whom Tony Richardson jealously described as "that poisoned dwarf." Griffin was telephoning quite a lot at the time. He did suggest the midnight visit. However, he was costarring with Madonna. A minx who, after seeing me looking pink-cheeked and keen (read: desperate) behind the movie set's barbed-wire fence, said, "Griiiffin, your girlfriend is here to see you." Peering through, he looked appalled. The director, James Foley, got annoyed that there was commotion. And I—accompanied by the ever-supportive Annabel—scampered through the floodlit bushes, vowing to forget Griffin and never visit another film set again.

Andy Up Close

The next time Andy and I properly saw each other was at a New York benefit in October 1984. Although I'd come as Fred Hughes's date, I talked to Andy throughout dinner. Dressed in a black wool Max Mara skirt suit (which I ended up wearing to his funeral), I'd become quite different. My hair was longer and back to my natural chestnut-brown color. Andy was interested that I worked for Chatto & Linnit, which represented Torvill and Dean, the Olympic ice-dancing champions. They'd become huge stars when performing to Ravel's *Boléro,* and they continued to fill stadiums internationally. "They must make a ton of money," Andy said. Right as ever: Torvill and Dean made money hand over fist over skate blade. He also

guessed that the skaters must seriously annoy the agency's distinguished thespians. They did, and to an astounding degree. When Alan Bates couldn't get through to Michael Linnit, his agent, he'd taken to saying, "Well, just say that Torvill and Bates called." It was surprising behavior from an actor who was pretty even-keeled. But I was equally surprised that Andy tapped in to that. He heard, saw, and understood all, but in public he preferred to camouflage it in a sea of "gees" and "greats." After bantering about British families we both knew, like the Guinnesses and Lambtons, we talked about *The Weaker Vessel*, my mother's book about seventeenth-century women that had unexpectedly hit the *New York Times* bestseller list. Andy had read Mel Gussow's lengthy profile about her in *The New York Times Magazine*. "It must have helped book sales," he said. Gussow's article had. Andy then said, "Natasha, you should write a *Mommie Dearest* about your childhood." Somewhat surprised, I replied, "You mean describe how she hit my siblings and me over the head with her books as opposed to wire coat hangers?" He laughed—closing his eyes and tipping his head back—but I did wonder if he was testing me.

The following year, in mid-August, a few months after I had moved, we had dinner at Mr Chow in Los Angeles. The dinner was organized by Wendy Stark—the equivalent of Hollywood royalty, since her grandmother was Fanny Brice and her father was Ray Stark, a producer and former studio head. She'd known Andy and Fred since forever. An excellent friend to have, Wendy was on close terms with everyone, from big stars like Jack Nicholson and Warren Beatty to powerful ladies who lunched such as Betsy Bloomingdale. Wendy had just been in England, where she'd seen the Business perform, a band of upper-class musicians keen to hit the big time. "I went along with Mick [Jagger] and they were very cute and happy about that," she said. I could only imagine but was more interested in hearing

about Madonna and Sean Penn's wedding. Andy and Fred had attended the nuptials, and it was definitely the hottest ticket in a town that then prided itself on being low-key and private.

It had happened on Saturday, August 16—Madonna's twenty-seventh birthday—and everything, including the location in Malibu, was meant to be top secret. Even though I was living in the flats of Beverly Hills, I could still hear those helicopters filled with paparazzi photographers headed for the beach. They were that loud. Andy had enjoyed that detail—suitably weird—as well as the fact that the photographers had actually been hanging out, desperate to get images.

The Madonna and Sean Penn event was major. In fact, during my two years of living in Hollywood, nothing got the media more riled up than the marriage of those dramatic lovebirds. I asked Fred about Madonna's outfit. Her contemporary-styled Edwardian outfit won his approval. "I liked the little bowler," he said, referring to the hat topping off the wedding veil. "That was cute." I knew what he meant and was surprised to see Andy make a face. It was a bit unkind. And I then wondered about the relationship between Fred and Andy.

During all the Madonna–Penn wedding media coverage, Andy was mentioned as one of the guests. True, his white blond wig was hard to miss. Still, it captured how he had become a full-blown celebrity outside the art world. He had signed up with the Zoli modeling agency, he was endorsing eye frames for l.a.Eyeworks, he had appeared on the cover of *New York* magazine with celebrity impersonators under the headline "Social Climbing: How to Do It in the '80s," and eventually appeared on the two hundredth episode of *The Love Boat* in October 1985. Although Andy was much more of a star than when we first met in 1980, there was never a sense that he'd sold out or gone too far. Being in the business of being famous—that's what he did—was the attitude of his friends. Everyone accepted his behavior and almost

basked in the glow of his performance. There was just a little problem, to quote Peter Brant: "Most of his friends didn't think to collect War-hol. And often they were well-known and wealthy." Nor did articles by Robert Hughes, *Time* magazine's revered art critic, help matters.

No question of a doubt, Robert Hughes did irreparable damage to Andy's reputation as an artist when he wrote "The Rise of Andy War-hol" in *The New York Review of Books* in February 1982. A memorably brilliant and blistering attack, it presented Andy as having sold out on every level: a business artist who was commercial but "still unloved by the world at large." Indeed, Hughes not only claimed that Andy did his best work in the years 1962–1968, but he also exposed Andy's en-tourage as pretentious toadies, described *Interview* as "a social-climbing device for its owner and staff," and dismissed his recent exhibitions.

"Fatuous" was how Hughes termed the 1979 Whitney show, *Andy Warhol: Portraits of the 70s.* Then he asked, "What other 'serious' artist . . . would contemplate doing a series called 'Ten Portraits of Jews of the Twentieth Century' [exhibited at the Jewish Museum in New York in 1980]?" Continuing with: "There is a big market for bird prints, dog prints, racing prints, hunting prints, yachting prints; why not Jew prints?" A portrait show of sports stars at the Los Angeles Institute of Contemporary Art in 1981, underwritten by Playboy Enterprises, was dissed as "a promotional stunt" and "peculiar." And *Andy Warhol: A Print Retrospective* at Castelli Graphics at the end of the year chilled because of its "transparent cynicism" and "Franklin Mint approach."

The problem about Hughes's thoroughly researched piece was the emperor's-new-clothes tone and the underlined message being: Don't be fooled by Andy Warhol. It would send repercussions throughout the art world, which was infinitely smaller then than it is today. Collectors were also an elite, select breed who took the opinion of people like Hughes into consideration.

Not that Hughes's article gave painter's block to Andy, who never stopped churning out his lucrative portraits. Nor did the glamorous people stop posing for him. In 1985, for instance, he did portraits of dancer Martha Graham, actress Joan Collins, style icon Tina Chow, and Princess Caroline of Monaco, Grace Kelly's daughter.

One project, encouraged by Bruno Bischofberger, Andy's Zurich-based dealer, was his small *Retrospectives* and *Reversals* group, produced in the early '80s. Andy essentially made negatives and reversed the color scheme of his famous icons such as *Flowers, Marilyns, Campbell's Soup Cans*, and *Death and Disasters*. The paintings were safe and summed up characteristic in a way that Andy's *Rorschach* (inkblot) paintings in 1984—abstract and expressionist in style—were daring and innovative. Viewing the work as contemporary, Abigail Asher says, "it is hard not to think of Christopher Wool and his black-and-white repetitions."

Asher describes his abstract and minimalist *Shadow* paintings of the late 1970s as "ahead of the curve of many artists of the 1990s." She also views his *Self-Portraits (Fright Wigs)* as outstanding. "Before Andy died, there was a return to Sturm und Drang—paint and expressionism—in the art world when he was not doing his most insightful work," she offers. "There again, it is possible that he was anticipating something extraordinary." The tide can also turn against an artist. "De Kooning's late work was shunned," she states. "Apart from Picasso, no artist sustains a popular period all the time."

Larry Gagosian represented Willem de Kooning when critics attacked his later work and even suggested that the artist should give up. "But that moving work is some of the best that he ever did," Gagosian says. "Critics can get it wrong." Artists too. Gagosian was in the Factory having a tuna sandwich lunch with Andy and Fred Hughes when he noticed paintings "rolled up like a carpet with plastic." Gagosian asked what they were. They were the *Oxidation* paintings, which the

artist referred to as the "Piss paintings," since they were achieved by pissing on the canvas. "Nobody wants them," said Andy. However, Gagosian found them interesting. "Do you think you could sell them?" Andy asked. Gagosian succeeded in selling all of the twenty-foot canvases, which were shown in a truck dock on West Twenty-third Street, for between $200,000 and $300,000 each. "Andy came to the opening, he was a big sport," Gagosian recalls.

Andy also attended the show for his collaborations with Jean-Michel Basquiat. Exhibited at the Tony Shafrazi Gallery in 1985, the paintings, which were Bischofberger's idea, did not sell. "I was disappointed," admits Bischofberger. Thirty-two years later, opinion continues to be divided between those who dismiss the paintings and those who don't. Asher finds them "pathetically weak," putting them down to "an old man falling for a handsome drug addict," whereas Thaddaeus Ropac says he "still cannot understand why they're not more successful."

With hindsight, Bischofberger offers, "The problem with a collaboration is it's neither fish nor fowl and people only think in market terms." Whatever the reason, it's obvious from Andy's final exhibition, *The Last Supper*, in January 1987, that he was in charge, even if he collaborated with Basquiat on the ten punching bags, hanging on chains, that were painted with different versions of Jesus' face.

Although Andy played bland and acted as if he didn't care about his work and so forth, he did desperately. "He often complained that his work was not considered," says Ropac. "You have to understand that people were really not looking at Warhol in the 1980s." Wilfredo Rosado recalls Warhol's fear about his age. "He had this conflict that he was not considered the hot artist anymore." However, Andy's chief complaint to Vincent Fremont was that he was undervalued.

"Andy was so clever and so knowledgeable, but he ruined his reputation by painting whatever you gave him—cars, cats," says the art

dealer Rudolf Zwirner, who exhibited Warhol in Cologne in the early 1960s. "It became a problem for MoMA and others."

The interior designer Jacques Grange recalls the rejection of Andy, just before his death. "There was this attitude, 'He's become so manufactured' and 'He's going a little gaga.'" However, Warhol continued to have a strong presence in Paris. "We were not like the New Yorkers," Grange says. "It was always Andy, Andy, Andy."

Ever aware of the situation, Andy did have a professional trick up his sleeve. "He wanted to get back into filmmaking," says Vincent. Hence making the deal with Tama and her book *Slaves of New York*. "But he did say, 'Don't tell Fred.' This was because Fred wanted Andy to stick to painting and got annoyed about outside projects." On one occasion, Andy had almost given $50,000 to *Nunsense*, an off-Broadway production about nuns. "Fred exploded when he heard," says Fremont. "The musical became a huge success and would have made Andy's money back."

The next time Fred returned to Los Angeles it was without Andy. He was there in the late fall of 1985 for the wedding of Tina Gill and Doug Simon, the grandson of Norton Simon, the owner of the museum and one of LA's non-entertainment multimillionaires. I acted as Fred's date to the wedding, which was held at the Bel-Air Country Club. Jennifer Jones (the second Mrs. Norton Simon Sr.) was part of the marital cortege. Initially, Fred was taken aback by the simplicity of the former film star's outfit—it resembled a cashmere jogging outfit—until eyeing the ginormous diamond earrings on her lobes. "Reaaally sporty," he then said, which was so Fred.

Interested by the gossip surrounding the maids of honor, Fred dared me to speak to a few, to check if they actually were the bride's personal shoppers. For a West Coast society wedding in the mid-'80s, it was a pretty unusual state of affairs. Most turned out to be, and I

duly reported this. Fred was surprised that I had the gumption, but I told him that it had been a laugh. It was!

One thing led to another, and the next time Fred came to Los Angeles, he offered me a job on *Andy Warhol's Fifteen Minutes*.

Since it first aired in 1985, the show had widened Andy's reputation and influence across America and helped the sales of *Interview*. To add a little female flounce, the program began using excerpts with Blondie's Debbie Harry and interviews conducted by models like Jerry Hall. But Fred Hughes, a keen Anglophile, wanted to up the content and felt that a British accent would achieve this. He talked about me to Andy, who approved. The only fly in the ointment was Jerry Hall. She was still sore about my dalliance with her boyfriend, Mick Jagger. Jerry gave Andy an ultimatum: "It's either me or her, choose." And according to Fred, Andy half teasingly said, "Bye-bye, Jerry." Then swiftly gave the supermodel her portrait from his defunct *Beauty* series. Smart Andy.

I was a little nervous around Miss Hall since the incident in the bushes. Another problem was her friendship with Lauren Hutton. The equally beautiful Miss Hutton was still the girlfriend of Malcolm McLaren. She was irritated by my relationship with Talcy Malcy. Fred had seen Lauren and "heard her wrath" but implied that Andy had been rather amused. His attitude being that as long as I kept my cool, all would be fine.

I arrived at the Warhol Studio building, at 22 East Thirty-third Street, for lunch on Thursday, February 19. Andy appeared later. Fred brought me to him and reminded him that I'd be joining the MTV program. I was hired with the idea of researching guests with an exotic element—they might be innovative social types or European VIPs—whom I would eventually interview. Andy was friendly but didn't want to talk. His complexion was flushed and he seemed

scattered. He was going through bags as if searching for something. Fred then became agitated. It felt odd being in close quarters with both of them. I was totally unaware that Andy was going to the hospital. The fact was kept top secret. The next day, he entered New York Hospital under his pseudonym Bob Roberts. Three days later, Andy Warhol would be pronounced dead.

Zara Metcalfe, my roommate, broke the devastating news to me. "Tasha, Andy died," were her exact words. As if on cue, Fred Hughes then called. "Natasha, please be at the Warhol Studio by nine a.m.," he said. Naturally, I tried to say how sorry I was, but Fred's tone was businesslike and unapproachable.

Both Zara and I were in a state of shock. Andy Warhol, the American godfather of Pop art, was dead, over and out, and kaput. He'd gone into hospital for a simple gallbladder operation and died less than forty-eight hours later. I realized why he'd been so jumpy. It was well-known that Andy had a horror of hospitals. He'd even predicted that the next time he checked in, he would die there. The fear stemmed from his eight-week spell at St. Vincent's in 1968, after Valerie Solanas from SCUM—the Society for Cutting Up Men—had tried to assassinate him. Firing two bullets from a .32 caliber gun, she had managed to hit his stomach, liver, spleen, esophagus, left lung, and right lung. Later, Andy compared the sensation to "a cherry bomb exploding inside."

Fred had been in the Factory when it happened. He was the one to call for the ambulance. When Valerie had pointed her gun in his direction, he said, "*Please!* Don't shoot me. You'd better get out of here right away." He then said, "There's the elevator, take the elevator, get out of here." Strangely enough, Valerie did. And whatever anyone says about the Warhol–Hughes relationship, Fred's handling of Andy's thwarted assassin made a lasting impression. He was brave, with super instincts. Fred was also the consummate professional.

I was in the Warhol Studio hot seat. However, instead of my being groomed for the cameras, my first Monday meant fielding calls about Andy and sitting outside Fred's office. The premier person to telephone was Diane von Furstenberg. "My first instinct was to call Andy on the phone," she now recalls. "I listened to his voice on the answering machine! I was shocked." Everyone else I then spoke to sounded in an equivalent state. Thaddaeus Ropac, an unknown twenty-six-year-old gallery owner who had a brand-new Warhol show slated for August 1987, had called from a Swiss gas station. He was driving in a snowstorm, and his car radio kept cutting out. "Then it suddenly announced that Andy Warhol had died in New York and I was like, 'It's not possible.'" With each call, Fred became more clipped. He was just repeating the same information. Andy was dead. It was awful, but he had little else to add.

And so began my career at Andy Warhol Enterprises, a career that lasted two and a half years. Historically, I was the last person to be hired under Andy's reign. Actually, make that the last of the English Muffins, described by Vincent Fremont as "a great cycle of women" with a whiff of family scandal. The tradition was born in 1971 with the Lady Anne Lambton, a cheeky seventeen-year-old armed with a gravelly voice who happened to be my father's goddaughter. Her father was Lord Lambton, the disgraced Tory minister. He'd resigned from the Conservative government after being linked to prostitutes and drugs. The tradition continued with the Honorable Catherine Hesketh, a friend of my sisters. She was bright and bold and straight out of Trinity College Dublin, the renowned Irish establishment; her grandmother was Diana Mosley, the beautiful Mitford sister who had married Oswald Mosley, the leader of the British Union of Fascists. (Hitler had attended the nuptials.) The other well-heeled blue bloods

were the Lady Isabella Lambton (sister of Anne) and the Honorable Geraldine Harmsworth, whose mother, Pat "Bubbles" Rothermere, was hard to miss in her Zandra Rhodes frilly dresses and could get feisty. "Call me Bubbles again and I'll knee you in the nuts," she warned one aristocrat, in front of the Princess of Wales.

Kenneth Jay Lane views the English Muffins as "a rather nice ploy. Rather than adding silly American girls, Andy had well-born English girls," he says. "It was part of the mystique there." Taking it further, Sabrina Guinness opines, "Andy liked Englishwomen because we were living, not thinking of our nest egg, prising paintings from him. Otherwise Anne Lambton would have tons of Warhols!"

It was probably Fred Hughes who invented the nickname English Muffins. "It was his sensibility," Anne Lambton says. Still, the term annoyed her because "English muffins didn't exist in England." It was one of her obsessions, along with New York's old-fashioned plumbing and thinking that ten dollars equaled one pound. "I thought everything like champagne was really cheap, and that spooked Andy dreadfully," she recalls. Anne also presumed that the Factory was a pea-processing factory. "So when Fred invited me to work there, I was furious and said I have better things to do with my time than watch peas on a conveyor belt." At first, Anne distrusted Andy. "I thought he was a pervert and wanker because of his tape recorder," she admits. They then bonded over their love of John Wayne. "Andy and I were the same age, really," she says. "It was like having another innocent." In 1975, when Warhol traveled around America, promoting his book *The Philosophy of Andy Warhol*, she became his bodyguard. "It was a very clever concept to have me protecting him because I was small, furious, and English and would say, 'Don't you understand Mr. Warhol doesn't want to talk to you,'" Lambton recalls. "And you know how

Americans are intrinsically polite, even crazy ones, they'd say, 'Oh sorry, ma'am,' and leave, whereas if it had been a big burly person they would have tried to go on." Still, the Lady Anne had her limits. "Andy would say, 'Gee, what would you do if someone came at me?' and I'd say, 'Get out of the way.' And he'd say, 'But you'd do something,' and I'd say, 'No, really I adore you, but I really wouldn't.'"

In spite of being "a real liability"—her own admission: "I wouldn't let Lou Reed and Bob Dylan into the Factory, I couldn't take messages, and sobbed because I didn't know how to work the Xerox machine"—Andy et al. cherished Anne. An account was even set up for her at Halston to buy clothes, but what Anne really wanted were a pair of Yves Saint Laurent rimless rose-colored sunglasses with her initials in diamonds. Thanks to Bob Colacello, *Interview*'s editor in chief, she finally acquired them. However, supper at home with Liza Minnelli and Lorna Luft—"Every time they opened the fridge, it would set them off into another show tune"—put an end to the glasses. When Anne was leaving, Minnelli grabbed and hugged her, and Anne felt the glasses "crumble down" her face.

Other activities included hanging out with the Rolling Stones to check that they weren't wrecking Montauk, Andy's newly acquired house. Jade Jagger was there "with a matchbox full of bugs." Or going to the studio and diverting Andy when he was painting. "I made him laugh," she says. "Sometimes he'd say, 'Gee, do you want to go to the Anvil?' and describe naked men stirring their drinks with their cocks, and I'd say, 'I'd rather die.'" In spite of being "feisty and wild," Anne had "a sixth sense that Andy should never see anything I did. I was very careful to maintain my privacy," she says. Meanwhile, although Andy's radar "would occasionally disappear with beautiful boys," the experience changed her life. "Andy gave me the impression that I could do anything that I wanted," she says.

Peter Frankfurt senses that Anne and the other English Muffins were Fred's way of cleaning up "the downtown freak-show business" and changing the atmosphere at the Factory. As Fred was "an Anglophile, hiring English girls like Catherine [Hesketh], who was insane entertainment, and then having all these English beauties around was part of his fantasy," he says.

Robert Mapplethorpe introduced Catherine Hesketh to Andy. "I was having lunch with him," she recalls. "And he was taking a portrait that he had done for *Interview* up to the Factory in 1975." In spite of letters of introduction to powerhouses in American television, she could not find a job "for love or money." That was until Fred suggested *Interview* and staying at his house on Lexington Avenue. "The first day, Fred said, 'I'll show you how to use the subway, it's only two stops away,' and we ended up in Harlem," she says. "He had no idea himself!"

A few weeks beforehand, Robert Hayes had started at *Interview*. "So Robert and I were dealing with subscriptions and things like that, very lowly," Catherine says. "Then we climbed our way up." Dinners organized by Fred and/or Bob Colacello led to Hesketh's befriending the artist. "Andy was very clever," she says. "He got everything before you even said it." As for the financial side, "Fred was meant to be the business one, but he and Andy very much discussed everything: the pair of them together."

A love of film stars and collecting "everything we could lay our hands on" bonded Warhol and Hesketh. "Everyone thought it was really weird of us to steal ashtrays from hotels," she says. "But then they were social climbing and I was social descending, I hoped. I wanted to meet the weird people." Warhol, on the other hand, "didn't like weird people at all. Amanda Feilding and Joey Mellen came around with photos of them trepanning—drilling a hole in their

skull—and Andy thought it was the most disgusting thing ever." As for his reputation suggesting the contrary, Catherine says, "He allowed people to do their weirdness but he just wasn't into it." People were always giving drugs to the artist "but he would pass them on to someone else. I don't think Andy ever did drugs," she notes.

When Catherine's friends hit Manhattan, they were invited to the Factory on Union Square for lunch. The Factory lunches that usually came from Balducci's became quite the tradition. "I remember one lunch at the Factory with Rachel Ward and her sister [Tracy Ward]— they were total babes," says Peter Frankfurt. Even if Hesketh was "inviting people who would amuse Andy," the main aim of the Factory lunches was to gather more commissions for portraits. "Andy needed to make money," she states. There was also the artist's permanent hunt for ideas. "Andy never knew what to paint and was always trying to find people to give him inspiration," she says.

Whereas Andy admired Hesketh's late-night stamina, she was impressed by his way of "always working." "A cute kid to interview, meeting people for a portrait, going to a nightclub, there was always a point and it made such a difference. I was never bored." They went to Studio 54 a lot. "It was like all nightclubs, absolutely ghastly," she says. "We'd go to the back room that was literally the basement covered in rubble with pipes, and Halston, Liza Minnelli, Steve Rubell, Andy, and I would sit there having a lovely time." Rubell was very hyper and "New Yorky." "We loved him because he gave us free VIP tickets and looked after us." According to Robert Couturier, the interior designer, "Andy wanted to see what a million dollars looked like and so Steve laid out bags and bags of cash on a table to show him."

Openings at galleries and museums meant traveling with Andy, Fred, and often Bob Colacello around the United States. "The local grandees would have us to these dinners," says Hesketh. Once they flew

to Las Vegas to give Paul Anka his portrait. "The next day, he didn't summon Andy or pick up the picture," she recalls. "It was so bizarre. Like keeping a head of state in an anteroom. Andy was a bit put out." To kill time, they gambled with Telly Savalas and watched magicians.

Catherine had watched Jed Johnson, Andy's boyfriend, direct *Bad*, a film made for Factory Films. Even if the couple was getting on really badly and bickering. On the weekends, Hesketh would stop by the Factory and find the artist "painting on the floor, quietly at the back. I would go and talk to him," she says. "On Sundays, after church, Andy was always nicer about people."

Among the Factory team, Vincent was "the steady one." "Andy trusted him and he didn't trust everyone," she says. "Fred was kind *au fond* but would have hangovers or flip out. One time I said, 'Well, I just assumed,' and he said, 'Never assume.'" Bob was a brilliant editor, but according to Hesketh, he loved his vodka. And Brigid Berlin, who had "disappeared to her house for a year to lose weight," was "a cow." "She was just so jealous," Hesketh says. "Andy was hers."

In general, Brigid, who was one of Andy's Superstars—a clique of New York personalities during the 1960s that included Baby Jane Holzer, Edie Sedgwick, Nico, Viva, and Candy Darling—did not take to the English Muffins, including yours truly. That is, apart from Geraldine Harmsworth. "Brigid used to take me to the hairdressers to get my hair untangled," she says.

Geraldine followed Isabella Lambton, the third English Muffin, who had been "fired by Fred for letting in Crazy Matty," the resident loony stalker. Unlike her sister, Isabella had hated the Factory experience. "She thought the whole thing was dreadful, and ended up working in a deli on Lexington Avenue," Anne says. "She fell in love with Vincent, but I don't think she ever saw Andy's point."

Geraldine, on the other hand, was at the Factory because "Andy

asked me and I liked him." They had met in Paris through Bob Cola-cello. She was then modeling for photographers like Guy Bourdin and living with her father, the British press baron Vere Rothermere, on the Ile Saint-Louis. Once when Andy was picking her up, she introduced him to her father. "Andy was charming and Daddy was thrilled because he had quite a quiet life." On another occasion, Warhol had shown her "his scars" from his assassination attempt "when he was getting into a taxi." "I was so shocked," she says. "Years later, I twigged what it was."

Afterward, Warhol kept in touch with Geraldine. "He'd say, 'You must come and work for me in New York.'" The moment arrived when her father was going to New York at the beginning of 1979 and offered to take her on the Concorde. "He said, 'This is your one chance.'" Geraldine worked at the *Interview* offices. "I would let people in and occasionally type," she says. However, when sent out on errands, she was terrified of getting mugged. "Union Square was full of drug ad-dicts and really run-down," she recalls. "It was like the film *Serpico*."

During the period, Geraldine barely owned any clothes. "I had one Pucci shirt and this embarrassingly awful shocking-pink trouser suit—it had a quilted jacket and quilted trousers—that I had bought in Jaipur," she says. When Andy took her to see the musical *Sugar Babies*, she wore the "embarrassingly awful" outfit. Sometimes they would talk. "I would say that I was annoyed with my mother or something had happened, and Andy would say, 'Well, they can't have done too much wrong because you're so amazing.' It was really nice."

Like all English Muffins, she made mistakes. "One day, I buzzed in two loonies from the 1960s," Geraldine recalls. "They went straight into the Factory and I got into total hell. So the place was in shut-down. No one could leave until we got rid of them." The other occa-sion involved Richard Gere. "Either I lost the call or said Bob [Colacello] was on the loo," she says. "Anyway, Bob came out and had

a massive tantrum with me. He said, 'That was Richard Gere. What are you doing?'" After this episode, she was "put into this tiny broom cupboard" where all the original *Interview*s were kept. "I had to go through and write down how many celebrities were mentioned," she says. "It was the equivalent of doing lines at school except that I loved reading all the early *Interview*s and seeing Fred and Bob with long hippie hair." After that, *Interview* asked her to be fashion editor.

The moods could get a little crazy—cocaine was the drug of choice—but, Geraldine says, "being brought up in a mad family, I just thought everyone had mad or manic moods. I was totally innocent and didn't do drugs." After six months, she left to marry David Ogilvy, a Scottish lord. "Andy was sort of horrified," she remembers. "He said, 'You belong here and you're just throwing yourself away. You're better than that.'" An interesting take because, according to Bob Colacello, "Andy always advised someone to marry someone rich." In any case, Geraldine "never really saw him again, after that."

Fred went to Geraldine's wedding in 1980. We danced together. It was one of the better society balls because it took place at the Rothermeres' country home; was superbly organized by Lady Elizabeth Anson, the Queen's cousin; and had the right mix of generations, and an element of surprise via glamorous characters like the former King Constantine of Greece and fashion empress Diana Vreeland.

During my brief period of assisting Fred at the Warhol Studio, Vreeland had called. However, just as I was getting used to Fred's friends, habits, and signs on his desk like SHIT OR GET OFF THE POT and NO FAVOR GOES UNPUNISHED, I was replaced by Sam Bolton—one of Andy's walker-cum-minders. Suddenly I was working for Vincent, whose official title was vice president of Andy Warhol Enterprises. His large office was on the studio's ground floor and opened onto the reception area. Lacking windows, it had to be artificially lit.

Thinking back, I doubt that any other organization—whether based in New York, London, or Los Angeles—would have kept me on. It would have been a straightforward case of "Andy died and so did your job description." Allowing me to stay demonstrated the tremendously decent side of Fred. He knew that I was a wage slave who counted on a monthly check. And so I became Vincent's assistant and haunted the studio's glorious ground floor.

Having been a former Con Edison building, it had soaring ceilings, bleached wooden floors, and long corridors, and boasted certain areas that were painted fire-engine red and Irish Kelly green. The entrance consisted of a towering early-twentieth-century paned window with a gothic-style door. Andy et al. had arrived there in 1984 from 860 Broadway, the former Factory. There was still that just-moved-in atmosphere. In the ground-floor corridor there were an old carpet-covered sofa and Romanesque busts, while artworks like Andy's *Flower* paintings, a Palais de la Nouveauté framed poster, and a nineteenth-century female portrait leaned against the tiled wall, and Keith Haring's papier-mâché elephant perched on a ledge just below a stuffed lion. Fred had been the studio's unofficial architect. His upstairs lair—painted Diana Vreeland red—was much more organized. It had a neo-gothic bookcase, a pair of Andy's *Liz* paintings, and a tiger-skin rug. On one side, there was the dining room with a long table where friends or business associates were either entertained over lunch or grilled about their intentions. On the other side of Fred's office, there was a narrow balcony that looked over the studio's reception area. Pushing open the sliding doors, Fred would either come out barking orders—a sharp-suited version of Julius Caesar!—or have a quick smoke or tell a little story that amused him. The last was the most frequent.

Being Fred, he had his bêtes noires. One was an older woman

named Ruth from the company's accounts department. Clad in a thick coat even in the spring months, she was a skinny little creature with a light puff of gray hair on her head. "Good evening, Mr. Hughes," she'd croak. Somehow Ruth would always catch Fred on his Caesar-like perch. And as soon as she left, Fred would imitate her, saying, "Good evening, Mr. Hughes."

I wondered what irritated him. Ruth was well-meaning and harmless. Yet he claimed she was disingenuous. Perhaps she was a reminder of someone or something from his childhood. It was strange because Fred was chivalrous toward women, particularly older ones.

It was behavior that I never witnessed with Vincent. Good-natured, he had a West Coast and former hippie's "We're all equal" respect for people. Having originally come to New York in August 1969 when he was part of a rock band—the Babies—he had enough of a seasoned sense of humor to deal with the studio's pet monster, Brigid Berlin; Jay Shriver, the studio's resident stud; Sam Bolton, who appeared to have problems; and Ed "Fast Eddie" Hayes, the new official attorney for the Andy Warhol estate.

The overworked Vincent had his moods—his favorite expression was "cranky"—but no sweeter guy existed. He enjoyed the company of women: his terrific wife, the art director Shelly Dunn, certainly indicated this and was also amused by a strong character. It was just as well. Vincent now claims, "I thought you were wonderful until I started asking you to do things." Apparently, I would hand back assignments with a smile. I love the idea of being cheeky but strongly doubt that I was that bad. I think Vincent was surprised to have inherited me and didn't quite know what to do.

A Speedy Gonzales on the typing keys, Vincent had never had an assistant before. Until Andy's death, he'd been a one-man show who looked after the books, chased debtors, and made sense of the

organization. However, it was to change with the business of Andy's litigation, the lawsuit against the New York Hospital, and all the old Warhol art that was coming out of the woodwork at an alarming rate.

Andy's final show, *The Last Supper*, had opened six weeks before his death. Commissioned in 1984 by Alexander Iolas, the work was based on Leonardo da Vinci's masterpiece and planned for an exhibition in Milan at the Palazzo delle Stelline. Warhol produced nearly one hundred variations on the theme via silkscreens and acrylic paintings on canvas.

At the time, *The Last Supper* was viewed as the largest series of religious-themed work created by an American artist. Rupert Smith, the master printer in Andy's studio, couldn't find a decent photograph of Leonardo's painting—the images were too dark. So Andy and his team worked from a white plastic sculpture found on the New Jersey Turnpike, because that had clear definition, as well as images found in a Korean religious store and a Jesus night-light newspaper advertisement.

Other series that Andy had been working on included his *Fright Wig* self-portraits, his Piss paintings (he had done a 1982 portrait of Basquiat using the oxidized technique), his *Camouflage* paintings, his *Statue of Liberty* paintings, as well as *Ten Great Conductors of the Twentieth Century*, which was commissioned by Thaddaeus Ropac for his Salzburg gallery. "Andy was obsessed with Herbert von Karajan—how he was an untouchable," recalls Ropac. "And the idea was to do five historical conductors like Gustav Mahler and Toscanini and five living ones like Georg Solti and Leonard Bernstein." The project was to take a year and the goal was about 150 drawings, paintings, and prints, but Andy died halfway through.

Since the show was slotted for August—a prime time in Salzburg—Ropac had to rustle up a new one. With the help of Leo Castelli,

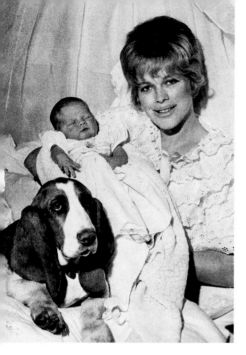

With my mother and Bertie, our dog, on March 14, 1963, four days after my birth.

Our 1963 Christmas card photo, taken outside our London home: Poppa, Mum, me, Rebecca (left), Flora (right), and Benjie (center).

Held by my father, braving the pebbles of Cooden Beach, Norfolk, in 1965.

This photo was taken in 1965, but I still feel like this. I was wearing the same dress when Bertie attacked my face.

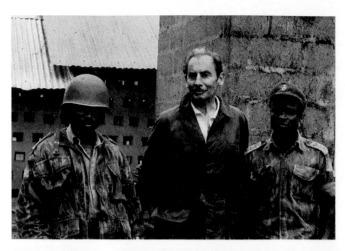

My father and hero,
in Biafra in 1967,
at the beginning
of the civil war.

With novelist Edna O'Brien in
Scotland, 1968. I'm wrapped
in a Fraser tartan rug.

With Mum and Heather, our nanny,
at Penny Ridsdale's wedding,
London, 1969.

My mother and my siblings and me with my aunt Rachel Billington (right), photographed for *Life* after Mum's *Mary Queen of Scots* triumph.

Mum reading to Benjie (looking over her shoulder), Damie, and me in 1970. Her voice gave magic to every book.

On my seventh birthday, wearing Mum's present, a custom-made pink satin prima ballerina's outfit.

LEFT: At my brother Benjie's tenth-birthday party, March 1971. He was Richard the Lionheart, and I was a devil.

RIGHT: The softest smile, marking my last day at Lady Eden's School, July 1974.

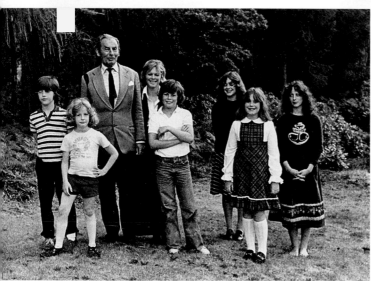

My father's general-election photograph, 1974. It was quite far-out for a conservative MP.

With Orlando, outside Buckingham Palace on the Queen's Silver Jubilee Day, June 6, 1977.

ABOVE: My first time wearing makeup, for *Harpers & Queen*'s teenage issue, August 1978.

RIGHT: Clive Arrowsmith's portrait of me, taken for *Harpers & Queen*'s teenage issue but never used. He was fabulous.

At Barbati Beach, Corfu, in August 1979, weeks before I started Queen's College, London.

This *Vogue* shoot, at Atalanta and Stefano
Massimo's home in November 1979, was a blast.

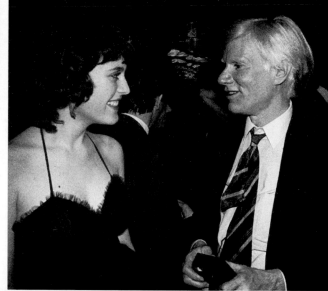

Andy was Nicky Haslam's
guest of honor, but I followed
him around, feeling charged
by his presence.

A *Vogue* outtake.
I can still remember
having Tom Bell fix
my cleavage and
feeling doll-like.

Front billing in Tina Brown's September 1980 *Tatler* article "Faster, Faster, London Girls," which got me into endless trouble.

When harassed by paparazzi in November 1980, I gave them the British equivalent of the finger.

ABOVE: With Mum and Harold at his fiftieth-birthday party, a memorably amazing occasion.

RIGHT: My only fashion-model shoot, photographed for *Harpers & Queen*, May 1980.

Accompanying Roberto Shorto in 1981—I'm sporting my seduction outfit, which I wore constantly then.

NATASHA FRASER COMES OF AGE

Natasha Fraser, Lady Antonia's youngest daughter who is cramming for her A-levels at Mander, Portman and Woodward, took time off to try out her stiff-upper-hip pose before celebrating her eighteenth birthday with a dance at Campden Hill Square. The glossy crowd, including Mark Boxer and Anna, Nicky Haslam and Tom, were spaced out by punky Old Etonians and spiced up with friends of her mother like Emma Tennant. The press were kept decidedly out, until movie mogul Sam Spiegel rolled up, and Sebastian Taylor was left standing while photographers had ample time to snap Natasha and Sam — who are just good friends.

Natasha Fraser wears a black organza dress with a tiered skirt, about £300, made to order from Bellville Sassoon, 73 Pavilion Road, SW1. Hair and make-up by Francine using Lancôme cosmetics. Photographed by Nick Jarvis.

This portrait was styled by Michael Roberts, whose inspiration was Queen Alexandra, wife of King Edward VII.

Sharing a chair with Guy Rowan-Hamilton at Tokyo Joe's London opening, 1981.

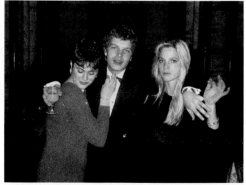

Hogmanay in 1984, with Ian Irving and Liza Campbell at Mount Stuart, on the Isle of Bute, Scotland.

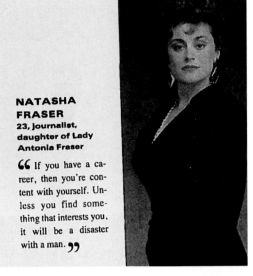

Photographed for *GQ*'s "Most Eligible Women in America" series—when my reality was collecting unemployment.

NATASHA FRASER
23, journalist, daughter of Lady Antonia Fraser

66 If you have a career, then you're content with yourself. Unless you find something that interests you, it will be a disaster with a man. 99

My favorite photo of Fred Hughes: it captures his relationship with Andy and his 1930s-style elegance.

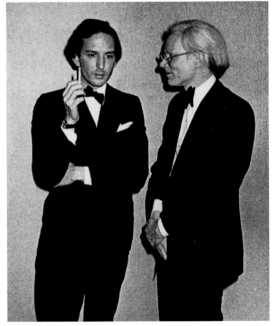

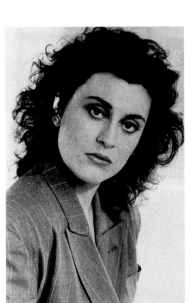

A headshot that ABC's Gary Pudney requested. I wanted a TV career and he promised to help.

With Michael Austin at Nell's, the best New York nightclub and one of Andy's watering holes.

Anglofile

Natasha Fraser keeps tabs on the city that never sleeps

My first "Anglofile" at *Interview*; the column began in mid-1988 and ended in September 1989.

Dear Mum,

I promised I would write as soon as I moved into my apartment on the West Side. I decided to do it on the Sunday that turned out to be Greek Independence Day; a friend helped me. In anticipation of the forthcoming floats, bands, and parades, Madison and Fifth Avenues were in a state of confusion. It was Greek to me how we managed to get across, but we did. It is very different here. There are many more dogs on this side of town, and you know my aversion to the little beasts ever since I had my nose chewed by one at the age of 4.

You always drilled into us that self promotion would lead to an enviable future. A few weeks ago a writer—who has a column in one of the more successful New York magazines, and a penthouse with a wraparound terrace where he gives little barbecues—invited me to a Japanese banquet. I arrived early to find large boxes in the hallway. I presumed "home sushi"

Anglofile

With her mum defrosted, Natasha Fraser waxes nostalgic for the long-gone fall of '88, when live events and all her old haunts were more than just memories.

Dear Mum,

I am so pleased that you were eventually coaxed into cryonics and allowed yourself to be frozen. I know it has been thirty years, but you have come to at an exciting time. The videos of the social events of the 1980s have been so successfully stored that just this week I have been viewing events I attended in New York in the fall of '88.

As I watched Elton John I realized that by the 2020s rock concerts had become a thing of the past. This one was held at the second Madison Square Garden before its roof was blown off by some heavy-metal band. You never see that sort of crowd anymore; people go to screenings of old concerts or watch them on compact vision. To see a rock star in the flesh is virtually impossible since so many of them are under ice or living in rejuvenating springs. Remember how Elton John was known not only for his extraordinary piano skills but also for his eccentric way of dressing? At this concert he wore a hat with a plume that matched his silk/satin midnight-blue suit. The video of the after-party showed him holding court at El Morocco, which had been made to look like a harem. People like John Reid, David Rocksavage, Brad Gooch, Cyndi Lauper, Barry Diller, Ivana and Donald Trump, Robert Stigwood, Richard Edwards, and Linda Stein sat on cushions covered in exotic prints. To get to them you had to pass two huge bodyguards in sober suits and untangle yourself from flowing material that acted as curtains. It was a little like what we remember as a B-movie film set: Bing Crosby and Bob Hope could have slipped in unnoticed.

Mehta, Estée Lauder, Kenneth Jay Lane, Anne and Brian McNally, Annie Leibovitz, John Richardson, Gabé Doppelt, Olga Liriano, Lorne Michaels, Bianca Jagger, Alana Stewart, John Head, Miranda Morrison, Steven Aronson, Damian and Tina Elwes, Fayette Hickox, Nan Kempner, Marietta Tree, Ivana Trump, Jerry Zipkin, Michael and Alice Arlen, Arthur and Alexandra Schlesinger, and Michael Austin.

Cornelia Guest became a household name twenty years later, but when I attended the party held for her at Mortimer's by Oggi International hair products, she was a society model for their posters. It is strange to think that with her TV talk show she became such an instant celebrity. At the party, where licorice-and-white balloons hung from the ceiling, Cornelia played a redheaded Alice to Bret Easton Ellis' Tweedledum and Jay McInerney's Tweedledee.

England's magazine Private Eye has been out of circulation for decades now, and I'm not sure if you were ever aware of an American equivalent called Spy. I watched the video of the party that celebrated their second anniversary and the publication of their book, Separated at Birth? The crowd included Phil Weiss, Susan Isaacson, Nancy Lemann, Spalding Gray, Al Styron, John Seabrook, David Michaelis, Elise O'Shaughnessy, Cynthia Heimel, and Jim Kelly. They danced to the Kit McClure Big Band, an all-girl orchestra renowned for keeping people up into the early hours of the morning. The rooms were so vast that many sought intimacy in drafty corridors or cramped passageways, but many celebrants were content to wait in a mile-

A later column featured Bret Easton Ellis and Cornelia Guest, an Andy intimate.

James Graham, Kate Betts,
and me enjoying Paris,
March 1990. Caroline Young,
a fellow reveler, took the photo.

Karl Lagerfeld's personalized New Year's
card for 1991. He achieved my likeness
in two minutes.

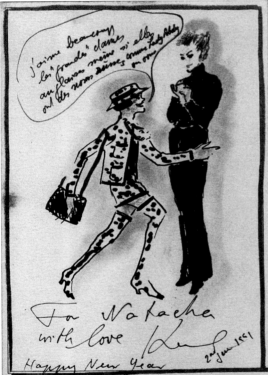

The famed hairdresser Monsieur Alexandre
tries out wigs on me at Chanel in 1990.

Johnny Pigozzi, Pauline et Mathilde Favier, Hubert Bouknobza.
Derrière : Natasha Fraser, Gilles Dufour, Victoire de Castellane et Patrice Calmettes.

Photographed by *Paris Match* in 1990, accompanying Gilles Dufour, his nieces, and a few French playboys at Les Bains Douches in Paris.

In Cap d'Antibes with Johnny Pigozzi, who was tremendously kind when I arrived in Paris.

Michael Roberts took this photograph at Les Bains Douches in 1992. "Chin up," he kept saying.

James Graham asked to do my portrait in 1991. I suggested dressing as a man.

Wig moment at the Galerie du Passage in 1991, with Pierre Passebon and Christian Louboutin.

Caught at Davé restaurant by Pamela Hanson, with the producer Robert Fox and Pamela's husband, George Klarsfeld.

Putting my head through
Christian Bérard's board
at Pierre Passebon's
Galerie du Passage, 1992.

Chez Davé, sitting next
to Dennis Freedman,
W's art director,
a joy to work with.

Spread out on
Pamela Hanson's
bed with
Madeline Weeks
and Christian
Louboutin,
Paris, 1992.

LEFT: Attending a Moulin Rouge gala featuring Charles Aznavour in 1992, with Jacques Grange and Pierre Passebon.

BELOW: Kicking back with Farida Khelfa, Christian Louboutin, Suzanne von Aichinger, and Pascal Greggory in 1992.

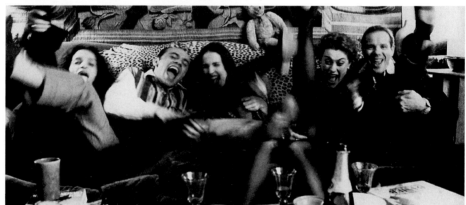

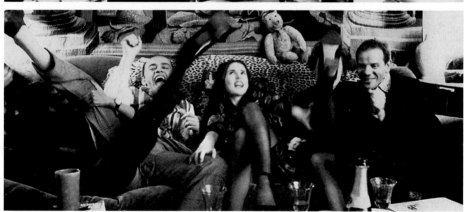

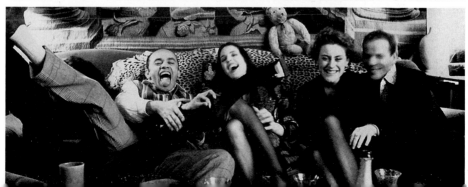

Dining with artist Laura Faber at Natacha's restaurant in Paris, where I went endlessly during the early nineties.

With Rupert Everett, photographed by Karl Lagerfeld at his party for Donatella Versace in January 1994.

Warhol continues via Peter Brant, Shelly Dunn Fremont, and Vincent Fremont, my first New York boss.

Photographed with Diane von Furstenberg in her Paris apartment in 1997, a decade after Andy's demise.

Andy's New York dealer, Ropac exhibited iconic work, such as a *Campbell's Soup Can* drawing, *Triple Elvis*, a *Marilyn*, and an *Electric Chair*. "At the time I sold a few, but it was hard," he recalls. "For instance, I couldn't sell the *Triple Elvis* that has become now one of the most demanded Warhols. People were complaining that it was wrinkled."

The *Triple Elvis* was then priced at $400,000 but today would go for $80 million or even $90 million, Ropac says. When Andy died, the market for his work was fairly flat. "The problem was that Warhol was not taken seriously during his life. He was considered a lightweight and social figure. But the brilliance of Andy was the incredible force of ideas. He took Marcel Duchamp . . . to another level."

Andy also had a wicked sense of humor, reflected in his attitude toward Jay Shriver, his last studio assistant. Jay liked roles and titles, but when working on *Andy Warhol's Fifteen Minutes*, which was directed by Don Monroe and produced by Vincent, he became anxious. "Jay asked me to ask Andy for a proper title," recalls Vincent. "And so Andy says, 'Tell him he's a big-shot executive.' So I said, 'Jay, you're a big-shot executive.' But I made him an associate producer."

Dear Jay, the producer not to associate with, except yours truly did. He lived in faded Levi's and button-down shirts. The look suited his body, which, with no effort, consisted of a toned figure, with broad shoulders and muscular arms. His chiseled face and large green eyes were quite beautiful. But the problem was his megalomania. Jay admitted as much, boasting that even Andy teased him about his ego.

Unsophisticated as Mr. Shriver was, he was *il capo dei capi*. It was actually part of his attraction and allowed him to swivel from being charming to being exasperating to being charming. A power game began between us. (Oddly enough, a few months before, a fortune-teller had predicted this.) Sometimes our arguments became so heated that Vincent would say, "Guys, pleeease," and tell us to

leave his office. But as often happens with two stubborn, feisty characters, there was a chemistry. The fights softened and cooled, and within a few weeks, he would ask why I wouldn't go out with him. Our courting sessions often occurred in the afternoon when I was doing the Andy scrapbooks.

Ordered from Airline Stationery, the scrapbooks were vast black books with stiff black pages that I would paste with countless newspaper clippings about Andy's death. It was an archival activity that I enjoyed, and having Jay's handsome presence at my side made it fun.

Warned by Fred that Jay was "a must to avoid" who only went out with models and the occasional fashion stylist, I held him off at first. Then lamely tried with "I'm not your type, Jay." This briefly led to Signor Shriver getting snarky until he tried the softer approach. "If I wore a suit, would that make a difference?" he once whined. Suit, when I found him hot stuff in jeans? Still, I thought it was adorable that he was prepared to make that effort. I was also touched by the description of his wearing bandages on his eyes when he was a little kid. That image lingered and touched a tender place.

Finally, Jay had a physical presence, a fact that Andy frequently mentioned in his diaries. And as my favorite biblical saying goes, "The spirit is willing but the flesh is weak." Put more simply, he had a body, I had a body. But it was doomed from the word go.

Shortly after it began, Fred and I shared a cab. Perhaps prompted by that afternoon's incident when Jay and I held up the studio's elevator, Fred suddenly said, "I hope you're not seeing Jay." I didn't answer. "Because he really, really has no idea." Then he stopped. Smart Fred. I was too wily to ask what he meant. But he was warning me again. Of course, I was keen to prove the old-fashioned Fred—who believed that the well-born should stick to the well-born, and likewise for the creatively bohemian and so forth—wrong. Jay lacked enthusiasm and

respect for Fred too. In his opinion, he couldn't light a candle to Andy, who "brought everything together and sort of balanced it all out."

As Fred predicted, it quickly transpired that Jay and I had fat zero in common except arguing and talking about work: dull after a certain moment. However, since it was my first New York romance—adding downtown into the equation—I was determined to make a valiant go of it. It appealed that he lived at 342 Bowery—a building belonging to Andy—that was right around the corner from Jean-Michel Basquiat's studio at 57 Great Jones Street, another Andy building. The tales about Basquiat's decadence were notorious. Wilfredo Rosado recalls "parties being catered by Mr Chow, six large tins of caviar bought with cash, and bringing out a bottle of Mouton Cadet de Rothschild costing $1,000 when it was Andy and just me." Thanks to Basquiat's extravagant handouts, there were also the hobos and tramps hanging outside his door who could be kitted out in the smartest Armani suits.

When Basquiat came into the studio to see Fred, it looked as if there were needle marks all over his hands. It was obvious that he was a full-fledged junkie. Although I doubted Jay's absurd idea that Basquiat had even injected his prick. Much as I admired the artist, I knew not to talk to him. Basquiat's face was a picture of pain and vulnerability.

In spite of the growing disastrousness of my relationship with Jay, I persuaded myself that each element meant something, whether we visited a fortune-teller together—calling Woody Allen—or waited in line for some dull artsy film or ate at a diner serving tasteless food. That said, I was hopeless at managing Jay's moods, which were omnipresent and roller-coaster exhausting. I'd always been with men who were talkers. Not so Jay, who was Mr. Big on brooding. It made me more and more uncomfortable. And finally, at the end of July 1987, we both threw in the towel.

The problem with a failed office romance is the aftermath and the daily reminder of the foolish behavior. And I certainly, albeit briefly, suffered. Occasionally, Vincent would leave little packs of Kleenex on my desk and not say anything. Then once I was involved in the Manhattan razzle and swing, the memory of our flirt evaporated. And Jay and I got on as a result, even if I was probably the only person in the organization not to be invited to his first wedding—funny that!

Several people became key to improving my social existence— namely Kenneth Jay Lane, who included me in all his smart Park Avenue lunches; Nell Campbell, the queen of the night and éminence grise of Nell's nightclub, who enlisted me in most of her dinners; and Peter Bergen, a journalist who'd been at school with my brother and had very wild nights at his Hell's Kitchen apartment. Other notable evenings included meeting Robert Altman with my stepfather (Altman had directed two Pinter plays for television); accompanying Vincent and the author Tama Janowitz to a screening of Merchant Ivory's *Maurice*; attending Nancy Huang's birthday party for musician Nile Rodgers, her boyfriend; having dinner with John Malkovich after seeing him in his smash-hit performance of *Burn This*; discovering Visconti's *Ludwig* and other Italian masterpieces with director Paul Morrissey; and accompanying director Mike Nichols (an old friend of my stepfather's) to Yankee Stadium and the private box of Lorne Michaels, *Saturday Night Live*'s producer.

Meanwhile, a welcome summer addition to the Warhol Studio was Len Morgan. He sat alongside Brigid Berlin at the reception desk, and I was relieved to discover that he was as wary of her but just wiser at hiding it. "The loyalty, how long Brigid had known Andy, and the fact that she was unfiltered could seem refreshing," Len now says. "The fact that she could say to him, 'You're not the greatest thing on earth.' So there was a certain gravitas that came with Brigid beside her insanity."

The insanity. Yet a lot of Brigid was pretty darn cool. In stark contrast to others who lived off their Warhol 1960s past, she never referred to it. Brigid also stopped taking drugs and drinking: an achievement.

Having been obese, she had slimmed down to reveal a patrician profile—Brigid had the perfect nose and chin. It gave innate class to her appearance braless in T-shirts and long shorts. Every day, while her pug dogs, Fame and Fortune, snuffled and lay at her feet, she either knitted up a storm or needlepointed slippers that she would then sell for a famous fortune! There were also her moments of getting off on cappuccinos. Drinking seven in one bout and occasionally burning her tongue in the process, she would dance around the room claiming to see polka-dot bows.

The problem was that Brigid didn't get my point. This was apart from a brief few months when she gave me one of her mother's Scaasi dresses, showed me her "Prick Book" packed with pictures of famous artists' members, and invited me to her younger brother's home in Boston; she defined unpredictable diva. It was a shame, because Brigid was an original. Her stories about her privileged childhood alone merit an autobiography. Instead we endlessly fought, particularly about the air-conditioning. Her crowning blow to Len was, "Natasha is the sort of person who takes books out of libraries." I did and do.

Fortunately, this was never the case with Len. He was wicked. He took a look at Linda, Fred's new assistant who had a long dark braid that fell down her back, and she instantly became "Pocahontas." And Len's nickname stuck. Sharp-tongued but so pretty, imagine shiny chestnut hair falling fetchingly to the side, heavily lashed navy blue eyes, flawless tan, and relaxed preppy look via polo neck, long shorts, and bare feet in loafers. Andy treasured his company. With Wilfredo Rosado and Sam Bolton, Len would take him to parties. "The minute

that Andy wanted to leave, we took him back home and could return to the party, if we wanted. You'd deliver him to the front door, he'd say, 'Good-bye and thank you,' and that was it." Still, every function was about business. "I never understood Andy's terrible reputation," he says. "I remember my mother once saying, 'What am I supposed to tell people?' I said, 'Tell them I work for Andy Warhol.' It wasn't as if he took drugs ever. We behaved more in front of Andy than behind him. . . . The minute he went, sure, but not in front of him."

Andy could be perverse. "Once when I came into the office in shorts and a T-shirt, he picked that night to take me to a very grand dinner at Mortimer's with Pat Buckley and people like that," recalls Len. "I think purely based on the fact I was inappropriately dressed for the evening. And I remember thinking, 'Do you really want to walk in with a seventeen-year-old looking like this?' Still, everyone was very pleasant. There was a harmony to and around Andy."

Once Brigid left Warhol Studio for the night, I would slip into the seat next to Len and we would watch *The Partridge Family* or *The Brady Bunch* on a minuscule black-and-white television set. Or we would talk and talk and talk. Vincent could not believe it. Coming out of his office, he would say, "Do you two never stop?" I learned so much from naughty Len, who was at Brown University and no stranger to fabled boats, châteaus, and *Schlösser* in Europe. And in turn I would throw in a few chestnuts about upper-class life in stately homes that never ceased to amuse him.

Occasionally, Crazy Matty, the resident loony stalker, whose real name was Matthew Reich, would try to come through the Warhol Studio door. Len and I would pretend to cower but enjoyed the drama. Vincent, on the other hand, took his threats seriously, since Crazy Matty had been around in 1969 when he was "involved with the actress Geneviève Waïte." Obsessed with Andy, he threatened and

stalked him from the '70s onward, and he continued to stalk people after the artist's death. "Since he was beginning to torture Brigid—he was the type to call all night from a pay phone—I went up to him and said, 'Listen, it's over, Andy is gone,'" Vincent says.

I met Matty once. Dark and wiry, he was a John Cassavetes type. Afterward I became "the girl with Ava Gardner's eyes." Briefly, I did wonder how mad he really was! Only Jay was intrigued, viewing Crazy Matty as a bona fide original. No one else did. Crazy Matty infuriated Fred, particularly when he hovered around his house on Lexington Avenue. On one occasion, he found Harry Fane, one of my cousins, entertaining Crazy Matty in his kitchen. "I just could not belieeeve that," Fred later said. Eventually, Ed Hayes took control of the situation. "His private cops took him for a ride and Crazy Matty disappeared for some time," states Vincent. "I don't know what they did, but he didn't bug us for the longest time. At least six months . . ."

Meetings concerning Andy's memorial took place upstairs and involved Fred, Vincent, and George Trescher, who was organizing the event. Considered *the* party planner in Manhattan, Trescher was the type to be trusted by Jackie Onassis, Brooke Astor, and Annette Reed (later Mrs. Oscar de la Renta). Nevertheless, Vincent recalls Fred being "the main organizer," since Ian Schrager, Fred's friend, offered the space for the lunch. "The crazy thing was that everybody like Robert Isabell, who did the flowers, said, 'We'll do it for free,' and then we got these big bills from everyone." Meanwhile, Christopher Mason, one of Trescher's assistants, cracked me up. A fellow Brit, but a Cambridge University graduate, he was such a bow tie–wearing, silver-tongued go-getter. I should have taken lessons from him about managing Manhattan because somehow, after working on the memorial luncheon, he hustled a job from Fred and briefly did *Interview*'s

PR, a newly invented position. Quite a coup, except that after the hire, the *New York Post*'s Page Six and other gossip columns seemed to mention only Christopher. At the time, he was writing witty songs and performing them for the likes of Reed, Onassis, and Ivana Trump, when "the Donald" acquired Adnan Khashoggi's yacht and rechristened it *Trump Princess*.

Fred, ever conscious of column inches, would say: "Mason has been written about again." And without fail, I'd find Christopher at *Interview*'s Xerox machine, frantically copying that day's piece. It was a needed light moment. Ed Hayes had just moved in at the studio. Although we'd met in Los Angeles—he'd taken me out to dinner at Musso and Frank—his telephone conversations were hard to deal with early in the morning. His voice boomed. Friends were also making inquiries. "What exactly is Ed Hayes doing there?" they'd ask, because among a certain set, it was known that Ed was brilliant at making plea deals for drug charges (I knew two people he'd helped) and further skilled at getting people off jury duty. However, he had zilch to do with the art world.

Meanwhile, a rash of Andy's artwork was appearing at the studio to be verified by Fred and/or Vincent. Some of it was quite surprising—early self-portraits from the 1950s—and some of it was laughingly F for fake. The characters were a mix of hippies who hunted down art at out-and-beyond estate fairs (passionate, they were fascinating to converse with) and intense types who clutched their booty and avoided talking with Chatty Natty!

As far as Andy's inventory of work that was left upstairs in the studio, not all the canvases were stretched or, indeed, signed. This sounded like a potential problem. Years later, the Andy Warhol Foundation sued Agusto Bugarin, Andy's former bodyguard and the brother of Nena and Aurora, his devoted Filipino housekeepers, and

blocked the selling of a $20 million Liz Taylor portrait that he claimed was a gift from the artist.

Agusto was often in a hopeless state. His dark eyes were pools of despair. Initially I thought it was out of grief. He'd even claimed to have seen Andy's ghost upstairs in the studio. Naturally, I wanted to believe him. The idea of Andy's ghost was rather fantastic. Eventually, Vincent fired him.

Tony, Agusto's younger brother, could not have been more different. Short and boyish, he was energetic, helpful, and a source of pride to his older sisters, who had become housekeepers for Jed Johnson, Andy's former boyfriend. Tony and I often talked. It was usually about his female conquests. To judge from his descriptions, he was clearly the diminutive type who liked big, bouncy blonds.

George Malley, the studio's superintendent, was another sweetheart with a lovely, calm energy. Having been a bartender at the Waldorf Astoria, he worked for Andy et al. for years. "George's great claim to fame was that he served a drink to Marilyn Monroe," recalls Vincent. "I don't know how he got to us. We always picked up strays."

13 *Frederick W. Hughes*

Fred Hughes was the first person to be told by New York Hospital that Andy Warhol had died. It made sense, since Warhol had named him next of kin. As Andy's will revealed, Fred was named the sole executor of Warhol's estate—viewed as one of the largest amassed by an artist. To quote again from Bob Colacello's profile for *Vanity Fair*, it would give him "financial security, social prestige, and real power in the upper-most echelons of the international art world." Indeed, it was felt that after having been Andy's shadow—in photographs he was the slight, slick-haired, 1930s-styled gent by the artist's side—finally Fred was front and center, dangling the keys to the kingdom.

Having worked at the Factory since 1967, Fred had quickly won the artist's trust by being efficient and reliable. Then he'd seamlessly evolved into a private manager-dealer who took ten- or twenty-percent commission instead of the fifty percent that Leo Castelli demanded. When asked by Bob Colacello if he had ever added up the value of what he sold for Warhol, Fred initially said, "Yes, but I don't want to say the wrong thing," and then answered, "It's *decades of millions*." This was vintage Fred. To know and love Fred, aka Frederick W. Hughes, aka Fritzie to pals like Marisa Berenson and Diana Vreeland, was to appreciate his quips. They were frequent and demonstrated his lively mind, rich imagination, and heightened wit. When attending Peter Frankfurt's surprise nineteenth-birthday party, he appeared with Mick Jagger. "Frankfurt, Mick is your present," he said. "You can have Mick and do what you want with him."

Fred was a one-off who may have been born on July 29, 1943, in Dallas, Texas, but was completely self-created. He first came to prominence via Dominique de Menil, the French-born, Houston-based art collector, internationally renowned for her taste. On occasion, Fred referred to the de Menil connection as his "dowry." His tightness with the family certainly impressed Warhol. Fred persuaded Dominique and her husband, John de Menil, to finance Andy's movie *Sunset* for $20,000. Following Fred's lead, the de Menil children also collected Warhol's work.

Like many a prismatic character, Fred was closer in style to his grandparents than to his handsome father, who was nicknamed "Honest Hughes" and was a hardworking traveling representative for various furniture manufacturers. Fred's paternal grandparents owned a steel-equipment factory in Muncie, Indiana, and lived in a Victorian house crammed with Oriental carpets and European antiques.

"They were insatiable collectors," he told Colacello for his *Vanity Fair* profile. Meanwhile, his maternal grandmother, "Flaming Mamie," was a twice-married bon vivant from New Orleans. A fervent Fred fan, she spoiled him madly, taking him to Disneyland and Las Vegas, and this probably explained his sensational confidence with the female sex. Few could tease as mercilessly as Fred yet get away with it.

In a bid to protect him from his bouts of childhood asthma, his grandmother tried to send him to boarding school in Arizona, but his father insisted on a Catholic education, hence his enrollment at St. Thomas High School in Houston, where, according to Colacello, he made the honor roll.

When Fred began at the Factory, there was slight amazement, on a par with "What's a nice boy like you doing in a place like this?" Except that, to Fred's mind, the Factory seemed like "small-time loony stuff" in comparison to what he endured and witnessed with his high school's "Scottish priests of the Order of Saint Basil" and "boys studying to be priests. There's nothing like the Catholic element to bring surreality into your life," he told Colacello.

It was in the early 1960s, while majoring in art history at Houston's University of St. Thomas, that Fred met John and Dominique de Menil. Armed by a family fortune that stemmed from the Schlumberger oil-equipment company, they were the town's most committed art patrons, later renowned for creating the Rothko Chapel in the 1970s. With characteristic generosity, the de Menils financed the university's art department, which consisted of about seven students in Fred's day. It was run by Dr. Jermayne MacAgy, who curated innovative biannual exhibitions that her students both catalogued and installed.

When MacAgy died in 1964, she had been hanging a show, and that was when Dominique de Menil stepped in and took over her

duties. According to Louise Ferrari, then MacAgy's assistant, Fred and the de Menils "clicked immediately. They loved the same old things— oddball things, far-out things, avant-garde things, things that were exquisite: *art*." The de Menil children also accepted Fred. Far from being perceived as a rival, he was swiftly adopted as a member of the family.

Within no time, Fred was taken on art-buying trips to New York and Europe, as well as being entrusted with the run of their Manhattan town house and securing his first job at the legendary Alexander Iolas gallery in Paris, which represented the Surrealist artists René Magritte and Max Ernst. In 1952, when running the Hugo Gallery, Iolas had shown *Fifteen Drawings Based on the Writings of Truman Capote*, Andy Warhol's first solo exhibition, which had been inspired by his obsession with the American writer.

Fred would work for Iolas—who was rarely called Alexander—for several years. An ideal mentor, he was cultured, took risks (he championed Roberto Matta, Victor Brauner, Joseph Cornell, Yves Klein, and Niki de Saint Phalle, among other artists), and understood the mentality of the rich. The de Menils and many others relied on Iolas's opinion. Born privileged in Alexandria, Egypt, he was one of those chic Greeks; his father controlled the premium on Egyptian cotton, considered the ultimate in luxurious quality. Having trained to be a musician in Berlin, Iolas became a ballet dancer in Theodora Roosevelt's company and then the Marquis de Cuevas's fairly eccentric troupe. Since ballet wasn't his physical calling, he began the Hugo Gallery in New York during the Second World War. The grandson of Victor Hugo financed the venture. Iolas then arrived in Paris, where he became known for his extravagant appearance, memorable openings, and exquisite catalogues. "Iolas had wonderful cocktail parties because he was popular with all the Surrealist artists and the fun people in Paris," says designer Gilles Dufour.

When he first appeared in Paris, Fred was shy and rather plump. "But we immediately took him under our wing because he knew no one, was touching in spirit, and learned French within a few months," recalls André Mourges, Iolas's boyfriend. At the time, society hostesses like Jacqueline de Ribes and Marie-Hélène de Rothschild were being written about in newspapers and magazines. "Fred asked all these questions," says Mourgues. "He had that 'Who?' and 'Why?' mentality that went with his nose for people and his instinct for art." Within no time, Fred understood the inner workings of Paris. "The hierarchy appealed," reckons Mourgues. Yet he was a loner. One time, Mourgues took him to Castel's, an exclusive nightclub frequented by the well-born, fashionable, and elegant. "Afterward, Fred would often go there alone, taking in the scene."

Those years in Paris completed Fred's education that had begun with Dominique de Menil. "Returning to New York, he became an aesthete—severe and thin," says Mourgues. Still, there was the continued charm. "At a Factory lunch, there were the daughters of the March Spanish banking family," says Mourgues. "Fred turned to me and whispered, 'Aren't they so Velázquez?' They were." Another time, when Andy gave a *Campbell's Soup Can* drawing to Mourgues, Fred said, "This shows how much we love you." Nevertheless, there was a social insecurity that hovered. "He could be cruel," says Mourgues. "Particularly if he felt that a woman was vulgar." It would never be the case of Dominique de Menil, who was as admired for her taste as she was for her appearance.

It had been Fred's idea that Warhol's band, the Velvet Underground, play at a benefit for the Merce Cunningham Dance Company (underwritten by the de Menils) to be held at Philip Johnson's Glass House in New Canaan, Connecticut. It was also Fred's idea to meet Andy.

Andy was piqued that Fred was in his early twenties and had both

the ear and the trust of the de Menils. Naturally, it was appealing that Fred had bought one of his paintings and had arranged for some of his movies to be screened down in Houston. Andy was also intrigued by Fred's dandy-like appearance. "He was so perfectly tailored—like something out of another era," he wrote in *POPism*. Firmly an uptown boy, Fred's first trip to the Factory on Forty-seventh Street was the farthest south he had ever gone in Manhattan. So that dinner with Andy in the Village felt "like an expedition."

Magnetically drawn to the Factory, Fred would divide his days between the de Menil Foundation and meeting with bigwigs like Nelson Rockefeller and MoMA's Alfred Barr Jr., then returning to sweep floors for Andy et al. With time, the artist noticed his future business manager getting "more and more outrageously elegant— black jackets with braiding on them, shirts with bow ties to match."

Fred's sartorial elegance was much admired. "Timmy Stanton [another Fred friend] and I used to sneak upstairs and go through Fred's closet, he was so legendary," recalls Peter Frankfurt. Len Morgan, on the other hand, was struck by the subtle preparation in the late '80s. "The suits would come from his tailor, Mr. Nicolosi, and a day or two later Fred would have worn the edges with a razor blade so that they didn't seem too new," he says.

There was also his way of attracting young people. When Frankfurt was sixteen, Fred had taken him to Le Jardin, Studio 54's precursor. "Le Jardin was gay, but it had the best-looking women that I had ever seen in my life," Frankfurt recalls. That very night, he met Barbara Allen, a Warhol intimate and good-natured party girl, admired for her sensational figure. "Being with Fred made you feel cool," says Frankfurt. "He was friendly with so many beauties."

Staying at his home at 1342 Lexington Avenue felt "cool" too. Each bedroom was quite dark and nineteenth-century in ambience.

In one of them, the Egyptian cotton sheets were crisp and the bed was comfortable, and there was an attached bathroom: a luxury that I certainly didn't have back home in London. Hazel, his African American housekeeper, was a wise bird who was incapable of being shocked. On one occasion, junkies from a smart family tribe had left dirty needles lying about. "So Mr. Hughes says, 'Hazel, I'm very sorry about this, they are diabetics,'" she recalled. "Nooow, I think he's forgetting that I'm from Harlem!" Our talks would always take place in the kitchen, where her cousin would be pressing Fred's shirts.

On form, Fred was the ideal companion from beginning to end. Describing him as "fearless with total conviction," Peter Frankfurt always felt as if he "was in a movie with him." Fred gave off an undercurrent of glamour and romance as he introduced people, made funny little asides, and kept the conversation light at the table. "I'm deeply superficial" was a favorite Fred line.

For Fred, who was best in the company of women, humor or a shared joke was key to the relationship. Our somewhat extended joke was called "the Lady Antonia Fraser look-alike contest." In a nutshell, at parties, we hunted down blonds who were the dire opposite of my mother. Quite suggestive in their getup—sparkling halter necks were a favorite, as was a mass of pastel eye shadow—they were either floozies at the table or wildly enthusiastic on the dance floor. Extremely silly, it gave a charge to the evening.

There were also his Frederick of Union Square sessions that had begun in the Factory in the 1970s and continued at the Warhol Studio. Using tape, he gave nose jobs and face-lifts to anyone who happened to be standing nearby. His urge to give aesthetic improvements tended to happen at the end of the day. Fred enjoyed giving me a little piggy snout. "Natasha, this reaaally does wonders," he'd say. On one occasion, I got so used to my Frederick of Union Square lift that I

forgot to remove the tape when Bruno Bischofberger and his beautiful wife, Yoyo, arrived. Defining the art-world power couple, he was in a somber suit and she was decked out in an ivory-colored Chanel suit. I was in an L.L. Bean stripy turtleneck with tape on my face.

That was the delightful, whimsical side of Fred. As was his wistfully looking at a band of yelling kids waiting outside the Plaza for Michael Jackson, who was staying at the hotel. "Awww, that's sweet," he said. "I love young fans." As was Fred's need to draw cigarettes on every face in *Interview* when he was trying to give up smoking. We were on a train whizzing toward his teeny country house and he was determined to stop his daily rate of Marlboros: an impossible task for him.

When the Marquess of Worcester, Harry Somerset, married Tracy Ward in England, Fred naturally went. He returned triumphant with his Princess Diana tale. "So she arrives on the dance floor," Fred began. "Looking so beautiful, that skin, those eyes, the teeth, the body, and then she begins dancing like a . . . truck driver." Naturally, he imitated her, showing elbows out and bended knees. It was a hit to every type of audience.

Chivalrous, when Marisa Berenson was divorcing her second husband, Richard Golub, in 1987 and there was a problem over Andy's wedding gift, Fred rushed to her defense. Andy had done three portraits of Berenson, and Golub was insisting on co-ownership even if the late artist was his wife's friend. Thanks to Fred's appearance in court, Berenson got them back.

The chivalry extended to children too. While he was sharing a house with Shelly and Vincent Fremont, their young daughters Austin and Casey found a dead animal and were pretty upset about it. "Fred did this whole elaborate funeral procession," Vincent recalls. "We went in a little line and dug a hole."

Dutiful, he always went to Mrs. Vreeland's Sunday dinners, which

required him to be serious and grave-faced. At her side, he was almost taking the role of Reed, her late husband. True, the grande dame had peered into my face and said, "I thought your father was greaaat." Otherwise, I privately found the atmosphere to be staid and depleted. The gathered people were clearly there out of politeness. Fred, however, would hear no wrong. After Dominique de Menil, Mrs. Vreeland was his second mentor. So albeit an ingrate, I appreciated his staunch loyalty and his refusal to admit that her Sunday affairs were snooze-worthy.

Vreeland aside, Fred was fairly frank about society's ways. He had a horror of the pretentious. "Who does that writer think he is?" he said about a friend's boyfriend. "He kept on asking, do I like berries. Of course I like berries." When I got upset about a Park Avenue lady failing to send a book, Fred said, "Oh, for God's sake, Fraser, you cannot be annoyed with [X], who's been cheated on by her husband in New York, Paris, London, and St. Moritz. Pick on someone else of your own strength."

Like a stern headmaster, he also insisted on standards from his male buddies. He blasted Whitney Tower Jr. and James Curley for endlessly sniggering at one of Mrs. Vreeland's dinners. I presume that they were stoned. He also blasted Mick Jagger when he brought back "an unsuitable date" to a friend's Hamptons home, Fred's somewhat practical reasoning being, "She'll be there for breakfast!"

Mick and Fred were good together. I remember one Saturday evening when I joined them at Fred's home. There had been a torrential rainstorm and I arrived with sopping-wet clothes and water in my shoes. "Fraser, don't you own an umbrella?" Fred asked. A cozy scene then ensued downstairs in his kitchen that led to his enthusing over his favorite silent epic films while Mick silently towel-dried my hair and then combed it.

Like everyone, Fred had his moods. But the demon drink was a disaster for him. It became a case of Mr. Hughes and Mr. Hyde. Unfortunately, in the mid-'80s, his drinking got out of control. And the embarrassing incidents began to mount, such as his taking his trousers off at Nell's or firing off crazing monologues at restaurants like Mortimer's. "Andy found it rather sad what was happening to Fred and didn't know how to react," recalls Kenny Jay Lane. "He wasn't going to get rid of Fred, but it was a case of 'What am I going to do with him?' Fred got messy. We don't like messy."

When he was traveling with Andy and Fred in the mid-'80s, Christopher Makos recounts, certain mornings Fred woke up drunk. "Andy would get so pissed off with him," he says. "They were like a married couple because their business relationship was so tight. And Andy couldn't really get out of it and start anew because Fred knew everything."

This contrasts with Bob Colacello's memory of traveling with Fred five years earlier. "He was wonderful because he always boned up on the language, whether it was Germany or Italy, and he also boned up on the architecture," he says. "So we'd be in Düsseldorf and Fred would take you to the grandest houses, point them out, and give you a history of the families that owned them." Andy, on the other hand, was bored by the guided tour. "His reaction to most architecture was, 'It's just a pile of rocks,' or 'It's so cold and probably has no heat.'"

With hindsight, Makos wonders if Fred wasn't deeply unhappy with both the work relationship and the fact that "he wasn't fully attuned to his own homosexuality."

Although gay, Fred vehemently hid that side of his life. French interior designer Robert Couturier had a secret affair with him in the late '70s. "He was incredibly intelligent, his taste was phenomenal,

but there was a huge bitterness," he says. "He regretted not belonging to a certain world."

Instead, Fred was more comfortable nursing public crushes on Marina Schiano, the stylist and former Yves Saint Laurent executive, whom he married, allowing her a green card; Loulou de la Falaise, the style icon; and Sarah Giles, *Vanity Fair*'s editor at large; and a lengthy infatuation with Natasha Grenfell, a banking heiress whose mother was Tennessee Williams's executor. All women were European and looked quite different from one another. They were socially apt at any occasion and known for their strong personalities.

These women brought out the best in Fred, in the same way that macho men made him into the class nebbish who egged on the playground bully. I noticed this when artist Julian Schnabel appeared at the Warhol Studio. Famous for his plate paintings, he was the piping-hot artist at the time. Very handsome and dressed in pajamas, he arrived with a tray of little bun sandwiches from Sant Ambroeus, the Madison Avenue hangout, then proceeded to chomp through all of them. I was sitting at reception and he kept snarling in my direction. What was I meant to do? Hide my face? Fred then returned from their lunch and said how rude Schnabel had been about me. It was so unlike Fred that I put his behavior down to the artist's influence.

When Fred chose architect Peter Moore to renovate the building, it was obvious that Peter's WASP style and charm had helped. The same went for Tim Hunt, the younger brother of Formula One champion James Hunt. Plucked from Christie's tribal art department in London, Tim was hired to help Steven Bluttal bring Andy's inventory together. Yet both Peter and Tim were mild-mannered, elegant gents who must have been aware of a vague crush but never took advantage.

The same could not be said about Ed Hayes, a man-about-town

whom Fred appointed to be the lawyer of the Andy Warhol estate. Indeed, Fred would fire Robert Montgomery of Paul, Weiss, Rifkind, Wharton & Garrison, who had represented Andy for decades, and replace him with a man who knew nothing about the art world. "They both wore bespoke suits," offers Vincent Fremont. Shocking as it may sound, it was the bespoke-suit connection and Hayes's macho bravado that attracted Fred.

"Fred came over with Hayes and he had a huge crush, you could see it," recalls Peter Frankfurt. "I mean, Fred went to see a Bruce Springsteen concert with him. It was wacko. And Hayes was totally on the make." Suzie Frankfurt had a Biedermeier desk, similar to one that Andy owned. "Hayes wanted her to take it apart to show him the secret compartments," continues Frankfurt. "He was worried that Andy might have hidden diamonds or jewels in his."

Hayes, thanks to Tom Wolfe's book *The Bonfire of the Vanities*, was a bit of a star. True, he was a Queens-born Columbia University Law School graduate and former Bronx assistant district attorney with a small office practicing in criminal cases. But most people knew that Wolfe—a famous novelist—had based his hero on Hayes. And if they didn't, Hayes was happy to tell them.

It was all very tough chic glamorous, including a huge white wedding to a former catwalk model and guests including Robert De Niro and his girlfriend Toukie Smith, Tom Wolfe, TV personalities, police chiefs, and Bruce Cutler, the loudmouth lawyer of John Gotti.

And Fred lapped it up. I wonder if he felt he was one of the big guys. The problem was that Hayes was inexperienced, and in spite of claiming that he would work only on Warhol's estate, he was still doing his own practice. I gleaned this because he would have early-morning meetings and liked to boast that money didn't change hands but fancy carpets and other such items did.

Hayes was always drawing attention to my breasts. It was pretty weird. "Breathe in, breathe in," he'd say. Implying that they would look bigger. Once when I was interviewing someone on the telephone, he came up behind and grabbed me roughly by the waist. Shocked, I turned around and told him to fuck off. He went quite red in the face and had the nerve to berate me afterward. When I tried to reason with him and say, "Listen, Ed, what *you* did was incorrect," he flipped. In a nutshell, that captured Mr. Hayes.

Yet Fred was smitten. He felt protected by Hayes, who, when Andy died, arranged security from the Major Case Squad for the artist's house. "We had probably the highest-quality security in the Western world," Hayes informed *Vanity Fair*'s Colacello. "I wanted guys I knew, homicide detectives."

Hayes was flash, he was brash, and he was the worst person to have on board when someone became sick. Fred's multiple sclerosis flared up within less than a year of Andy's dying. It was tragic to witness. At the beginning of 1988, I was with Fred outside Hammacher Schlemmer, when he fell and could barely get up. In a drunken state, he had always tumbled, but this was different. It was the early afternoon and he was stone-cold sober. With difficulty, I got him into a taxi and suggested that I take him home since we were on the Upper East Side. However, Fred wouldn't hear of it. He was fine. And when we returned to the Warhol Studio, Vincent wasn't in his office. Instead, we were welcomed by the loud voice of Ed Hayes.

Meanwhile, others who cared about Fred would say, "Is he all right?" "His jokes were just not as funny, not quite as well judged," says Anne Lambton. "I would think, 'This isn't like Fred. What's got into him?'"

14 *Preppy Vincent— The Only One with the Warhol Enterprises Checkbook*

After several weeks, I began babysitting for Shelly and Vincent Fremont. With their daughters, Austin and Casey, and their stylish downtown apartment, they represented a different side of Manhattan. It was one of family values and interest in American arts and crafts. Through their steadily acquired collection, I discovered Mission furniture. Talks with Vincent also showed a more caring side of Andy. Their relationship was fight-free and different from the others.

"He trusted preppy Vincent and let him run the Factory," says Anne Lambton. "It showed how even-keeled and clever Andy was." At Warhol Enterprises, Vincent was the only one with the company's checking account. Andy also loved and respected his wife,

was a godfather to their elder daughter, and guessed when the couple were going to elope. "Andy was in Texas with Fred, he called and I said, 'Are you coming back for the weekend?' and he said, 'Oh, are you getting married?'" recalls Vincent.

With this in mind, it must have been horrendous for Vincent to deal with the lawsuit against the New York Hospital. "Andy's death made me realize two things: Don't get operated on the weekend, and never hire a private-duty nurse, because the nurses on the floor don't come in," Vincent now says.

The problem was that Andy's gallbladder had become gangrenous. "He would have died if they hadn't taken it out," notes Fremont. "It would have poisoned his entire body." Accompanied by Ken, a tall blond who "was nice but not the brightest guy in the world," Warhol checked into the hospital. "Andy took a small private room and went under his assumed name [Bob Roberts]," Vincent continues. "I told the day nurse, 'You can call him either Mr. Warhol or Andy inside the room, but he doesn't want anyone to know he's here.' Andy really wanted to get home as soon as possible."

After the operation, at eight forty-five on Saturday morning, Vincent saw Andy in the recovery room and then went home. "It was Austin's fifth birthday," he says. "And I had hired a private-duty nurse—based on the instructions of Denton Cox, Andy's doctor." Vincent then returned in the afternoon, around four-thirty. "I waited until he was back and acclimatized in his room and I now regret that," he says. Having been sedated, Warhol was sleeping with an IV attached to his arm. "His wig was off," he says. "The day duty nurse said, 'The operation went well, and better than expected.'"

Later that night, Andy called and spoke to Shelly's mother. "He couldn't remember the second private number of his house," says Vincent. "There was one number and then the private number that Fred,

Pat Hackett, and I had." At six-thirty the following morning, Vincent was informed that Andy was dead.

On every level, the New York Hospital screwed up. After Warhol's gallbladder surgery, performed by Dr. Bjorn Thorbjarnarson, more than twice the required volume of liquids was pumped into him. This resulted in internal pressure, which in turn resulted in his death from heart failure. Not helping matters was the fact that he had been given morphine, a painkilling drug that further suppressed his pulmonary capacity.

"Andy kept putting that operation off," recalls Catherine Hesketh. Anne Lambton remembers "a terrible seizure" on the 1975 book tour after he had eaten chocolate. "It was so frightening," she says. Nevertheless, the artist was prepared to suffer the gallbladder attacks because he had an eerie sense about returning to the hospital.

Meanwhile, Vincent had an eerie feeling about Fred and his decision to hire Ed Hayes. "The biggest mistake post Andy's death that precipitated a lot of headaches was firing Bob Montgomery," he reasons. "When Fred told me, it was already fait accompli that he had brought in Ed Hayes, who had no experience in estates and foundations." Cole Porter, Marilyn Monroe, and Andrew Lloyd Webber were a few of Montgomery's clients, and he excelled at protecting the integrity of their work—as exemplified when he managed to stop the maker of a toilet-bowl cleaner from changing Porter's lyrics to "I've got you under my rim."

Since I was a better on-foot messenger than typist, I was always delivering important documents to the offices of Paul, Weiss, Rifkind, Wharton & Garrison. Although never privy to the contents, I gathered from Vincent's tense expression that the correspondence was heated. Once, I was in the elevator of the lawyer's swanky building—it was made of dark glass, and located in the lower Fifties on the East

Side—when it suddenly dropped about thirty-five floors, for what seemed like several seconds. Then the elevator dangled for a few minutes and swiftly returned up to the law offices, the point of origin.

It was strange. Vincent insisted that I must be exaggerating. "That's a lot of floors," he said. Then I began to doubt my short-term memory. However, I hadn't been alone. The young woman accompanying me—I presume a legal assistant because she remained steely-eyed and unruffled—got out at the same floor I did. Naturally I tried to let the incident go. But never quite could. There was something surreal about the experience, and in a way it captured an element of my first year of Adventures in Warhol Land. I was surrounded by dramas that had nothing to do with me and yet I felt strangely protected by the cast of characters. The likes of Fred, Vincent, Zara, and new arrivals, like Cosima Vane-Tempest-Stewart with her boyfriend, Johnson Somerset, were never dull.

On one occasion, Fred got quite tipsy in Shelter Island, where he rented a house with the Fremonts. "I'm just a leaf swaying in the trees," he said. It was a surprise but a delightful one. However, if anyone was swaying, I was. After several years of living in Los Angeles, where I had pretended to be focused and directed, I was content to be malleable. And when dipping into Manhattan's social pool saying that I worked at the Warhol Studio suited the situation. If I have one lasting regret, it was not following the advice of Andrea Brenninkmeyer, who did a series of odd jobs for types like Xavier Moreau, Helmut Newton's American agent. Having spent three years at Boston University, she was better accustomed to the East Coast than I was. "You've got to smile more," she said. Her argument being that New Yorkers might mistake my look as cold and snooty. Smart Andrea, dumb Natasha.

Meanwhile, Miss Zara Metcalfe was appalled by my English Muffin and Warhol Studio status. "Tashie, you just did two years in

Hollywood away from your family connections," was the gist of her argument. "You cannot now return to being 'the daughter of' when working in New York. You're capable of doing something much more serious." Her logic nagged because she had a point. "Why don't you write?" she'd say. Because the *w* verb was associated with my mother and other members of my family, I'd privately think but not necessarily voice. However, I have to thank Zara for planting the writing seed in my head.

Writer and director Nora Ephron could not hear enough about Zara and her adventures. It was easy to comprehend. In a city where so many were influenced or borrowed aspects of their personality, Zara was A-to-Z herself. I guess a certain amount stemmed from incredible social confidence that comes from being a member of a smart British family. Her great-grandfather was Lord Curzon, a viceroy of India, and her grandfather was the well-connected Fruity Metcalfe, a pal of the Duke of Windsor. And then there was her father, David, a popular figure whose range of pals included Henry Ford II and Lord Lambton. But tipping the family tree and adding Slavic mystery and exoticism was her mother, Alexia, a Canadian beauty of Ukrainian extraction who had been the third, and much younger, wife of Sir Alexander Korda, the esteemed film producer.

Both Andy and Fred were crazy about Zara. They had initially met in 1975, at her eighteenth-birthday party, held at Boodle's, a private club in London. It was meant to be a *"comme il faut"* night that would finish early. However, since Zara's best friends were Rachel Ward, Clio Goldsmith, and other great beauties, Warren Beatty, Jack Nicholson, Andy, et al. gate-crashed, just before dessert. Hard liquor suddenly appeared, as did a major stash of drugs. Zara's father was furious, but his daughter's reputation was made.

After arriving in New York, Zara worked for the art dealer

Wildenstein & Company. Placed in the basement, she was meant to be cataloguing the rare illuminated books. Eating food was banned. This did not, however, stop Zara from enjoying a tuna sandwich during her lunch break. That was, until she heard footsteps coming down the stairs. She slammed her magazine shut, including the sandwich, but forgot to retrieve the latter. A few days later, whiffs of tuna began wafting into the gallery, and that was when Zara hopped it to the public relations department of Calvin Klein.

She made instant friends with Kelly Rector, the future Mrs. Calvin Klein, but fashion wasn't quite her calling. When I moved into her home at East Sixty-eighth and Madison, a spacious apartment that belonged to her stepmother, Sally, Zara was reading screenplays for the director Susan Seidelman, who was responsible for the sleeper hit *Desperately Seeking Susan* starring Madonna and Rosanna Arquette.

An irresistible personage, Zara had her quirks of character, such as nursing strong passions for people and then suddenly sending them to the Zara Tower of London, refusing to lock up the apartment, forgetting to pay her phone bills, and renting out the maid's room, which was a no-no for the building's co-op board. Being woken up in the middle of the night to let Zara in was tolerable. As was walking into a cow's skull when she was going through her Georgia O'Keeffe phase. But one day, I returned to find a petrified-looking Zara. "Tashie, we might be evicted," she began. It turned out that the woman in the maid's room had stopped paying rent and had done the double-dirty by informing the co-op of Zara's unforgivable deed. Suddenly I had visions of the apartment being sealed off, tough-looking policemen, and Zara with Oscar, her parrot, not far from their sides. No doubt screeching up a storm, since Oscar was the possessive type and loathed the intrusion of any and all males.

Fortunately, Henry Jaglom, the alternative film director known for *Can She Bake a Cherry Pie?*, rode in and saved Zara. It turned out that he was the most important co-op member. But far from being a knight in shining armor, Henry claimed to be a knight in a nightie! Unbelievable midnight conversations would take place between Jaglom and Zara that began with his description of his night garment. Naturally, I was listening in. Still, Mr. Jaglom promised to save Miss Metcalfe and remained true to his word.

Jaglom's interaction was just as well, because one member of the board might have been gunning against Zara. I refer to a certain doctor who soothed the nerves of his patients during the day and beat up his wife at night. The couple lived over Zara's bedroom, and like clockwork we'd hear the beast arrive and smack his wife down to the floor, and she would then sob. This might have merrily continued, until Zara decided to ride a bike to work.

In Zara style, she'd chained her bike to the railings outside the apartment's entrance. The "mess" offended the doctor, who complained to the doormen, who passed on his displeasure. The high noon of Bikegate happened in the elevator one morning. Wearing a mink fur hat, Zara entered the elevator followed by a hatless me. There we found the doctor looking the opposite of proud and imperious. Turning her back to him, Zara said, "When you stop hitting your wife, I will stop chaining my bike to the railings." Since we were on the fourth floor, a strained silence followed. And for a brief moment, the domestic violence stopped.

No one was more popular than Zara. Her list of New York–based devotees included John Malkovich, who was the only man capable of calming Oscar; Kelly and Calvin Klein; writer Susan Minot; her sister Carrie Minot, who worked on *Late Night with David Letterman*; director Michael Austin; writer Robert Hughes; and Fred.

Fred admired Zara's spontaneity and her "Anything goes" style of entertaining. He had witnessed this when she and pals rented various houses in the Hamptons. "The places were shacks," he told me. "But when Zara and her friends threw a party, everyone went in droves because they knew that it would be *fun*." The likes of Steve Rubell, Bianca Jagger, and Andy would come up from Montauk to revel in the happenings. Sophisticated, Zara knew that the magic lay in the mix of crowd, not the brand of vodka or the size of plate or form of glass.

I experienced only one of Zara's holiday rentals. It was in New Jersey, in the heart of foxhunting territory, so she nicknamed the place "Tallyho." Fred, on the other hand, referred to the place as "Tallyhole," a cheeky reference to the amorous-themed rumors he claimed to have heard about. The weekend I stayed there had Malkovich, Annabel Brooks, and me. According to John, we were clad in Victoria's Secret all weekend. Not sure about that detail. But I do remember going to a supermarket and his utter bewilderment.

"I noticed that security was following you around," he later said. "At first, I thought it was because you were all so pretty and then I noticed that you were just picking up packets of biscuits, eating a few, and then returning the opened package back to the shelves." Led by Zara, we were all grazing—eating items that had not been paid for. Fortunately, none of us were prosecuted. But it does give a sense of the goings-on that spiraled around Zara.

Fred hadn't given up on the television gig for me. A screen test had been arranged with Don Monroe, who had directed all of Andy's MTV programs. "Keep still and stop moving your eyebrows up and down," Don advised. I had also met Gary Pudney, an ABC executive who thought I could offer something different to television. I even

organized a series of headshots for him. But Zara scrunched up her face and was dismissive of both ventures. "Tashie, write," she said.

Bizarre as it may sound, I actually itched to. It had started slowly at first. Then haunted me on a daily level. I would have dreams where I was at a desk scribbling and scribbling away on scrolls of paper that fell around my feet. I can only compare it to a woman who suddenly decides that she must have a baby. All my life I had dismissed the idea of writing. It annoyed me when people asked when I was going to publish a book. Annoyed, because I resented being linked to my mother.

Meanwhile, she and my stepfather were happy that I was gainfully employed—important when you have six children—but made little mention of the Warhol Studio. They knew Andy's work, recognized his relevance, but it was not really of their taste. My little brother Damian, however, thought it was pretty cool, like most of the younger generation did. And he was thrilled when an American traveling acquaintance described my workplace as "that den of iniquity."

Putting pen to paper felt easy. It was probably because my mother had always paid my siblings and me to write holiday diaries. "Great cash prizes," she would cry. A pound per page was generous for the mid-'70s. Still, she had her standards and refused Damian's entries that just recounted the menus. Perhaps of note, the great man is now in finance.

Determined to write, I signed up for a class at New York University in the early summer of 1987. It was on Tuesday nights and, since I was paying, I didn't miss one, and complained when one of the professors kept looking at the clock. Insecure, I didn't mingle with my fellow students, but I do remember one woman with dyed orange hair writing a memorable piece about "jiggling." Every time I took

the subway home, the relevance of taking the course resounded. It gave inner confidence and instilled a sense that it would matter.

When Gael Love was ousted from her position as *Interview* magazine's editor in chief in August 1987, I started wondering about going there. Obviously there would be a new regime, and I decided to throw my hat in the ring. *Interview* had been essential to Andy's existence. Most mornings, he would go up to Madison Avenue and distribute signed copies of the magazine with the hope of securing new advertising. "Now it's about social media, but in those days everybody tried to get ads," Christopher Makos says. And every time Andy went out at night, his much younger escorts, such as Len Morgan, were expected to bring a stack of *Interview*s. "It was always about business," recalls Len. "Someone might want to advertise, someone might want to be in the magazine. If you met someone cute, let's have them in *Interview*. It was, how can you relate everything you do in your normal day back to *Interview*, the business and the brand."

Interview was on the other side of the building from the Warhol Studio. The entrance was on Thirty-second Street. Personally, I liked Gael. She was sassy. Fred, on the hand, was allergic. As soon as he heard that none of her staff liked her, he organized a coup d'état. After that Len loudly sang, "Ding-dong, the witch is dead," and Lucy, in charge of accounts, claimed that Gael had stolen loo rolls from *Interview*'s supply.

It was pretty rough considering the poor lady was in hospital and, it turned out, lacked a contract in spite of being at *Interview*'s helm for twelve years. I guess Fred had always been desperate to get rid of Gael, finding her vulgar in her faux-Chanel suits. But I thought she was a trip, with her big David Webb baubles and big pastrami sandwiches. Gael cracked me up. Then again, ballsy American broads

tend to. Like them or not, they are authentic to themselves—give me them any day over the faux Brits I met in Manhattan in the 1980s!

After Gael's dramatic exit, writer Kevin Sessums filled her high heels. It was a temporary position, since Fred was keen to change the magazine from being viewed as downtown and lacking in content to finally having substance. A few months later, in the beginning of 1988, he would hire Shelley Wanger, whose background was *The New York Review of Books* and Condé Nast's *H&G*. The introduction of Shelley had been a surprise and a disappointment for Kevin. Unfortunately, Fred had never been entirely clear about the situation.

15 *Andy's Sale at Sotheby's*

When I was working for Vincent, my first desk was a brass-and-marble 1930s wonder that was purchased by Andy on one of his European buying sprees. In strength and size, it felt as if it had belonged to a luxury liner. French in provenance, it had a rectangular black marble top and a long drawer flanked by four short drawers. Evoking the glamour of the era, each drawer was covered with a brass plate that showed a scene of transportation or navigation. The desk had ample room for the knees and was smooth to the touch.

Outlandish as the desk looked, I became quite sad when it was taken away. "It's for the Sotheby's sale," Vincent informed me. And that was how I first heard that ten thousand items of Andy's were

being gathered to go under the hammer at Sotheby's. "Andy bought so much that the entire sale should take several days," Vincent reckoned. As the weeks passed, other pieces were spirited away from the Warhol Studio. My friend Ian Irving started to come in on a regular basis. Having initially proposed the sale to Fred, he became Sotheby's front man.

Taking away Andy's acquisitions caused a void. However, no one else in the studio voiced such sentiment. No emotion was involved. It was business. Everything was being sold in order to finance the Andy Warhol Foundation for the Visual Arts, set up in the artist's will to "support and award grants to cultural institutions and organizations in the United States and abroad."

Fred began referring to the catalogues. There would be at least five or six. "Mind-boggling" is Ian's expression for describing Andy's house and collections. "You had no idea of the marvels," he says. "The Art Deco was fantastic." Jacques Grange recalls Warhol coming to Paris and buying Art Deco pieces. "The movement wasn't fashionable, but all the people in the know, like Yves Saint Laurent, were fascinated," says the interior designer. "The interest in Art Deco was created by the antique dealers, not the museums." Peter Brant, who accompanied Warhol on many trips, remembers, "Andy liked signatures. Not that he always knew what they said or meant. He deferred a lot to Fred."

Keepers of the Andy flame Steven Bluttal and Tim Hunt were in constant attendance when Sotheby's went over everything. Steven, who had been at MoMA, and Tim had been initially hired by Fred to do a professional inventory of the Warhol Studio and then were pulled in for Andy's treasure trove.

"We could not believe the amount that was there and how many of the pieces were of serious, top quality," Ian enthuses. "It was proof that Andy had a great eye but he also had very good people advising him." The list of advisors included the French antiquarian Félix

Marcilhac; jewelry dealer John Reinhold, who was one of Andy's best friends; and Jed Johnson, his ex-boyfriend.

One antiques dealer both Warhol and Saint Laurent enjoyed was Jacques Lejeune, at Comoglio on rue Jacob. "It was a bazaar, and Jacques—who was a little nuts—was always bringing out things," says Jacques Grange. "Since it wasn't organized, we all enjoyed discovering pieces. There was the occasional surprise such as the Brancusi chimney, bought by Ronald Lauder."

With characteristic chutzpah, Len Morgan had asked to see Andy's house before all the belongings were cleared or taken away. I was surprised. After all, he had gone there constantly when chaperoning Andy. However, Len informed that "very few people were allowed inside." Then I recalled staying in the taxi when Fred had stepped out and rung Andy's doorbell. Remembering how the front door was flanked by a pair of columns but had no number.

Kenneth Jay Lane had been to the house. "It wasn't cozy, and like a museum in a funny way with arranged chairs," he says. "I went into the small Art Deco library and the only other person was Sister Parish [the legendary decorator]. I liked Sister, but I found it rather interesting. Then, Andy was 'interesting.'"

Len, on the other hand, found it fascinating. "It was not the Collyer brothers, nor did it strike me as a place where someone actively used all the rooms," he says. "Andy probably went up to his bedroom and that was it." Nevertheless, it reminded him of Andy's daily routine of visiting Vito Giallo's boutique on Madison Avenue. "The shop was microscopic and he'd buy little objects," he says. Andy also went shopping with Stuart Pivar, a voracious collector, whom Len describes as having "one of those weird mini Chrysler stretch limousines that was vaguely embarrassing."

The Sotheby's sale exposed Andy's secretive side. Typically, it ap-

pealed. Privately I wondered if that wasn't his way of keeping sane and "far from the madding crowd." With his silver-white wig, he was such an instantly recognizable figure. Of course, he used that to his advantage. However, being sensitive, it was fundamental that he escape in order to recharge, gather his thoughts, and create.

In Fred's preface in the Sotheby's catalogues, he recalled Andy's first home on Lexington Avenue, which he shared with his mother, and rooms crammed with an amazing diversity of objects ranging from carousel equipment to bizarre Victorian furniture to modern contemporary art. In spite of mingling with renowned collectors and creative types from the early '50s, Fred stressed "the strong influence" of Andy's background. Naturally, there was Julia, his whimsical, Eastern European mother, who'd buy "little things from dime stores," but there were also European immigrants who had built up art collections.

Regarding Andy's second home—a six-story Manhattan townhouse on East Sixty-sixth Street, where he moved in 1974—Fred highlighted the importance of Jed Johnson, who assisted in mounting the collection. He also drew attention to the American artist's split personality, which was successfully resolved only in his paintings. Andy loathed the idea of "appearing conventional or grand," yet he enjoyed the luxury of the surroundings. When Jed left, he changed the arrangement by keeping two or three rooms furnished and free of clutter and using all the other ones for storage.

Viewing Andy as a lifetime collector, it was his lack of pretension and blind enthusiasm for everything that touched Fred. "If American Indian baskets attracted him, he suddenly wanted lots of them," he wrote. "To him, it was all so much fun." Occasionally, when the purchasing went beyond fever pitch, Fred would intervene and calm things.

After seeing the private preview of the Warhol Collection at

Sotheby's on April 20, I wrote the following in my diary: *What a collector! We are talking thousands of Navaho rugs, masses of exquisite watches, endless cookie jars, elegant desks and the best photographs. It's the most extraordinary collection I have ever seen. He was the most amazing hoarder. Apparently before coming to the Factory at around 2 or 3 pm, Andy would just go on daily shopping sprees with Stuart Pivar. And when there were large items of furniture, Andy would try and hide them from Fred. Jay [Shriver] is quite funny about that. . . . Typically, Jay complained that he didn't think that there was one thing of interest in the collection.*

Thrilling as Andy's collection was, it was a vast and thorough mess that required Sotheby's to do a complete inventory, from A to Z. Moving in with computers, two experts had catalogued all the contents that were retrieved from cupboards, closets, stacks, piles, crates, and unpacked boxes. Over twenty curators and other employees had then combed through the treasures, transferring most items to a warehouse and curatorial offices. During the process they tidied up the house while retaining the character of the collections.

With Vincent, I had seen Andy's house mid-cleanup. The writer Andrew Solomon described the house being "like a bizarre dream, magnificent rooms letting on to other magnificent rooms, all painted in unappealing shades of Wedgwood green and highlights of gold and olive drab." I, on the other hand, couldn't believe how antiquated it felt. But now, having met many more collectors and ventured into their homes, I know that can come with the territory. "Collectors rarely go for the spare look," offers Gordon Watson, an antiques expert. "It's all about the hunt, the chase, and the kill." Of course, if they have an interior decorator, that person then accommodates and places the item. In Andy's case, Jed had moved out.

The house had two large rooms on each floor, an important landing, a broad staircase, and modern decorative touches. Organized by

Jed, these ranged from faux-marble columns in the hallway to stenciled patterns on the bedroom walls and ceilings to wall-to-wall carpeting. Nevertheless, Solomon's description of the rooms "all filled with exquisite objects, and all strangely vacant, barren, unoccupied" was apt. As this was Andy's personal museum, the almost formaldehyde-like atmosphere was to be expected.

Ceramics expert Louis Lefebvre attended the preview of Andy's sale, the hot ticket at the time. "It was well presented," he says. "There was none of that business of seeing the bed that Andy had died on or any of that voyeuristic nonsense." Lefebvre, who ended up buying four cookie jars, was amazed by the choice. "It was very much the collection of an elegant gentleman," he says. Gordon Watson, however, was exhilarated. "The excitement upon arrival, the room upon room, cabinet upon cabinet, every nook and cranny crammed with endless, extraordinary things," he says. "Throbbing with people—the adrenaline in those salesrooms kept me high for weeks."

The Andy sale went down in auction history as a vast hit. A mob scene, it was conducted for ten days and made $25 million. I can still remember the excitement of the first day, April 23, 1988. That Saturday, his Art Deco and Art Nouveau possessions were auctioned off. Seven thousand bidders, including collectors, dealers, and fans, poured into Sotheby's on York Avenue between Seventy-first and Seventy-second for the main event. Few were allowed into the salesroom, where there was standing room only. To the delight of everyone at the Warhol Studio, the sale made $5.3 million. It was twice more than Sotheby's initial estimate.

Everyone was pleased about the Sotheby's auction apart from Paige Powell, in charge of *Interview* magazine's advertising, and Tama Janowitz, the writer. Both felt that a museum should have been set up to preserve Andy's memory. At the time, I viewed both dark-haired

women as Debbie Downers. Nor did Fred help matters by privately referring to Paige as Rage Bowel. I saw the sale as prolonging Andy's reputation as an artist and establishing his eagle eye. But then, I wasn't emotionally involved with Andy as they had been. Still, their idea of a museum went against Andy's desire; he didn't want any "leftovers."

According to Jed Johnson, Andy "just wished his body would disappear and not be a problem for someone else to dispose of." With this in mind, Johnson sensed that the artist would have wanted the same fate for all his belongings.

In *The New York Times*, art expert Rita Reif highlighted the record auction prices being paid. She singled out an ivory-inlaid ebony armchair with rounded back designed by Émile-Jacques Ruhlmann that went for $154,000; a sharkskin and sycamore console table, raised on bulbous legs, by Pierre Legrain that sold for $209,000; and an ebonized-wood center table, discovered in Andy's hallway with its legs still wrapped in paper, by Charles Rennie Mackintosh that went for $275,000. "The table looked so nondescript that Fred had to tell the security guard to get his feet off it!" recalls Vincent.

With the spectacular sales of the French Art Deco silverware, I was particularly pleased for Fred. When he traveled to Paris with Andy, and Sandy and Peter Brant—fellow Art Deco enthusiasts—their biggest coup was visiting the Puiforcat emporium and finding a dusty showcase devoted to the work of Jean E. Puiforcat, the most famous silversmith of the '20s and '30s. "We asked the incredulous assistants if any of these objects (which to them were totally outmoded) were for sale," Fred wrote in his Sotheby's catalogue preface. "And consequently bought almost every item for little more than scrap value."

Although it was slightly beyond my means, I bought the $95 six-volume catalogue, which was presented in a dove-gray box. Keen to uncover Andy's "Rosebud" or defuse the enigma, I remember reading the

memories or the pieces written by his inner circle. In volume 1, the essay by Sydney and Frances Lewis, fellow Art Deco collectors, referred to Andy searching Les Puces in Saint-Ouen, Clignancourt. "The flea markets allowed his compulsiveness, elusiveness, and sharp eye to work in tandem," they wrote. Like most collectors, Andy was someone who "just had to have it. A collector gives little thought to where something will be placed or will it fit."

In volume 2, which catalogued collectibles, jewelry, furniture, decoration, and paintings, the antiques dealer Vito Giallo recalled the artist's process. "We would compare notes before a sale and I would do the bidding for both of us." When the lots arrived at Giallo's shop, "Andy would rush up, buy what he wanted, and then rush back home with his purchases only to put them in a closet."

On most mornings, around eleven, Andy would arrive at Giallo's shop with "several *Interviews* under his arm, ready to pass them out and autograph them. Andy's collecting was an extension" of his art. When Andy was buying "rows and rows of mercury glass vases, copper luster pitchers, Victorian card cases," Giallo was "reminded of his paintings of multiple images."

The banal Andyisms like "Oh, this is fabulous" were an act. "He always had to appear as though he were an imbecile because that would give him an edge," Giallo said. Still, he understood that Andy was "very canny," while Rupert Smith, the artist's master printer, was impressed by how Andy poured his acquisitions back into his art.

On two occasions Andy photographed two thousand pairs of discontinued shoes that Smith had bought (somewhat typically, he would also snap up the boxes and wrapping).

Suzie Frankfurt's essay in volume 3 animated Andy's love of jewelry. Having met the dynamic redhead through her son Peter, I imagined her and Andy's adventures, such as compiling *Wild Raspberries*, their

cookbook; collecting celebrity autographs; lunching at the Plaza Ho-
tel's Palm Court; enjoying the opera; and going to Forty-seventh Street
to meet with the jewelry dealer Larry Ford, who sold Andy "scores of
wonderful and valuable things." According to Suzie, Andy ignored the
trends and "developed a penchant for the design of the forties. He loved
all those big clunkers—the bigger and more outlandish the better," she
recalled. Within no time, Andy became "a student of gemmology," al-
lowing him to limit "his collecting to specified categories. He set trends
and made fashions." And occasionally he wore them. At Studio 54, she
noticed "a slight bulge under his Brooks Brothers shirt, which turned
out to be a rather grand emerald necklace."

Catherine Hesketh also accompanied Warhol on his bauble hunts.
"He bought these incredible jewels that he would hide," she says.
"There were certainly boxes all over the house."

Rupert Smith recalled jewelry pieces designed by Jean Schlum-
berger and David Webb—both leaders in their field—and revealed
how the bargain-hunting Andy "hated to pay for Tiffany's straight up
unless he could figure out how to call Paloma [Picasso] or somebody
and get a discount." As far as Andy's large watch collection, "he
generally shopped for them himself," yet somewhat typically wore
only one watch: "a woman's gold mid-seventies Rolex" that "never fit-
ted. Sometimes he would wear the watch over his shirt cuff," Smith
wrote—a style copied from Fred.

One of Andy's more intriguing quotes concerned his collection
of Navajo rugs, seen in volume 4 of the catalogue. He had told *The
New York Times*' Rita Reif that the Indian weaving he called "ladies'
art" was comparable to American quilts and "yet another proof that
women are the world's major artists." Due to the whole Edie Sedg-
wick business, it was accepted hearsay that he used women and didn't
particularly respect them. I wonder about this.

True, Andy resented being used and could see through pushy, ambitious women, whom he would certainly target in his infamous diaries. Yet he was friends with Alice Neel, Marisol, and Florine Stettheimer, all extremely talented artists. There was also Brigid Berlin, who in the 1960s had been a muse for his Polaroid photography, as well as creating her own *Tit Prints*, and his mother, Julia Warhola, his greatest influence, who had done most of the calligraphy for his commercial artwork in the 1950s. In my opinion, he had a fondness for spontaneous females who were not unlike his mother in spirit. In the Sotheby's catalogue, David Bourdon refers to her "folksy babushka, her ever-cheerful smile, her old-country manners," the endless cooking for her son, and the perpetual pouring of milk for the cats. Julia Warhola was an eccentric. This was illustrated when Andy gave her a tape recorder. Her son's idea being that she would record herself and then send the tapes to her family and friends in Czechoslovakia. Instead, Julia Warhola recorded herself singing Czechoslovakian folk songs and then played them back, preferring to sing "duets with herself."

When entering his bedroom for the first time, the art historian John Richardson was struck by the "large bedside crucifix and a devotional book" by his bed. "How unlike the popular notion of Andy Warhol the bedroom was!" he wrote in his essay for volume 5, *Americana and European and American Paintings, Drawings and Prints*. Somehow Andy's daily, celibate life, attended to by his devoted housekeepers—Nena and Aurora—was as pure in tone as a priest's. "Before going out to a grand dinner," Richardson revealed, "Andy would eat a simple meal in the kitchen, especially during what he called his 'turkey and mashed potatoes phase.'"

In Richardson's learned view, "there was a definite pattern to his [Andy's] haphazard way of collecting. Thanks to an innocent but canny eye for things that were off-beat or out of fashion, he was

always in a position to be one jump ahead of the game." As for Andy's hoarding, Richardson notes that it "was only surpassed by Picasso," who "hung on to old envelopes and cigarette packs."

Andy "hid what he had," Jed Johnson wrote in an essay also in volume 5 of the Sotheby's catalogue. That stemmed from "the peasant's wisdom that if people (either the very rich or the very poor) knew that you had anything good, they'd probably take it away from you."

Henry Geldzahler, a Metropolitan Museum of Art curator, presented Andy's collection as constituting "an isle of invulnerability in a world that, at the same as it rewarded him financially, was yet full of pitfalls, vicious journalistic harangues among them." Geldzahler sensed that Andy "longed to be" an "establishment figure" but that constant criticism stopped him.

The final question of what Andy would have thought of his very own auction remains. "Would he be mortified to think of people gaping at the goods he left behind?" Jed Johnson wondered in his essay. He recalled running into Andy when John Lennon's "personal effects were being put up for auction" by Yoko Ono. Johnson asked him what the stuff was like and the artist cringed and said, "Oh, it's just, you know, toilet paper that he touched." Demonstrating his sense of the ridiculous, Andy had had a good old laugh about it.

16 *Andy's Estate and Aftermath*

While the Sotheby's sale became seed money for the Andy Warhol Foundation for the Visual Arts, there was the rest of the artist's estate, which included his Manhattan house, Montauk acreage, land in Colorado, downtown properties, and an inventory of art that *The New York Times* described as rivaling the permanent collection of the Museum of Modern Art.

In 1982, Andy changed his will. Fred Hughes remained executor, but Vincent Fremont replaced Jed Johnson as backup executor. Meanwhile, the main thrust of the eleven-page document stayed the same. True, a foundation was to be created "for the advancement of visual art"—and it was incorporated on May 26, 1987—but it was also stipulated that business be conducted as usual. Warhol's paintings

would finance every endeavor, as they always had. It was a balancing act—"we had to keep enough paintings in the foundation," Fremont says—but on the other hand, "since the main asset of the foundation was the art," it was up to Hughes and Fremont to "create cash."

According to *The New York Times*, the estate's art inventory was so vast—imagine 700 paintings, 9,000 drawings, 19,000 prints, and 66,000 photographs by Warhol, as well as works by other contemporary artists—that an entire team of people was required. This included the aforementioned curators Steven Bluttal and Tim Hunt, plus Beth Savage, who eventually became collections coordinator for the Andy Warhol Foundation, and Sally King-Nero, who is now working with Neil Printz on Warhol's catalogue raisonné.

In the inventory, there were stacks of 1950s drawings dating from Warhol's commercial and fine art periods. "Andy never liked showing those," says Fremont. "He didn't like looking back. He liked to create." Nor was all the work signed. From the '70s and '80s, there were all the thousands of Polaroids used for the portrait sessions as well as stacks of remaining paintings. Each sitting with Warhol usually led to a choice of four portraits, but since clients rarely bought all of them, a surplus amount was created. Warhol's later work consisted of *Shadows* (1978), the *Oxidation* paintings (1978), *Dollar Signs* (1981), the *Rorschach* (inkblot) paintings (1984), *Self-Portrait* (1986), and the *Camouflage* paintings (1986), as well as the work that had not been exhibited, such as the *B&W Paintings: Ads and Illustrations* (1985–1986) and all his collage portraits from 1975.

Nevertheless, the cream of the crop was Warhol's secret stash of 1960s work. What he referred to as his "rainy-day paintings" included the *Jackies*, the *Marilyns*, and the *Elvis* canvases that were printed and kept on a roll, then cut according to demand. "Andy never wanted

people to know what he had," Fremont says. To such a point that when Warhol became interested in insuring his rainy-day treasures, he abruptly stopped. "Because he realized that he'd have to reveal what he had," continues Fremont.

An extraordinary concept, considering the fire hazard attached to every working art studio. And the Warhol Studio, on a daily level, was both highly functional and experimental. There was a risk factor. Yet the strange, obsessive behavior fit in with Andy's "peasant's wisdom," as Jed Johnson wrote, to hide his belongings because people—"either the very rich or the very poor"—were not to be trusted and could take it all away. It's hard not to think of an Isaac Bashevis Singer novel. Nevertheless, such wisdom was further illustrated by the discovery of a "secret stash" of precious jewels, designer watches, and unmounted gemstones hidden in a space between two stacked metal filing cabinets. Found in late June, it led to another Sotheby's sale in December 1988, named the Andy Warhol Collection: Jewelry and Watches Part II.

In general, Warhol's paintings were not stretched on frames, because they were easier to transport that way. "We didn't use art handlers then," says Fremont. This was a decision Andy welcomed because it not only was cost-effective but also kept affairs private. When Si Newhouse and other prominent collectors were shown paintings, they were looking at flat canvases—or, in Charles Saatchi's case, inspecting a *Marilyn x 100* (1962) stapled to the wall. Such events usually happened on Saturday because no one else was around.

Famous for saying, "Good business is the best art," Warhol actually meant it. Financially, he felt responsible for all the enterprises he had created. As he often said to Wilfredo Rosado, "I've got to keep the lights on." Being enmeshed in the money side, Andy kept tabs on

promised checks arriving in the office, even when traveling in Europe, and he surprised Larry Gagosian by being "accessible and uncomplicated when it came to business."

Still, this practical, commercial side did not stop him from being deeply serious about his craft. Indeed, the most telling entries in his diaries are the Andy Agonistes ones about the art world. These range from noticing a fake *Campbell's Soup Can* at a show of his "early stuff" at Irving Blum's New York gallery; realizing that his prices are a seventh of Roy Lichtenstein's and a tenth of Jasper Johns's in the fall auctions of 1983; complaining that he has "only two collectors" while his contemporaries have fifteen or twenty; questioning whether Leo Castelli was "getting senile" when his New York dealer dissed his work in a *USA Today* interview; and being offended when the British gallery owner Anthony d'Offay ignored his suggestions regarding the 1986 *Self-Portraits (Fright Wigs)* show.

Even though most entries illustrate Warhol's stalwart belief in his talent, like most creative types, his fear was being dismissed and left behind. Yet unlike most creative types, he had constant attention via his fast track to the media. Andy defined terrific copy. The provocative quotes, the instantly recognizable face, the band of celebrity and jet-set friends, the nightclubs and parties, the Cheshire Cat—now you see me, now you don't—stance. However, in many ways, while courting the press, Andy did in his reputation. "The art world did not embrace him," recalls Peter Brant, a key Warhol collector. "There's a line out of *Death of a Salesman*—'He's liked, but he's not well liked'—that applied to Andy in the art world."

Nowadays, Warhol's need to publicly pour himself into everything would be applauded. But in the 1980s, pre–social media, it perplexed. To repeat Thaddaeus Ropac's theory, "People became tied up with Andy's performance and not the art."

Larry Gagosian, like many others, agrees that "the performance" confused people. "Unlike his contemporaries Robert Rauschenberg and Jasper Johns, Andy was a swish gay," the art dealer says. "He wasn't locked in his studio, having dinner with German curators, and going to bed at nine-thirty." Established art collectors did not know what to make of it. "David Geffen—a smart guy—didn't collect Warhol because of associating him with Studio 54 and seeing him there at one a.m."

Yet no one was more industrious than Warhol, or more involved. As Fremont, Gagosian, and many others attest, he was constantly in his studio, working there on weekends and fixing the mistakes of his assistants, particularly if they screwed up the colors. If Warhol had a hero, it was Pablo Picasso. "Andy had his eyeballs set on Picasso and always joked about it," says Fremont. "Andy wanted to do more than him." But when publicly asked about Picasso, Warhol's reply was characteristically glib. "I never think about Picasso, I just think about Paloma."

The fecund and ever popular Spanish artist had died on a professional top note. This was not the case with Warhol, whose market value was way down. The highest price for a '60s painting was $600,000. With this in mind, the aim of Hughes and Fremont was to rebuild Warhol's reputation as the great American artist via important exhibitions such as MoMA's retrospective. It opened in February 1989, then traveled, into the following year, to the Art Institute of Chicago, London's Hayward Gallery, Cologne's Museum Ludwig, Venice's Palazzo Grassi, and Paris's Centre Georges Pompidou. Curated by Kynaston McShine—reputed for his Marcel Duchamp and Joseph Cornell exhibitions—it was a haunting reminder of the force, scale, and breadth of Warhol's achievements.

"Andy had to die to have a show at MoMA," comments Fremont.

True, yet it became an Andy event without the distraction of Andy. Viewed as "a blockbuster" by *The New York Times*' Michael Brenson— it had three hundred works spread over two floors as well as an accompanying program of Warhol films—he described it as "the most ambitious solo show at the Modern since the Picasso retrospective in 1980."

A considerable success—"even if they put the *Disaster* paintings in the basement," notes Gagosian—it encouraged discussions for a Warhol museum in Pittsburgh, the artist's birthplace. In his will, Andy made no mention of such an establishment. "It came from Robert Becker, a former *Interview* editor who came from Pittsburgh," says Fremont. "He was contacted and then contacted Fred." The city of Manhattan wasn't interested.

"There were three partners," says Fremont. "The Carnegie bought the building and the artwork was provided by the Dia Art Foundation and the Warhol Foundation." Concerning the artist's personal inventory, an art advisory team decided on the selection of paintings. "The quality had to be exceptional for the museum," Fremont states. It would open in spring 1994.

Naturally, Bruno Bischofberger continued to organize shows in his Zurich and St. Moritz galleries. However, the role of Leo Castelli was totally eclipsed by Larry Gagosian. Everyone loved Leo. Few weren't charmed by the handsome Mitteleuropean powerhouse who played a key role in shaping American art and fostering international acceptance of Jasper Johns, Robert Rauschenberg, Roy Lichtenstein, and Frank Stella. Yet almost everyone agrees that Leo did not love Andy's work. Johns was more his aesthetic. Castelli's lack of understanding was demonstrated by the incident, fabled in the art world, when he dared to show Warhol's *Dollar Signs* and *Knives* in the basement. Still, it takes Brant to point out it was a group show celebrating

Castelli's twenty-five years in the New York art world. "Andy had a *Mona Lisa* upstairs next to one of Rauschenberg's eagle paintings," he says.

Nevertheless, Gagosian swooped in, or was "banging on the door," to quote Fremont. His first show was Warhol's *Most Wanted Men*, in 1988. "I couldn't afford the catalogue but I sold the work," he says. Soon his galleries began to exhibit all of Warhol's later work, such as the abstract *Shadows*, *Rorschachs* (inkblots), *Camouflage*, as well as *Dollar Signs* and *Ladies and Gentlemen* (drag queens). "Larry was essentially doing shows of unpopular Warhol work that nobody wanted," recalls art expert Abigail Asher. Gagosian, however, viewed it differently. "I was doing shows of overlooked work," he says. "They were not always well considered but nor were they properly dealt with. I showed the paintings with conviction and gave them a dignity. Andy was the biggest name in the art world and I believed in them."

Some argue that Gagosian's charisma and growing reputation as an art dealer did change the Warhol marketplace. Excellent as MoMA had been, seventy-five percent of the exhibition had been 1960s Pop art. Gagosian's continuous shows, however, began a reevaluation of Warhol's later work.

Peter Brant, on the other hand, holds Fremont as most responsible for improving the Warhol market "because he approached it in a scholarly way. Vincent developed a constituency, he approached entrepreneurial people, made the catalogues, and spread the religion across the world." A few exhibitions linked to Fremont include *Andy Warhol Drawings* (Anthony d'Offay, London, 1988); *Heaven & Hell Are Just One Breath Away* (Gagosian Gallery, New York, 1992); *Andy Warhol: Portraits* (Museum of Contemporary Art Australia, Sydney, 1994); *Gems and Skyscrapers* and *Stitched Photographs* (Galerie Bruno

Bischofberger, Zurich, 2001, 2002); and *Public Faces, Private Lives* (Galerie Thaddaeus Ropac, Paris, 2002).

"I'd agree that Andy's performance detracted from the painting," says Irving Blum, the legendary art figure. "But now what's left is the work. And it looks better and better with time." In 1996, Blum's *Campbell's Soup Can* paintings—exhibited at his Ferus Gallery in 1962—were acquired by MoMA for $15 million in a partial sale, partial gift arrangement. An exceptional arrangement, given that Blum had bought them from Warhol for $1,000.

Alas, this was not to happen to Fred Hughes. Unlike other collectors who were holding on to their Warhols in the early '90s—1992 was a slump year for contemporary art—Fred decided to sell ten of his paintings in May 1993. "I need the money," he told Carol Vogel from *The New York Times*. Being seriously stricken with multiple sclerosis and lacking medical insurance, he clearly did. However, the sale was rife with problems. "It was not a good market," says Brant. Warhol's prices were on a roller-coaster ride. In 1989, the record price for a Warhol was set when a *Shot Red Marilyn*, a forty-inch-square painting from 1964, went for $4.07 million. Otherwise Warhol prices were taking a beating, unless the work was viewed as extraordinary; the *210 Coca-Cola Bottles* from 1962 sold for $1.4 million at Sotheby's. According to Brant, the quality was mixed. "Some of those pictures were not meant to see the light of day," he says. But Fred was desperate. His MS had also affected his eyesight. "He was no longer able to authenticate Warhols," recalls Fremont.

Before Sotheby's, some of the paintings had been shown at Bruno Bischofberger's gallery in Zurich. Fred would not let them be sold. "I had people who were interested," Bischofberger recalls. "But Fred said, 'You don't give me enough money.'"

Thomas Ammann and Larry Gagosian had tried to buy all the

paintings privately from Fred. "We made him a big cash offer," says Gagosian. The selection included a *Double Elvis* from 1963, a *Telephone* from 1961, and a *Princess Diana* from 1982. "But Fred refused," says Gagosian. "He believed Dede Brooks [the head of Sotheby's], who said that the prices would go through the roof, and of course they didn't."

Out of the ten paintings offered, only two found buyers—a *Telephone* and a *Princess Diana*—and both reached less than their estimate. "The prices were too expensive," says Bischofberger. "It was very bad for the Warhol market." All in all, it had been a disastrous night for contemporary art at Sotheby's. Only forty works out of seventy-seven had sold. The next night at Christie's, all eyes were on the four Warhols and none of them went. Two weeks later, Carol Vogel referred to "a domino effect in the entire Warhol market. They brought to the forefront lingering questions about how many great Warhols actually exist," she wrote, "forcing dealers and collectors to reassess their holdings." Fremont recalled that the auction disaster did make Warhol collectors nervous. "But no one reacted." To have further flooded the market would have defined foolish. "It was a dreadful error that should have never happened," Irving Blum commented to Vogel at *The New York Times*. The poor sales also affected the value of the artist's estate, which was the focus of an extremely bitter lawsuit.

Ed Hayes, the lawyer for the Warhol estate, was suing the Warhol Foundation, contending that he was owed two percent of what he estimated the artist's estate to be worth. Hayes put the estate at $600 million, whereas the foundation came up with $120 million. Hayes's claim gave a bout of negative publicity to the Warhol market. More problems would continue between him and the foundation.

Meanwhile, Fred was managing to battle with both Hayes and

Archibald Gillies, who took over as head of the Warhol Foundation in 1990. Gillies—a man Fred appointed and then ultimately loathed. Fortunately, it would come to a cease-fire between Fred and the foundation in July 1993, when Christie's estimated that the estate's value was $220 million, and he was awarded a $5.2 million fee for his services. Reached on vacation in Venice by *The New York Times,* Fred was happy the matter had been settled. "On the subject of Mr. Hayes, the less I say the better," he had concluded.

Joining Andy Warhol's Interview *Magazine*

Once Shelley Wanger's appointment as *Interview*'s editor in chief was announced, I began to plot and plan to get over there. It was my belated New Year's resolution for 1988. Although I had fooled around on camera for director Don Monroe—Fred was keen that I end up with a presentable TV screen test—writing was my new goal.

I wasn't quite as bad as Richard Harris, who'd disguised himself as a waiter when trying to be re-cast as King Arthur in *Camelot*. Desperate to capture the attention of the musical's director, Michael Rudman, Harris arrived singing and serving. Then again, I was pretty shameless with Shelley: dropping my mother's name and Harold's too. Had my five

siblings been present, they would have been horrified. Naturally, I harped on about how much my mother had "loved" writing for Shelley at *H&G* magazine. But after the third time of mentioning this, even I felt mildly embarrassed.

Shelley was elegant, poised, and cool. Others might have been stopped in their tracks by her immaculate Agnès B. uniform of blouse, cardigan, and short pleated skirt, and by her general allure. Not me, because I was convinced that working for her would change my life. It did actually! But like a gun dog, I pointed myself in her direction whenever I could. It didn't matter if it was a social event like a lunch at Kenny Jay Lane's, where we were surrounded by Park Avenue princesses looking flawless in their gray flannel getups; I would barrel in and sell myself. Shelley didn't mind my pushiness. As the daughter of film producer Walter Wanger, she was familiar with the "I can sing and I can dance" routine. I also made her laugh—Shelley is known for her sense of humor. Finally, she felt familiar. I was reminded of my parents' friends, elegant literary types who were au courant and well connected but wore it lightly. They instinctively knew how to play intense at a dinner party and be frivolous too. A subtle art that I certainly lacked. That said, after my fifth or even seventh time of asking to move over to her side, Shelley agreed and took me on board.

Fred was positive about the move, as was Vincent. Brigid, on the other hand, stuck her nose in the air. I didn't really care about her reaction. Brigid represented the past, I ruthlessly decided.

Nevertheless, joining *Interview* was a shock. At the Warhol Studio, I had been one of the office pets who sort of did what I wanted. Occasionally, an exasperated Vincent would say, "Natasha, what exactly do you *do?*" Then a Warhol dealer like Hans Mayer might arrive and save me—I excelled at welcoming and offering tea, coffee, or soft drinks!—

or there would be a mini drama like the sudden appearance of Jerry Hall. Yikes. She came to be filmed for the final segment of Andy's show. I hadn't been warned. And, to the huge amusement of Vincent and Fred, I disappeared and powdered my nose for over two hours. There was also my very own version of Disney's "Sorcerer's Apprentice" when I attempted to change the water cooler outside the dining room. Unaware of the weight, the tank fell from my hands, cracked, and suddenly Fred was greeted with a river of water during a business meeting with Japanese clients. "Fraser," he yelled. "Is that you?" He actually laughed. Whatever the circumstances, it tended to be active at the studio.

Not that it was dull at *Interview*. However, under Shelley's reign, it became ordered and controlled. Before joining Condé Nast's *H&G* magazine, she had earned her stripes at *The New York Review of Books*, where she assisted Barbara Epstein and Bob Silvers, renowned for their exacting standards. Such an attitude was certainly new for *Interview*, which, to quote Bob Colacello, had prided itself on its "Yes, we're deeply superficial" stance and way of being "serious but so undone." During Gael Love's reign at *Interview*, I'd seen her and Marc Balet, her art director, going over the proofs of an issue. Essentially, they were correcting pages, but it didn't stop either of them from eating chocolate-covered Häagen-Dazs ice creams as they did so. A splat of ice cream or chocolate and the page would have been ruined.

Such behavior would have shocked Shelley to the core. She was admired for her conscientious ways, and certain writers were so in awe of her they nicknamed themselves "Wanger's Rangers." No demand was too much, and since Shelley worked grueling hours, everyone followed suit. Sometimes her art director, Angelo Savaides, took it a little far. For his first issue, he actually slept in the office. Still, Shelley's work ethic was steely and strong. Since *Interview* was a small

magazine, it was family-like. On the upside, there was coziness, a united front and sense of belonging. On the downside, there was role-playing and dynamics: winning Shelley's attention versus losing it. Occasionally, it was high school–like, but that didn't stop me from joining in. Jeffrey Slonim was a quiet riot to fool around with. He was convinced that, because of her thick reading glasses, Shelley was really a spy. "Spy for who, Jeffrey?" I would say, but he was off imagining her in cloak and guise. Meanwhile, I had a powerful fast track via the Lady Cosima Vane-Tempest-Stewart, a post-Andy English Muffin hired by Fred, who had become Shelley's assistant.

I began working for Kevin Sessums, one of the magazine's top interviewers. Just as Shelley became a professional mentor, so did Kevin, although he managed to double as a life coach. Andy also had a weakness for the "Mississippi Sissy"—Kevin's self-invented nickname and the title of his first autobiography. A former actor, he became a downtown Errol Flynn–style heartthrob when appearing nude in *Equus*. He had also worked in Paramount's press department, where, true to form, he dared to tell Eddie Murphy, the studio's box-office superstar, not to wear outfits showing his chest hair.

An "in ya face" outsider, Kevin was the first militant gay I ever met. Refusing to sport the then preppy uniform of most gays, he wore snug T-shirts, tight jeans, and biker boots. Since he had a well-toned body and a lovely shaved head à la Yul Brynner, he got away with it. There was also the wit. I remember asking if John Travolta was gay. "I don't know about him, honey, but his boyfriend is," Kevin said. True, Shelley hired me. However, Kevin was the first person to edit my copy and give confidence. He was also the first person to talk about gay rights, the need for the right to marry, and the Reagan administration's cowardly attitude toward AIDS.

Fun was to be had via staff meetings. We would all squeeze into

Shelley's teeny office and suggest title headings. Much as I enjoyed the sessions, a lot of gossip was shared and the behavior could turn quite raucous. My contributions frequently missed. I was reminded of playing Scrabble during my childhood. The only time I scored was regarding an interview with Gore Vidal. I piped up with "the chore of being Gore" and it actually made the magazine.

As a consequence of the small staff and lack of funds, I was allowed to interview and write about young, upcoming stars like Julie Delpy, Christian Slater, and Patricia Arquette, who appeared in the front pages of the magazine. Despite the shortness of prose (read: extended caption), I took my research extremely seriously. Alas, this was absolutely the wrong technique. It led to long, overcomplicated questions on my part and a stunned silence or even "Huh?" from Patricia Arquette. Fortunately, the stunning photographs by Paul Jasmin and others made up for my occasionally dotty copy.

With so much new added seriousness in the magazine—for example, Germaine Greer interviewing Federico Fellini—Shelley decided some froth was needed. Both she and Mark Jacobson, the features editor, noticed that I was never off the telephone and was always off to a madcap cocktail party for an eccentric WASP or on my way to Nell's for dinner or to stay with the film director Michael Austin at his house in Shelter Island, where a weekend party might consist of the actor Ian McKellen and the writer James Fox. With that in mind, I was given a monthly social column. Called "Anglofile," it began in format as a personalized letter to my mother—the embarrassment, and naturally "Dear Mum" was delighted—but then, after six months, became a standard roundup of events.

At first, I was thrilled. Styled by Lisa Wolford, *Interview*'s junior fashion assistant, I was photographed by Chip Simons at Twin Donuts with an old-fashioned typewriter in front of me. Wearing a Donna

Karan black dress with satin lapels and flaunting a large diamanté cuff by James Arpad from Beverly Hills, I felt extremely glamorous. *Fame at last*, I thought. But then I soon realized that hip people found my column rather lame. Make that extremely lame. So in characteristic fashion, I wavered between thinking this was wildly funny—a kind of "Yeah boo, sucks to you"—and wondering if I was a total loser.

For a brief moment, I thought about joining Lorne Michaels at *Saturday Night Live*. "The Lorne"—my cheeky term—had professionally pursued me and The Lorne could probably professionally tempt a nun. But ultimately the setup didn't appeal: an assistant to an assistant, with my ego? After several meetings, negotiations fizzled out. Still, to experience The Lorne was to experience the smoothest of operators, with his apartment on the Upper West Side, country pad in Amagansett, private box at Yankee Stadium. His list of intimates included Paul (as in Paul Simon), Mike (as in Mike Nichols), Jack (as in Jack Nicholson), Mick . . . as well as his kingdom at NBC. Several times, the Canadian-born Michaels said how bored he'd been as a child, staring at the same piece of road. I wondered if a change of circumstances and a dull childhood would have led to my ruling the world with an Upper West Side apartment and so forth. But seriously doubted it.

After a few months, my "Anglofile" column improved in pace and tone. According to readers' complaints, it needed to. Having been long on commentary and heavy with anecdote, it became more hardhitting and easier to digest. Yet, flawed as the early columns were, they captured New York at a certain moment. A birthday party for Duran Duran's Nick Rhodes at MK, Eric Goode's new nightclub; a book signing at Scribner's for Elia Kazan and *A Life*, his autobiography; the outrageous last-Thursday-of-the-month soirées organized by

Susanne Bartsch at the Copacabana; the launch of Cher's fragrance Uninhibited at the Plaza Hotel; the opening of Comme des Garçons' shirt boutique on West Broadway; the Fête de Famille benefit held outside Mortimer's; and the reopening of Steve Rubell and Ian Schrager's Royalton Hotel, coinciding with the publication of *Fred Astaire: His Friends Talk*, compiled by *Vanity Fair*'s Sarah Giles.

Fitting for living my adventures in Warhol Land, a series of male admirers were in and out of my life at that moment. Mick Jagger would call from France and Japan. Pleasant until I heard that Jerry Hall was seeing a Scottish lord. Then I wondered if Mick wasn't trying to get his own back. He, on the other hand, was going through his brief "Elephant Man" stage.

Having always been "relax max" about being recognized, suddenly Mick's famous features were swaddled in scarves and he was playing mysterious and incognito. Apparently, this odd behavior was due to the disappointment of his second solo album, *Primitive Cool*, which had scored only in Japan. In my usual frank fashion, I did try to say, "What's with the scarves, Mick?" but he didn't really answer. Poor Mick, it must have been awful.

According to Bob Colacello, "Andy liked Mick but also thought he was incredibly cheap." I never found that. I wonder if he and others weren't threatened by the fact that Mick, away from the strobe lights, was relatively well balanced. His knowledge of music was also unbelievable. I was going through a jazz period and he always recognized Thelonious Monk or whoever else was playing at my home.

Malcolm McLaren returned, and surprised by claiming undying love. It had been the idea of Menno Meyjes, the screenwriter, that he should just be honest and voice his passion. There was also an Irish film director who was buzzing around. The gesture was more manipulative than attractive and it was fortunate that nothing happened. A

successful journalist from *Rolling Stone* would have been more fun, but he was even more neurotic than I was. There was also Ramin— my platonic Iranian admirer—who had once telephoned *Interview* asking to speak to "sexy baby." The magazine's relatively green receptionist called out, "Sexy baby, sexy baby, who here goes by the name of sexy baby?"

And then there was the German-born and exquisite Nana, who'd fallen in love with my photograph published in *Quest* magazine and was convinced that I secretly lusted after women. On our one date we went to see the performance of her great friend Sandra Bernhard, the outrageous comedian who was the famous lesbian of the 1980s.

After Sandra's performance, we gathered at the Gold Bar, a place downtown where I was clearly the heartthrob of the night, since I was encircled by twenty women spearheaded by Sandra and Nana. A strange but not unpleasant experience. Just when I was thinking, "Thank God no one I know . . ." I heard the voice of Michael Austin—a dear friend but aka Radio Austin. "Darling, is that you?" he began. "And is there anything you'd like to tell me?"

Meanwhile, the son of a famous novelist became one of those permanent "Should I or shouldn't I go there?" We met in the best Andy way possible—at a children's party in the Dakota given by the granddaughter of a Warhol collector. After being introduced, he asked if I was a ballet dancer. Talk about a terrific pickup line. Actually, I was smitten, finding him both good-looking and intriguing. The problem was that, despite his claiming to have my number by his bed, he was the master of the disappearance act. If it was Nicaragua one minute, it was Nantucket the next, but just not Natasha.

With my unqualified magnet for fellow freaks and commitmentphobes, I was destined to attend all of my *Interview* column events alone, until one fateful spring evening in 1988. Wandering into the

host's kitchen, I found Richard Edwards, who was "sooo bored" that he was doing the washing up. Since he was chirpy with an infectious laugh, I quickly joined his side. And that was the beginning of the Nat and Dickie friendship.

Although he was a high-powered British-born lawyer from Herbert Smith, one of London's top legal firms, Richard accompanied me checking out the latest diamond setting from Israel, attending a Sade concert at Madison Square Garden, and chanting a mantra with Richard Gere at a Tibet House benefit. An ideal companion, the Cambridge-educated Richard chatted everyone up—he pushed me onto Sean Lennon at Mapplethorpe's Whitney exhibition and encouraged me to photograph Jasper Johns for my column.

After a few months, I began to add Richard's name to the roll call of VIPs, which included Lorne Michaels, Calvin and Kelly Klein, and Barry Diller. Occasionally, Shelley would ask, "Who exactly is Richard Edwards?" and my response ranged from "a dear friend" to "someone who's going to be deeply important." (Richard is now the power behind the Baldwin Gallery and the Caribou Club in Aspen.) Both worked with Shelley. She was pretty tolerant.

Shelley also protected me from the wrath of Paige Powell. From a distance, no one was prettier. Each morning, she'd arrive at the office with her Dalmatian, whose black spots on white seemed to set off her enviably straight hair and bangs and colorful outfit by Steven Sprouse or other downtown designer.

I did notice that Fred had little time for Rage Bowel, and remembered how he'd groan about her lack of sophistication, and her self-importance, pushiness, and greed, mentioning that it was all starting to "grate on Andy's nerves too." Even Wilfredo Rosado, Paige's friend, sensed that her relationship with the artist "was like an obsession. She felt like his wife!" says the jeweler. According to Vincent, "Paige went

a little nuts. She was going to have a child by Andy." Warhol's diaries mention Tama Janowitz being in cahoots with the idea. His attitude being "What's wrong with them? Can't they see they're barking at the wrong tree?" Professionally, Paige had also stepped on Vincent's toes. "When I was doing the MTV programs, Paige could sabotage the shooting lineup," he says. "We were working for the same organization."

But that often happens with members of an erstwhile family: people behave bizarrely and not everyone can get along. So I was rather flattered that Paige liked my British accent, presumably thought advertisers might agree, and invited me to the occasional business lunch with her. During our halcyon days, she even arranged a discount on my pair of navy Belgian shoes. Then it was obvious that I talked too much, wasn't scared of voicing my political opinions, and was quite happy to order dessert when no one else did. Whoops! So the lunches stopped, my column began, and then Paige organized an *Interview* party and invited only a few people from the magazine. I thought it was unfair—very unlike Andy Warhol in behavior (only to be corrected by Kevin Sessums that "it was oh so like Andy!")—and called Paige to air my grievances. Suddenly her voice changed from passive Paige who articulated every word like a creaky old granny to a New York harpy. "Fuck off," she snapped. *Finally*, I thought.

Somewhat miffed, Paige tried to take her revenge by getting me to handwrite all the invites for her future events. Her argument being that I was an assistant, after all. When the stack of invites increased to several hundred and dear Paige accused me of having "fucking attitude," Shelley managed to intervene. With her habitual calm, she then declared, "Oh dear, she [Paige] has gone off her head." And so my adventures in Warhol Land via *Interview* continued.

18 *Life with Talcy Malcy*

At the end of September 1988, the exhibition *Impresario: Malcolm McLaren and the British New Wave* opened at the New Museum in New York. Eclectic, it documented Malcolm's contribution to the British and American worlds of music, fashion, and popular culture from the punk and New Wave eras to the present. Tangible objects like photographs, videotapes, film, clothing, and other items from McLaren's fashion boutiques showcased the impresario's career, from his early days as a self-described "cultural anarchist" to his latest music, theater, and film projects.

In the *Impresario* catalogue, Paul Taylor, the show's curator, described Malcolm as a "bad guy" of contemporary pop culture, which gave him serious

kudos in the late '80s. Taylor also made a valid point that Malcolm was "like a new type of artist. A 'producer' in more than one sense of the word, he has literally orchestrated new musical events and created provocative 'cultural texts' within the mass-media. McLaren is a popularizer, which is to say that he is a pioneer."

As I've mentioned, Malcolm McLaren was like Andy Warhol for my generation in England. And the *Impresario* show confirmed this. Through fashion with Vivienne Westwood, and the music world with the New York Dolls, the Sex Pistols, Adam Ant, and other bands he managed, Malcolm provided a scene and gave us aspirations.

The major difference was that Andy was tireless and worked all the time. With his "I've got to keep the lights on" ethic, he knew how to pace himself and remain organized, and reliable. Whereas Malcolm had an "I know how to avoid paying the electric bill" mentality. He worked extremely hard, but in fits and starts, and he could disappear. It explained why Andy had an inner core group and Malcolm didn't: he was scattered and irresponsible, and ultimately people felt used and occasionally abused. To cite Nathalie Delon again, "Chriiis, he 'ate you and he love you." It was a shame, because Malcolm was a cultured original with a spongelike mind that could also brim over with ideas.

In general, there was a tremendous fondness for Malcolm. Whatever city he arrived in, there was always a movable feast of old and new pals who seemed to sway around him. Through him, I met musicians like Bootsy Collins and Iggy Pop, and photographers like William Klein. He had a Pied Piper effect. Malcolm was best in the company of women; among younger, attractive males, he became a long-winded raconteur, with all the old chestnuts involving Sid Vicious and the rest of the Sex Pistols.

Malcolm could be a mensch. Or he was with me. I realized this when Brigid Berlin decided to rubbish my "Anglofile" column. It was at the beginning of September, less than two weeks away from Malcolm's show *Impresario*. And Brigid had burst out, "I cannot understand your ego, and who cares what you think?" The features of her refined face had hardened, and her delivery was scathing and entirely unexpected. I just happened to be in the Warhol Studio paying a friendly call. Instead of which I felt assassinated on the spot.

I called Malcolm and within half an hour he was at the diner opposite my office. "Why did she do that?" I kept asking. "Because she's a nutter, a fruitcake," Malcolm replied, and then explained that Brigid was one of "those old birds" who was "a casualty of the sixties. She's probably forgotten what she said," he reasoned. But I knew that dear Brigid hadn't. He then explained that via my column, I was pushing myself forward. "You're getting attention and not everyone is cool with that," he said. "But no one reads 'Anglo-fucking-file,' Malcolm," I screeched. "It's a total fucking disaster."

This cracked him up. And it cracked me up too. For several minutes, we could not stop laughing. Then, with a certain wistfulness, I said, "Oh God, what are we doing here?" And Malcolm bounced back into action and said, "It's not so bad, Nat." After all, he was about to launch a huge show at the New Museum. Nevertheless, I often wondered about him and America. Then again, it wasn't as if he had much choice. The Sex Pistols had sued him for embezzling funds and there had also been the disastrous court case against Richard Branson and Virgin Records. The United States of America flickered as Malcolm's last hope. His CBS contract in Hollywood had petered out. And now it was the music and art scene in New York.

A few months later, George H. W. Bush's inauguration beckoned. Thanks to my friend the writer Laurie Swift, her contacts in

Washington, and my mother's friendship with Evangeline Bruce—one of the capital's grandes dames—I attended all the inauguration balls and the celebratory parties around them. It was one of my better "Anglofile" columns. Dressed in Calvin Klein's cruise line, borrowed from the fashion house, I met various powers such as Katharine Graham, the owner of *The Washington Post*; Art Buchwald, a famous journalist and wit; J. Carter Brown, the National Gallery of Art's patrician director; Mary Jane Alsop, an éminence grise of the Camelot era; and Pamela Harriman, who'd been my father's childhood friend. With Evangeline, I attended the National Gallery's grand soirée, where the gossip of the evening was more about Harriman's face-lift—the seventy-year-old siren had dropped two decades and resembled a Romney portrait—than Barbara Bush and her brood. With my newly svelte physique, Calvin's 1930s sailor-type styles looked spiffy. A few admiring glances came in my direction, but I could think only of Malcolm.

So when I returned to the Big Apple and the Great Man—ahem—declared undying love, I fell for it hook, line, and sinker. "I adore you, I adore you," he began. Taking my advice, Malcolm had met and spent several days with his mother, described as "man mad" by his grandmother, who raised him. I was convinced that his chronic commitment problems stemmed from his lack of relationship with his mother. Needless to say, it didn't make an iota of difference. In fact, he then disappeared for twelve days without a trace!

I gave up on him there and then, thankful that I had not moved into his apartment as he had suggested. Strangely enough, it was at that precise moment that Page Six wrote about Malcolm and me. Since no mention was made of my mother—a first by a gossip column—I didn't mind. This played in direct contrast with Carrie Fisher, whose opening line to me was: "Oh yeah, your mother's a big

deal in London, right?" (A few months later, Carrie sincerely apologized. Since she'd just done an *Interview* magazine evening with Mike Nichols, I felt flattered.) It was also poles apart from a *New York Times* journalist who asked, "What's it like being the daughter of someone famous and accomplished?" This was in April 1989, when my mother's book *Warrior Queens* was being launched in New York. I stared at the journalist. She repeated her question and I replied, "I'd have to think about that." My mother interrupted. "Say something, darling," she said. But I couldn't.

After Malcolm's letdown and endless fibs, I began to wonder about my future at *Interview* and my future in New York. Through Kevin Sessums, I'd met Barry Diller, who was then running Fox Broadcasting Company. Barry was taken by my vitality and humor. "If only we could capture that energy on television," he told Kevin. I then discovered that he'd said the same to Angela Janklow, a great friend. My TV test was promised when I went to Los Angeles. It was a TV test that was promised and would hover until I left the United States in September 1989. As the daughter of a top agent—Mort Janklow—Angela got further.

The Publishing of Andy's Diaries

In 1989, Manhattan was rife with an onslaught of VIPs, confirming Andy's legendary prediction: "In the future, everyone will be famous for fifteen minutes." There were various categories: the "almost famous," the "recently famous," and the "once famous." In many ways, the thirst for fame gave rise to the gossip culture and the celebrity gossip columnist who did, after all, write about all and everyone.

With this in mind, Beauregard Houston-Montgomery monitored the New York Dish seminar. Held at the Puck Building, it was an event presenting a panel of gossip columnists such as Page Six's Richard Johnson and *The Village Voice*'s Michael Musto. The goal was to discuss and promote

the importance of dish, juice, and so forth in Gotham City. Alas, flop sweat was the best way to describe my participation.

I should never have agreed. I was hardly a bona fide gossip columnist; dishing dish was not my raison d'être. But I liked Beauregard, who worked at *Details* magazine during the day and was a walker of golden-oldie stars by night. "You'll need to talk briefly about yourself," he said. It was, after all, going to be my very own fifteen minutes. I heard him but forgot. Or rather, had no idea that I should have prepared. Instead, I was more concerned about my wardrobe, choosing black pants and a cropped wool jacket from Charivari that Fred Hughes described as "multo contessa."

Michael Musto and others got up before me. Glorified divas of dish, they lapped up the moment and caused the right titters in the audience. At first, I joined in the appreciative laughter about my fellow journalists. Seated side by side, we were on a stage overlooking a packed house. Then I began to inwardly freak, realizing that my turn hovered and I had precious little to offer. Suffice to say that I rose from my chair, introduced myself, mentioned *Interview*, and spewed out three or four incoherent sentences punctuated by a few *err*s and *um*s. The situation worsened when I spotted a fellow journalist in the audience with whom I'd recently had a falling-out.

At the end of the disaster, Laurie Swift's grandmother came up and complimented me on my appearance. What a ninety-one-year-old swell she was. It was the only pleasant moment of the afternoon. "Na-ta-sha. What. Happened?" said Beauregard, who widened his eyes and looked aghast. No doubt, he had pushed the importance of my participation on Michael Musto et al., who must have grudgingly agreed. Then it was so very much about image—whom you were seen and photographed with—and I projected *loser* on every level. Only

Richard Johnson was sympathetic—even if the quizzical expression on his handsome face implied, "What the hell possessed you to do this?" He was the only straight member on the panel. And despite his reputation as the great white in the shark kingdom, he could recognize a damsel, well, a dodo, in distress, while the others weren't interested. The disastrous situation was furthered when supposed pals like Nancy Huang, Selina Blow, and *Vogue*'s Gabe Doppelt appeared by my side and decided to say nothing. One big fat lie would have actually helped, ladies!

Clearly, the stars remained unaligned, because I then went to the opening of 150 Wooster, the new Brian McNally restaurant, co-owned with Nessia Pope and Sylvia Martins. There, I bumped into my *Rolling Stone* journalist admirer, who chose that very moment to yell at me. Resembling a furious penguin—his flapping arms resembling wings—he claimed to have left four telephone messages and was apoplectic that I had ignored his calls. In hindsight, it was a shame that he hadn't arrived at the Puck Building (later filmed in *When Harry Met Sally*) and exploded at the New York Dish seminar. It would have added a dash of dish in my direction!

Ten days later, *Paper* magazine described my answers as "comatose," then adding, "But what would you expect from someone who has such a birdbrain column?" Shelley had shown me the article. "I thought it better to warn you," she said. However—to show how topsy-turvy my adventures in Warhol Land were—a few minutes later I received a call from *Vogue*'s Anna Wintour. I presumed it must be about a party she was giving—mentally, I was "really up there," to requote Andy—but it concerned an assistant position that had become available.

Five days later, I crept into the Condé Nast building. Where was Mick's Elephant Man disguise when I needed it? The position would

mean assisting Michael Boodro, who was one of Anna's chief editors. "Do you like fashion?" Anna asked. "Because you'll have to like fashion if you work at *Vogue*."

It turned out that quite a few from *Interview* were jumping ship or planning to—best explained by all the scary rumors about the magazine being put on the block. On May 9 it was officially announced that the magazine had been sold for $12 million to Sandy and Peter Brant, aka Brant & Co, who owned *Art in America* and *Antiques*. There was a universal sigh of relief because the Brants were reputed for holding on to the editorial staff. Perhaps, but would they help with my green card and immigration problem, I wondered.

Alas, my green-card situation put a wrench in the works at *Vogue*. Sarah Slavin, a Condé Nast harpy, reproved me for not having proper working papers. "I cannot understand how *Interview* has been employing you all this time," she said in a tone that reminded me of childhood teachers. Ultimately, I'd have to restart the green-card procedure if I began at *Vogue* "and with only one year to wait, you'd be foolish to give that up," she advised. The news was depressing. Anna called a few days later. "Legally we can't employ you," she said. "But should you get married, or when you get your green card, we'd be terribly happy to hire you."

Around this period, I took Estée Lauder's photograph at a party. The makeup maven was not pleased. She had even put a gloved hand up to her perfectly powdered face to mark her displeasure. I thought nothing of it until the next morning, when she called my office and threatened to tell the immigration authorities. "I've heard that you are working illegally," she warned. Just as I was about to lose my teeth, give birth to kittens, and burst into tears, I suddenly heard the faint lilt of a Glaswegian accent in "illegally." It was that rotter Joe

McKenna, one of Helmut Newton's favorite stylists and one of the fashion world's acknowledged practical jokers.

Being fired didn't really pass my mind until late June, when I heard that the editor Robert Walsh and other big cheeses at *Interview* were being asked about their new offices and all their requirements. Alas, no one pulled me into a corner, but then I never really did have an office. I sat on a stool in the main production room. If the situation was meant to demean me, it didn't. Indeed, I found it endlessly entertaining since there were always photographers and illustrators going in and out. I remember funny chats with the then unknown David LaChapelle.

One sadness was losing Kevin to Tina Brown at *Vanity Fair*. I'd been made privy to all the negotiations. So I was somewhat put out when he chose to have his final hurrah lunch with Brigid Berlin. That was, until they returned. Brigid had slid off the wagon and ordered five margaritas! Fueled by the alcohol, she walked into Shelley's office, put her feet on her desk, and then discussed all the interviews that she'd taped for Andy, including Truman Capote's. Shelley handled the situation with characteristic sangfroid, Brigid overstayed her welcome, and childish individuals such as Mark Jacobson and me were literally on the floor, near to tears with laughter.

The situation with Fred Hughes had become dire. From being the White Rabbit, he had gone from the Mad Hatter to the unreasonable Queen of Hearts. To cope with his multiple sclerosis, he was taking steroids that made him seriously nuts. "People would come and see Fred and be in tears afterward because he was so mean to them," says Vincent, who became "the damage control."

Fred would charge over from his office to Shelley's aerie. The rattle of his walking stick made everyone hide because he would be on a tirade, yelling and slamming doors or crashing into fire exits. It

was tragic to witness someone who had been a droll and graceful dandy morph into a feared mutant. And the more uncomfortable Fred felt, the more violently verbal he became.

Yet to a certain point, deep pity for Fred and his ailing health protected him from the outcry following Andy's diaries, which were edited by Pat Hackett. The 807-page book, sold to Warner Books for $1.2 million, lacked an index. A wise decision made by Fred and Ed Hayes, the foundation's lawyer. So *Spy* magazine, then run by Graydon Carter, quickly published one. A few of the shockers described Elizabeth Taylor as "a fat little Kewpie doll," Margaret Trudeau "sitting on the toilet with her pants down and a coke spoon up her nose," and Halston providing "a bottle of coke, a few sticks of marijuana, a Valium, and four Quaaludes" after Liza Minnelli had arrived, saying, "Give me every drug you've got." Taking a potshot at certain marriages, Andy claimed Bianca Jagger "can't go to bed with him [Mick] because she just doesn't think he's attractive," and referred to Calvin and Kelly Klein as "a hot media affair."

Bianca Jagger sued from England, where the libel laws were more favorable to the plaintiff. "And she won," recalls Vincent. Halston, on the other hand, "threatened to sue because of the cocaine references," but stopped when reminded that almost everyone working for Andy had taken coke with him! Meanwhile, Victor Hugo, the designer's former boyfriend, referred to the journals as "The Satanic Diaries." "I feel I've been gang-raped and beaten by a dead person and a bunch of thugs that work for him," he told Michael Gross at *New York* magazine. "It is the most vile, disgusting piece of pulp literature." *Vile*, *disgusting*, and *pulp literature* probably helped sales!

A weird mix of blunt, outrageous, funny, banal, and quite self-confessional, Andy's daily entries were infinitely readable. A kind of exposé of his friends and his world, to quote Ronnie Cutrone, the

artist's former assistant, they revealed that, far from being "passive, shy, anything-for-the-limelight," Andy was "a time bomb with feelings. He thought [the people he wrote about] were glamorous, but he pitied them," Cutrone told Gross at *New York* magazine.

Nicky Haslam, who met Andy at *Vogue* in 1962 when he was still a commercial artist and appearing with "sheaths of drawings for the shoe department," views it differently. "I think Andy was fascinated by the ins and outs of people's lives and had no compunction to repeat the information." Bob Colacello also adds another element: "Andy was always trying to find out what love and relations meant." Since the artist was "not so good at them," he would "adopt this cynical pose."

I was not close to the people who were exposed, like Bianca Jagger. Quoting from Warhol's entry on December 6, 1976: "Bianca took off her panties and passed them over to me and I faked smelling them and then tucked them in my handkerchief pocket. I still have them." It was an accusation she vehemently denies. Or like socialite Barbara Allen, who was described as a desperate gold digger with a penchant for married multimillionaires (billionaires not yet being a feature). Or like Catherine Hesketh, who came across as potty-mouthed and raunchy.

"He was so rude about me in the diaries, and none of it is true," says Catherine Hesketh, who reckons that "he wanted to be amusing to Pat Hackett. They would talk in the morning and he would say things so that the diary wouldn't be boring." Since "Andy liked to put a bad spin on things" and "you can always be rude about everyone if you want to be," Hesketh advises, "everything in those diaries needs to be taken with a pinch of salt." Vincent Fremont offers, "Andy didn't exaggerate but he did have a funny take on things." Vincent also makes a point that it was a different period, when S&M clubs

were the accepted norm. "Dinners were given where the poppers would come out afterward and people changed from business suits to leather gear and then went to the clubs," he says.

The diaries were a talking point at almost all the parties that I attended from May onward. No one attacked me about them, thank God. Nevertheless, there was a sense of betrayal with regard to Andy, just as there had been with "La Côte Basque," the first chapter of Truman Capote's *Answered Prayers*, which *Esquire* had published.

Indeed, one or two chivalrous types like Kenny Jay Lane expressed concern about the reputation of their spurned girlfriends. The big shock was that the upwardly mobile Fred didn't edit the diaries more. Then again, Mr. Hughes hadn't escaped Andy's critical eye and was equally skewered for his blind love of the British aristocracy, and drunken and/or grandiose behavior.

Steven M. L. Aronson, who helped edit the diaries, insisted that they were important and merited the same respect as the writings of Samuel Pepys, Anaïs Nin, and Cecil Beaton. "There was a genuine novelty to anything Andy Warhol did," he told *New York* magazine. Aronson made a valid point, because Andy was a VIP insider. Peter Beard, on the other hand, who was also featured in the diaries, called them "existential." We were at a dinner given by the Robert Miller Gallery in honor of the California artist Robert Graham, and immediately delved into a good-natured argument about his use of the word *existential*. "Come on, Peter," I said, aware of Beard's provocative nature. "'Existential' means important questions about life. Hardly the case of Andy's entries . . ." But the photographer would not budge. And since Andy's diaries were topical, our entire table joined in. The general feeling seemed to be: True, certain entries were harsh, but nothing stated was probably inaccurate.

The diaries had been achieved via Pat Hackett, who had talked

to Andy every morning for ten years. When working at the Warhol Studio, I had warmed to Pat. Slightly cockatoo in appearance, with reddish spiky hair, greenish eyes, and a glowing Barbra Streisand complexion, she was skinny, always dressed in black, and had that New Yorker's issue with daily weight gain of about ten grams. I found her without malice. In many ways, Pat was brittle, observant with humor, and what Europeans would term as a hundred percent made in the Big Bagel. She was the ideal scribe for Andy because she shared his cultural references and had no desire to rub shoulders with the people he was describing. This contentment to be a voyeur injected the diaries with a detached element and took a potential bitterness out of the pages. Those who were annoyed by the diaries dismissed Pat as a wannabe. True, she keenly promoted the diaries, which Warhol called her dowry. But as she was paid peanuts when Andy was alive, who can blame her?

Ed Hayes, however, seized his moment. It helped that Fred refused to talk, and it helped that "Fast Eddie" gave great copy. "I advised Fred [Hughes] that he had an obligation to publish," Hayes told *New York* magazine. "Could he give up millions because he didn't want to discomfort the people he has dinner with?" Hayes continued, and then revealed that he didn't regret his professional decision in spite of the insults hurled in his direction and how being persona non grata meant eating in "for the next six months."

Again and again, I was surprised by what Andy wrote about Fred, and then wondered if the very sick Mr. Hughes cum Mr. Hyde had concentrated on the text. Later, I heard that he was expecting Hayes to wade through the pages. But lazy-daisy Hayes hadn't, presuming that Fred had done his homework.

Nearing the end of the book, I found Andy's attitude pretty depressing and wrote the following in my diary: *Jesus, here I am fucked*

up as hell and he was almost forty years older and worrying if Sean Len-non liked him less than Keith Haring? How pathetic is that? Fame and fortune neither improved his self esteem nor made him less anxious.

Yet twenty-seven years later, Andy's impressions and opinions en-capsulate the "Me" Decade and beyond. "The diaries were fun," says Diane von Furstenberg, who didn't escape criticism. "Mean and fun." Bruno Bischofberger was equally amused. "Andy described me as driving them all crazy in his studio, and it's true," he says. "I would come into New York for a few days and push them to see new work and nobody likes to be pushed." Meanwhile, Peter Frankfurt, whose mother was constantly attacked for being socially ambitious, thinks the entries "are historical" and "will weather well. I don't think it was Fred's job to clean them up," he says. "Andy was kind of a bitch, but he didn't say anything about my mother that my brother and I didn't already tell her. She was a social climber and we'd often say, 'Why are you doing this?'" In Frankfurt's opinion, Andy wasn't judging. "He was recording and keeping the camera running." His argument be-ing, "If you're upset by them, you don't get Andy." With regard to his mother, "she was just happy to be in them."

Ultimately, I was won over by Andy's tremendous work ethic and his self-effacement. He was the type to admit that when he declared, "I hate Richard Avedon because he uses everyone," his entire entou-rage turned on him and yelled, "So do you, Andy."

20 *Headed for Paris*

When writing about French personalities for *Interview*'s "What Ever Happened To . . ." column, I cast my thoughts back to Paris. Having fallen in love with the city in 1976, I remembered shaking the sugar in my first *citron pressé*, the smell of the baking baguettes wafting in the afternoon, and the blunt bangs of a little girl sucking a lollipop.

I'd rather had it with Manhattan. It was not a place to be poor and unconcerned with accumulating wealth. This hit home when being entertained by Gayfryd and Saul Steinberg in their 17,000-square-foot Park Avenue apartment. They had just rented Eilean Aigas—my former family home in Scotland—and reached out to make contact. Saul was a jolly bon vivant, but Gayfryd was hard to gauge. Unlike

Nan Kempner, C. Z. Guest, and the old guard of socialites I'd met, she didn't appreciate my questions or British sense of humor. Strange, when she looked lively in photographs and personified Snow White in person. I struggled to talk to her about her numerous charitable causes—there were quite a few—and hopelessly failed. It was excruciating for both of us. I was longing to escape the gilded and cathedral-sized cage, and she must have been relieved to see the back of me.

In the meantime, I kept finding examples of Manhattan's misery in strange corners. Walking to work one morning, I found a bedroom slipper in a pool of blood. I looked up at the apartment building and decided that the slipper's owner had jumped. There was no other evidence, but it demonstrated my mind-set. When walking to a swimming pool on the far Upper West Side, I witnessed Jed Johnson and Alan Wanzenberg having a furious screaming match on the corner. Usually both beauties were so calm. It was also strange because I'd just seen them at an intimate New York City Ballet fund-raising event.

Every time I left the city, I felt better. My brother Damian's graduation from the Harvard Kennedy School put me in an optimistic mood. Benazir Bhutto gave the commencement address. It was an uplifting experience furthered by my discovery of the dancer and choreographer Mark Morris, who was performing for the Boston Ballet. His production of *Dido and Aeneas* was life-changing. Morris was a large lad, possessing a massive torso and tree-trunk thighs, but his delicacy of technique and understanding of music transformed him into an enchanting woman. There and then, I realized that belief was what counted and everything else followed. And I started to think about the possibility of moving to Paris.

Not that my life in New York was so bad. I had moved into the Upper West Side apartment of Carrie Minot, Zara Metcalfe's great

friend, who worked on David Letterman's show. It was through Carrie that I discovered the Victorian art of decoupage, which would give me peace of mind. I was also making necklaces out of semiprecious stones and charms or bits and bobs that I owned. My very first necklace broke on Amsterdam Avenue; I hadn't mastered the importance of weight and the clasp. When I finally did, I gave them to friends such as the novelist Susan Minot, Carrie's sister, who wore my necklace when reading from her book *Lust and Other Stories*, and Quintana Roo Dunne, Joan Didion's daughter, who sported hers at her graduation party. Meetings about my necklaces were also organized at Ralph Lauren and Oscar de la Renta, even though both fashion houses deemed them too "ethnic."

Making the jewelry was much more satisfying than writing. It was just as well, because after Sandy Brant's dictates, my "What Ever Happened To . . ." column was terminated, and I gathered from snippets of conversation that our new boss didn't rate "Anglofile" either.

Nevertheless, my decision to leave *Interview* had nothing to do with the Brants. It happened because Warhol Studio was "no longer responsible" for sponsoring my green card, or so Fred Hughes informed me. Sitting in his blood-red office, I could not believe my ears. When I tried to reason with him that they initially employed me and so forth, Fred exploded with an *Exorcist*-like tirade of mumbo jumbo. Scary to witness! But I forgave him because he looked so green and ill.

In the middle, Vincent came in and then swiftly disappeared. I'd heard that it was happening a lot, the whole business of tiptoeing around Fred and his tsunami moods. In desperation, I went to see Ed Hayes, who repeated Fred's company line. I breathed in and channeled my best Susan Hayward. "This is my life on the line," I began.

"I'm in desperate need of help." He didn't budge. His dark eyes looked sharklike, and that's when I decided that Paris beckoned.

For the following two weeks, I used the *Interview* phones and worked on Parisian connections. I went to see Kenny Jay Lane, who dismissed my necklaces—"You can buy the equivalent for tuppence on a street in Paris," he said—but set me up with Leo Lerman at Condé Nast and with Grace Mirabella, who then ran her namesake magazine. Kenny was firm about continuing to write. "You're talented," he said. "No talent should ever go to waste."

I had dinner with Ed Epstein, a Francophile, who said that it was "essential to find a place to live." I thought of Fred. He owned a Paris apartment. In his diaries, Andy frequently referred to the place. During his European portrait-painting jaunts, he and Fred would stay there. I briefly wondered whether I should ask Monsieur Hughes about borrowing the place. But an attempt to do so misfired. I caught him in another foul mood and he screamed and shouted. Saddened by the episode, I thought of Shelley's prediction: "Soon he'll be in a wheelchair."

After finding a studio in the Marais through Fiona Golfar, an English friend, I mentally checked out of Manhattan. When Sarah Giles called about Mick Jagger's birthday, how sexy he looked and how poor Steve Rubell was sick with AIDS, I kept thinking about the Paris fashion world. Anna Wintour had faxed Gilles Dufour, Karl Lagerfeld's right-hand man at the Chanel studio; Loulou de la Falaise at Yves Saint Laurent; and Jean-Jacques Picart at Christian Lacroix and then talked about each individual. It was unbelievably helpful. Names are never enough. Then she looked at "The Mermaid and Her Friends," my collection of jewelry designs.

I'd created the collection because of Min Hogg, editor of *The*

World of Interiors. When I'd casually revealed my plans to create jewelry in Paris, she asked if I'd been to design school or had any experience to speak of. "Because if you don't," she said, "I suggest you start doing a portfolio of your designs immediately." Her delivery was quite sharp—make that harsh—but Min was right. Later she admitted, "I could not believe your arrogance, Natasha." Actually, it was probably more like foolhardy youthful confidence. Then again, Min's idea proved to be an excellent one.

I returned to *Interview* once more to pick up my last check. I bumped into Shelley, who'd clearly heard about Anna sending all the faxes to the fashion houses. Who was her Condé Nast spy? I wondered. "You don't waste time, do you?" said Shelley. And I replied, "No, I don't." Nor did I plan to ever again. Shelley did give me a great letter of recommendation, as did Fred, who managed to freak out when signing his letter and then calmed down and apologized.

When flying to Paris, I drank the water of one of my neighbors by mistake. When I admitted to the fact, she smiled and said, *"Pas grave,"* meaning "not a big deal." I liked the *pas grave* attitude and felt it was a good sign for the future.

21 *Andy, Mick, and Yves*

I was in love with Paris.

Thanks to Anna Wintour, I met key fashion players within days of my arrival. As Andy's name sparked interest but *Interview* magazine didn't, I quickly abbreviated my New York work experience to his studio. Give the Parisians what they want. Just as I also referred to myself as Scottish, not English—the Frasers were Norman knights, I found myself saying, due to the good "Auld Alliance."

Others from my past were less impressed. Indeed, the negativity reached an extraordinary crescendo when, within ten days of my arriving in Paris, three different individuals—an ex-boyfriend, an heiress, and Tony Richardson—appeared in my life to deliver the same message: You're too poor to cope with this city.

Fortunately, an adventurous spirit catches the attention of the Parisians. They are too canny or conventional to be fearless themselves, but they do appreciate courage. It explained why they liked Andy Warhol, whom they viewed as brave and pioneerlike. "Andy represented so much that we respected," says Jacques Grange. "Provocation, freedom, the Factory, the cinema, and he was totally unique." Like their mutual friend Yves Saint Laurent—the most influential designer of the second half of the twentieth century—Andy had extraordinary confidence in his craft and knew exactly what he was doing. However, whereas Saint Laurent played neurotic, indulging about his tortured self, Andy was more practical. Enigmatic, he hid his thoughts in public. In diverse ways, both Warhol and Saint Laurent were untouchables. Ultimately, all they cared about was their creation: an attitude that will always win respect in Paris.

Having lived in London, Los Angeles, and New York, I can safely vouch that none of those cities respect the creative with the same passion that Paris does. Many describe the City of Light as being one of the most beautiful capitals in the world yet essentially dismiss it as a historical museum town. Within a few weeks of living there, I became aware of a different heartbeat. Creation, on all levels, was taken very seriously in Paris. Intellectually, it was viewed as more important than the business of money or success.

Six months before my arrival, I. M. Pei had designed his pyramid in the Louvre. It had been unveiled on April 1, 1989, and yet there were still newspaper editorials that were either for or against the building. It was a happening that would have blown over in an Anglo-Saxon capital but not in Paris. People cared and had no fear expressing that they cared.

There was something else. In style, Paris was super-1970s. The decor of the cafés, the grown-up way people dressed, the general

formality during the weekdays, the continued sensual influence of photographers Guy Bourdin and Helmut Newton, the admiration for the singer Johnny Hallyday, the golden-oldie tunes of Bryan Ferry, as well as the attraction of film stars like Jack Nicholson and Warren Beatty.

Then there were the enduring icons, and without a doubt these were Saint Laurent, Mick Jagger, and Andy. The three men had strong personal ties. Mick had used Andy's artwork for his *Sticky Fingers* album cover; he described it as "the most original, sexy and amusing package that I have ever worked on" in the *Andy Warhol: A Retrospective* catalogue. Bianca Jagger's wedding outfit was by Saint Laurent. Famously Andy did portraits of both men. Those of Mick were part of Andy's celebrity series—an experience that Jagger described in the same catalogue as "a very painless exercise," and "it was fun staying up all night signing the lithographs." The images were taken from photographs; Andy was using Mick's fame and charisma to reflect a cultural phenomenon, just as he had with Elvis, Jackie Kennedy, and Elizabeth Taylor. Later, in the *Andy Warhol Portraits* catalogue, art historian Robert Rosenblum described the lineup of iconic faces as being "perpetually illuminated by the aftermath of a flash-bulb."

As commissions, Saint Laurent's four portraits were more personal. Proustian in ambience, a requisite for Saint Laurent, who admired the French novelist, they captured the reflective, inquiring, and anxious side of the designer. Out of all the series referred to as Warhol's society portraits, which were taken from Polaroids and turned into silkscreens, the ones of Saint Laurent remain among his greatest. They captured the mutual respect between the two. "Yves thought that Andy was the greatest living American artist," says Pierre Bergé, Saint Laurent's former lover and business partner. "And Andy referred to Yves as the greatest living French artist."

Nevertheless, when Warhol first appeared in Bergé's life, in Marrakesh in the late 1960s, Bergé had not been enthused. Jacques Grange and Loulou de la Falaise had rushed to meet the artist, "and Pierre was so dismissive and accused us of being groupies," recalls Grange. "But then several years later, who commissions Yves's portrait? Pierre."

When Yves received his Warhol portraits, Mick Jagger happened to be present. It was midnight, and Vincent Fremont had been called into the Factory in order to videotape the historic event. The home movie indicates the contrast of styles among the men. A long-haired Mick tinkles quietly away at the piano. Showing his back to the camera and dressed in sloppy clothes, he looks annoyed to be involved. Andy, seated in one of his studio armchairs, wears his signature transparent glasses, dark vest, Brooks Brothers shirt, and jeans. He's smiling but remains reticent. In fact, it's very much Yves's hour. Wearing a velvet pantsuit and bow tie, he's unusually chatty. "The bottle of Dom Pérignon had just come out," recalls Vincent. "Because before that he was quite shy." In rapid fire, he enthuses about Andy's work, particularly the five mini portraits that were a surprise present from the artist. When all four portraits were bought, Andy often threw in a sweetheart gesture.

Bob Colacello recalls, "Andy and Fred were always afraid of offending Yves and Pierre Bergé." Nowadays, that may sound strange. However, in the 1970s, fashionable French society was rife with competitive behavior. "You had to declare your loyalty," said Colacello. And the designer and Bergé were renowned for their exclusive group and for keeping a stranglehold on stylish, sought-after Parisians. Colacello continues: "I was always being told by Fred, 'Don't tell anyone that we had lunch at São's [Schlumberger],' or 'Don't tell anyone that São had her portrait done,' because she was really not part of the Saint

Laurent group that included Marie-Hélène de Rothschild and Hélène Rochas."

Although Saint Laurent and Bergé were stalwart Warhol patrons— the designer also commissioned portraits of Moujik, Saint Laurent's dog—they rarely communicated in English to the artist. "Fred spoke French but Andy didn't," says Colacello. "And Andy was always mildly annoyed that they did that." Then again, when Warhol had his *Mao* exhibition at the Musée Galliera in 1974, Saint Laurent gave a cocktail party for him at his rue de Babylone home. Nicky Haslam had gone to the show. "I remember Andy arriving and saying, 'Gee, these paintings are great. Who did them?'"

Paris was the only city where Andy ever stayed in an apartment rather than a hotel. Clara Saint, one of Saint Laurent's employees and an Andy intimate, had told him about the place. ("I negotiated the deal with the French lawyer," recalls Bergé.) Situated on the rue du Cherche-Midi in the exclusive sixth arrondissement, it had belonged to Violet Trefusis, and thus had the needed romance and artistic provenance. A well-born English writer and heiress, Trefusis was a renowned personage, reputed for her affair with Vita Sackville-West, the green-thumbed poetess. Virginia Woolf covered their relationship in *Orlando*, and Nancy Mitford featured Trefusis as a fictional character (Lady Montdore) in her novel *Love in a Cold Climate*.

The polished wooden steps leading up to the first-floor apartment remain in place. Yannick Pons, the present owner, however, has transformed the nineteenth-century home by breaking down the walls and brought in light by creating extra windows. In Andy's day, it consisted of three somber reception rooms with stucco walls and high ceilings, a large bedroom under the alcove where he slept, and a little poky bedroom, up a narrow flight of stairs, where Fred was installed. It's hard to believe that this tranquil spot is in the heart of Paris.

"There were lots of amusing dinners there," says Gilles Dufour, then a Saint Laurent intimate. "Decorated by Fred, the apartment summed up bohemian chic with its mix of English, French, and Italian furniture that he had acquired from Les Puces or dealers." And everyone remembers the tulip-covered Art Deco rug designed by Ernest Boiceau because it was so Warhol-like. Dufour, like many Parisians, was amazed by Warhol's humbleness. "Andy was easy and straightforward," he says. "He never played up his fame, ever."

Saint often went to the apartment. "I remember seeing the lineup of Andy's wigs," she says. "They were all different. Some were cut short in front and others were cut to the side." It was in the salon that she organized the Italian *Vogue* photograph shoot that led to Andy's being immortalized in a coffinlike space by Helmut Newton. "Helmut said that it was one of the best portraits that he ever did," she says.

In spite of being referred to as Andy's apartment, it was actually Fred's, and indicated their particular financial arrangement that not even Vincent Fremont was privy to. "Fred was not on the Warhol Enterprises payroll," he says. According to Bruno Bischofberger, "Fred thought he wasn't paid enough, because Andy gave him art." Yet the apartment became the base for the artist's European operations when he came to do his society portraits.

Until his death in 1987, there was a system in place. Andy and his team, which included Colacello until he left *Interview* in 1983, and Christopher Makos from the early 1980s, would take the Concorde from New York. "Andy believed in traveling first class all the way, as it was tax deductible," states Colacello. "Andy could be cheap about salaries but not about expenses. He saw that as robbing the IRS." The artist traveled lightly and well. Still, he had his quirks. "On the Concorde, he stole all the silverware," Colacello continues. In fact, greedy

to have more—"the silverware was designed by Raymond Loewy," states Makos—Andy used to shove trays from the cocktail service into the photographer's bag. "He always felt, 'Well, the tickets are twelve thousand dollars round-trip," says Makos. During those trips, Colacello realized that it was a myth that Andy didn't read. "That was just a PR pose, because he read the newspapers and traveled with big, big biographies, often on Hollywood personalities but not only."

Colacello hated the Paris apartment, where he was "relegated to a little place in the basement" that Yannick Pons viewed as "unfit for an animal" before he transformed it. Nevertheless, fun times were had. "Fred would go out antiquing and on his long walks," Colacello re-calls. "And Andy and I would do the diary or work on the philosophy book and then we'd meet Fred, who would set up Polaroids for some-one's portrait." Makos recalls flying to places like Düsseldorf or Cologne—"not your glamour capitals," he says—then being Andy's de facto assistant. "Andy would do the Polaroids and I would peel them off. It was kind of 'If you're spending twenty-five grand for a portrait, you better put on a show of some sort.'"

22 *Getting the Keys to Karl's Kingdom*

In the late '90s, when fashion exploded with big brands and billionaire businessmen, Karl Lagerfeld began to be viewed as the Andy Warhol of his world. For American *Harper's Bazaar*, I would even write an article comparing the two. Called "Karl's Posse," it was illustrated with a photograph of the designer surrounded by his far-extended pals and members of his studio.

Later, I discovered that Karl resented the comparison. "First of all I'm better groomed," he told *The New Yorker* in 2007. "And, also, [Andy] pushed people. I never push people. There was something more perverted in his mind than in mine."

Karl is straightforward, as well as brilliant and entertaining in four languages. At fashion shoots,

I've stood at his side while he's made people laugh in German, French, Italian, and English. Andy played at being faux-naive and passive, and Karl is cantering ahead, keen to show that he understands and cares. He dares to be vital.

Refer to Karl as an artist and he'll get annoyed. "I am a fashion designer who makes clothes," he has said. "I am not an artist." He doesn't like to refer to old collections, because he's always looking forward and ahead. Just as Andy was instantly recognizable, the same could be said of Karl's signature appearance of white ponytail, high collar, and dark suit. He has dabbled successfully in every medium and has become famous for his self-portraits. He has made models into stars. Motored by a commercial sense, he still has fun with fashion. Andy needed a small entourage around him. Karl did and still does. Call it required protection against fans.

When I arrived in Paris, the German-born designer had had an almighty bust-up with Ines de la Fressange, his former muse. Having admired everything about the tall, slim, aristocratic beauty, Karl was suddenly spitting tacks about her in the press. It made me a little nervous, even if the breakup was dismissed as momentary by the fashion savvy. In fact, whenever I mentioned the Chanel studio and the possibility of assisting Karl, the reaction was unanimously positive. "He'll love you," people kept saying, as though it were a fait accompli. Initially I was pretty happy about this, and then I began to nurse doubts. What if Karl didn't "love" me? Actually, what if he couldn't stick the very sight of NF? There was always that chance.

Oddly enough, there were several Warhol connections with the house of Chanel. In 1985, two years before his death, Andy had done a print series of Chanel No. 5, the legendary fragrance. In 1973, Karl had also acted in *L'Amour*, one of Andy's movies, which was inspired by *How to Marry a Millionaire* and cowritten by Warhol and Paul

Morrissey. Certain scenes were filmed in Karl's Left Bank apartment. Nowadays, the designer dismisses the film as "the most childish moviemaking ever." He also rolls his expressive eyes, albeit hidden behind dark sunglasses, when certain folk refer to it as "a masterpiece." Yet he's there playing Karl, a fashion designer, offering sage advice to a gigolo (Max Delys), a beauty industrialist (Michael Sklar), and two hippies searching for sex and rich husbands (Donna Jordan and Jane Forth).

As with Andy, much has been written about Karl. He intrigues on every level and has the requisite three T's to succeed in fashion: talent, timing, and temerity. Everything is then furthered by his extraordinary curiosity and Prussian discipline. In fashion, I cannot think of anyone who works harder than Karl—he draws all his own exquisite sketches—and is as turbocharged, in spite of his international success. Many creative types, at some point in their career, descend into decadence and are brought down by drugs, drink, or an inflated ego. Not so "the Kaiser," as *Women's Wear Daily* called him, and not so Andy in the art world.

Waiting to meet Karl in 1989 took weeks and felt interminable. Though I knew to temper my impatience, every ten days, I would call up Gilles Dufour and ask if there was any news. He was always unfailingly polite, but there never was "any news." It defined frustrating. However, in the interim, I met other principal characters in fashion and that gave a firm grasp of *la mode*'s landscape. Since Karl was being proclaimed "king of the hill" left, right, and center, at least I would have something to compare him against.

I was warned that Loulou de la Falaise, working at Yves Saint Laurent, was unpredictable. "Catch her at night," one friend advised. Forgetting this, I telephoned Loulou in the morning. "I cannot see you until the end of October," she explained in raspy tones. When I

thanked her, she became vexed. "I haven't promised you anything yet," she said.

Christian Lacroix was sweet but otherwise engaged. His fashion house on the Faubourg-Saint-Honoré, spruced up by the Paris-based designer duo Elizabeth Garouste and Mattia Bonetti, resembled *Alice in Wonderland*. There was a continued theme of playing cards, enlarged mushrooms, and eccentric furniture. Adding to the impression was the sight of Lacroix rushing down the stairs, decked out in a thick tweed suit. Not quite the Mad Hatter but elements. Mopping his brow, he was then followed by Jean-Jacques Picart, his CEO and business partner, and a team of rail-thin ladies who looked equally tense. They were leaving on a trunk show for the United States, accompanied by France's leading fashion journalists, and nothing was ready, or so Picart claimed.

I was there to introduce my scarves, inspired by the house of Lacroix. Concentrating, Picart flicked through my twelve designs, went back and looked at several twice, but ultimately declared, "They're much too Chanel for us." He then called Lacroix's studio to see if there was an available position. The place was full.

Ariel de Ravenel, running Kenzo's fragrance division, was so enthusiastic about my jewelry designs—"They're quite beautiful and probably rather right for us," she said—that the head of accessories was called down to meet me. I was also given a tour of the Kenzo studio, full of chic young women sporting buns and crammed into brightly colored Kenzo pants. Nevertheless, employing a non–French speaker was out of the question.

François Lesage, on the other hand, was unpleasant. A self-acclaimed Napoleon, in charge of the great house of embroidery, he flicked through my jewelry collection and ended with "Learn to draw, and swiftly too." I was slightly surprised. "Because you don't

stand a chance with these images," he continued. "They are much too primitive and naive." When I mentioned Gilles Dufour and Chanel, he shot me down with "Well, prepare to be disappointed, because your precious contact Gilles is best described as Karl Lagerfeld's valet." He went on and on about how difficult Paris was. Adding insult to injury, Lesage then terminated the meeting with an unexpected display of flirtatious behavior. "I won't forget you," the slimy toad promised, sketching my eyebrows. Afterward I collapsed on the stairwell outside and sobbed. It was all rather nineteenth-century, even if sex hadn't taken place.

Gaining composure, I found a telephone booth (this was before cell phones) and called Susan Train at American *Vogue*. After all, she had arranged my meeting with Gilles Dufour and the lousy Lesage. "Ignore François," she said calmly, in between taking drags on her cigarette. "He doesn't know the ins and outs of Chanel. Besides, Gilles liked you and was pleasantly surprised, seriously."

Frances Stein—then creating silk ties, wool scarves, and other duty-free accessories for Chanel—was not so sure. "No one in that studio could be described as reliable," she warned. Her attitude was probably colored by the fact that Karl et al. nicknamed her "Frankenstein." Personally, I found Mademoiselle Stein to be a hoot. Chic and skinny (it made sense that she'd been an editor for Diana Vreeland at *Vogue* and was pals with Halston), she sat on the floor, surrounded by swatches of elaborate Italian fabrics, speaking a smattering of Italian and French to a gripped audience of three women, and dipping into an enticing box of chocolates. "Take one," she said, pushing it my way. It was a command as opposed to an offer.

Predictably, it was thanks to Anna Wintour's final and rather sharp nudge that I ended up at Chanel. After October's ready-to-wear collections, she had hosted *Vogue*'s party at the Petit Palais museum.

Just when Gilles Dufour—my new best friend!—and I were busy mugging for the cameras, Anna appeared. She was wearing high-heeled strappy sandals, and her sculpted legs were pushed back to their limit, insinuating attack mode. "So, Gilles," she said. "When is Natasha starting at the studio?" Gilles looked mildly surprised and then came out with "The end of November, Anna." A *mission accomplished* smile briefly appeared on La Wintour's face before she turned and walked off.

It was amazing to witness, even if the gallant Gilles was left looking mildly perturbed. David Shaffer, Anna's then husband, happened to be standing nearby and proudly compared his spouse to Wellington: a general of few words but much action. Indeed!

23 *The Chanel Studio*

By the end of November 1989, I was finally working at the Chanel studio. To quote Jean "Johnny" Pigozzi, the French-born playboy and billionaire, I was "living in the rue Cha Cha [my apartment was on the rue Charlot in the Marais] and working at Cha Cha." The slight snag was being paid a monthly two pence. Naturally I complained to Pigozzi, who replied, "The trouble is that you look rich." It was a "trouble" that I viewed as a plus, and quickly stopped whining about my lack of funds, my argument being, if I looked the part, it was enough.

When I did finally meet Karl, I was thoroughly seduced. Initially, it was the ceremony. The fleet of tote bags filled with books, colored pencils, note-books, and gifts appearing before he did. Then there

was the seemingly simple but fairly grand entrance. Chanel's ground-floor receptionist telephoned to warn that Monsieur Lagerfeld was on his way up. Lipstick was applied, high heels were slipped on, and there were gasps of "Karl" as soon as he pushed open the studio's door. It was enjoyable to witness the first time and actually every time.

Gilles brought me forward and said, "Karl, this is Natasha Fraser, who I've been telling you about." But the great man with the powdered ponytail refused to look up. "Yes, I've met her mother through George Weidenfeld," he said while burrowing through a bag. (It made sense; Weidenfeld, my mother's highly social Austrian-born publisher, had fingers in fashion, art, and politics.) Far from being put off by his strain of shyness, even if hidden under a defensive front, I was reminded of my stepfather, Mick, and Malcolm McLaren. Indeed, anyone who's wary of being scrutinized in spite of being in the public eye.

A few days later, my second encounter with Karl proved dreamlike. At Gilles's insistence, I showed him my jewelry collection and my scarf fabrics. After choosing two pairs of earrings—one was a blue enamel seahorse and the other a mussel holding a baroque pearl—Karl focused on a fabric. The pattern was of a teapot pouring out jewels. He took a large piece of paper and a thick pen, quickly marked how the teapots should be placed, and then handed it over to Gilles. "We'll add some double C's and use it for prêt-à-porter," Karl said. And the following ready-to-wear season, my teapots were splashed across a black satin silk fabric. Manufactured by Cugnasca, the Italian silk house, it was used for Chanel blouses and jacket linings.

This was an excellent beginning that I would instantly mar by catching hepatitis (or "hip hop hep," in the words of the artist

Dominique Lacloche, my childhood friend). Like most dramas in my life, my bout of hepatitis was a result of my greed. When wolfing down seafood, I was warned to be careful of the sea snails, to avoid anything that was hard to retrieve. But I ignored such sage advice, only to turn yellow "like a banana," to quote my new French doctor, and discover the importance of the liver, an organ of which I had hence been unaware when living in England and America.

For a month, I lived in my mother's house. Suddenly I was back in the world of the Moustaches—as the writer Peter Morgan used to describe my dusky-haired girlfriends such as the novelist Kate Morris and Dominique. Finally, I could meet my three godchildren, Tancredi Massimo, Ella Harris, and my niece Stella Powell-Jones. I encountered Mary Byrne's domestic setup—the first of my generation to tie the knot—and also spent time with my grandmother Elizabeth Longford. After a simple lunch in her Chelsea flat, we would spend hours talking. She compared us to characters from a Tolstoy novel, whereas I was always surprised by her openness and modernity of thought. Such cozy factors had been lacking when I was living in the United States for four years. But though content to be back in Europe, I nursed no desire to live in London.

When I returned to Chanel, my very first ready-to-wear show had a series of Warhol-influenced prints. It was an auspicious sign. The prints were camouflage-like with a mix of day-glo Pop colors; Karl's idea was to make silk shirts that his star models would wear over leggings and mules: a look channeling Carlyne Cerf de Dudzeele, the in-demand *Vogue* stylist.

Carlyne—whom Gilles nicknamed "Carlyne Horse"—possessed a dynamic way with accessories and clothes. Whatever she wore looked apt. In many ways, she was my first experience of Parisian chic, because she weaved in personality with taste. Camille Miceli also

caught my eye. Then working in Chanel's press department, she had a way of mixing clothes that defined charming. True, her body was ridiculous—in the summer months, Camille would appear in swimsuits!—but there was an innate knowledge of colors and details. When Gilles nicknamed me "Nathalie Fraîcheur," Camille shortened it to "La Fraîcheur." Many complain that Parisians lack humor. Not when they're authentic to themselves.

At the Chanel studio, I was working in the fashion equivalent of Mount Olympus. The beauty of supermodels such as Linda Evangelista, Christy Turlington, Claudia Schiffer, Naomi Campbell, Helena Christensen, Karen Mulder, and Yasmin Le Bon was incredible. Yet I couldn't stop eating. Gilles had warned that I needed to watch my diet post-hepatitis. It was considered wisdom that I failed to follow, which led to my packing on the pounds. Unlike the heroine from a Paris-based novel, I didn't suddenly transform into a sylphlike creature in a little black dress and pearls.

Oddly enough, it didn't matter to Karl. A complexion snob, he was taken by my porcelain skin, describing it as "flawless," and he even took my portrait on several occasions. The first time was embarrassing. I couldn't even squeeze a plump forearm into the teeny Chanel clothes and had to be artfully wrapped in fabric. Yet miracles via Victoire de Castellane's costume jewelry and Chanel's opera-length gloves were achieved and I ended up resembling a Spanish infanta.

In general, Gilles was always after me to make an effort and "be less of a big bully. Please, Natasha, heels or lipstick," he would say before Karl arrived. I didn't, for the simple reason that it annoyed and I was more occupied calling my English girlfriends. As Karl later said: "Natasha, you spent your life on the telephone." Hard to believe, but even when he was present—and that meant fittings of models,

discussions of fabric, or choosing of accessories—I would continue to
yack away with my pals.

There were also the calls from Alain Wertheimer, Chanel's big
boss and co-owner, telephoning from his private plane. I could never
understand him. And he could not understand why I answered the
phone when I neither spoke French nor knew who he was. When Karl
was around, I occasionally looked up and caught his glance. There
would be more than a hint of amusement and warmth, otherwise I
would have hung up—somewhat wisely. Instead, I would smile
back—my face had dimples then—and swiftly return to the mindless
gossip concerning London's W11. When Karl met my mother at a
lunch organized by Liz Tilberis, then British *Vogue*'s editor, he said
that I reminded him of a Belle Époque actress because I was always in
a good mood. Karl, on the other hand, was the master of the thought-
ful gesture. Once when leaving for New York in 1990, he asked if he
could buy me anything. "Ava Gardner's memoir," I said, and quickly
forgot. A week later, the book appeared.

Without Karl around, the Chanel studio resembled a finishing
school with ooh-la-la elements bringing to mind Colette's *Gigi*. Gilles
reveled in teasing the models. "This season, we want all the blond
models to dye their hair black," he told Karen Mulder, renowned for
her fairy-tale-princess coloring. He then nervously and quickly called
the Dutch supermodel back. Meanwhile, he encouraged all the stu-
dio assistants to make more of our assets. "Wear tops to show off your
bosom, Natasha," he advised. "A bosom is the female equivalent of a
grand zizi [big penis]." There were also the hair-coloring sessions.
With my profile, I could resemble Kim Novak, or so he felt. No one
else quite saw the comparison. So I was marched off to Édouard at
Carita beauty salon. A large man with a delicate touch, Édouard was
Catherine Deneuve's secret weapon. Every month or so, he added

luster to her glorious mane of cornsilk hair. He refused to do any more than a light frosting to my hair—"She has a brunette's complexion," he stated—but agreed to bleach my eyebrows. It was a bit of a non-event, but then Gilles trumped it with my flame-haired phase. "You'll bring to mind Jane Russell, that other bombshell," he enthused. I didn't, and Karl was appalled. "Natasha, that color is dreadful," he said. "You look like the madame of a nineteenth-century brothel."

But Gilles remained determined to transform me. He shared his plans with Monsieur Alexandre—then Paris's most famous coiffeur and responsible for Chanel's runway dos—who naturally boasted Miss Russell as a client. "Why don't we cut off your hair first?" Monsieur Alexandre suggested. And after plonking myself in the middle of the studio, he did precisely that. "Off, off with the bush," he cried in English, with scissors in hand. This led to my shaking with laughter, which was quickly joined by Gilles and the small band of coworkers who understood my mother tongue.

I was lucky. Almost everyone in the studio was welcoming and kind. There was Armelle Saint-Mleux, who helped me with my lack of French. Franciane Moreau, who shared my sense of silliness. Virginie Viard, who impressed me with her extraordinary precision and excellent British accent. Victoire de Castellane, a marquis's daughter and Gilles's niece, who was always playful. I admired her passion for jewelry and her elegant manner with everyone from artisans to models. Karl often sent Victoire down the Chanel runway. Maybe she lacked a model's height, but her Penelope Tree–like face and coquettish personality revved up the photographers.

And then there was my first fashion *meangirl*. Workwise, it was impossible to fault the former model. When a thousand of Chanel's signature silk camellias needed color coding, she was the person.

Nevertheless, she was always making snide remarks about my weight and dress sense. I refused to react. But it was relief to discover that almost everyone felt the same way as I did.

Once when the meangirl wasn't around, a fair amount of tittle-tattling about her went on in front of Karl. There were a few salacious rumors. After listening, he barely reacted. "Everyone is free," he said calmly. Of course, there was a collective look of disappointment, but I actually respected his attitude. The following season, to perhaps mark his point, Karl both photographed the meangirl for one of his exhibitions and used her for the catwalk.

During that period, the studio's workload revolved around the four collections: haute couture and prêt-à-porter for fall–winter and spring–summer that happened in January, March, July, and October. In preparation, Karl's sketches were distributed to the respective ate-liers, which were either *flou* (drapery and dresses) or *tailleur* (suits). Three characters come to mind—Madame Edith, who ran the prêt-à-porter *flou* atelier; Monsieur Paquito, who was responsible for the haute couture *tailleur*; and Madame Colette, who ran haute cou-ture *flou*.

Madame Edith was a dragon but humorous and a bit of a *titi parisienne* (street smart). Having worked for Gabrielle Chanel, she was an authority on the Chanel style, a style that Karl was busy breaking up and making contemporary. Occasionally, she took issue with some of his ideas. He showed respect by patiently listening to her technical problems, tolerating her occasionally barbed comments but gently persuading her to his way of thinking. Karl never raised his voice, whereas Edith went from squawking to quiet, then walking off, as if on air; Karl's undivided attention did that. I wondered if Madame Edith was a lonely old soul on the romantic front, but I was informed, *"Au contraire,"* there were girlfriends. Madame Edith

certainly had crushes on models like Marpessa and Dalma: the more boyish and narrow-hipped, the more enthusiastic she became.

Monsieur Paquito was a Latin charmer. He enjoyed teasing and had the easy confidence of someone immensely skilled at his game. His jackets defined perfection and clearly gave tremendous satisfaction to the mischievous Spaniard. He only got testy when Karl was late on Friday night, because that was Monsieur Paquito's appointed evening to pull young men (I presume at nightclubs). Whenever I went to England, he was on my case to buy poppers, I suppose for his Friday sessions. In poor French, I tried to say, "That's not quite my bag, Monsieur Paquito." And he was amazed. "But all the other Brits I know take every drug under the sun," he replied.

Madame Colette was different. Dark-haired and good-looking, she was more nervous than the other two. Since I was smiley and polite—I lapped up her picture of a sea-swept bare-chested Alain Delon pinned prominently in her corner—she always offered me biscuits or other homemade treats when I went up to collect outfits from her atelier. The *"on dit"* was that she and Monsieur Lesage—my bête noire— were close. After clicking his heels around Karl, he did scamper up the narrow staircase to her atelier. At the time I was horrified but now understand. Monsieur Lesage, or François, who I later came to befriend, was a flirt and probably made the melancholic head seamstress laugh.

Poor Colette had a ring of doom around her head. Unfortunately, her career at Chanel would end dramatically during the couture show in July 1990. Her mistake was sending Christy Turlington and Linda Evangelista out in two spectacularly embroidered redingotes with matching thigh-high boots. All well and good, except the flap covering the pelvic area was left unfastened on each coat. So both supermodels appeared flashing their panties. Karl was fit to be tied. His

clients, such as Caroline of Monaco, on the other hand, saw the funny side. "Does this mean that we'll be showing our panties next season?" she asked the actress Carole Bouquet.

Both women had known Andy Warhol. He had even taken Polaroids as well as done commissioned portraits of Princess Caroline for French *Vogue.* Just as there was a swirl of famous or social women around the American artist, there was the equivalent with Karl. However, whereas such types saw Andy at the Factory, usually at one of the celebrated lunches, Lagerfeld separated church and state. His Chanel studio was reserved for high-powered fashion professionals. Celebrities like Sylvester Stallone and the singer Michael Hutchence were allowed entry only when their ladyfolk were in the show.

Such visits usually happened a day before the collection, when accessories were chosen and added to outfits. Karl managed to do it all—inspect the models and the look of the clothes, as well as charm the person, such as Hutchence, sitting next to him. In his studio, Karl had an infectious joie de vivre.

Whatever was put in the rue Cambon flagship—whether it was a miniskirt hemmed with a signature bag chain, Chanel double-C moon boots, or a classic navy blue jacket—flew off the shelves. Karl had installed an appealing and contemporary attitude to a fashion house that had been dead on arrival when he began in 1983. I presumed, incorrectly, that all the frantic buying was typical for Paris, but it wasn't.

Via Karl and the mythic Chanel atelier, I learned about the nuts and bolts of a couture house. I witnessed how a *défilé*, or show, was over in eleven minutes. How it required elaborate detail that had to look light and effortless to the audience's eye. That there were extravagant adventures like ordering a mass of celadon taffeta camellias

to match Linda Evangelista's eyes for an haute couture dress that never hit the runway. And discovering that some models, like Kristen McMenamy—a Karl favorite—were charmingly insane. The shoot was for a *Women's Wear Daily* preview. Kate Betts, my Paris accomplice, was the fashion editor. The location was the place de la Concorde. The skirt suit was haute couture and created entirely with pink grosgrain ribbon. Before leaving, the seamstress in question warned me to take care of the outfit. I promised, then got waylaid gossiping with Kate. Little did we realize that once the shoot was finished, the wild-eyed Kristen would rip the top and skirt off and then head toward oncoming traffic wearing only her panties.

Another afternoon, I had to play Naomi Campbell's bodyguard in the Hotel Ritz. She was convinced that Sylvester Stallone was going to jump on her outside her bedroom or in one of the interminable corridors. Sitting there waiting for the "Black Bardot" (Naomi's nickname in the French press) to finish her Versace fittings was not the best way to be introduced to Ines de la Fressange.

Wearing a white shirt, cropped black pants, and *ballerines*, Ines happened to be strolling by with Luigi d'Urso, whom I'd known during my "it girl" days in London. "Natasha? Natasha Fraser, what are you doing here?" he asked. Rolling my eyes, I explained my plight. "So next time, buy a six-pack of beer like all the other bodyguards," Luigi teased. Fortunately, it was my first and last bodyguard experience.

Linda Evangelista, then a star in the magazines and on the catwalk and famous for saying, "We don't wake up for less than $10,000 a day," was the unofficial head girl of the supermodels. Lucid, she would say, "From now on it's carrot sticks," if the fit of the Chanel jackets became snug. Ever bold, she tried out every different hair

color and was one of the first to crop her hair short. After doing a fitting for Karl that happened in front of Anna Wintour, Liz Tilberis, Grace Coddington, Carlyne Cerf de Dudzeele, Michael Roberts, and other fashion notables, Linda asked if she should "grow or cut" her hair. "Cut it," everyone cried unanimously, spearheaded by Anna. It was one of those comradely moments that often happened around Karl.

24 *Chanel and Paris's Social Swirl*

Within six months, I was in proud possession of a contract with Chanel. At the studio, I was put in charge of the camellias, working with Madame Jeanne at the Lemarié atelier. In my spare time, I had also created two new fabric prints for Karl. The first was inspired by my father's losing a chunk of his inheritance on chemin de fer at Le Touquet casino.

Created via decoupage, the print consisted of playing cards that naturally had a double-C insignia, jeweled charms of a gambling nature that I had found in a Christie's catalogue, and large diamond drops that I described as representing tears spilled at the tables. Karl described it as "fun and very Chanel." The colors were strictly blue, white, and red—and

the adorable Françoise Marlin, who was in charge of fabrics, sent it to Cugnasca.

Françoise had trained under Primrose Bordier, a flamboyant Frenchwoman who'd created a revolution with fabric by imposing different colors and prints. Primrose was brilliant but a bit of an empress. Françoise, on the other hand, was a soft-voiced blond angel dressed in black Chanel crêpe wool outfits and two-tone *ballerines*. With grace, she was always trying to encourage me to be more soigné. "*Ma chérie*, perhaps less of the biscuits and sweets . . ." "*Ma chérie*, gray roots will never do, particularly with men."

Such advice was needed because Paris was then extremely formal. There were smart parties, even balls galore, where it was de rigueur to dress up to the nines. Jeans were strictly kept for the weekend, as I would discover one Wednesday afternoon when I wore a faded pair on the rue Saint-Honoré. The daring act led to lingering and disdainful stares.

Meanwhile, Marie-Hélène de Rothschild and her best friend, Alexis de Redé, kept *le mondain* (high society) in check, even if they rarely left the Hôtel Lambert, a magnificent house that they shared on the Ile Saint-Louis, noted for its frescoes by Charles Le Brun in the Gallery of Hercules. The power that Rothschild and de Redé wielded brought to mind the nineteenth century, and elements of Balzac's novels.

"Marie-Hélène was rather imperious and frightening," says Bob Colacello. "But Andy thought she had great style and was impressed by the obvious display of wealth." To such a point that when they attended the engagement party of David de Rothschild, Marie-Hélène's stepson, held at Ferrières, the fabled country château, the artist turned to Colacello and said, "Why are those portraits in the front of the house not by me?" Then Fred Hughes was rebuked for it.

"We were all dazzled," admits Bob. "It was hard not to be. Americans do not entertain on that scale."

Meanwhile, social Parisians were "dazzled" by Andy. "He was society's favorite artist," says Florence Grinda. "No one else from the art world was invited to balls like Andy was." Being invited to attend the legendary Surrealist Ball—given by Marie-Hélène de Rothschild—was a huge compliment coming from a famous French hostess reputed for being exclusive and discriminating.

Because of this, Andy et al. really saw only members of Parisian society as opposed to artists. "He loved that line of Fred's that 'In Paris, they give dinners against people, not for people.' The idea being that they can leave people out," says Colacello. "Andy was kind of fascinated and infatuated by the idea of high society. He approached it like he approached everything, very tongue-in-cheek, pretending to be an innocent abroad."

In Paris, Andy became acutely aware of the one-upmanship among the Parisian ladies. "They all competed to have the most glamorous dinner parties and food, the grandest decor and the most beautiful couture dresses," recalls Colacello. "Seemingly more than in New York. Because in New York, you didn't have to declare your loyalty to one particular hostess and one particular clique like you did in Paris."

Karl was entertaining too. However, having fallen out with Saint Laurent over his boyfriend Jacques de Bascher, he was viewed as the enemy by the Saint Laurent group. Giving a taste of the era, he invited the English Queen Mother to his eighteenth-century château in Brittany. Alas, I wasn't asked to that intimate do. I would have relished seeing the Queen Mother stepping out of her Rolls-Royce and saying, "It's like a painting," waving her gloved hand at Karl's roses and then being plied with numerous gin and tonics, her favorite drink. However, I was included in Karl's fashion dinners, like the one given

in Anna Wintour's honor at Lamée, his country house just outside Paris. The house was packed with famous stylists—I remember Sarahjane Hoare, who was then doing exquisite fashion shoots for British *Vogue*, talking to Jenny Capitain, a German-born stylist, about her days modeling for Helmut Newton.

Driving back to Paris, Gilles and Victoire decided to stop off at the Bois de Boulogne to see the hookers. They wanted to check out the thigh-high boots and latest trends. This was a laugh, until several policemen came up and accused Gilles of soliciting or even pimping. They must have thought that Victoire, dressed in a Mugler miniskirt suit, and me, in more modest Agnès B., were ladies of the night.

Dinners in Karl's apartment in Paris were fairly grand. He was the great eighteenth-century expert, as he had read endless volumes about the period and also purchased key items. And from arrival to departure, the candlelit experience was both ethereal and romantic.

Around the same time, the Saint-Bris family gave a Renaissance-theme ball to celebrate Leonardo da Vinci. When working for the French king Francis I, the Italian artist had lived in Château du Clos Lucé, the family's country home in the Loire Valley. The party's high point was the arrival of Prince Pierre d'Arenberg, who appeared by helicopter and was naturally playing Leonardo.

Vogue's André Leon Talley, who had started his journalism career at *Interview*, gathered quite a different crowd. When throwing a dinner in honor of Madonna's Blond Ambition World Tour, he invited chic members of *la mode* and other characters from a creative milieu. It was there that I finally met Loulou de la Falaise. She was friendly, but I certainly didn't mention our initial call.

Johnny Pigozzi, however, was appalled by my choice of Rifat Özbek skirt for the Rolling Stones' Urban Jungle Tour concert. "What are you wearing?" he growled. "You look as if you're dressed for a bar

mitzvah." We were about to climb into a minibus with Larry Gagosian and other high rollers. "Fuck off, Johnny," I said, or something equally elegant. But I did feel miserable as we headed toward Bercy. Apart from Johnny, who was in his signature Hawaiian shirt, everyone else was in a white T-shirt and faded jeans. *What was I thinking?* I said to myself as I limped along in my high heels.

Johnny—known for his moods and for his paparazzi shots of Andy—then decided it was quite funny. My early years in Paris often meant staying at his house in Cap d'Antibes, on the Riviera. As long as his telephone wasn't used, he was a wonderfully generous host who believed in mixing everyone together. Through Johnny, I met Ettore Sottsass, the Italian designer and creator of the Memphis movement; Heinz Berggruen, the German art collector; and Helmut Newton. The latter two men were irresistible. Berggruen took me gambling in Monaco and talked about his affair with Frida Kahlo. "She shaved in between her eyebrows when we were together," he said. Helmut offered to take my portrait. "Breasts with just a bit of pussy," he said. "Just a bit." It never happened.

Within a year, I felt that I had got my social bearings in Paris. And met most of Andy's friends who were mentioned in his diaries, such as Cristiana Brandolini, Maxime de la Falaise, Florence Grinda, Hélène Rochas, Clara Saint, and São Schlumberger. Making an impact was the presence of the Warhol portrait in the homes of worldly hostesses, as opposed to a grisly lineup of nineteenth-century family ones. And whether it was Grinda, who wrote French *Vogue*'s social column during the '70s, or Rochas, who was christened "La Belle Hélène" and held court from her sumptuous abode in the rue Barbet de Jouy, or Schlumberger, who was a patron of the arts and a keen couture client, a Warhol portrait would have pride of place in the salon, often above the mantelpiece.

True, I didn't know Mr. and Mrs. Mondain—Alexis de Redé and Marie-Hélène de Rothschild. Nor did I want to. They sounded scary and complicated. The only problem was my job at the Chanel studio. It sounded so good, but since I wasn't obsessed with fashion, I felt like a dilettante. Being three years away from thirty, I was itching to write again but was too proud to admit it. Karl had even started to tell Paris acquaintances that he was "surprised" that I was still in the studio, apparently concerned that it wasn't "intellectually stimulating enough."

Then a writing assignment came up via *Vogue Décoration*, a publication devoted to interiors. It was while compiling the piece on the West Coast that I decided to leave Paris. A fairly radical idea, but being around creative friends in Hollywood who were acting, directing, or writing put me in a radical mood too. Paris was so uptight, formal, and trying, I suddenly decided.

It was simple: I would work for the jeweler Lee Brevard, who had acquired quite a following, and then interview people for television on the side with the goal of getting my own cable show. It defined ambitious, but that's what was both fun and rather mad about Hollywood, a place of broken dreams and crazy make-believe.

As for Lee Brevard, he was decades ahead with his craft, using a medieval style and chunks of amethysts and other semiprecious stones before anyone else. He thought that my upper-class accent, use of occasional Parisian slang, and strong personality could make him internationally famous. At times when he called up, it sounded a bit far-fetched. Little did I know that dear Lee—who looked well fed and respectable—dabbled in hard drugs. He hid his game well, until he was found dead at a friend's house.

With newly dyed black hair—my red hair had gone orange in the California sun—I returned to Paris and announced my departure. I

didn't mention Lee or my plans to be the next Barbara Walters, both pie-in-the-sky ideas versus the combined force of Karl and Chanel. Instead, I pretended that I was madly in love. The Parisians would understand. They created the idea of *l'amour, l'amour* after all. Gilles, however, was horrified. "What is this nonsense?" he said. "You cannot give up an excellent position for a holiday romance." Then he revealed, somewhat darkly, that he would "have to tell Karl. He won't like the idea, at all," he warned. I didn't care, or thought I didn't, until it transpired that Karl had said, "Make Natasha leave immediately." Fortunately, Gilles had calmed the waters by saying that I was *un peu midinette* (soppy about love) in my relationships but that I treasured working for him: I did.

And suddenly I saw another side of Karl. "Do you really love him, Natasha?" he'd ask while a model was checking out the sleeves of a new jacket or Victoire de Castellane was showing him a set of bejeweled cuffs. And I would insist that I did. "It's good to be romantic," he offered. "All women should be. But you should also be reasonable and think about the future." Then he asked what my mother thought. To be honest I hadn't dared broach the subject after an ex-boyfriend annihilated the idea.

"Let me get this straight," he boomed. "You're planning to ditch the highly regarded Karl Lagerfeld and the illustrious Chanel studio to work for Lee Brevard, a total nobody outside the Beverly Hills."

Lee Brevard continued to make contact throughout September and October. "Natasha, we need you desperately," he would say. By November, I came to my senses. And for the Chanel studio's benefit, I lied and implied that there had been a long weekend with the boyfriend that hadn't gone well. It blew over and no further mention was made.

However, in February 1991, my life would turn around when Kate

Betts decided to leave Fairchild and return to the United States. The episode is chronicled in her bestselling book *My Paris Dream*. Being a patrician blond beauty who was both industrious and well reputed in the fashion world, she seemed perfect for *Vogue*. I mentioned her to Anna Wintour, who jumped at the idea. Albeit thrilled—nothing beats helping a close friend—I was reminded of my dissatisfaction at work. Much as I enjoyed the company of my colleagues, I had truly done my Chanel studio experience. And that was when Kate suggested that I meet Patrick McCarthy, who ran *W* magazine and *Women's Wear Daily*. "They need someone like you," she said.

A secret meeting was arranged at the Ritz Bar. Well, as secret as a meeting could be when a tall person wearing high heels arrives with a monumentally large clippings book. Patrick defined smooth operator: suave, handsome, and au courant—until he laughed; his was both loud and donkeylike somehow. He offered a job in the Paris office, but the actual title had to be confirmed. "Obviously, we want you to leave on friendly terms with Chanel," he said. Patrick counted Karl as one of his designer intimates.

To make peace, Mr. Fairchild—the big cheese at the organization—had made a point of calling Karl. This was unusual and showed his respect for the designer. As was his way, Karl had said, "Natasha spends her life on the telephone." But Mr. Fairchild was delighted. "Great, Karl," he replied, "because that's what journalists do: spend their life on the telephone."

25 *The Reign of Frogchild*

Covering the waterfront at *Interview* was ideal preparation for *Women's Wear Daily* and *W* magazine. As Bob Colacello and Fred Hughes used to cry, "Yes we're superficial, deeply superficial," and so was I. A media boot camp, Fairchild Publications was often hilarious, occasionally nerve-racking, on a par with the dark moments of Tudor England. Heads could roll. Yet it was never dull. "Did you bring back the bacon?" a senior editor would cry, after an assignment. And I quickly learned the rule that when the door was slammed, it meant climbing in through the window or the equivalent. There was always another way. That when couturiers like Thierry Mugler turned icy cold and said, "I refuse to talk to *Women's Wear*," it was important to repeat the question just in

case they changed their mind. Fat chance with Thierry—"I already told you, I refuse to talk to *Women's Wear*," he hissed—but still! And that everything was possible because "I can't do" was not an option at Fairchild: a key rule for journalism.

After Karl, John Fairchild became my second fashion mentor because he was the real deal. Like most greats, Mr. Fairchild—always addressed as Mr. Fairchild—was interested in the authentic and had a horror of the pretentious and pompous. No question, Fairchild had a sort of genius for his world. He worshipped at the altar of Yves Saint Laurent—I understood, even if Yves's great fashion moment had been in the 1970s. Fairchild coined the terms "Jackie O," "hot pants," "Beautiful People," and "walker" for those gracing the pages of *WWD* and *W*. He understood that the British "shabby chic" lifestyle would become the rage and influence the minimal 1990s.

I first spied Mr. Fairchild at the Warhol Studio. He was one of the contenders to buy *Interview* in 1987. I can still recall the shock of white hair, his roomy wool overcoat, the sway of his suit trousers, and his polished shoes. Accompanied by Patrick McCarthy, he went up to see Fred, whose elegant figure happened to haunt the society pages of *WWD* and *W*.

When encountering him at the Chanel studio, Mr. Fairchild reminded me of an overgrown leprechaun. He had cocked bushy eyebrows and blue eyes that were both alert and amused. In a harmless, old-fashioned way, he flirted as he would with any woman possessing a British accent. "Patrick is wearing his new jacket from Huntsman, what do you think?" he asked. I replied that it was handsome but the buttons were "twinky." It was my way of saying "queeny," and Mr. Fairchild loved it. According to Kate Betts, then Fairchild's bureau chief, *twinky* became a favorite word for the next few days.

During that period, he dissuaded his employees from getting too

close to fashion folk. Being a detached observer was preferable for interviewing and writing reviews. He also nursed doubts about the designers' grasp of reality. "They're all liars, liars," he occasionally barked. Nevertheless, Saint Laurent was an untouchable. And sometimes it became nutsy. "He's as strong as an ox," Mr. Fairchild would declare after the frail couturier had literally slobbered down the runway.

Mr. Fairchild—or Mr. Frogchild, as Kate nicknamed him—was a curious mixture. In one way, he was very gallant, looking after the swans who'd been forgotten. Or offering unsolicited advice: "You should get married," he told Diane von Furstenberg, eyeing her pantherlike legs stretched out at a fashion show. Or immediately contacting Marc Jacobs when financing fell through on the designer's company. Clearly concerned, Mr. Fairchild's squawk morphed into a soft and dulcet tone. Being hypersensitive, he knew how to handle the creative. Or playing the disapproving parent or uncle figure. When lunching at the Ritz Bar, he caught sight of Tom Ford's hairy chest and announced, "Your shirt is buttoned too low."

Then there was the other side, which led to his being called the "Ayatollah of Fashion" by Taki Theodoracopulos, or worst type of grown-up and spoiled child. If designers turned down Mr. Fairchild's request (usually it involved getting advance info about their collections) he took it very personally, hence his feuds with designers Geoffrey Beene and Pauline Trigère. More often than not, Mr. Fairchild would take his revenge by barring them from *Women's Wear*, then viewed as the all-important fashion bible.

When I arrived at *Women's Wear Daily*, he still had that power and was annoyed when it was not respected. André Oliver, then the right-hand man of Pierre Cardin, had been discourteous with me, and Fairchild was furious. Later, there was the Oscar de la Renta debacle

christened "Oscar of the Right Table–gate." It was at a party given to celebrate his arrival at the house of Balmain. There were seventy tables. Oscar's ladies—read: bejeweled beauties and powerhouses—filled up the first ten and I was put at table 69 with the Polish seamstresses and unknown foreign journalists.

"Why that little . . ." Mr. Fairchild said when he heard about my placement. A call was made to Oscar. "But John, I believe that any table that I'm sitting at is the right table," he had purred. The designer oozed suave. But it was too much for Frogchild, who wasn't afraid of a fight. "Oscar," he boomed. "That's the biggest load of bull . . ." And for a brief moment, the designer was christened "Oscar of the Right Table" chez Fairchild.

I watched my premier Valentino couture show in the front row, sitting next to Mr. Fairchild. It was July 1991. "Look at that suit," he announced, clearly excited. "It has snap, crackle, and pop." "Snap, crackle, and pop" meant that it was flawless. A suit that could be traveled in for ten hours and, because of the cut and choice of fabric, wouldn't have a single crease. It was an invaluable lesson and an excellent way to be initiated to the high standards of the Italian-born couturier. A day later, I was put in the front row again at Chanel. "Good for you," said Lucy Ferry, the wife of rock star Bryan Ferry. In fact, it was a question of politics. Having lost Kate Betts to *Vogue*, Fairchild was keeping up appearances.

The Chanel show, held at the Beaux-Arts, was sweltering, or "hot as Hades," to use the favorite expression of Dennis Thim, Fairchild's bureau chief. Yet it didn't stop Chanel's couture ladies turning up in their power tweed suits. Tiny and doll-like, they were practically melting. All apart from Paloma Picasso, the jewelry designer and daughter of the famous artist, who turned up in a stripy cotton Hermès shirtdress and gold sandals. "She looks chic," I said. Fairchild

remained tight-lipped. And I soon learned that he only ever voiced his opinion in the privacy of the car afterward.

When my mother's New York friends heard that I was working for John Fairchild, certain of them were horrified. In their minds, he was the beast who created the infamous "in" and "out" list as well as masterminded cruel exposés. My mother, on the other hand, refused to hear a word against him, "I'm on the side of anyone who employs my children" being her party line.

Within days of arriving at Fairchild, I realized that while my colleagues in Paris were good-natured and funny, the New York office was different and even tricky on occasion. Mildly chippy, some seemed convinced that I did nothing in Paris but swan around swilling champagne and downing smoked-salmon hors d'oeuvres. That too—I was "deeply superficial"—but I was also never off the telephone, keen to fill the society or home interior pages. Sometimes my connections could surprise. The entertainment editor was put out that I'd befriended Molly Ringwald, the teen actress. After reading my piece, she called back and said, "We only want to know one thing, Natasha, did she or didn't she fuck Warren Beatty?" This rather stopped me in my tracks. The same editor also called up asking if Marseilles was a museum. But on a power level, New York had the upper hand and needed to be endured. Occasionally, Patrick McCarthy, Fairchild's unofficial dauphin, had to step in and intervene. However, as he once warned: "Natasha, if I brought you over for the New York collections, my office would eat you up for breakfast." Naturally, I played nonchalant when he said this but secretly shook in my boots and vowed never to go near the place.

True, I was opinionated and irritating, but I had a much-valued secret weapon—social access, armed by the fact that I delivered religiously. And until the mid-'90s, when Patrick decided to do a 180-degree turn with *W* magazine and focus on Hollywood film

stars as opposed to the exclusive chic of European society, that made me untouchable.

Fortunately, my premiere months at *W* demonstrated this. My first task was persuading Mollie, the then Marchioness of Salisbury, to give an interview, going with a set of photographs of her garden taken by Christopher Simon Sykes. Having turned down Jim Fallon, who ran the London office, she immediately agreed to my request. It helped that I knew her and her brood. Fairchild et al. were delighted, but Jim attempted his revenge. That often happened with members of the Fairchild dysfunctional family.

My next article concerned Loulou de la Falaise. She had just bought a nineteenth-century country house in Ile-de-France, and although it was far from finished, she agreed to have it photographed. A legendary fashion stylist, she was equally talented with interiors.

During the shoot, Loulou sped around. If she wasn't moving furniture or arranging the wildflowers, she was picking herbs from the vegetable garden and supervising lunch. The article showed that the thoroughly chic Loulou was a country gal at heart, and Fairchild was delighted with the story. Loulou and her family—including her mother, Maxime de la Falaise; uncle Mark Birley; brother, Alexis de la Falaise; and niece Lucie de la Falaise—could do no wrong in his eyes. "They're the real McCoy," he said.

Nevertheless, my Volpi Ball coup eclipsed everything else. All summer long, *le tout* Paris, New York, and Milan had been talking about Giovanni Volpi's ball for his goddaughter, Elizabeth de Balkany. Held at the beginning of September, at the height of the Venice season, it promised to be the jet-set event with billionaires, beauties, and ball gowns. It was very Andy in tone: he knew most of the contenders, had done portraits of quite a few, and used to go to Venice most summers.

Cristiana Brandolini, one of the Serenissima's social powerhouses, had actually turned down a Warhol portrait. "It was much too expensive, nor was it quite my mind-set," she says. However, she had admired the picture that Warhol had done of her brother, Gianni Agnelli, the influential automobile industrialist. "Andy would stay at the Cipriani hotel," she recalls. "And I would notice him sitting in the Piazza San Marco. Now you see people looking strange. But then to see this pale man in this white wig who was photographing and photographing. It was funny. But Andy was way, way ahead of us. He knew and understood before we did."

Regarding the Volpi Ball, Glynis Costin and Art Streiber were up against it. Since they ran Fairchild's Milan bureau, they were friendly with *tutto il mondo*, but Count Volpi was press-shy and refused to have journalists. And that's when I trotted in on my Shetland pony. Giovanni was the half uncle of Dominique Lacloche. She gave me his cell number. I called him up and invited myself. He agreed, to my utter surprise and the shock of everyone else. It turned out he thought I was another Fraser, living in London.

Being a gent, he didn't go back on his word. Indeed, wearing my elder sister's red taffeta Bellville Sassoon gown, I went to the ball of the '90s that was held in the Volpi family's palazzo. It was my first time in Venice. I ate at Harry's Bar. I saw Jacqueline de Ribes and other members of the International Best Dressed list close up, as well as the next generation of beauties. However, exciting as it sounded, the actual ball was a big fat anticlimax. The smart Italians only hung out with one another and rather stuck their noses up at the rest of us. I had never felt so excluded.

"These people are dreadful," I remember saying to Dominique, who'd been brought up with most of them. "It's because we don't look the part"—professionals had not done our hair and makeup—"and

they're not interested in us," she said. Still, I had never come across that before, being judged exclusively on my appearance.

Naturally, I didn't report this to Glynis and Art, who were probably keen to hear the worst. Schadenfreude would have been human and oh-so-Fairchild-family–like. Instead, I made out that it was fantastic and that I had made tons of new friends. Behind my back, they then nicknamed me "the duchess." If only! One genuine highlight had been watching Richard Avedon. He was taking photographs of Tatiana von Furstenberg and other nubile creatures for *Egoïste*, an elitist French magazine. Otherwise, the experience was a disappointment. My mistake was going with expectation. I thought it would be a Visconti version of the balls of my youth, but I was forgetting that I knew everyone at the English balls and that made a crucial difference.

An encounter with Fred Hughes had also been dire, bringing to mind the tragic undertones of Thomas Mann's short story "Death in Venice" but without the romantic interest. Staying at the Gritti Palace, Fred had masterfully transformed the salon by switching the paintings with his own, covering the sofas with fabric, and using scarves to calm the lighting. Unfortunately, he was ensconced in a wheelchair and had become even more tempestuous.

While he was ordering tea, I had sneaked a raspberry tart from the plate of petit fours. Two minutes later, Fred noticed that it was missing and started freaking. He called the hotel management and accused the staff of stealing. Marisa Berenson, visiting at the same time, tried to soothe and steady him. Turning quite pink, I admitted that I had stolen the tart (no doubt made "all on a summer's day"). "Well, why didn't you say so, Natasha?" Fred said with renewed calm.

Warhol Land Continues to Haunt

My early years at Fairchild continued to be an extended version of Adventures in Warhol Land because I was often dealing with people who Andy knew, collected his work, or had even been painted.

In January 1993, on a trip to Saint Petersburg, Thomas Ammann, the art dealer and Andy intimate, was one of my fellow travelers. We were on a Stroganoff Foundation trip organized by Baroness Hélène de Ludinghausen. I had met Thomas through Fred Hughes and instantly admired the Swiss-German's boyish looks and gentle elegance. Having worked for Bruno Bischofberger from 1971 to 1976, Thomas had gone off and become a successful art dealer. Andy trusted Thomas and even allowed him to rent the second floor of his house to sell Picasso

paintings and other artworks. "It's extremely unusual for a dealer and artist to be that close," Vincent Fremont states. But Thomas was a one-off, "honorable, generous, and fun." All this would be confirmed in Russia.

The Saint Petersburg trip promised to feature an unequaled *W* magazine crowd, meaning social, stylish, and super rich. Hélène de Ludinghausen, Mr. Fairchild's dear friend, ran Yves Saint Laurent's couture salon and knew everyone. Proving this, she rustled up esteemed art collectors like Monique Barbier Mueller, Anne Bass, Beth DeWoody, several South American tycoons, and Mark Thatcher, the son of Britain's prime minister. Meanwhile, the cast of characters I knew were Andy's former circle and included the newly married Barbara Allen Kwiatkowski, Bob Colacello, Wendy Stark, São Schlumberger, Florence Grinda, André Leon Talley, and the artist Ross Bleckner, who had come with Thomas.

Keen to have their Anna Karenina moment, all the ladies had brought their largest and most opulent fur hats and coats. The problem was that the weather was unseasonably warm. So each time a private tour to the Winter Palace or another incredible site was organized, a discarded stack of furs peeped out from the back window of our bus.

Within less than a morning, I reckoned that Thomas was the person to follow. At the Hermitage, he asked the group's guide if the enormous reception room had been restored. "Yes, about nine years ago, with four kilos of gold leaf paint," came the reply. In the State Russian Museum, I was introduced to the importance of Kandinsky and Malevich, even if Thomas was appalled by the conditions. The canvases were simply leaning against a wall, many upside down, without evidence of temperature control. "The paintings were handed out to us like potatoes," Thomas said a little later on the bus. "No one

seemed to know how to treat the works of art." He then estimated that if they sold one of the masterpieces, it could properly renovate the ailing museum.

I could have listened to him all day, except his female friends were annoyed by my Ammann hogging. Thomas—dressed in an array of becoming turtlenecks and tweed jackets—was the most popular guy on the trip. Being from *Women's Wear* and penning articles titled "Postcard from St. Petersburg," I was Miss Must to Avoid. Thomas was too polite to let on, but Ross Bleckner later told a friend that everyone was "always trying to escape that girl from *WWD*." Ignorance is bliss. To be honest, I thought everyone was fleeing from Mark Thatcher and his loud voice!

Besides, there were other dramas: Aeroflot airlines forgot André Leon Talley's Kelly bags, custom-sized for his six-foot-six frame; Liz Mezzacappa's fur coat caught fire in St. Nicholas Cathedral; Barbara Allen Kwiatkowski was mugged, her purse with $10,000 swiped from her hand outside the Hotel Europe; I ran up a huge telephone bill despite being warned that all calls were made via Helsinki; and then Rudolf Nureyev died, and so Bob Colacello had to leave.

Thomas managed to meet one of Nureyev's best Russian friends, the scientist Liuba Myasnikova—the man's connections were neverending. He also encouraged me to go to St. Nicholas Cathedral, where the dancer's life was being celebrated. "The mourning is something to witness," he said. Inside the medieval cathedral, the loud sobbing was pretty upsetting. It was such an intense display of emotion. Six months later, Thomas would die of the same disease as Nureyev. It certainly wasn't apparent that he had AIDS.

Fairchild was famously tightfisted with its staff, always counting pennies, but occasionally it went too far. When covering my first Lynn Wyatt birthday in 1992, I was put up in a wooden shack that resembled

the Bates Motel, the South of France version. Maurice and Josephine Saatchi, who had given me a lift back in their Rolls-Royce Corniche, were aghast. The contrast between my personal circumstances and those I was professionally covering often defined extreme.

In 1980 Andy had gone to Lynn's birthday party and was thrilled to be introduced to Johnny Carson and talk frocks to his beautiful wife, Joanna. At my first Wyatt do, *I* was placed between photographers Slim Aarons and Helmut Newton, and so it continued. Media attention has been paid to the Texan Rose's face, hair, figure, and couture clothes. Yet Warhol's portrait achieved in 1980 captured her grace, whatever the circumstances. Her guest list might have included Jack Nicholson, Joan Collins, Liza Minnelli, Elton John, and Roger Moore, but everyone, including yours truly, was treated in the same manner. In Lynn's opinion, anyone invited was a star. Her attitude created a tremendous ambience. There was also Oscar, Lynn's oil magnate husband, who did not mince his words. I saw him turning to Liza Minnelli and saying, "Liza, you must be happy because when you're happy, you're thin." Minnelli, wearing a rainbow-colored gown, smiled. "And when you're unhappy, you're . . . not," he continued. She looked less at ease.

Diane von Furstenberg, another Andy subject, was also a skilled hostess. *Le tout Paris*, ranging from actresses to writers to Rothschilds, would pile into her apartment on the rue de Seine. Her parties were lengthy bohemian affairs where some guests would have supper in her salon and others would eat on her bed. Anything went, and it defined atypical.

I met so many people through Diane, or "Mrs. von Diller," to quote the superagent Sue Mengers. Still, *Vanity Fair*'s Graydon Carter proved to be the most professionally valid. In the fall of 1992, he came courting when I secured the story about São Schlumberger and her new apartment. It was a story that every important New York

magazine, whether a fashion glossy like *Vogue* or an interiors expert like *House & Garden*, was panting over.

What happened was so Paris, so '90s, and so New York media of that era. Using Gabhan O'Keeffe, a fairly outrageous Irish-born decorator, São had done up her new home. Having been overshadowed by the death of her husband, an unsavory love affair, and problems with her children, São was back with a force and was suddenly the talk of Paris and New York.

Naturally, there were two schools of thoughts: those who found the apartment vulgar—"the salon was like a torture chamber," says one Parisian socialite—and those who admired the boldness. Gabhan delved into exaggerated detail and brilliant color in the same way that Mongiardino and other subtle masters avoided it. Still, it was news, and São flexed her muscles (read: feminine wiles) by turning down everyone's request to photograph it. Being Fairchild-trained, or rather, having Mr. Fairchild breathe down my neck, I took the alternative route and put the focus on São.

After traveling with São to Saint Petersburg, I sensed that she was keen to be perceived as a personality. Who else could look at a Jack and the Giant–sized lapis lazuli urn in the Hermitage Museum and say, "Everything is relative," when everyone else was swooning? Content to be admired, São was also a beautiful woman and prominent couture client who had been painted by Salvador Dalí and Andy.

"Amongst the ladies in Paris, São was the closest to Andy," says Bob Colacello. "She was a genuine lover of artists and liked hanging out with bohemian types. Whenever she came to New York, we always had a lunch for São and a dinner for São. She went to crazy gay clubs with us. She was funny. Nothing could shock her."

I knew that she had financed Robert Wilson productions and attended Andy's shows such as the *Hammer and Sickle* exhibit in Paris

and *Drag Queens* in Naples. At the time, however, I didn't realize that she helped finance Warhol's retrospective at the Beaubourg in Paris in 1990. "The museum was short of money and São was singled out," says Vincent Fremont. This led to her insistence that her portrait be used for the exhibition's poster. "There was more than one poster," adds Vincent.

There were those who were scared of São. She could be blunt, even bitingly rude. But she was always nice to me, sensing that I was on her side. To my mind, São was an adventuress and cultured gypsy in couture who shared my horror of mixing with stiff, conventional Parisians.

With this in mind, I suggested a portrait of São in her favorite room. She immediately agreed. Looking resplendent on a sofa in her bright emerald-green library, the Portuguese-born socialite was photographed by Christopher Simon Sykes wearing a Saint Laurent haute couture suit. Everyone was amazed by the coup, particularly Graydon.

A clandestine meeting was arranged with Monsieur Carter in Paris. I was flattered and excited by the idea of working at *Vanity Fair*. Finally, I would be out of the Fairchild orphanage, I thought. The only potential fly in the ointment was a meeting with Hamilton South, Graydon's acolyte and socially connected editor. I'd made inquiries about the handsome Hamilton, who was alternatively described as "so charming" and "Little Miss Evil," a line from *All About Eve*. Our meeting felt as if I had been put into a cage with a tarantula. First, Hamilton asked who I knew. My list of friends sounded pathetic. I forgot about Lynn Wyatt, DVF, Éric and Beatrice de Rothschild. However, it prepared me for Hamilton's next question: "So, does *W* magazine know that you're here?" Looking at him straight in the face, I replied, "Er, I guess they do now, Hamilton!" Ten days later, I returned to Paris to be informed by Kevin Doyle that I was

getting a forty-percent pay raise. So I guess I should thank dear, dear Hamilton and Christian Louboutin, who had pushed me to meet Graydon.

Right from the start of our friendship, Christian drilled the necessity of being more up front and taking everything less personally. On one occasion, I had been complaining about running after the actress Hanna Schygulla for an interview. The former muse of German director Rainer Werner Fassbinder, she was either impossible to get ahold of or would telephone at midnight and propose the interview then and there. I said, "It's so embarrassing, I've called her about fourteen times." And Christian replied, "It's hardly embarrassing, *cherie*, you're just doing your job. You're being professional. She's not. But there's no reason to take it personally. Separate the two." Sound advice that I've never forgotten but rarely keep to.

At the time, Christian's shoes were sold only in the first arrondissement. There were naysayers who hinted that it couldn't last. He and his business partners did choose to launch the brand in 1991, a catastrophic year financially. However, I would have bet my last penny that Christian was going to explode and that his brand would become famous. He thought on an international scale—rare for a Parisian—was photogenic, and a delight for all journalists, yet he had a grounded attitude toward his business.

Naturally, I wrote about Christian for *W*. It was his first article in the American press. However, it was another *W* article, written a year later by my fellow editor Heidi Lender, that would actually attract buyers. As usual, Christian arrived late, and as Heidi waited, Princess Caroline of Monaco appeared. The mention of Grace Kelly's daughter led to interest and sales.

India Hicks, a model and the daughter of David Hicks, the interior designer, introduced Christian and me. At first, I found Christian

invasive and controlling. Then, at an Italian playboy's house, we bonded over the story of François, my first beau in Paris. I had been bored. So was François, actually. So one night, I just wrote *Au revoir, François* with my red lipstick on his gilded eighteenth-century mirror and then caught the Métro home. The telephone was ringing off the hook when I arrived. 'Twas François, who was furious. Not because he missed me—the Gallic charmer—but because how would he "explain the lipstick mess to the maid"?

Before meeting Christian, my social life in Paris was determined by my lack of French speaking skills. Occasionally, I did think, *Is that all there is?* Where were the bohemian Parisians, the Jean Cocteaus of the day? But thanks to Christian, I was suddenly thrust into a fascinating world that was composed of famous French actresses and directors, fashion muses, decorators, gallery owners, antique dealers, and journalists.

Christian transformed my existence in Paris. I can only compare it to sitting in a poorly lit room and turning the light on. Being part of his gang meant rushing after work to his tiny flagship on the rue Jean-Jacques Rousseau. There always seemed to be action, either in his boutique—trays holding coupes of champagne would waft down the Galerie Véro-Dodat from the nearby café—or general silliness at the Galerie du Passage, owned by Pierre Passebon, one of his best friends.

Behind my back, Christian had painted my childhood as very *Wuthering Heights* meets *Gormenghast*. Depending on his mood, he described my family as either scrounging herbs off the land or drinking one another's blood. "They wrote notes as opposed to speaking," he would whisper. So when I turned out to be a straightforward loudmouth with a healthy appetite, his friends were pleasantly surprised. True, my French was pretty good rubbish, but I got the jokes.

Many nights with Christian ended up at Natacha's—the Parisian version of Elaine's, and the "in restaurant" of that period. He knew Natacha Massine, the feisty owner, who served questionable food but was responsible for the winning ambience. "Christian, tell your friends to quit making so much noise," she would yell. It didn't stop us. Meanwhile, I would totter around on his high heels, with Minnie and Mickey—his nickname for my cleavage—on prominent display.

Suddenly my articles were infiltrated with a refined sense of Paris. Jacques Grange became the main feature of "Le Chic Rustique," my article about the *"gauche caviar"* (champagne socialist) mood in 1992. It described how elegant Parisians like the interior designer were no longer holidaying in Saint-Tropez but choosing the bucolic bliss of Saint-Rémy-de-Provence instead. Wearing velvet carpet slippers, a seductive Jacques was snapped among a herd of sheep. Mr. Fairchild was delighted. It was everything that *W* aspired to: capturing a new trend and showing an exclusive talent in an astonishing setting.

Paris was changing. On the one hand, there was the small but powerful contingency of couture clients where Hubert de Givenchy ruled supreme. Relied upon for his approval, the revered designer advised on their eighteenth-century interiors and was the type to insist that full makeup was de rigueur on vacation. In force, such dames turned up for the retrospective of Le Grand Hubert's work at the Palais Galliera. Since they defined stiff and unapproachable, it was more exciting to meet Yves Saint Laurent. "Bye-bye," he said mischievously, imitating Mr. Fairchild. Then to interview Audrey Hepburn, whose voice and manner were as enchanting as her face. Finally there was my attempt to chat up and quote Bunny Mellon, the American grande dame. Dressed in Givenchy, she flew off mid-sentence when realizing that I was from *WWD*.

Meanwhile, there was the other side of Paris where *la vie bohème*

was beginning to seep in. Dinners were given in the kitchen as opposed to stiff affairs around the dining room table, and *W* was the first magazine in America to reflect on the changing social phenomenon. There was also a growing interest in gardens, or so Mr. Fairchild sensed. One Friday afternoon, I was sent off to the countryside to cover Courson, France's relaxed equivalent of the Chelsea Flower Show. It was pouring rain, someone informed that Jackie Onassis had died, and just when I was thinking that it was a wild-goose chase, Italian style icon Marella Agnelli appeared. Andy had done her portrait in 1973.

Occasionally, Mr. Fairchild could get it wrong. Writing about a Ferrari-crazed dentist in Germany who claimed to have done Liza Minnelli's choppers as well as a mild-mannered plastic surgeon in Belgium were probably a little off kilter. Yet in general, he had a sixth sense about social events and fads. He did not like divas among his staff. *Occasionally*, I was put back in my basket. Well, major attempts were made.

Fortunately, he was not around for my *Reine Margot* adventure. And I think the beady-eyed Kevin Doyle must have been crazed from handling all the foreign editions of *W Fashion Europe*—a new magazine that was published in French, Italian, and German—because it was left unnoticed that I slipped off for three days to be filmed among French stars such as Isabelle Adjani, Daniel Auteuil, Jean-Hugues Anglade, and Pascal Greggory.

Naturally, it had happened through Christian, who egged on his girlfriends to be audacious in much the same way that Andy did. At Natacha's restaurant, we were often bumping into Patrice Chéreau, *La Reine Margot*'s director. One night, I pushed myself onto Patrice— flaunting Minnie and Mickey in customary fashion—and said, "My white skin is perfect for your film set in the sixteenth century." It was, and—true to his word—I was contacted.

I was accompanied by Suzanne von Aichinger—a top catwalk model—and we both behaved shamelessly. Wearing elaborate Renaissance-style wigs and corseted to the nines, we unabashedly flirted with every straight man or gay cutie who crossed our path. I particularly gave the baby-blues goo-goo treatment to the gorgeous camera operator.

Our main scene was with Anglade and Auteuil. Although devastatingly attractive, they were so serious about their craft that both Suzanne and I became rather tongue-tied. My favorite moment was actually watching Patrice in action. For one long scene, he spoke Italian to Virna Lisi, then French to Isabelle Adjani, then German to Ulrich Wildgruber, and then Italian to Asia Argento. The way he used his hands, the way he spoke, it resembled a linguistic dance. Alas, Patrice is no longer with us. He was gruff but a great.

27 *Fashion's New Guard*

In the 1990s, cocaine had hit Paris again. And certain friends and acquaintances would crowd around the recognized providers. Personally, I didn't need the white powder. I was totally high on working at Fairchild. Empowered by the reputation of the Ayatollah of Fashion, I was in the eye of the storm as well as belly flopping with a series of delicious but ultimately disastrous love affairs.

In total denial of my "Faster, faster, James, and don't spare the horses" existence, my main concern was my hair. An adorable Spaniard called Katie would straighten my bob with flounce in a local salon. "Natasha, you look like Liz Hurley," Patrick once screeched. The married Mr. Fairchild, on the

other hand, was impressed that I had found a hairdresser in spitting distance of the office. "Good for you," he said.

Actually, it wasn't particularly "good" to base my entire mood and existence on the state of my hair. But it was my one bid at being Parisian, or so I convinced myself. During the period, I bumped into an Italian ex-admirer. "Where are your curls?" he said, clearly dismayed. Away with the birds, like her good old-fashioned common sense, someone might have answered.

"*Mon dieu*, you and your colleagues were pests," remembered Caroline Laurence, who then worked at Ralph Lauren. At the time, everyone else seemed more serious. Heidi Lender was the fashion editor, Godfrey Deeny and Katie Weisman were covering the business beat, and Sarah Larenaudie and Alev Aktar were writing about beauty. Nevertheless, the Fairchild credence was instilled in all of us: a door slammed shut meant a window. When *Women's Wear Daily* released financial figures concerning French fashion or beauty, complaints were directed to Godfrey or Sarah. Complaints about the social coverage, however, were my department, and rarely happened by telephone.

Just as I was feeling rather chic at Sybilla de Luxembourg's royal wedding—I had squeezed into a vintage Saint Laurent suit and was about to hop into a chauffeur-driven car with a Belgian prince— a Parisian socialite stood in my path. Screaming like a fishwife: it concerned my article about her ball. "How dare you not publish pictures of Sally Aga Khan?" she said. "She came with Amyn Aga Khan," the crazed blond continued. It was embarrassing for three reasons. I didn't realize that the Aga Khans had been at the party (a serious Fairchild faux pas), it felt as if my waistband was slicing into my stomach, and I was worried about missing my lift. Fortunately, the

explosion swiftly blew over. Or rather, her sensible husband whisked her away with a fixed smile plastered on his face.

Paris had become such a heady swirl. I was out every single night and could be counted on to expose Minnie and Mickey in a snug Rive Gauche top or Azzedine Alaïa dress and wearing my Louboutin heels that were medium height then. The European fashion scene had also livened up with a changing of the guards. I lucked out and met two individuals—John Galliano and Tom Ford—who became pivotal to the movement. They were completely different. John was a flamboyant romantic who designed his own label, shown in Paris, whereas Tom, promoted to Gucci's creative director, was a mean machine and brilliant strategist striving for perfection in Milan. Yet both were to light slow-burn candles in the industry and gradually go from strength to superpower.

I'd heard about John from my London friends. He was then the unruly boyfriend of Jasper Conran, a designer I'd worn in London in the 1980s. Viewing him as "the real deal," Malcolm McLaren had used John's design for his *Fans* album cover. After seeing John's collection in September 1991, I understood the fuss. The show defined charged. Outlandish for the period, there were models sporting ringlets and/or vast galleon-type hats on their heads. Rigby & Peller bras and panties peeped through the long transparent white dresses, but there were also superbly crafted jackets. I was sitting next to Godfrey, and we both turned to each other afterward and agreed that it was different and incredible.

There was a new talent in town and he was called John Galliano. That often happens in fashion: one show can be enough to start the tom-tom drums rolling in Paris. Still, when we got back to the *Women's Wear Daily* offices, our enthusiasm was ignored. Writing a few lines for the paper would be enough.

And there marked the gap between my generation and that of Patrick McCarthy, Kevin Doyle, and Etta Froio, who was Patrick's accomplice and a top editor at *WWD*. They were interested in power and advertising via Gianfranco Ferré at Christian Dior, Hubert de Givenchy, and Yves Saint Laurent, whereas Godfrey and I recognized that a sensual and feminine rock-and-roll rebelliousness was needed in the fashion ranks. John Galliano understood that like few others. It was an exalted mix of lightness of touch and fantasy.

He also managed to win over the discerning Parisians immediately. They were moved by his savoir faire—crafting a jacket in a tiny attic—and his obsessiveness, such as holding a wedding dress under the full moon to change the fabric's tone. It also appealed that his financing kept falling through. He was an artiste, after all, and that happened.

For one mythical collection in 1994, São Schlumberger lent John her former home—a seventh-arrondissement *hôtel particulier*—while supermodels such as Linda Evangelista, Christy Turlington, and Cindy Crawford worked for free. Seventeen looks were achieved in three weeks using remaining stock fabric and fusing 1940s tailoring with Japanese Kabuki. Deemed a hit, it would eventually lead to Galliano's signing a contract with LVMH's Bernard Arnault and getting the house of Givenchy.

The Kabuki collection was exquisite, but I was more stirred by his 1992 collection at the Salle Wagram. Put together with spit, the models appeared shimmering with lilac powder. Accompanied by Christian, I felt this extraordinary experience. Mr. Fairchild referred to it as a tingling in the toes. The conditions were lousy. Most of the seats were broken. Yet the artfully lit stage highlighted the delicate artistry of the bias-cut clothes and it became a moment.

A few weeks later, I saw John in quite different circumstances.

Out with the fairies, he had scrambled down onto the floor of a friend's brand-new BMW and was wailing, "I want Christian, I want Christian." Louboutin was his comforting self. John did not barf and there was a sigh of relief all around. Well, particularly from my friend's husband.

This wasn't a situation that would ever occur with smooth operator Tom Ford, who had first gone to Studio 54 with Andy in 1979, was acquainted with the Factory, and, with the help of Paige Powell, had even started writing a screenplay about the artist based on Bob Colacello's book *Holy Terror*. We were introduced by Cristina Malgara, who did Gucci's PR and was one of my best friends. It was difficult not to be charmed by Tom, who was good-looking, funny, and a delicious flirt. Still, I could not believe what a perfectionist he was.

At one point, our talk had turned to the supermodels. "Some of them really need to change their voices," he said. "I mean, they look so beautiful and then they open their mouths and it's a disaster." He had a point, but was it really worth it, I privately thought. Then we discussed a film star he'd seen topless on the beach in St. Barts. "She should get a tit job," he offered. Considering her romantic success, it sounded unnecessary.

Nevertheless, as Tom moved mountains at Gucci and made it into the piping-hot sexy Italian brand, it was obvious that his perfectionist ways were working. "All could be improved" appeared to be his attitude. And the models on his runway summed up über-stunning and über-slick. Evolving into *the* Gucci experience, it was relied upon in every Milan season and repeated in an endless flow of advertisements. The clothes also flew off the shelves.

At first, the old guard did not get Tom. He was a stylist, and that was relatively new to them. Indeed, a conversation between Patrick and William Middleton, a new Fairchild editor, remains etched in

my mind. "You know, William, that friend of yours Tom Ford is really not very good," began dear old PM. They were in the back room of the Fairchild offices at rue d'Aguesseau. William tried to politely disagree. However, Patrick was convinced. Tom did not just last—his perfectionism was to affect the entire industry, globally, and not necessarily in a good way.

28 *Andy's Flower Paintings Leading to Louboutin's Red Soles*

During the haute couture season, there was always *the* party to attend. In January 1994, the main event or sizzling soirée was Karl Lagerfeld's party for Donatella Versace. It was Karl, it was Donatella, and it was also Rupert Everett. Indeed, that night under the candlelight at Karl's eighteenth-century *hôtel particulier*, Rupert was the unequaled star because he had a key role in Robert Altman's *Prêt-à-Porter*, a big Hollywood movie that aimed to capture the fashion world.

The buzz factor around *Prêt-à-Porter* was huge. In many ways, it confirmed the Parisians' rather naive, 1950s vision of Hollywood. There was also the fact that *Prêt-à-Porter* came well packaged. Thanks to

Short Cuts, Altman was an Oscar-nominated director and had gathered a list of actors that included Danny Aiello, Anouk Aimée, Lauren Bacall, Sophia Loren, Marcello Mastroianni, Richard E. Grant, Stephen Rea, Julia Roberts, and Rupert.

Privately, I had my doubts. Altman had screwed up *The Room*. It was one of my stepfather's plays that he had directed for television; it had starred John Travolta and Tom Conti. True to character, Altman was his laid-back, cowboy self. Without consulting Harold or his agent, he had changed half of the play and then later claimed it was "just the room number." It was an irreverent attitude that suited the director of *M*A*S*H*, *The Player*, and *Short Cuts*, but not necessarily the works of Harold Pinter or indeed Harold himself, who had a prevention clause in his contract about tampering with his words.

Still, I said nothing. To have been negative about Altman was going against everyone's enthusiasm. And again, the project's potential was tremendous. Or rather, it was tremendous with everyone apart from Mr. Fairchild. He mistrusted Altman immediately. It affirmed the expression "It takes one to know one." Being mischievous and a troublemaker, Mr. Fairchild sensed the same with Altman. Making matters worse was that he was "a Hollywood type"—which suggested more power and more danger—and Mr. Fairchild had also heard that, gasp, Altman was "a pothead."

Mr. Fairchild was in fairly frisky form, it has to be said. He'd just recovered from life-threatening food poisoning and was obsessed with *le retour* of Pamela Harriman. Because of her good works for the Democratic Party (PamPAC and so forth), President Bill Clinton had made her U.S. ambassador to France. And the British blue blood was captivating the political community just as she had captivated Prince Aly Khan and other highfliers during her youth.

When Fairchild had been living in Paris, the flame-haired, blue-eyed temptress had fled the city, marked as Élie de Rothschild's mistress. But now she had returned in unfathomed respect and splendor as a diplomat. "She's slept with everybody, everybody," Mr. Fairchild declared when he first heard the news. (Hardly everybody, just the super-duper rich.) Since he was slightly high on the news, he then asked who I had slept with. "Nobody, nobody," I had replied, making the mistake of imitating his voice. Fortunately, it was both forgiven and forgotten.

At her embassy's Independence Day party, I had gone up and introduced myself to Mrs. Harriman. "Hello, I'm the daughter of Hugh Fraser," I said. My father had, after all, known her since childhood and been called upon when she thought of becoming a Catholic. Looking at me, she said, "Oh, I loved Hugh so much," and that was it for all her years in Paris! Meanwhile, Robin Hurlstone had witnessed the entire episode and had lip-read my words. He teased me about it afterward. Being, tall, blond, and male, he got further with her.

Smart Pamela also invited Mr. Fairchild to lunch at the embassy's very grand nineteenth-century residence. Considering that *W* magazine had published an article about her with an entire page covered with snapshots of her lovers, it was surprising that she didn't poison the food. No doubt, she sensed that it was wiser to have the Ayatollah of Fashion in her camp.

Typically, Mr. Fairchild was won over by her intelligence and knowledge, as well as the chance to nurse his usual schoolboy crush with regard to the well-born Brits. He also enjoyed the sprinkling of Winston Churchill quotes, a reminder that the great man had been her father-in-law. "As Winston used to say, all you need is a bed and a cigar," she said. A little rich coming from a merry widow who had fleeced the Harriman art collection! But Mr. Fairchild fell, or rather, made the decision to fall for it hook, line, and sinker. He was further

thrilled when he heard that her arduous gentleman caller was Gianni Agnelli, the dashing Italian car magnate, who'd been the ambassadress's fiancé. "Thrilled" because it proved to Mr. Fairchild that the passion behind great love affairs never quite dwindled.

Yet soppy and teenage as Mr. Fairchild could be about *l'amour, l'amour,* he was his hard-nosed self about Altman taking on his world. The Hollywood director was notorious for his cynical approach, and the idea that he would come in and misjudge a world that was easy to lampoon worried Mr. Fairchild. On the quiet, he called up everyone he knew and advised them not to cooperate, warning that they would regret it if they did. To a certain extent, *Prêt-à-Porter* became Mr. Fairchild's last public stand.

In the office, it was understood that the big boss was anti-Altman. But when the cat was away . . . certain Fairchild mice ran after everything connected to *Prêt-à-Porter* because such events offered Hollywood glamour and that so rarely happened in Paris. Of course, this was hidden from Mr. Fairchild. In my case, it was equivalent to smoking grass in my bedroom and not being caught by my fashion dad, because I went to all and everything that was tagged with *Prêt-à-Porter.*

I wasn't alone. And when Rupert appeared in the Fairchild office, there was a frisson. Albeit casually dressed, he had a prima ballerina's presence in his sweats. There was the tremendous height, the dramatic face, and the voice. For a minute, my stock rather shot up among my colleagues—helped by the fact that Mick Jagger had just called at the office. (He adopted an Irish accent for the task, and Ruth Benoit, an Irish-born editorial assistant who heard his voice, said, "Natasha, someone with a crap Irish accent wants to speak to you.")

Having Rupert in Paris meant raucous dinners and late nights. He was always picking up the bills and mixing his friends ad infinitum. Naturally, he regaled us with stories from the set. Chivalrous as

Rupert can be—he'll run after purse snatchers at the risk of falling and breaking his glasses—he initially took against Lauren "Call Me Betty" Bacall. Certain stories implied that she was a homophobe. I wondered, since Leonard Bernstein was one of her best friends.

Anyway, Rupert took to Betty-baiting, describing her as being treated like a huge star in Paris but "run over by taxi drivers in New York." Having interviewed the feisty blond, I knew she could more than give it back. Still, Rupert went a little far, as British charmers do. He told her "what a nightmare" it must be for her son Sam Robards to be on the same film set.

Nevertheless, his fight with Danny Aiello beat all his Betty-baiting. The American actor got Rupert's goat for several reasons. Aiello's negative reactions to his ideas had annoyed Rupert, as did Aiello's sucking up to Sophia Loren and Marcello Mastroianni. *Prêt-à-Porter* required improvising from all the actors. During the scene where Sophia Loren faints dramatically, Aiello suddenly decided that his character was a doctor. Using this excuse, he pushed all the other actors out of the frame and insisted that he give La Loren mouth-to-mouth resuscitation, to which Rupert quipped, "You want to kill her?" Aiello went berserk and pushed his face up to Rupert's. It might have become violent had Miss Bacall, of all people, not intervened. The incident caused shock waves in the Actors Studio and the community. Taking the role of peacemaker, Robert De Niro offered to fly into Paris to calm everyone down. And naturally, I kept the entire office enthralled with the latest installments of Rupert's filming even if no one was allowed to tell anyone in the New York office.

Mr. Fairchild, on the other hand, continued to be on the warpath about *Prêt-à-Porter*. This was demonstrated when the house of Sonia Rykiel sent out a letter informing journalists that Altman would be filming during the Rykiel show. The house warned that attending

meant giving permission to be included in the movie. Red rag to a bull, Mr. Fairchild went nuts. He got on the telephone and blasted the house for such a suggestion, his outraged attitude being: "How dare they! We're not actors! We're here to do our jobs, not for some Hollywood lark." A daring act, considering Mr. Fairchild never even went to Miss Rykiel's collections. Nevertheless, the point was made and the pot was starting to stir.

He also had the nerve to call up Altman and warn him against the co-screenwriter Brian Leitch, who happened to be a former Fairchild employee. Put charitably, Brian was a misfit in the Paris office. So there was a sigh of relief when he left to work for Altman and William Middleton replaced him. Unlike Brian, the Kansas-born William was witty and a team player, and since he was all-American handsome, he became the fashion world's gay heartthrob.

Meanwhile, I managed to get invited to Altman's birthday party on February 20. It happened because at a *Prêt-à-Porter*-connected cocktail, I bumped into his utterly lovely wife, Kathryn, who recognized me from our dinner in New York with Harold and my mother.

The party was held in their rented apartment in the seventeenth arrondissement and was a mix of their Parisian friends. I only knew Marisa Berenson and two fashion models, Tara and Georgina, who had been cast in *Prêt-à-Porter*. Altman's birthday cake arrived to the accompaniment of the sound track of *Short Cuts*. This struck me as a little bizarre, but Altman looked blissed out by the experience.

Afterward I sent a thank-you note, and thought nothing more about it, until Suzy's gossip column appeared in the *New York Post*. It was unusually snide for Suzy (aka Aileen Mehle), and the ever-so-sensitive Mr. Altman flipped. Surprising for someone who was in the public eye. Altman thought that I was the informant, when it was actually Marisa who'd innocently spilled the beans.

Kathryn advised that I call her husband. I tried, but he wouldn't take my calls. Then I remembered that Altman had the Iago-like Brian Leitch in his production office, who was clearly not whispering sweet nothings about *moi*.

In retrospect, *Prêt-à-Porter* would have been more accurate about the fashion world if Brian had delved into his mean-queen, occasionally deluded behavior. Rupert thought he was "absolutely ghastly," but when I bumped into Il Leitch, he smugly informed, "Rupert and I have been writing dialogue together." They had? It was news to Rupert, who hardly needed Il Leitch. Indeed, they had had several arguments. And then there were the mad spats that Il Leitch and I seemed to have on odd street corners. (Was the creep following Fairchild's sneaky society editor?) Each of us was arched and puffed up with our preposterous self-importance.

Being curious (read: nosy), I did ask about the film's story line and, with shining eyes and utter glee, Il Leitch said that he couldn't tell me but it was "brilliant." Brilliant? My response to this was, "I do hope that it's not too fashiony because that will narrow down the audience." Il Leitch rose a little in stature and grandly said that he was no longer in fashion; he was a screenwriter. A writer? Thinking back, I see it was mad how we loathed each other's guts and felt licensed to express it.

Either stoned or revved up by Il Leitch, Monsieur Altman decided to call me at home. He began calmly and then went ballistic. However, since I was unfairly accused, I hopped on my soapbox and went ballistic too. He was such a tall, bearded bully, telling me to "leave Fairchild" and generally "get a life." But I stood my ground—it helped that he had totally fucked up Harold's play—and yelled back until I was hoarse. It was a totally mad scene: a famous Hollywood director screaming at a total nobody on an early Saturday morning.

Then again, it illustrated the director's growing paranoia when working in Paris. Or was it just a case of too much grass?

The drama reached Rupert, who called up and said, "N, what is going on?" I explained. He understood. Mr. Fairchild, on the other hand, was a little miffed. But before I could be accused of being a double agent or Nata Hari, *Town & Country* magazine saved my bacon. They published a huge article on Waddesdon, Jacob Rothschild's stately home that the great man and lord had promised to us at *W*, or so we thought. When this happens in the world of glossy, it can turn nuclear. Kevin Doyle had a meltdown when he found out. Patrick was pissed but cooler. "As far as I'm concerned, Jacob Rothschild can go and fuck himself," PM said. This was rapidly followed by the Isabelle Adjani incident, taking further attention away from my Altman birthday attendance.

All was fine until Isabelle—then considered France's Greta Garbo, and a former *Interview* cover girl—began listing her dictates. Photo approval was normal. And then came the problem of her age. "You cannot ask how old she is," stated Adjani's assistant. I told this to Patrick, who paused and then said, "Whaaat . . . ?" Needless to say, the story was off, and focus on *Prêt-à-Porter* was back on.

In spite of my yelling match with "Bob," I was invited to his wrap party. It was either a mistake or a desperate bid to fill the reception rooms at Pavillon Ledoyen, where it was being filmed. In atmosphere, the bash was not unlike one of Andy Warhol's films from the 1960s. But then, according to Andy's diaries, Altman copied many of his ideas.

Christian Louboutin was my date. Beforehand, we'd had dinner with Diane von Furstenberg, who said that we were "so lucky" because it was "like watching history being filmed." Once we arrived, we both tried to outcompete the other with our film star experience. Christian kept banging on about "the tension" in Sophia Loren's

back, whereas I couldn't resist flirting with the wildly attractive Richard E. Grant, who was sporting a vast hat. Fairly giddy, I began lifting my beaded top and flashing my black satin bra at Eve, the skinhead model. That was until Rupert stopped me and said, "Natasha, Eve likes girls and she's getting very excited."

A few hours later, Godfrey Deeny and I met in Ledoyen's parking lot. View us as the fashion version of Deep Throat, even if we had to cram into his sports car, bicker about certain details, and then dictate our copy to the New York office. Naturally, Mr. Fairchild found fault. "How could they forget to mention Marc Bohan [a former Christian Dior designer]?" he said. Kevin then told us off for this.

Rubbing shoulders with all the stars had been fabulous. Still, even then, we had a sixth sense that the film would be a stinker. Altman had an idée fixe that fashion folk had endless sex between and after shows. Wrong! As a result, the film's plot kept Julia Roberts locked in her hotel room. The film came out in December 1994 and bombed. Little mention was made of it in *Women's Wear Daily* or *W* magazine.

Rupert would continue with his fashion experience via Yves Saint Laurent perfumes. He became the male face of the Opium fragrance opposite Linda Evangelista, who was his female equivalent in the advertising campaign.

Yet in many ways, it became Christian Louboutin's hour in the world de la mode. Particularly after he took the radical decision to color the soles of his shoes red. Christian never knew Andy. But the American artist would have appreciated his company. Like Andy, he worked and networked like a demon and had that knack of putting everything back in his brand. Covering many social fronts, Christian was also starting to befriend all the famous stars of the time. On MTV, Madonna had held up a pink satin Louboutin stiletto with marabou fur and provocatively purred, "It's like a weapon."

Andy initially caught attention with shoes. He began his New York professional life with his blotted-line illustrations for I. Miller shoes and Fleming-Joffe, the luxury leather company. Hailed for its whimsical yet commercial quality, his work won various awards in the same way that Christian's eventually would.

A strange coincidence, but Christian was actually working on his Pensée (pansy) shoe, inspired by Warhol's *Flower* paintings, when he had the brain wave to paint his soles red. "I was thinking of all the colors Warhol used," Christian now recalls. The shape of the shoe's footbed worked, as did the pansy and the height of the heel. Still, something was missing. That was, until Christian caught sight of his assistant, who was doing her nails. Grabbing the red varnish, he began to paint the Pensée's sole. The flash of color was the needed touch. The "needed touch" morphed into Louboutin's red-sole signature and turned his little business into a hugely successful shoe empire.

Epilogue

Every erstwhile Alice needs a Cheshire cat. During my adventures in Warhol Land, it was Andy. I first heard about him in 1971, when I was eight; it concerned his film *Sleep*. We met when I was sixteen. He tried to tempt me with an Armani model, the son of a Warhol collector. I was a schoolgirl, called one of the "new beauties for the eighties," by British *Vogue*. "The world is their oyster," predicted the magazine. Four years later I wanted his world and out of England. "You should write a *Mommie Dearest*," Andy advised. I moved to Los Angeles and had dinner with him at Mr Chow, after the Madonna–Sean Penn nuptials. It was a media event that shocked then low-key Hollywood but delighted Andy. He liked the paparazzi hanging out of the helicopters

and the fact that they noticed his white wig. At our final meeting I had a handshake agreement for his *Fifteen Minutes* program on MTV. Five days later, I was screening calls about his death. Six weeks later, en route to Andy's memorial lunch, I shared a taxi with the aforementioned Armani model. During my first trip to Gstaad in 1992, it was all about owning Picasso. But on my last trip there, in the spring of 2014, the chalet of the jeweler Laurence Graff was the hot subject of conversation, as were the priceless Warhols on his walls: *Liz Taylor*, *Marilyn*, and a *Self-Portrait*.

These memories and many more flooded back when I was in the Art Institute of Chicago in the summer of 2014. I had been in Colorado—a state where Andy once owned land—and I was in Chicago before a flight back to Paris. Suddenly, I came across a giant *Mao* and stood still.

Everyone has a favorite Warhol painting or period. Irving Blum mentions the *Electric Chairs* series (1964–1967). "They were absolutely brilliant and remain so relevant today," he says. Peter Brant cites *Shot Blue Marilyn* (1964): "It was my second purchase." Larry Gagosian enthuses about *Atomic Bomb* (1965), which he calls "a masterpiece, made in one size and one color." And Bruno Bischofberger refers to *Orange Car Crash Fourteen Times* (1963), which is part of the Philip Johnson collection at the Museum of Modern Art.

Like most other art world powerhouses who played a key role in Andy's career, these four highlight the early work that "changed the entire world of art history," to quote Rudolf Zwirner, the work the artist referred to as his "rainy-day paintings." But I am a casual observer who has been emotionally stunned by Warhol's mammoth-verging-on-monstrous *Mao*. The portrait equals the Great Wall of China. It's today. It's tomorrow. It almost threatens. Painted in 1974, the fifteen-foot-tall painting captures Warhol's genius, demonstrating

that he was a prophetlike artist whose impact continues to surprise and remains omnipresent. His Cheshire cat smile—whether represented by one of his famous sayings or one of his repetitive-imaged silkscreens—lingers and haunts art, fashion, music, and social media.

Among the Andy books, Bob Colacello's *Holy Terror* touched me most. An employee who built up *Interview* magazine into a monthly contender, he yearned for Andy's respect yet also questioned his modus operandi. *Holy Terror* is erudite and funny, and it ends with empathy: Colacello admits to feeling sorry for the world-famous artist.

I, on the other hand, have come away feeling more thoroughly impressed by Andy. He was a public figure who remained present. Most successful lives have an element of Julius Caesar's *"Veni, vidi, vici,"* and tend to turn either dull or decadent when people have made it. Not so, in the case of Andrew Warhola, as he was born on August 6, 1928. He never became smug or self-indulgent. Forever motivated by curiosity, he was also relentlessly motivated by a work ethic and the inner war cry "I've got to keep the lights on." Financially, he always felt responsible.

A solitary individual—"Warhol's best friend was probably his work," offers Christian Louboutin—Andy was detached, thought differently, and was often misjudged for being heartless. True, he was not a saint, but nor was he a sicko. Thanks to *Interview* magazine and Warhol's Studio, many young people, ambitious or hapless, found employment. There was the thoughtfulness. To his not exactly wealthy girlfriends, he gave rainy-day paintings—mini versions of the *Flowers* and *Mao*—that he knew they would sell, and he was fine with that. There was his strange mating call to certain doll-like girlfriends that consisted of showing the scar where he'd been shot. "Zorro-like, it was carved across his chest," says Clara Saint. There were his daily prayer sessions at St. Vincent Ferrer, a Catholic church.

"We'd sit in the back and pray for ten to fifteen minutes," recalls Wilfredo Rosado. "There was a comfort level between us and it was a tender moment." Warhol was also *the* famous artist who preferred to live surrounded by the paintings of others—his friends Jean-Michel Basquiat, Jasper Johns, Roy Lichtenstein, and Cy Twombly—but who kept his own canvases in the closet. "Andy wasn't self-congratulatory," says Bischofberger.

Andy was too poetic for that. There were various stages in his life: the childhood in Pittsburgh; the parents who both encouraged his art; the Factory years with the exciting but uncontrolled; the discovery of Europe's high society after the assassination attempt; the superstar 1970s and early 1980s; and the period of disappointment with the art world, and of reevaluation of television and film projects.

Peter Brant, a Warhol collector from the age of eighteen, liked the inner circle around Warhol. Andy, he says, was able to "choose and bring out the best in people." Albeit with a camp sensibility, there was an element of the Knights of the Round Table around Andy. It's easier to imagine him as Merlin, though he had Arthurian qualities. Andy's holy grail was the art establishment, always slightly out of his reach. Yet the best of his paintings touched on the religious and mysterious—his self-portraits haunt and are mystical and almost Christ-like. As for his gathering of feisty knights who were mentally prepared to jostle, there was Fred Hughes, who during his heyday won over the European gallery owners, the tycoons and their wives; Vincent Fremont, who kept Camelot together; Jay Shriver, Andy's official assistant, who ran the studio; Christopher Makos, who accompanied Andy on his pot-of-gold trips to the Rhineland; Alexander Iolas, who exhibited Andy's first-ever solo show and commissioned his final one, *The Last Supper*; Wilfredo Rosado, who found the "fright wig" at Fiorucci; and the knights who got away—Jed Johnson

and Bob Colacello. There were the Morgan Le Fays—Brigid Berlin and Paige Powell—and the sorcerers from Europe—Andy's art dealers, including Bruno Bischofberger, Hans Mayer, and Thomas Ammann, who kept "Les Must de Warhol" portraits going.

Diane von Furstenberg's portrait session happened in the kitchen of her Park Avenue apartment. "He needed a white wall and I only had a small one in the kitchen," she says. "That is why I put my arm up."

The portrait of Suzanne Syz, the Swiss German jeweler, was done in the studio. "I didn't like the result," she says. "I told Andy that I was a happy person but he made me look sad. He was surprised. I don't think every sitter was as frank. But two weeks later . . . he'd done my new portrait in three different colors and gave them all to me. I'd only commissioned one."

Farah Diba Pahlavi's portrait was painted in the Niavaran Palace in Tehran when she was the empress of Iran. "We'd already met at the White House at a state dinner given for my husband by President Ford," she remembers. "I was excited to talk to Andy but he kept on running away from me. . . . He was scared that I was going to ask him to dance."

Farah Diba's portrait is one of the best—resembling Sophia Loren, it implies a lighthearted existence before her life with the Shah. Irving Blum describes the series of which it is a part as "hits and misses with the occasional wonderful ones." The best of Les Must include portraits of Gianni Agnelli, Willy Brandt, Diane von Furstenberg, Yves Saint Laurent, Peter Ludwig, Dominique de Menil, and Joseph Beuys. Meanwhile, Bischofberger is quick to point out that prominent art collectors who "only commissioned portraits of their wives and family now regret not being included."

Sir Norman Rosenthal, who recently curated a show of portraits

from the Hall Collection at the Ashmolean Museum at Oxford, stresses that Warhol's work has held up. "It was because Andy had no fear of honesty. His magic comes down to honesty."

There was also the talent. "His very early drawings are up there with Egon Schiele," says Nicky Haslam. Marcel Duchamp is another frequent comparison. Éric de Rothschild, who sat for Warhol in the nude—"I was inspired by a portrait of Louis XV at Versailles, and he needed $20,000 to finish the film *Trash*"—refers to him as "one of the great, great American artists." As with Fragonard, "there was more to his work than niceties. Warhol dared to show the anguish."

Rothschild accompanied the artist to the Surrealist Ball, a legendary society gathering. Andy, he remembers, wore jeans because he didn't like the pants of the black-tie suit that he had rented for the evening. "And everyone thought it was fantastic." Later, at Studio 54, Rothschild would watch "as women poured their hearts out to Andy while he remained silent. It was a terrific technique."

Peter Brant also points to Andy's way of inciting and inviting assistance. "He played delicate, as if he needed protecting, but he was very competent. To know Andy was to work with Andy."

Underneath Warhol's benign presence was a steely force, and his death would lead to a permanent loss in New York and a descending darkness on his self-created Camelot. Fred Hughes became hideously invalided with MS—"it was a slow, cruel death," says Gagosian—and as a result of his poor choices of accomplices with regard to the Warhol estate and then the Warhol Foundation, the structure that he envisioned collapsed. Christie's now takes care of Andy's diminished inventory.

Meanwhile, with the Warhol museum, the exhibitions in major museums, and the efforts of Vincent Fremont and gallery owners including Larry Gagosian and Thaddaeus Ropac, Andy's reputation

has gained momentum. The appearance of a Warhol artwork is guaranteed to excite the marketplace.

Nevertheless, Christian Louboutin poses a valid question: "What would have happened if Warhol had lived longer? He was the seer of the last century, the man who predicted almost everything, so where would that leave him? Would he have lost his point?" I reckon that Andy would be right where he wanted to be, keeping the lights on.

ACKNOWLEDGMENTS

After Andy wouldn't have been possible without Blue Rider's publisher David Rosenthal and editor in chief Sarah Hochman, who edited this book. Sarah was tireless, encouraging, and fun. I always looked forward to our calls. There were quite a few instances of "Natasha, I'm sure that this was a very important moment for you, but it simply doesn't work here." They did make me smile. What a difference a civilized editor makes.

I was extremely fortunate to have interviewed Vincent Fremont on three separate occasions. He is such an Andy expert—he worked for the artist from 1969 to 1987—and is so generous with his time and knowledge.

I am indebted to the following people who were kind enough to give interviews: Abigail Asher, Pierre Bergé, Bruno Bischofberger, Irving Blum, Cristiana Brandolini, Peter Brant, Andrew Braunsberg, Robert Couturier, Peter Frankfurt, Diane von Furstenberg, Larry

Gagosian, Jacques Grange, Sabrina Guinness, Geraldine Harmsworth, Nicky Haslam, Catherine Hesketh, Beauregard Houston-Montgomery, Kathryn Ireland, Ian Irving, Anne Lambton, Kenneth Jay Lane, Louis Lefebvre, Christian Louboutin, Christopher Makos, Christopher Mason, Len Morgan, Farah Diba Pahlavi, Thaddaeus Ropac, Wilfredo Rosado, Norman Rosenthal, Éric de Rothschild, Clara Saint, Shelley Wanger, Gordon Watson, and Rudolf Zwirner.

The following helped secure interviews and/or provided information: Celestia Alexander-Sinclair, Doris Ammann, Ivor Braka, Jean Bickley, Gabriel Braunsberg, Mary Byrne, Beatrice Caracciolo, Alexander Cohane, Fiona DaRin, Vincent Darré, Karen Denne, Marie Donnelly, Richard Edwards, Alain Elkann, Jérôme Faillant-Dumas, Marie-Laurence Gimeno, James Green, Dominique Lacloche, Molly Laub, Amabel Lindsay, Laura Lindsay, Anna Mathias, Dr. Suzanne Neuberger, Lucien Pagès, Pierre Passebon, Nathalie Peters, Alessandro Pron, Raphaella Riboud, Cassandra Robinson, Alexandra Schoenberg, Pascal Sittler, Natascha Snellman, Silvia Sokalski, Peter Soros, Courtney Spieker, Taki Theodoracopulos, Electra Toub, Linda Van, Ron Wilson, and Tino Zervudachi.

As always, *un grand merci* to my network of supportive writer and artist friends: Louise Baring, Ruth Benoit, Kate Betts, Godfrey Deeny, Alicia Drake, Kathy Gilfillan, Marion Hume, Prosper Keating, William Middleton, Kate Morris, Robert O'Byrne, Mitchell Owens, Susan Owens, Sarah Raper Larenaudie, Charles Sebline, William Stadiem, Jerry Stafford, Dana Thomas, and Caroline Young.

Many thanks to Yannick Pons, the present owner of the Paris apartment where Andy always stayed.

I am indebted to Alan Davidson, paparazzo extraordinaire, who took the picture of Andy and me at Régine's—love the snap—and other jolly ones capturing my foolish youth. You were always my fave!

I am also indebted to Pamela Hanson and Jean Pigozzi for kindly allowing me to use their images. I am grateful as well to Harriet Wilson and Brett Croft at Condé Nast Archives.

A book with so many painting titles needs a knowledgeable copy editor. I was very lucky to have secured Kathleen Go. Thanks also to art director Jason Booher, jacket designer Ben Denzer, publicist Marian Brown, assistant editor Terezia Cicelova, and everyone else at Blue Rider.

Both my mother—Antonia Fraser—and Richard Edwards, one of my very best friends, were two of my first readers. I remain grateful for their comments and suggestions.

Finally, for the three Virgos in my life: Ed Victor, my wonderfully supportive agent, and my daughters Allegra and Cecilia, who remain my best creations. Both have been their good-natured selves about this book and the process.

—Paris, March 10, 2017, my (Studio) 54th birthday

NOTES

After Andy began in early March 2015. My initial idea was to write about Andy Warhol's lasting influence and rise in the art market. I would do this by weaving in knowledge acquired from my experience working at the Warhol Studio and *Interview* magazine and covering the social and fashion beat for both *W* and *Harper's Bazaar*, as well as penning a biography about Sam Spiegel, a film producer who knew Warhol but collected Picasso.

Via my agent, Ed Victor, I was introduced to David Rosenthal and Sarah Hochman at Blue Rider Press. "What about a memoir-type book?" said David. I didn't quite get it. "You would be the Boswell and central to the story," he said. With me positioned as an insider, it would be a book anchored by my experiences with Andy and my encounters with people post-Andy and seen through the lens of my life at the time. In Sarah's opinion, this would "give a personal touch" and "bring so much of the internal about Andy rather than the cultural veneer that everyone is familiar with."

After Andy is firmly not a biography about the brilliant artist. The goal behind it was to capture the importance of Europe to Warhol, his friendships with certain women, the introduction of the English Muffins, the continued Warhol effect in art, fashion, and music, and Andy's eternal influence on other people's lives.

And so began my return to Adventures in Warhol Land. On three occasions, I interviewed my former boss, Vincent Fremont. Thanks to his introduction, I then spoke to Peter Brant and Irving Blum. Jean Pigozzi put me in touch with Larry Gagosian. And no doubt, all these names helped when the Zurich-based Bruno Bischofberger agreed to be interviewed.

All the *After Andy* interviews began in New York and ended in Paris. They were conducted over a period of almost two years, from April 2015 until March 2017. There was nothing last-minute about the project, but three last-minute interviews became key: Wilfredo Rosado, Andy's employee and almost confessor-like companion; Éric de Rothschild, a member of a family known for centuries of collecting; and Christian Louboutin, whose signature red sole was indirectly inspired by Warhol.

01 *Andy's Memorial*
Andy's memorial needed to be as visual as possible. My diaries of that period described Issy Delves Broughton, Fred Hughes, and the Warhol Studio, whereas Christophe von Hohenberg's superb photographs brought the event back, as did his book *Andy Warhol: The Day the Factory Died* and Grace Glueck's article "Warhol Is Remembered by 2,000 at St Patrick's," *The New York Times*, April 2, 1987. Regarding Andy's final years, I interviewed Abigail Asher, Pierre Bergé, Bruno Bischofberger, Irving Blum, Peter Brant, Doris Brynner, Bob Colacello, Peter Frankfurt, Vincent Fremont, Diane von Furstenberg, Jacques Grange, Sabrina Guinness, Geraldine Harmsworth, Nicky Haslam, Catherine Hesketh, Kenneth Jay Lane, Len Morgan, Thaddaeus Ropac, Wilfredo Rosado, and Norman Rosenthal.

02 *Early Years*
For this chapter, I referred to "The Write Stuff," an article I wrote for *Harper's Bazaar*, June 2000, and looked at photograph albums of my mother, Antonia Fraser. Equivalent to an archaeological dig, her general wealth of material ranges from photographs to newspaper clippings to baby hair to my childhood drawings and essays. To date, I have never seen albums like hers. Since she's a historian who has an eye and humor, they are masterpieces, an archival version of Andy's time capsules.

03 *Early Lessons in Style*
To capture the tone of the period, I interviewed Nicholas Coleridge, who doubles as a bestselling author and president of Condé Nast International. I've known him since I was seventeen, and he continues to have an extraordinary memory. Thanks to Harriet Wilson and Brett Croft, chief archivist, I went through the Condé Nast Archives.

04 *Holiday Home*
Once again, I relied on my mother's albums and my memories of Scotland, via my article "The Feminine Mystique," commissioned by Eve MacSweeney, published in *Vogue*, October 2005, and my essay "Understanding Chic," in *Paris Was Ours*, edited by Penelope Rowlands. I also interviewed my childhood friend Dominique Lacloche and Farah Diba Pahlavi, whose children came to Scotland when her husband, the Shah, was still in power.

05 *The Bells of St. Mary's Ascot*
This chapter was achieved via my mother's albums, my diaries, my essay "Understanding Chic," in *Paris Was Ours*, edited by Penelope Rowlands, and interviews with Mary Byrne, a fellow Ascot old girl, and with Richard Edwards, who briefly worked at Biba.

06 *When Harold Met Antonia*
For this chapter, I drew on my mother's book *Must You Go?*, which describes her relationship with Harold Pinter, as well as my diaries. That summer of 1975 brought a huge change for all of us in the family.

07 *The Effect of Punk Rock on England*
The photograph of Andy and Jordan has always been one of my favorites because it demonstrates how the artist understood the importance of a movement before anyone else.

To capture Jordan's impact and charm, I quoted from Alexander Fury's "Fashion People: The Sartorial Genius of Jordan (No, Not That One)," *The Indepedent*, November 30, 2013. For the Sex Pistols, I referred to conversations with Malcolm McLaren, as well as Alexis Petridis's "Leaders of the Banned," which appeared in *The Guardian*, April 13, 2002. The famous *Daily Mirror* heading appeared on December 2, 1976. On London in the late 1970s, I interviewed Nicky Haslam and quoted from his *Ritz* column in 1978.

08 *Early Euphoria Under Thatcher*

For Warhol's early 1970s European years with Fred Hughes, I drew on interviews with Bruno Bischofberger, Peter Brant, Andrew Braunsberg, Peter Frankfurt, Vincent Fremont, Jacques Grange, and Clara Saint, as well as Bob Colacello's "The House That Fred Built," *Vanity Fair*, August 1993.

For Warhol's German art market, I am indebted to the expert Rudolf Zwirner, who patiently explained the situation with regard to the collector Wolfgang Hahn and his influence on Peter Ludwig, the renowned collector. I was in contact with the Hahn Archive at the Museum Moderner Kunst Stiftung Ludwig (mumok) in Vienna. Maybe something was lost in translation—it was a frustrating experience. I do hope that one day a bilingual writer will tackle that world.

For my giddy premier years in London, I relied on Nicholas Coleridge and Nicky Haslam; Louise Baring's "Southern Comfort (Marguerite Littman)," British *Vogue*, May 1994; Tina Brown's "Faster, Faster, London Girls," *Tatler*, September 1980; and my portrait in "New Beauties for the Eighties—The World Is Their Oyster . . . ," British *Vogue*, March 1980.

09 *A Whirl with Michael J*

To capture this moment, I consulted my diaries and verified information with my mother. To add flavor, I drew on these articles: Brian Vine, "Jagger Walks Out on Jerry for a Teenager," *Daily Express*, November 11, 1980; "Push Off, Jerry!," *Daily Mirror,* November 13, 1980; William Hickey, *Daily Express*, November 13, 1980; Nigel Dempster, *Daily Mail*, November 24, 1980; "Mick Is the Best Lover Ever—Jerry Hall," *The Sun,* December 1980.

10 *Discovering the Joys of a Monthly Paycheck*

For my activities and relationships during this period, I drew on my mother's photograph albums, and articles by British gossip columnists. They included Nigel Dempster, "A Perfect Teenage Hostess," *Daily Mail*, March 12, 1981, and "Bubble Trouble," April 12, 1981; Compton Miller, "Stone Love Gives the

Frasers a Headache," *Evening Standard*, February 24, 1981, and "Oh Natasha, Not Again!," April 14, 1981.

11 *Leaving England*
Leaving England for Los Angeles was one of the most important decisions in my life. Memories flooded back via Ian Irving, and Nigel Dempster's "Natasha Bash a Smasher," *Daily Mail*, March 20, 1985. To give insight into Andy's attitude toward Catherine Hesketh, Fred Hughes, and Anne Lambton, I interviewed Bob Colacello, Vincent Fremont, and Christopher Makos and referred to *The Andy Warhol Diaries*. For my years in Los Angeles, I consulted my diaries.

12 *Andy Up Close*
For Andy's later years as an artist, I am indebted to the expertise of art world powerhouses Abigail Asher, Bruno Bischofberger, Peter Brant, Vincent Fremont, Larry Gagosian, Jacques Grange, Thaddaeus Ropac, and Rudolf Zwirner, as well as Robert Hughes, "The Rise of Andy Warhol," *The New York Review of Books*, February 1982. To explain the English Muffin phenomenon at Warhol's Factory, I am equally indebted to Peter Frankfurt, Vincent Fremont, Sabrina Guinness, Geraldine Harmsworth, Catherine Hesketh, Anne Lambton, Kenny Jay Lane, Christopher Mason, and Len Morgan. Reading matter included Bob Colacello's *Holy Terror*, *The Andy Warhol Diaries*, and Phaidon's *Andy Warhol "GIANT" size*.

13 *Frederick W. Hughes*
For Fred's early years, I relied on André Mourges, the boyfriend of Alexander Iolas, and Bob Colacello, "The House That Fred Built," *Vanity Fair*, August 1993. Otherwise, to capture his prismatic personality, I interviewed Robert Couturier, Peter Frankfurt, Vincent Fremont, Anne Lambton, Kenny Jay Lane, Christopher Makos, Len Morgan, and André Mourges, as well as Frank DiGiacomo, "A Farewell to Dapper Fred Hughes," *The New York Observer*, January 29, 2001.

14 *Preppy Vincent—The Only One with the Warhol Enterprises Checkbook*
On Andy's modus operandi and relationship with *Interview* magazine, I drew on Vincent Fremont, Christopher Makos, Len Morgan, and Wilfredo Rosado. On Andy's untimely death and the aftermath, I relied on Ronald Sullivan, "Care Faulted in the Death of Warhol," *The New York Times*, December 5, 1991; Tina Kelley, "Robert H. Montgomery Jr., 77, Entertainment Lawyer, Dies," *The New York Times*, September 4, 2000; and John Taylor, "Andy's Empire: Big Money and Big Questions," *New York*, February 22, 1988.

15 *Andy's Sale at Sotheby's*
To encapsulate Andy's richness as a collector, I interviewed Peter Frankfurt, Vincent Fremont, Jacques Grange, Catherine Hesketh, Ian Irving, Kenny Jay Lane, Louis Lefebvre, Len Morgan, and Gordon Watson. Besides my diaries, I relied on John Taylor, "Andy's Empire: Big Money and Big Questions," *New York*, February 22, 1988; Andrew Solomon, Gloss Finish (http://andrew solomon.com/articles/gloss-finish/); *The Andy Warhol Collection* (Sotheby's auction catalogue), volumes 1–6; and *The Andy Warhol Diaries*.

16 *Andy's Estate and Aftermath*
I referred to the expertise of Abigail Asher, Bruno Bischofberger, Irving Blum, Peter Brant, Vincent Fremont, Larry Gagosian, and Thaddaeus Ropac; and Michael Brenson, "Looking Back at Warhol," *The New York Times*, February 3, 1989. *The Andy Warhol Diaries* were essential reading to gauge the artist's attitude to his world. I am also indebted to Carol Vogel's articles for *The New York Times* that capture the general mess of Fred Hughes's Sotheby's sale and the Warhol estate and Warhol Foundation. These include "Still Arguing the Value of Warhol's Estate," June 16, 1992; "The Art Market," April 9, 1993; "10 out of 12 Warhols Go Unsold in First of Big Spring Art Auctions," May 4, 1993; "The Art Market," May 21, 1993; "Value Put on Estate of Warhol Declines," July 21, 1993.

17 *Joining Andy Warhol's* Interview *Magazine*
For this chapter, I relied on interviews with Bob Colacello, Vincent Fremont, Len Morgan, Wilfredo Rosado, and Shelley Wanger, as well as my "Anglofile" columns for *Interview*, 1988–1989.

18 *Life with Talcy Malcy*
To capture Malcolm's charisma and chaos, I drew on my diaries from the period and Paul Taylor's introduction in the New Museum of Contemporary Art's catalogue *Impresario: Malcolm McLaren and the British New Wave* (New York: New Museum of Contemporary Art, and Cambridge, MA: The MIT Press, 1988).

19 *The Publishing of Andy's Diaries*
I discussed the effect of the publication of the diaries with Bruno Bischofberger, Bob Colacello, Peter Frankfurt, Vincent Fremont, Diane von Furstenberg, Nicky Haslam, and Catherine Hesketh, and relied also on Michael Gross, "The Satanic Diaries," *New York*, May 29, 1989. On the selling of *Interview* magazine, I referred to the business section of *The New York Times*, May 9, 1989.

20 *Headed for Paris*
To capture this emotional moment, I relied on my diaries—I wrote so much during this period—and my column "What Ever Happened To . . . ," published in *Interview* in July 1989, which concerned France's bicentenary and inspired my move.

21 *Andy, Mick, and Yves*
When I arrived in Paris in 1989, it was all about Andy, Mick Jagger, and Yves Saint Laurent. To illuminate this phenomenon, I interviewed Pierre Bergé, Bob Colacello, Gilles Dufour, Jacques Grange, Nicky Haslam, Christopher Makos, and Clara Saint. I also watched Vincent Fremont's home film of Saint Laurent being presented with his Warhol portrait. I referred as well to Bob Colacello's *Holy Terror*; *The Andy Warhol Diaries*; Kynaston McShine, *Andy Warhol: A Retrospective*; and Tony Shafrazi, Carter Ratcliffe, and Robert Rosenblum's *Andy Warhol Portraits*.

For the opportunity to view Fred Hughes's former apartment in Paris, I am indebted to the present owner, Yannick Pons. Looking around and seeing Andy's bedroom and then Fred's gave me a sense of their existence in Paris.

22 *Getting the Keys to Karl's Kingdom*
To capture the tone of the period, I relied on my diaries and drew on John Colapinto, "In the Now—Karl Lagerfeld," *The New Yorker*, March 19, 2007.

23 *The Chanel Studio*
My diaries and Kate Betts's *My Paris Dream* were the best sources for this fashion-charged chapter.

24 *Chanel and Paris's Social Swirl*
To capture Andy's social activities in Paris, I drew on interviews with Bob Colacello, Florence Grinda, and Clara Saint, as well as Kate Betts's *My Paris Dream*, Bob Colacello's *Holy Terror*, and Jean Pigozzi's *Catalogue Déraisonné*.

25 *The Reign of Frogchild*
For the account of this rewarding change of employment, I relied on my diaries and these articles of mine from *W Fashion Europe*: "Lady Salisbury's Green Thumb," July 1991; "Château Loulou," September 1991; and "Molly Blooms," June 1994.

In a March 10, 2017, conversation, Taki Theodoracopulos confirmed the expression "Ayatollah of Fashion" from the 1990s, but he could not remember the publication: "I was writing for all and everyone then," he says.

26 *Warhol Land Continues to Haunt*
For the time, the tone, and the characters in this chapter, I interviewed Bob Colacello and Vincent Fremont and referred to my articles: "Postcards from St. Petersburg," January 11–13, 1993, *WWD*; and "Venezia Fête City," October 1991; "Le Chic Rustique," September 1992; "Provocative by Design," September 1992—all for *W Fashion Life*.

27 *Fashion's New Guard*
For this chapter, I referred to my diaries. Working at Fairchild in Paris and being friends with Christian Louboutin meant nonstop parties that I rarely missed.

28 *Andy's* **Flower** *Paintings Leading to Louboutin's Red Soles*
My diaries, Nicole Phelps's article "Remembering John Fairchild" for Vogue .com, February 28, 2015, and Rupert Everett's *Red Carpets and Other Banana Skins* were sources for this chapter. Everett's outrageous autobiography reports the madness of the *Prêt-à-Porter* shoot even if I remember some details differently.

Epilogue
To bring Warhol's career and influence together, I interviewed Bruno Bischof-berger, Irving Blum, Peter Brant, Diane von Furstenberg, Larry Gagosian, Nicky Haslam, Christian Louboutin, Farah Diba Pahlavi, Norman Rosenthal, Éric de Rothschild, Suzanne Syz, and Rudolf Zwirner.

I am also indebted to David Bailey's documentary on Warhol, *In Bed with Andy*. At moments, the artist is exactly like a Cheshire cat.

SELECTED BIOGRAPHY

The Andy Warhol Collection. Sotheby's auction catalogue, 6 vols. New York: Sotheby's, 1988.

Bailey, David. *In Bed with Andy* (documentary). 1973.

Betts, Kate. *My Paris Dream.* New York: Spiegel & Grau, 2015.

Bischofberger, Bruno. *Andy Warhol's Visual Memory.* Zurich: Galerie Bruno Bischofberger, 2001.

Bockris, Victor. *Warhol: The Biography: 75th Anniversary Edition.* New York: Da Capo Press, 2003.

Brown, Tina. *Life as a Party.* London: André Deutsch, 1983.

Colacello, Bob. *Holy Terror: Andy Warhol Up Close.* New York: HarperCollins, 1990.

Everett Rupert. *Red Carpets and Other Banana Skins.* London: Little, Brown, 2006.

Fraser, Antonia. *King Arthur and the Knights of the Round Table.* London: Sidgwick & Jackson, 1970.

_____. *Must You Go? My Life with Harold Pinter.* London: Weidenfeld & Nicholson, 2010.

Greig. Geordie. *Breakfast with Lucian: The Astounding Life and Outrageous Times of Britain's Great Modern Painter.* New York: Farrar, Straus and Giroux, 2013.

Hughes, Robert. *The Shock of the New: Art and the Century of Change.* London: Thames & Hudson, 1991.

Janowitz, Tama. *Scream: A Memoir of Glamour and Dysfunction.* New York: Dey Street, 2016.

Louboutin, Christian. *Christian Louboutin.* New York: Rizzoli, 2002.

McShine, Kynaston, ed. *Andy Warhol: A Retrospective.* New York: The Museum of Modern Art, 1989.

Phaidon editors. *Andy Warhol "GIANT" Size.* Photo edited by Steven Bluttal. New York: Phaidon, 2006.

Pigozzi, Jean. *Catalogue Déraisonné*. Göttingen, Germany: Steidl, 2010.

Rowlands: Penelope, ed. *Paris Was Ours: Thirty-two Writers Reflect on the City of Light*. New York: Algonquin Books, 2011.

Shafrazi, Tony, Carter Ratcliffe, and Robert Rosenblum. *Andy Warhol: Portraits*. New York: Phaidon, 2007.

Thomas, Dana. *Gods and Kings: The Rise and Fall of Alexander McQueen and John Galliano*. New York: Penguin, 2016.

Von Hohenberg, Christophe, and Charlie Scheips. *Andy Warhol: The Day the Factory Died*. New York: Empire Editions, 2006.

Warhol, Andrew. *The Andy Warhol Diaries*. Edited by Pat Hackett. New York: Twelve, 2014.

_____. *The Philosophy of Andy Warhol*. London: Penguin, 2007.

_____. *POPism: The Warhol Sixties*. New York: Harcourt Brace Jovanovich, 1980.

PHOTO CREDITS

With mother and Bertie: Collection of Antonia Pinter

Christmas card photo: Geoffrey Keating/Collection of Antonia Pinter

On Cooden Beach: Antonia Fraser/Collection of Antonia Pinter

Photo from 1965: Antonia Fraser/Collection of Antonia Pinter

Father in Biafra: Collection of Antonia Pinter

With Edna O'Brien: Antonia Fraser/Collection of Antonia Pinter

At Penny Ridsdale's wedding: Collection of Antonia Pinter

Family with Aunt Rachel: Terrence Spencer/*Life* Picture Collection/ Getty Images

Mother reading: Collection of Antonia Pinter

Seventh birthday: Antonia Fraser/Collection of Antonia Pinter

Benjie's tenth-birthday party: Antonia Fraser/Collection of Antonia Pinter

Last day at Lady Eden's School: Antonia Fraser/Collection of Antonia Pinter

General-election photograph: Collection of Antonia Pinter

With Orlando: Antonia Fraser/Collection of Antonia Pinter

Harpers & Queen, *August 1978:* Mayotte Magnus/Collection of Antonia Pinter

Portrait by Clive Arrowsmith: Clive Arrowsmith/Collection of Celestria Andrew-Sinclair

At Barbati Beach: Antonia Fraser/Collection of Antonia Pinter

Vogue *shoot:* Stefano Massimo, *Vogue*, March 1, 1980 © The Condé Nast Publications Ltd

Andy as guest of honor: Alan Davidson/SilverHub

Vogue *outtake:* Stefano Massimo, *Vogue* © The Condé Nast Publications Ltd, Collection of Celestria Andrew-Sinclair

"Faster, Faster, London Girls": Nick Jarvis, *Tatler*, September 1980

Harassed by paparazzi: Alan Davidson/SilverHub

ABOUT THE AUTHOR

Natasha Fraser-Cavassoni is the author of *Sam Spiegel, Tino Zervuda-chi, Monsieur Dior, Dior Glamour, Loulou de la Falaise, BiYan,* Vogue *on Yves Saint Laurent,* and Vogue *on Calvin Klein.* She was the European editor for *Harper's Bazaar* from 1999 to 2004, after serving as a staff member and journalist at *Women's Wear Daily* and *W* magazine, and assisted Karl Lagerfeld at the Chanel studio. She lives in Paris with her two daughters.